Talking Art

Talking Art

*The Culture of Practice and
the Practice of Culture in
MFA Education*

GARY ALAN FINE

The University of Chicago Press Chicago and London

The University of Chicago Press, Chicago 60637
The University of Chicago Press, Ltd., London
Published 2018
Printed in the United States of America

27 26 25 24 23 22 21 20 19 18 1 2 3 4 5

ISBN-13: 978-0-226-56018-2 (cloth)
ISBN-13: 978-0-226-56021-2 (paper)
ISBN-13: 978-0-226-56035-9 (e-book)
DOI: https://doi.org/10.7208/chicago/9780226560359.001.0001

Library of Congress Cataloging-in-Publication Data
Names: Fine, Gary Alan, author.
Title: Talking art : the culture of practice and the practice of culture
 in MFA education / Gary Alan Fine.
Description: Chicago : The University of Chicago Press, 2018. |
 Includes bibliographical references and index.
Identifiers: LCCN 2018010071 | ISBN 9780226560182 (cloth : alk. paper) |
 ISBN 9780226560212 (pbk. : alk. paper) | ISBN 9780226560359 (e-book)
Subjects: LCSH: Art—Study and teaching (Higher)—United States. |
 Master of arts degree—United States.
Classification: LCC N346.A1 F56 2018 | DDC 700.71—dc23
LC record available at https://lccn.loc.gov/2018010071

♾ This paper meets the requirements of ANSI/NISO Z39.48-1992
(Permanence of Paper).

To

Lynne Browne, Collector

Marcia Cohen, Artist

Louise Shaw, Curator

Contents

Acknowledgments

I am grateful for the conversations and support from many colleagues and friends, who provided insights into the contemporary art world, bringing me out of an Impressionist fog into an impressive world. I particularly appreciate my conversations with Sophia Acord, Bridget Alsdorf, Claudio Benzecry, Yves-Alain Bois, Larissa Buchholz, Charles Camic, Carolyn Christov-Bakargiev, Marcia Cohen, William Conger, James Elkins, Andreas Fischer, Dianna Frid, Wendy Griswold, Tim Hallett, Irving Lavin, Gemma Mangione, Sakhile Matlhare, Eric May, Gianna Mosser, Ann Mullen, Geof Oppenheimer, Marc Parry, Alexander Potts, Lane Relyea, Joe Scanlon, Barry Schwabsky, Howard Singerman, Sarah Smelser, Hannah Wohl, and Queen Mecca Zabriskie. Several of these colleagues provided helpful critiques of this manuscript. I am grateful to Gianna Mosser and Gemma Brennan for their invaluable help in transcribing interviews.

Prologue

Good work. We claim that artworks reflect the grandest ambition of the human spirit. Artists are awarded the mantle of genius; their creations are housed in civic temples. Some gain wealth from auctions in which collectors compete to acquire relics that reflect distinctive, true, and authentic vision. Yet, artists are often ignored or mocked by those who disparage the object's form or message.

To be an artist is to shape culture or to desire to do so. Or perhaps to be an artist is to think of oneself as the kind of person who shapes culture: a statement of identity as much as outcome. But what is the process by which contemporary artists are made? How does one *become* an artist? How does one choose to create artistic forms and then announce those forms to the world? To answer these questions, I examine how young artists navigate their training, honing their craft and defining their selves, while enrolled in university-based graduate programs. Although I emphasize the daily lives of students, I also describe how students are shaped by their relations with faculty and with others in the art world. How do young artists fit into this world, and how do they, as students, think of the world after school? Throughout this book I ask: How do art students think of themselves as artists, and how do they discuss their practices with each other and with the outside world?

Every discipline has a preferred method of graduate training, a form of pedagogy judged essential for acquiring the skills to be seen as competent and for obtaining the occupational credential and collegial esteem. Through the rituals of socialization, those who were once novices gain authority

to enter a discipline. Law schools privilege Socratic dialogues; business schools insist that trainees interpret case studies; and medical schools organize grand rounds. Graduate art programs revere the *critique*, the gateway to artistic culture, reflecting the belief that artwork has a lineage and an intention, and that both must be explained and defended. Artistic betterment develops from the sting of communal evaluations.

For much of the public, attending a graduate-level MFA (Master of Fine Arts) critique might be disconcerting or disorienting. The critique is a form of group practice, attended by specialists, in which heated assessments and tough questions, directed to students, are possible, understood, and often desired. We, the public, are accustomed to hushed or crowded museums where we are exposed to works that have little in the way of explanation and to exhibitions in which the works have survived the sharp winnowing of curators. Museums are designed for pleasure and contemplation; the critique, for challenge. At museums we face works with the aid of wall texts or labels, uncovering meaning as we can, often focusing on visual appeal. Can we imagine this over our couch? Beauty is the basis of *museum love*. Judgment depends on the viewer and the object, sometimes aided by an enthusiastic docent.

An MFA critique is another matter. These occasions assess meaning, question intention, find connections, and reference theory. The viewing of paint on canvas or of sculpted stone is insufficient. The MFA critique makes interpretation insistent and evaluation essential. Material generates discourse, and words judge material. Passing through the rigor of critique demonstrates that one merits the label of "professional artist," a credential certified by the university or art school. Today visual art is a discipline, not just a calling or a pursuit. Yes, many young artists love their careers, but they must also develop the skills to survive within a tough reputational market.

What is a critique? It is an academic performance, a ritual of judgment. A room is set aside in which a student displays her work (always labeled "work," never "art"), reflecting the student's current focus or fixation.[1] Typically, these works are treated as belonging together; they are part of a series that reflects a signature style,[2] critical for the development of an artistic persona.[3] Through the choice of what to create and then present, the student is developing a public identity, and through this, potentially, a disciplinary (or market) niche. This niche—or public persona—becomes critical to the establishment of a post-school career. Whether or not all the work is part of the same series, critics expect that the stream of work will look as if it was made by the same hand, and, if not, disapproval may result. In most critiques works have a recognizable style. This may involve

traditional genres, such as painting, sculpture, or video, but it may also include an installation of created, found, or curated objects; a performance; or an "idea in material form," as in the case of conceptual art.

At a set time, faculty, students, and art world guests enter and mill about the room.[4] For video, film, or new media, chairs are provided, and viewers watch as an audience. After a suitable period (often five minutes), the student will be asked for an opening statement. Then the faculty and guests (and occasionally a brave student) comment on the work, question the artist's intention, or suggest lines of future development. The comments may focus on technique, but most often they question the justification of the project and consider whether the work successfully meets what is taken to be the artist's goal. As is true in all domains with local outposts, schools differ in their norms of evaluation and their cultures of judgment, part of their local cultures. There is no one right way to hold a critique, even if general expectations exist. These differences include the length of each critique; whether the audience stands, sits, or squats; whether the artist must respond; whether students are encouraged to participate; whether faculty advisers participate in the critiques of their students; and whether the comments are expected to be harshly critical or gently phrased. I discuss such issues in considering the *interactional politics* of critiques subsequently. But one moment is universal: At the end of the critique, no matter how hostile the questioning—how much blood is spilled—attendees applaud. The student has survived.

I describe a critique held in October at one of my research sites.[5] This was a midterm critique in which the work of each student was discussed for thirty minutes. (Critiques at the end of the semester last forty-five minutes.) The art building had once been a downtown factory, but had been retrofitted with art studios, classrooms, and gallery spaces. Ten students were judged each day, a mix of first- and second-year students. Characteristic of the program, a wide variety of styles and genres were represented, including painting, sculpture, video, photography, and installations of gathered objects. Both the form of the work and the topics of discussion shifted wildly from critique to critique.

This occasion revealed tensions within the critique as a discursive space, and it subsequently led to a program-wide discussion of the form that critiques should properly take. Should they be humane embraces, or should they reflect tough love, or both? I consider this question further in chapter 4.

The day begins with two dozen faculty members and students gathering in an exhibition space—a white-walled room—to examine the project of a student of color that combines installation, video, and performance.

Carlos[6] presents a *performance* in which he emotes loudly into a microphone (aided by electronically generated feedback), creating a deliberately inarticulate "language" that in its raucous chaos was intended to reveal threats to his self, referencing what he labeled the "politics of identification." As is often true of esoteric performances, some faculty members express frustration, with one candidly admitting, "I don't get it." Another remarks, "It is hard to get excited about not understanding something," disparaging this loud and boisterous act as dry, formal, and academic. To be called academic—or didactic—is typically a criticism. A third attempts a synthesis: "Is this piece about the reclamation of some imagined historical identity?" This is an invitation to explain. That the work is *personally* meaningful is not sufficient, the personal must become political and communal.

We amble to another room, spotting two new canvases by Dane, a young painter. Unlike many photographers, who produce much work and brutally edit what they elect to show, most serious painters are slow creators. Dane's canvases each took a month to create. Critiques often take into account the means of production. Two large works provide a sufficient basis of discussion and do not suggest a lack of commitment. (He also displays an older work to indicate his progress.) Dane fashions abstract works with a web of colorful, snakelike forms and geometric shapes. Abstraction had once fallen out of favor, but is back in style. The jeering that once suggested that "painting is dead" has passed, although abstract painters must justify that their intention goes beyond "decoration" (like "academic," "decorative" is typically a pejorative). In contrast to Carlos's presentation, Dane is not asked for the content-based meaning of his work. This discussion is about its effects on the viewer. Faculty recognize that Dane is skilled; he has the technical authority to make marks on canvas. One faculty member—a painter—refers to the ugliness of the work, suggesting of one shadowy image that "the shadow is almost a Rorschach, but not quite. There is some very unattractive color-making that is very exciting." Rather than claiming that an ugly painting reveals a lack of technique or is a failed object, they count as virtuous and provocative the fact that the palette is unattractive to a viewer, which differentiates the work from the genial pieces found at community craft shows, the province of Sunday painters. A second faculty member compliments Dane, observing, "There is a casualness in your decision-making," which suggests that Dane is confident enough to let his instincts guide him as to whether to layer heavy swaths of paint or use a lighter touch. Others comment on formal (but also emotional) aspects of the work, referring to the "unsettling diagonals" or noting that "yellow is such an unstable color."

But the primary thrust is to ensure—given the suspicion that "painting's role in the world is to please"—that the work is disturbing, a sign that the artist is challenging expectations. Dane agrees: "I make a pretty painting and then I want to fuck it up. . . . I want to loosen up the painting a little more."

A third student, Austin, displays a series of lush photographs depicting a community in Faulkner country. These are simultaneously aesthetically appealing and ethnographic depictions of a kudzu-laden reservoir and of local residents. Here the concern is different. No one critiques the photos as technical productions; instead they examine Austin's storyline. Everyone appreciates their beauty, but, as with Dane's work, beauty is a challenge. How can beauty be used purposively and avoid the taint of mere ornamentation? While artists take different stances toward the validity of aesthetic objects, in contemporary art most agree that beauty needs to serve the artist's intention; critical thinking must go deeper and lead to more than the mere production of gorgeous things. The challenge is to share meaning with an audience, as revealed by the photographs. One faculty member suggests severely: "These seem like illustrations. If they are included in a narrative I would be more excited." Another tells Austin, who is intent on capturing *something* about the South, that "you haven't figured out what is the connection to Faulkner you want to explore." Unlike paintings, naturalistic photographs demand an implicit, readable narrative; if not, they cut too close to what an amateur might produce.

The emotional crux of the day, a moment with institutional reverberations, occurs after a convivial lunch. The heightened drama emphasizes the reality of the sociopolitical (and gendered) field through which young artists navigate. Art is not equally open to all, at least in the best, most prestigious programs. This domain is not welcoming to those who see themselves—or, more pointedly, are seen by others—as conservative or those who embrace traditional values. Artists are diverse in their backgrounds, but rarely in their politics, recognizing the existence of various streams of progressive beliefs. To decide to become an artist often involves embracing a set of broadly shared values, as is true for joining the professorate.[7]

Michelle, the student being critiqued, does not define herself as a conservative, even if, compared to certain classmates, she fits more easily into mainstream culture. Her installation consists of objects and photographs with personal religious significance. She announces in her artist statement that she was raised as a Catholic, but that the Church "revealed an unfriendly dogma and I want to know if I can continue to believe. I desire the physical architecture of the church and the comfort of touch."

Like many young people, but unlike many artists, she struggles with faith. Still, her work references the personal. As with LGBTQ people and students of color, Michelle's practice helps her define her identity, coming close to providing a supportive therapeutic intervention. Such a personal approach with its surrounding discourse is hardly unknown in elite museum displays of contemporary art. Yet, while other artists "get a pass" when they expose their diverse lifeworlds, students addressing religious faith find themselves at reputational risk.

Whether because of the content of the installation or its theme, Michelle is harshly and robustly criticized by several faculty members. One suggests that this seems "very tired as a theme. Not this lovey-dovey metaphor of social unification." Other faculty members express skepticism over the value of the project, a challenge that students with other identities would be unlikely to face. The issue is dramatically raised by a senior faculty member, Paul, who responds sharply and personally, asking, "Why do you want to stick with an organized genocidal institution? Why don't you get over it? . . . I have some advice for you as a teacher. Stop doing it." At this point Michelle begins to weep, wiping away her tears, and apologizing for her own "unprofessional" response. While the heat of Paul's critique was unique during my observations, and while it fit his well-recognized interactional style, his response was shared by others in more modulated ways.

Michelle's intense emotional response also was not unique. I never witnessed other students in tears, but several female students admitted that they cried in their studios after a harsh critique; one male told me that he barely restrained himself from weeping. The drama of the occasion provoked mild defense from some faculty, and a partial backtracking from her critic, who concluded: "Personally I despise your religion, but if you want to work with it, more power to you." Later he offered Michelle an apology.

This occasion impressed me by its drama, and I do not argue that it is *characteristic* of critiques, but it emphasizes that critiques can have intense emotional moments linked to artistic ideology. Afterward several students told me that they agreed with Paul, but remarked that "there are much better ways to say it." In other words, be polite in your hatred of the church. The intensity of these comments crossed a line, but their substance did not. Subsequently Michelle's practice changed, with the work becoming more layered in its production and presentation, and she refrained from explicitly linking her work to her faith. Over time her work became more highly esteemed by faculty.

As I discuss subsequently, the program, its members shaken by the raw emotion displayed at Michelle's critique, held a meeting of students and faculty, discussing how to improve critiques.[8] As an outsider, I was startled and, at first, appalled, but I learned that Paul, himself a distinguished artist, was esteemed by many students, several of whom—of both genders—named him as their most important mentor. They recognized his intensity, but also believed that for him—and for them—art "really mattered," in that "something important was at stake." The force of his comments revealed (for some) that there are consequences to what you produce. Michelle's experience revealed challenges faced by those who express conventional values in the contemporary art world, and, just as important, it emphasized that art is not something that hangs on a wall, but something that hangs over the world, shaping hearts and minds.

Each episode of critique, as these four examples suggest, turns on issues important for the evaluation of visual art by a community: a community in which people know and, often, care about each other. The discourse in one room might not predict what happens in the next, but together they create a mosaic of talk and evaluation in which emerging artists learn what their mentors and colleagues will say publicly, even when consensus is hard to achieve. As Michelle's experience demonstrates, a critique is a performance in which each actor presents an identity, linked to a set of themes or theories about what it means to have an artistic identity and what it means to have a body of work.

By the end of the series of critiques, I left battered and bettered. For an outsider, work that seemed at first glance to be curious, obscure, or perverse contributes to a discourse that may change how one sees life. Art is philosophy—and politics—in visual form.

The Brave New World
of the MFA

At age seventeen I dreamed of becoming a professional art-
ist. Growing up blocks from the Metropolitan Museum of
Art, I was exposed to the masterworks within. I was en-
tranced by the color and exuberance of the French Impres-
sionists. Claude Monet was my man. These artists are, for
many Americans, the gateway into art appreciation. The
prettiness of their canvases is seductive. I started painting,
mimicking an Impressionist style. My logic was impeccable
and impregnable: If these works are so lovely, shouldn't we
wish to have more of them? But I was shocked to learn
from my high school art teacher that to paint Impression-
ist oils would lead not to a career, but merely to a hobby.
We need no more Monets. My work lacked the justification
that would permit it to be taken seriously. The Impression-
ist moment had passed, its style now limited to amateurish
craft fairs. I was crushed. Ultimately I chose an academic
field, sociology, over art. At least sociologists still revere *their*
nineteenth-century heroes.

––––––

Not so long ago the arts were the font of civic pleasure.
People visited museums to admire objects of beauty: the
splendor of the possible, the grandeur of talent, the height
of humanity. Artists embraced that goal. The arts generated
numinous and sensual delight. The "fine" arts were as close
as mere mortals came to the divine. One experienced the

arts for enlightenment: the Kantian sublime. Viewers hoped for the thrill of aesthetic rapture. While this is an overgeneralization—many artists over the centuries have had subversive or rebellious agendas, sometimes recognized by their audiences—here even the political was addressed with panache.[1]

In recent decades the art world has changed. My central focus in this book is to explore that change. Today artists increasingly create for each other, hoping for approval from those within the guild, and they must explain what they intend. Once artists were mute, today they talk and write as well as create. The art world is an occupational community, like sociology, medicine, or law. Now embedded in universities and art schools, art increasingly constitutes an academic discipline. This shift in focus might limit art's broad appeal, as the size of the audience for fine arts has declined over the past several decades.[2]

The change is institutional. University education affects art practice and art identities. During the past half-century, Master of Fine Arts (MFA) programs have blossomed. To be a "serious" artist is to have a serious degree. By observing three university art programs over a period of two years, I am able to describe the changes wrought by university graduate education. Here is an institution in which techniques of making and career skills of professionalism are not collectively taught, as one might imagine. In their place one finds theory, talk, self-presentation, and evaluation. These constitute the means by which artists define themselves and art programs claim the mantle of autonomy as sites of ideas. For many artists truth has trumped beauty. Surely the craft skills of object-making still matter, but increasingly MFA students have acquired those skills previously or privately. In short, university art programs claim the authority to define "good art," a claim that is contested against the powerful evaluations of the market. It is often said that the market dominates, but nonetheless the academy has great influence. Occupational socialization involves joining the discipline as aesthetic citizens, not joining the economy as craft workers.

Specifically, in this book, I ask how the arts have been transformed into a theory-driven field. Why does a painting demand discussion and not just appreciation, and why does this demand the credential of a graduate degree? Indeed, why do some of those in the field even assert that an MFA degree is not sufficient? The next step is a Ph.D. in visual arts, transforming cutting-edge art production into a field of research.[3] Further, what does this say about other contemporary aesthetic occupations, such as literature or filmmaking, particularly as practitioners of many cultural genres are now trained in universities?

In many cultural worlds, educational credentials are desired. Apprenticeships that used to be customary have been replaced by schooling. One no longer needs to labor for years with talented chefs to become a cook; instead, one obtains a diploma in culinary education from a quasi-university such as the Culinary Institute of America or Johnson & Wales University. One is trained in an institution, and not just by a person. Lacking a diploma, one cannot cut the mustard. By degrees we have become a country of disciplinary credentials. To be a poet—to belong to the community of serious poets—it no longer suffices to wield a pencil or a computer keyboard with literary skill; one requires a certificate from one of the writing workshops that dot the land, articulating the theory of poesy. The undegreed—and some who are degreed—wonder whether we need so much classwork to justify creativity. In numbers those lacking degrees still have the edge. The Census Bureau's 2012 American Community Survey, a survey of one percent of the American population, tells a tale. Only 16 percent of the 1.2 million working artists have arts-related bachelor's degrees (data were not collected specifically on MFA degrees), indicating that most arts workers lack formal disciplinary qualifications.[4]

The consequences of the changes in the organization of arts worlds are profound. Perhaps this is not *professionalization*, as found in medicine or law, but rather the *academicization* of the arts.[5] Professors have become oracles. One not only receives a degree, one is immersed in aesthetic theory and judged by disciplinary mentors. How did the arts become an adjunct of the university, and what are the implications for creativity?

In a 1975 essay, *The Painted Word*, the maverick journalist Tom Wolfe penned a controversial blast condemning the state of contemporary visual art. The book was not to everyone's taste. Contemporary art had just emerged from what had once been labeled "modern art." Wolfe was none too pleased with the new emphasis on artistic theory. He pointed to the in-bred community that he termed "Cultureburg," feeling that too many cared less about daubs and designs than about how that pigment might be used by the critical mind: "Not 'seeing is believing,' you ninny, but 'believing is seeing.'"[6] Wolfe speculated that by the turn of the millennium, art museums might no longer hang paintings, but only provide an explanation of the artist's intention. He imagined a grand New York retrospective of "American Art, 1945–75": "Up on the walls will be huge copy blocks, eight and a half by eleven feet each, presenting the protean passages of the period. . . . Beside them will be small reproductions of the work of leading illustrators of the Word from that

period."[7] For Wolfe, art was becoming less about feeling through seeing than about thinking through writing.

Despite his provocation, Wolfe was not alone in questioning art's direction. The division of good and bad art was being transformed into the question of whether something (an object, an act, or even an idea) is art at all and who chooses. As critic Harold Rosenberg pointed out, art was becoming "de-aestheticized."[8] Art became theory: discourse in material form, an argument prominently made by philosopher Arthur Danto.[9] Art depended on intellectual engagement, rather than a feel for the work.

Perhaps more important, art was becoming an occupation in which, similar to elite professions, standards of good work were judged by fellow practitioners, a system in which degrees and discourse were crucial. Art was no longer material craft, but a discipline like philosophy, politics, or even sociology. An academic program certified that the artist had mastered the ideas through which artists create and that determine how they think, how they present themselves to publics, and with which communities they associate. Identity and reputation were now based in university training, and as art became a discipline, artists themselves were "disciplined." The challenge became how to maintain a sense of authentic creativity, while being immersed in a regimen of training. In contrast to popular musical forms, such as jazz, rock, or rap, where training still takes place largely outside university halls and creators who are too highly educated may be scorned, art education has been embraced by universities and creativity is now viewed as deriving from and enriched by the examination of theory. While "Sunday painters" are common, "serious artists" are increasingly likely to point to their graduate degrees.

University-based art education is seen as valuable by a community composed of judges educated in similar programs. Perhaps the MFA began as an impressive credential, but degrees only have effects when they are seen as a marker of a set of abilities that the nondegreed lack. The existence of a community searching for autonomy allows the MFA (and to some extent the Bachelor of Fine Arts, or BFA) to provide a claim of competence. While this claim is not universally accepted, the degree has come to be seen as a marker of the ability to articulate one's intentions, to link one's work with that of others in the field's cartography, and to make a case that the work has a meaning, and not merely a presence. Although few patients would choose a self-taught physician, this is not yet true for collectors or galleries with regard to artists—but the change is palpable.

Gallerists increasingly choose to represent artists schooled in art practice, believing that well-trained MFAs can articulate intentions that allow them to participate effectively in a competitive art world. These skills,

admired by fellow practitioners and associated critics, curators, and collectors, constitute the autonomy that visual artists seek. Without such a belief, an art degree would be little more than a marker standing for provisional and routinized labor,[10] as in the case of interns.[11] Despite its critics, who doubt its cost/benefit ratio, the MFA has become an increasingly popular option that now defines artists and provides them with opportunities. The degree symbolically marks commitment to shared ideals, even if "occupational closure" has not entirely limited access to this labor market by the nondegreed.[12]

Jane Chafin, a West Coast dealer, suggests that the proportion of MFA artists shown in Los Angeles galleries is about 40 percent.[13] A prominent art theorist has indicated that approximately 60 percent of artists represented by a gallery in the Chelsea part of New York City had MFAs, and one of my informants estimated that about 70 percent of artists at leading New York galleries have MFA degrees (Field Notes).[14] Art journalist Sarah Thornton states that most artists under fifty in major museum exhibitions have an MFA from one of a handful of prestigious schools.[15] These are not precise figures, but the proportion is likely to rise. Wolfe, at the dawn of this era, does not discuss art schools. He writes of artists in bars, not in lecture halls; in cenacles, not in seminars. The number of university programs awarding MFAs had just started to expand when Wolfe had his say. By the twenty-first century academicization had triumphed.

Education affects what is produced at the highest level of the arts. We live in a world of the painted word. High school poets—and there are many—are unconcerned whether they obey standards of contemporary poetry. They wish to write a *cri de coeur* or a love sonnet that will satisfy their inner desires or those of their beloved. But to be a serious poet one must write for other serious poets. One must compose the poetical word. Cooks cook for each other, and dancers care passionately what their colleagues think. In each genre we find a niche for specialists.

This is my topic: What does it mean to be trained in the visual arts today? How does institutional training shape the identity and the skills of young artists? How do local environments create a group culture and establish ties to other institutions? How do universities matter as art increasingly becomes part of the institutional mission of higher education? To address these questions, I have situated my research within research universities, not free-standing art schools or for-profit art academies. While some of my arguments apply broadly to art education, I ask specifically how the university shapes art production and the autonomy of evaluation. This is a study of students in school; I do not follow these

artists into their post-school careers, though this is another important topic. I do discuss how, as students, they imagine those careers.

The MFA

The American university has not always been hospitable to artists. To be sure, undergraduate students were taught to write—even to write "creatively"—as early as the 1880s,[16] and students have been taught to draw and paint for over a century. However, this teaching was not treated as professional socialization; rather, it was designed to create a well-rounded collegian. The idea that the university might provide career training for artists took hold in the 1920s.[17] Over time the art world has embraced such a role for the university, lately with enthusiasm. Artistic training—in visual art, screenwriting, poetry, jazz, theater, even wine-making—was channeled into legitimate graduate programs, a form of what education scholar Mitchell Stevens[18] describes as the "creation of esoteric niches" in the American university. Today universities are integrative systems, linking what would otherwise be distinct social fields through the potential for networking on campus. The university is a hub of activities and an anchor for those activities.[19]

A half-century ago, an MFA degree in visual arts was a rarity.[20] As Howard Singerman points out in his essential account, *Art Subjects: Making Artists in the American University*,[21] the embedding of artists within the research university is a recent phenomenon. What are the effects on the artists who graduate, their practices, and the structure of the art market, both in aesthetic and economic terms? An MFA program is a site in which local artistic cultures are produced. Each program has its own culture, but because of relations within an occupational network, local program cultures have recognizable similarities.

Singerman emphasizes the shift of art education from apprenticeship to atelier training to university-based training.[22] Ignoring the exposure to art that students receive in elementary and secondary schools, many artists—even prominent ones—are self-taught. Classwork is not equivalent to creativity. However, with few exceptions, in order to be treated as a *professional artist*, a creator needs exposure to other artists and must be aware of a hierarchy of reputation. Whether one is working for an established artist, learning from a visiting artist, or being trained by a tenured teacher, a relationship between mature and emerging artist is crucial.

Despite the occasional wholly self-taught artist and the apprenticeship relationship, much training has moved to institutional environments. As

noted, universities are the site of my research for this book, but many MFA programs are located in museums and art schools that provide similar training. Of the top ten MFA programs in the visual arts according to the 2012 *U.S. News and World Report* survey, half are university-based (Yale, UCLA, Virginia Commonwealth, Carnegie-Mellon, and Columbia); the others are free-standing art schools (Rhode Island School of Design [RISD], California Institute of the Arts [CalArts], Maryland Institute College of Art [MICA], and Cranbrook Academy of Art) or affiliated with a museum (School of the Art Institute of Chicago). Others, not so highly rated, such as the Savannah College of Art and Design (SCAD), emphasize practical, career-based training in art and design.

The MFA degree in studio art began in the mid-1920s at the universities of Washington and Oregon, soon followed by Yale and Syracuse. By the 1940s, sixty graduate students were enrolled in eleven programs.[23] These early programs awarded degrees under various names (such as Master of Painting or Master of Creative Arts). It was not until 1960 that the College Art Association (CAA) approved the Master of Fine Arts as the appropriate terminal degree for graduate work in studio art.[24] The 1960s witnessed the growth of graduate education in the arts, in the numbers of both students and programs. In 1960 there existed only 72 MFA programs, with 31 additional programs opening that decade and 44 the next, more than doubling the number of programs in twenty years. The growth continued, with 10,000 degrees awarded from 1990 to 1995.[25] Data from the National Center for Education Statistics indicate that in 2010 approximately 3,000 MFA degrees were awarded in visual arts.[26] According to the CAA Directory of Graduate Programs (2013), there are 304 MFA degree-granting programs in "studio art and design."[27] This number includes some programs that are not strictly focused on visual art and excludes others that focus on art education or conservation. Still, whatever the precise count, the number reflects a wide expansion. The MFA remains the terminal degree for graduate work, even as some universities are exploring Ph.D. degrees, a transformation more advanced at present in Europe than in the United States.

Numbers alone do not tell the story. Critic Lane Relyea[28] points to leading curators who have moved into administrative or teaching posts. During the period of my research the Department of Art Theory and Practice at Northwestern University hired as a faculty member Carolyn Christov-Bakargiev, the influential artistic director of the 2012 "Documenta" exhibition in Kassel, Germany. As one prominent curator explained, describing the academicization of art, "The feeling artists have is that they have to have some academic formation to be artists." In

addition, over the past several decades, many universities have established serious museums. This happened at each university at which I taught over the years, as the University of Minnesota built the influential Weisman Museum of Art, the University of Georgia built a greatly expanded home for its Georgia Museum of Art, and Northwestern University transformed the Block Gallery into the Block Museum. Every ambitious college now requires a museum and a program that trains contemporary artists.

MFA vs. NYC

In late 2010 Chad Harbach, a novelist and an editor of the influential New York journal *n+1*, wrote a controversial and widely discussed essay on whether writers should attend graduate-level creative writing programs.[29] Does university training produce "better" writers? Or perhaps, given the ambiguity of "better," do universities advance creative writing? Harbach builds on the monumental contribution of Mark McGurl's *The Program Era: Postwar Fiction and the Rise of Creative Writing*.[30] McGurl argues that programs shape both institutions of literature and styles of writing, and that in the process they have built a substantial (and well-heeled) audience not evident before the rise of mass college education and the creation of a class of knowledgeable readers. As Gerald Graff points out in *Professing Literature*, writing programs have transformed themselves from an adjunct to literary analysis into autonomous units with their own agendas and audiences.[31] Schooling, for McGurl, affects how and what we read, creating a space for the literature that has become esteemed through university-based programs.

In the United States, New York City is acknowledged as the cultural and economic center in the production of serious writing. Recognizing this central role, we can ask whether residing in the cultural core is more beneficial to writers than being located on the periphery. New York is the center of both the publishing industry and the literary market, and home to surrounding events and relationships. The issue involves more than geography alone, as many academic programs are located in New York and numerous communities of independent writers are found in regional centers. What effects does university-based creative writing have on *literary literature*? Is there a collegiate form of creative writing, and is that form—often linked to a mimetic appreciation of other academic writers—bloodless and routine? Some critics suggest that "Great Literature" has been replaced by the lesser "Excellent Fiction."[32] Poet Donald Hall writes of a "McPoem," created in an institutionalized café, in which

McDonald's becomes the metaphor of choice. In these critiques poetry becomes a parlor game that softens and standardizes the writing.[33] Must writers reside in the real world (to the extent that New York—and not Iowa City, Ithaca, or Palo Alto—constitutes the "real world")? Is academic literature harming the great traditions of fiction and poetry, even while providing income streams and tenure's warm embrace?

Similarly, in the context of the visual arts, we must ask: Does the relationship among universities, museums, and galleries shape artists and their careers differently in New York or Los Angeles than in Chicago or Normal, Illinois? How do these geographically embedded social relations, tied to specific institutions, create the possibility of linking fields of activity?[34]

Perhaps the issue is not the diversity of personal experience (such as being "on the road"), but the form and organization of that community. Community is found both in academic centers and in commercial hubs. However, in MFA programs one's colleagues are selected by academic authorities and training is organized through the duration of the program and the requirement of classes. Students, anointed by admissions committees, come and go, rarely laying down roots. In New York, artists select the bars of their choice and may hesitate to give up their apartments. Each social system provides opportunity for sharing work, incorporating supportive spaces that belong to different networks. *New York Times* film critic A. O. Scott notes the similarities between these two fields of careerism: academic and market-based.[35] MFAs are subsidized by educational institutions, while NYC artists are subsidized by cultural industries that provide temporary or long-term employment. The division is exaggerated, as many artists combine teaching and selling, a crossover that balances the life of the striving gallery artist, hoping for a piece of lustrous capitalism, with the alienation (or satisfaction) of adjunct instruction. In peripheral locations, unlike New York or Los Angeles, the market may be distant, and visual arts students realize they may have to find employment on the art world penumbra, working in galleries, as artist's assistants, as fabricators, as journalists, or in photo shops. Many students, unable to establish careers as artists, must confront the reality of occupational failure, at least in light of their in-school goals.

Writers vividly depict the status and strains of literature. Words are their passion and their currency. But similar issues also confront aspirants in other art worlds. Despite the increasing prominence of Los Angeles, New York remains the American art center. This is where the major galleries are located, as well as the most prestigious museums, art world periodicals, ambitious artists, and wealthy collectors. Of course, writers

can hole up in a tiny garret, while many artists require postindustrial studios that permit their constructions.[36] Communities are often linked to the availability of suitable spaces, but this does not limit the art world to New York. Harbach and McGurl are concerned with writers, but a similar argument could be made of visual artists. While this is often portrayed as a tension between two oppositional communities—NYC vs. MFA—it is a fluid continuum, as creators migrate as opportunities and preferences warrant. The lure of being at the center is such that some artists quit secure positions to move to "the City," while others travel in the opposite direction, finding security for their work or life in other parts of the country.

The Purposeful MFA

What does the MFA degree do, and why? What is the goal of art education? The debate about the value of visual arts training has a long history, perhaps even more intensely emotional than the debate over creative writing training for writers.[37] Writing, after all, is something that has long been taught at all levels of schooling,[38] while art-making is often viewed as intuitive or treated as a luxury, to be cut during austerity. Although not referring to university education as such, Paul Gauguin spoke of the "bondage" of the academy, and the always pungent James McNeill Whistler asserted, "Whom the Gods wish to make ridiculous, they make academicians."[39] McNeil Lowry of the Ford Foundation, later a supporter of CalArts, was quoted as advising universities that "the best service you can perform for the potential artist is to throw him out."[40] Even those less histrionic have similar concerns. McPoems become Mc-Canvases. As Deborah Solomon suggests, "the proverbial romantic artist, struggling alone in a studio and trying to make sense of lived experience, has given way to an alternate model: the university artist, who treats art as a homework assignment." She notes that as schools have changed, they have remained the same: "While modern art began as an assault on the academy, post-modern art might be described as a return to the academy. Instead of the old academy of rules, now we have the Academy of Cool, schools that treat avant-garde rebellion as a learned occupation."[41]

Deborah Solomon raises a fundamental tension that is crucial to my project. Art programs emphasize the teacher-student relationship, while students are encouraged—even required—to work in ways that are counter to the evaluative control that institutions promote. The academicization of art rejects tradition in the name of new ideas and contentious

politics. Progress is a matter not merely of creating a novel aesthetic, but of *justifying* the artist's intention—a claim that will be embraced by some in the multi-headed discipline, while rejected by others. Universities train artists who are expected to reject the very judgments that are an essential part of that training. This is consistent with the fact that, as I discuss later, visual artists receive little training in canonical art history and often find knowledge of the past marginalized. The institution presents ideas and practices designed to be toppled.

Many occupations require advanced training, and often little doubt exists about the necessity of *some* form of instruction. While one hears debates about the proper form of medical or legal education, all agree that this instruction serves a purpose and has a goal. Technical knowledge, held by accredited insiders and obscure to those outside, must be mastered. In addition, skills or techniques—surgery or legal research—must be acquired for practitioners to be judged competent. Finally, and perhaps most consequential, elite occupations—professions—control their own borders. One cannot become a doctor or lawyer without being licensed. Within universities, we refer to the proto-occupational knowledge domains that constitute the arts and sciences as disciplines with their own boundaries and criteria for belonging.

Graduate-level arts education has some special features. Contrast visual arts training with medical education. Students newly admitted to medical school would never be considered—by themselves or by others—as doctors. They lack the experience and the skills to *practice* (a term used in both fields). In contrast, MFA programs in visual arts admit students who already are artists. Most successful applicants have had several years of experience as practicing artists. Some students even have stronger exhibition records than their faculty mentors. These applicants are persuaded that they need additional training or at least the time and resources that a graduate program can provide. The schools that I observed rarely taught advanced techniques of art-making in classroom settings. Further, unlike medicine, there is neither state licensing nor a professional organization for artists to join.[42] Institutions exist (such as galleries and museums) that aid artists in their practices and in the establishment of their reputations, but these institutions do not transform novices into artists, although they generate networks and award status capital. The credential of an MFA diploma is desirable, but not essential, and is often not sufficient for a continuing career. Prominent artists may lack that degree, even if today more artists choose graduate education and the identity and social relations that result. As one academic administrator points out, students "need the MFA as a place of first networking"

(Interview). Finally, an agreed-upon body of occupational knowledge is lacking. In medicine, while some disagreement exists over what should be taught and how, programs rely on an imperfect consensus of appropriate knowledge necessary for physicians.[43] This contrasts with MFA graduate programs, where the very idea of canonical knowledge may be derided. What one learns results from what individual faculty members choose to teach.[44]

Even if the MFA program does not teach technique, it exposes students to theories of art, models of discourse, evaluations, community, networks, and identity.[45] Olivia Gude argues that art education produces self-aware citizens in a democratic society.[46] Fred Lazarus, president of MICA, agrees, asserting that his school produces "citizen-artists . . . responsible citizens engaged in the world."[47] These claims have a cheery romance, but they remind us that art schools are about more and less than making artworks. They create *aesthetic citizens*: men and women who believe that their practices may better their communities. To be sure, they do not always achieve this goal, but they speak for the importance of art as a public institution, creating an aware citizenry.

In *Why Art Cannot Be Taught*, art theorist James Elkins writes, "Art departments are said to offer a 'supportive critical atmosphere,' 'dialogue,' 'access to large public collections' and to the art world, and the 'commitment' and 'passion' of their faculty. . . . These are all sensible things, and many of them are possible. . . . I just want to list them to suggest how much art departments teach that is not directly art. . . . Art schools would be very different places if teachers and students did not continue to hold onto the idea that there is such a thing as teaching art, even when they don't believe in it securely or analyze it directly."[48] Critic Boris Groys sugests that "today art education has no definite goal, no method, no particular content that has to be taught, no tradition that can be transmitted to a new generation . . . art education can be anything."[49] One hears a tightly held, if ironic, perspective that all artists are self-taught. As Howard Singerman puts it, "There's a very old and still quite strongly held belief that artists, if they are real artists, are not made in school. That they cannot be made there. . . . [There is] a certain version of the unschoolable artists, the irrepressible, unteachable real artist. . . . the very fact that these artists now come fully packaged, if not fully grown, out of art school and spring into galleries, is used as evidence of the shallowness of contemporary art, its lack of culture or maturity, its aesthetic, or even its moral emptiness."[50]

Taken together, these observations provide a chill assessment of what seems a successful institutional arrangement, a world that is hot in terms

of the number of applicants and cool for many who enroll. Many students appreciate the opportunity. Fully 88.3 percent of graduates from visual arts MFA programs surveyed in 2011–13 felt that their training was good or excellent (50.7 percent rated their institution as excellent).[51] Students are granted time and space to experiment with their artistic practice over two or three years, often with financial support, learning from a set of faculty situated within a departmental culture. Further, they gain mentors and a community. Finally, and this is crucial, students are provided with the opportunity—and the demand—to think and talk about their artworks in terms that link to the *theory* of cultural production as understood within the program, a process that affects the valuation of the work, not as an object standing alone, but as an object in a world of meaning. This provides a sense of self, a public identity, and a group culture that serves well as they navigate an uncertain career. Such features can be intensely valuable—for some, an "amazing" or "transforming" opportunity—which reminds us that, despite skepticism, the students believe that art education succeeds. Becoming an artist involves gaining awareness not only of forms of production, but of forms of discourse and self-presentation, helping students not only to be artists, but also to look the part. Art schools excel at teaching these latter skills. Discourse justifies artistic projects and an artistic self. Yet, as with so many justifications, what is to be learned? One faculty member, looking at the range of outcomes, concluded that MFA programs were necessary; he was just not certain if they were worthwhile (Interview).

Eyeing the Arts

As an ethnographer, my methodological stock-in-trade—my practice, as artistic friends might put it—is the interview transcript and the field note, and I cite my data as appropriate. I examine not institutions in general, but particular institutions with their own traditions, social relations, and forms of knowledge. These observational techniques, found in studies of many social scenes, are particularly appropriate for hazy worlds of taste in which talk is central.[52]

For this strategy, I needed access, relying on the kindness of strangers. I was fortunate to gain the support of administrators and many faculty and students at three schools, despite some understandable skepticism. As someone who has made a career of watching, I realize that my accounts have often surprised, sometimes shocked, and occasionally disappointed my informants. One loses control of one's narrative

to a researcher who is an outsider, uncovering what insiders might not notice or what they might reject. I had originally planned to compare MFA creative writing programs with those in the visual arts, but I found my access to the former blocked by writing teachers who considered their critiques a "safe space." I write, but I am not a writer. Visual arts critiques, unlike writing critiques, are open to invited outsiders, so my presence was less disruptive. Visual artists were more open, but with exceptions. I know of two faculty members who mistrusted my intentions. Neither denied access, but I respect their skepticism. An outsider might undercut the candid critiques that are central to art education.

Despite my adolescent passion for painting, contemporary art is not my life. I entered that world as a sympathetic outsider having some familiarity with the arts, but little experience in the production of contemporary art. I have painted and I snap photos, but I am not a painter or a photographer, and I am far from being a performance artist, ceramicist, videographer, or conceptual artist.

In selecting the boundaries for this two-year project, I made several decisions. The first was to examine students in university-based MFA programs. Chicago is home to the School of the Art Institute of Chicago (SAIC), currently the second-highest-ranked MFA program, according to *U.S. News and World Report*. Many prominent artists serve on the faculty or as adjunct faculty. It is a prestigious school with multiple MFA programs and, according to a dean, some 750 MFA students. Large art schools certainly deserve study.[53] However, my interest was in how graduate-level art education fits into a research university. As a result, I observed three programs in the Chicago area that were embedded in universities. Although I provide pseudonyms for students (except when specific approval has been given) and occasionally for faculty, the institutions examined are the Art Theory and Practice Department at Northwestern University, the School of Art and Art History at University of Illinois at Chicago (UIC), and the School of Art at Illinois State University (ISU). I also attended a day of critiques and interviewed two faculty members at the University of Chicago, and conducted interviews with faculty at Stanford and Indiana University.

My research in a second-tier arts community may not be fully relevant to MFA programs in the art centers of New York and Los Angeles. Columbia, Yale, UCLA, the Art Center College of Design (in Pasadena), and CalArts (in Valencia) all have larger programs than those I studied. Because of their propinquity to the economic engines of the art world, dealers are said to scout studios and troll exhibitions at these schools, hoping to find the "next new thing." Some ambitious students are happy

to oblige. This is not the case in Chicago, although SAIC, because of its size, stature, and downtown location, receives some art market attention. However, the MFA programs at UIC and Northwestern are largely outside the radar of elite gallerists, unless a gallerist is invited by the program to offer a workshop on career strategies or to participate in a critique as a guest. Dealers rarely pay "studio visits." Chicago does have gallery neighborhoods and, more important, numerous small, alternative spaces for exhibiting and selling art, locations in which some students participate. Illinois State, two hours from the city, is outside the attention of the art world. Compared to those of Yale, Columbia, or UCLA, the programs I studied inhabit the economic backwater (or perhaps, more precisely, midwater). Many faculty and students claim to prefer this location, given the prickly relationship between art and commerce.

I was welcomed into these programs by faculty who had a strong interest in social science or who had relatives or friends who were researchers or ethnographers. As noted, not every faculty member—or student—was enthusiastic about my presence, although I did gain interviews with every student I asked, and with nearly every faculty member (with two exceptions, one for reasons of scheduling). I attended some courses, though not all[54] (and some only at the start or end of the term), and I was welcomed at departmental critiques and studio visits. I was invited to discussions with students in their studio, watched them work, and joined parties. I sat in on an occasional faculty meeting, and attended public lectures, program meetings, gallery openings, and art shows. Each program had different preferences for what I was invited to observe. I was not able to attend end-of-term critiques in which groups of faculty evaluated individual students privately, nor did I travel on out-of-town trips (to Mexico City and Marfa, Texas). Still, despite these gaps, I witnessed much of the life of each program. I became friends with many students and faculty. At the start I was somewhat "exotic," and students were unsure of my attitudes to their practices, as I was myself. I learned to appreciate work that had once seemed bizarre, silly, casual, or offensive. I was forced to be self-reflexive, questioning my own well-honed, comfortable aesthetic judgments. If I was no longer a Monet man, I struggled with becoming a Chris Burden man (the artist who had himself shot and later crucified on the hood of a Volkswagen). As is understandable, students and faculty found it awkward to be watched; some worried about being treated as a "case study," despite the promise of anonymity, feeling that I might be critical of MFA programs or of their work (Field Notes). While some students mistrusted me, at least at first, others were welcoming. Referring to the sometimes caustic comments at critiques, one student, Denise, told me that "I always feel more

comfortable when you're in the room." As an observer who never gave negative feedback, I was a reassuring presence. Acceptance is always a process. Hanging around—being supportive (and bringing cookies)—worked its charm. As one student put it, "You're famous around here." When a faculty member learned that I had been invited to participate in a critique at another school, he commented, "Welcome to the Brotherhood." By the end of the project, students at one school presented me with a sweater in honor of the colorful sweaters that I often wore and called me up on stage at their graduation party. One student explained that "much of the work of being an artist occurs at bars" and asked, "Are you going to come?" I did on occasion, but never remained until closing time.[55] I wrote letters of reference for several students, evaluated an MFA thesis, and participated in a piece of performance art. Another student referred to me as observer in a performance: "Gary is here. He's been following us. I know it sounds really delusional, so maybe he's not here." The line received a warm laugh. Students routinely asked privately for evaluations of their latest work.

A challenging problem in all ethnographic observation is to draw limits on one's involvement. At the three classes I attended at UIC, I was asked to participate. (I did not participate actively in three of the five classes I observed at Northwestern.) I avoided dominating the classes, and decided that I would speak no more than three times in each three-hour class and never focus the discussion in a new direction or directly contradict faculty or students. I attempted to provide comments that extended the ongoing discussion. Class members recognized my participation without seeing it as distracting. The reading assignments were useful for my research, although doing the reading distinguished me, as students were often casual in their preparation, treating their artistic practice as central. My presence came to be expected, especially at Northwestern and University of Illinois at Chicago, where I spent the bulk of my time.

My observations took place over the course of two academic years. I observed midterm and end-of-term critiques at each school (with an additional observation at University of Chicago). I attended seven multiple-day critiques at UIC, four at Northwestern, and two at Illinois State. I audited three full courses at UIC and two at Northwestern, and conducted partial observation of three additional courses at Northwestern. In addition, I interviewed students and faculty at each of these institutions (twenty-five at Northwestern, twenty-seven at UIC, and ten at Illinois State; and an additional seven faculty members from other schools). These data were supplemented with articles in a variety of magazines, journals, and websites.

Art Sites

Each of the programs I observed had its own structure and culture (a topic to which I return in examining the group cultures of art communities). While they are distinct in their culture, which affects students, art programs show a certain similarity in their structure. Sociologists refer to this as constituting an institutional isomorphism.[56] There are certain tasks that need to be done, and programs will look to each other to see how those tasks are managed, with influential programs often setting the tone for the rest. In other words, there is considerable sameness and some difference between programs.

In my observations, I was startled at first that none of the programs requires art history and none requires courses in artistic technique. UIC requires three "theory" courses over the four quarters that students are in residence. These are seminars whose topics are selected by faculty or visiting instructors. Students can typically choose from two or three offerings each quarter; during the period I observed, these included such themes as "manifestos," "intentionality," or "the city of Chicago." At Northwestern students are required to enroll in courses on critique in the fall and spring quarters, and a course on writing in the winter. With its small size and multiple programs, much training at Illinois State is on an individual basis, but students take courses in visual culture and a proseminar that includes artistic theory.

In contrast to programs at art schools, each of these programs was small. Northwestern admits five fully funded students each year for its two-year program. UIC trains approximately a dozen students each year in its two-year program. Not all students have fellowships, but several fellowships are available, plus assistantships and tuition waivers. Illinois State University has a three-year program, which during my research enrolled thirteen students. Students have tuition waivers and some university funding for assistantships. While some students, particularly at UIC and ISU, took out loans, the level of debt was not as great as that amassed by students in free-standing art schools. The image of art students with an immense debt burden is more applicable to art schools than to university departments, where the graduate students receive some measure of financial support and depend upon the institution's endowment.

The art programs at Northwestern and UIC were not divided by genre. Students at Northwestern were not easily classified by style of work, and many focused on conceptual art projects or installations. UIC students

were less conceptual, but most students produced work in several genres, including painting, photography, sculpture, performance, film, video, new media, and installation. At ISU, students could choose programs in sculpture, ceramics, glass, photography, painting, printmaking, or video art. (During the period of my observation no students focused on video.) In general, the work at ISU was more traditional than in the other two programs. There was no opportunity for performance or conceptual art. ISU, located in the small, downstate Illinois city of Normal, is less prestigious than the other two and students were more likely to hail from local communities or to have been out of school for many years, and were less likely to have an established practice. Located two hours from Chicago, ISU students were less integrated into the Chicago art world. According to the 2012 reputational analysis by *U.S. News and World Report*, program rankings were 45 (UIC), 62 (Northwestern), and 127 (Illinois State) of 213 MFA programs in the "fine arts." None of the three programs was among the elite (and larger) university-based programs, but each is well regarded and has faculty known for their practices. Northwestern and UIC have faculty who show at major art events, such as the Whitney Biennial and Germany's Documenta. One faculty member received a MacArthur "Genius" Award; others have won prizes from the College Art Association. Many are represented by major galleries or have achieved notice for their films and videos. Northwestern and UIC have approximately equal numbers of male and female students, while most students at ISU are female. White students predominate in all three programs, but with a smattering of minority students (three of fifteen at Northwestern and a smaller proportion at UIC and ISU). Although I lack systematic data, several gay and lesbian students are enrolled at NU and UIC (I have no information about ISU). Because of the small size of these programs, numbers vary substantially from year to year and, in part, are a result of who decides to attend. Most students spent several years between undergraduate training and graduate enrollment, a gap that is common at other schools. Like MBA programs, MFA programs prefer students with seasoning in their field of study. For students at Northwestern between 2011 and 2013, the average length of time between college and the MFA program was 3.1 years, with only two of fifteen enrolling directly from college.

Lifeworlds and Art Worlds

Each artist has a personal story. Many—although not all—speak of themselves as "toddler artists." Drawing was a "gateway drug" for their artistic

career. These experiences shape their artistic identities, and their narratives justify those careers, a form of retrospective sense-making. Sociologist Samuel Shaw, studying the art scene in Portland, Oregon, quotes one informant as remarking, "I was painting on the walls with butter when I was two years old."[57] One of my informants is more vivid, explaining, "Part of my own narrative is me painting my shit on the walls, out of my diapers as a kid, and that carrying itself onward" (Interview). Students frequently credit parents or a supportive schoolteacher, modestly giving credit for their "genius" to others. They assign their acquired artistic capital to social support. One woman reminisced, "We would always do crafty things. I remember in the first grade, [my mother] entered me into this drawing competition for elementary school kids and the school picked mine. My mother still has the picture framed. It's a world with people holding hands" (Interview). Several students started to draw when they were preschoolers, doodling or making cartoons, only later realizing that being an artist is a profession. However, this transition typically requires institutional support from a teacher who serves as a role model, guide, or cheerleader. One professor referred to his high school epiphany: "The dean of my high school saw this drawing and said, 'you know, you have the drawings of a sculptor,' and it turned out he was a stone carver. He asked if I would be interested in doing an apprenticeship with him during the summer between my junior year and the beginning of my senior year. And it changed my life. It was formative, and I suddenly fell in love with a process like I never had" (Interview). Opportunities, epiphanies, pathways, and turning points define lives. Without art education in elementary and high school, the art world would soon empty. With more classes, it might be brighter still. In various ways artists depend on their habitus—the background conditions that are taken as the starting point for their career. However, at times they construct their narrative so as to make this development more dramatic.

In a social field, as described by French sociologist Pierre Bourdieu,[58] an aspirant must embrace local ideologies. For the arts, an autonomous cultural perspective typically requires a claim of "disinterest" in economic logic, whether or not that disinterest is true in fact.[59] Art is to be set apart rhetorically from lucrative careers, and this was clear in the schools that I examined. The distance of the making of art from the making of money is, as Bourdieu asserts, central to the claims made in MFA programs. Perhaps this is deceptive, but it is widely spoken. Although some artists become extremely wealthy and others live comfortable suburban lives, few admit this as a goal. The artist is to express inner convictions and to abjure public acclaim.

Four Artists

To demonstrate what it means to be an MFA student, I depict the lives and practices of four emerging artists. I gathered many life histories, but I select these because I admire their practices, they became friends, they were willing to be named and have their work shown, and they represent important features of the art world in their backgrounds, their artistic styles, and their orientations to education. Each case demonstrates the importance of turning points and group cultures. Without unplanned opportunities, these artists would have chosen other paths.

With more applicants than slots and with few objective measures of competence, the decision whom to admit is fraught. Faculty members lobby for students whom they wish to mentor or whose work they admire, although these programs operate on the belief that admitted students should not be too advanced or too fixed in their practice. One instructor explained, "Originality, you know it when you see it. It's like pornography. It's like buying a melon in the store. You have a sense. Sometimes you're wrong" (Field Notes). Northwestern, with a strong funding package (full fellowships and tuition for the two-year program), has the widest choice. The program accepts fewer than one in ten applicants. It admits five students[60] from a shortlist of about two dozen students who are invited to campus for a two-day interview weekend in which faculty and current students meet the candidates.[61] UIC has many more applicants than spaces, and ISU is selective as well. Schools make different choices depending on their local culture. Applicants uninterested in the relationship of art and "theory" are at a disadvantage at Northwestern, while ceramicists will not be accepted at UIC, or performance artists at Illinois State. Given their applicant pools, each program desires a demographically diverse student cohort and one whose work does not overlap.

Of the four students, two attended UIC, one Northwestern, and one Illinois State. All permitted me to use their names and show their work. One specializes in photography; another combines photography and sculptural installations; a third incorporates video, painting, and performance; and the fourth paints and does conceptual work and performances. Time will tell if the wider art world will know of them, but you, the reader, will get to know them well: Marissa Webb, Esau McGhee, Hanna Owens, and Soheila Azadi. They are not *representative*, although they have diverse backgrounds, aspirations, and careers. While I reference other art students, using pseudonyms, these four appear frequently.

Marissa Webb

Marissa Webb received her MFA degree from Illinois State in photography. She grew up in Rockford, Illinois, a small city ninety miles northwest of Chicago. Her parents, now divorced, both work in the arts. Her father is a theater director, and her mother is a fiber artist and costume designer. As a child Marissa acted on stage and sang in musicals. She explains that her mother encouraged her to draw and paint, as well as take piano lessons. Her interest in photography started in middle school. As Marissa describes, "I was handed a camera by my father and asked to photograph a theatrical production of his, and of course I butchered it because I didn't know what I was doing, and that's actually when I fell in love with photography." For Christmas she asked her parents for an SLR (single lens reflex) camera, and in time came to think of herself as a photographer. During college she took a semester off to work at Disney World in its Legacy Photo Booth and camera center. She eventually transferred to Columbia College in Chicago, specializing in arts and media, because of its photography program, taking out loans to do so because "I knew that this is what I want to do." She was so enthusiastic that she traveled from Rockford to submit her application. At first she focused on photojournalism, but eventually realized that she was more interested in artistic photography. Upon graduating, Marissa returned to Rockford, and was hired to take portraits for a local camera store, as well as documenting her father's theatrical shows. Wishing to live in New York, she applied to Brooklyn College for its MA program in art history, but after nine months decided that it was the wrong program because it did not permit her to fulfill her commitment to photography. She was accepted by Illinois State, which appealed to her because of its faculty, its extended three-year program, and a community less rushed than New York City. Marissa found the program a perfect fit. After graduating, she married, worked as the recruiting coordinator in the ISU art school, and eventually moved to Kansas City where she documents theatrical performances. Her goal is to teach photography in a local community college or a small collegiate program.

To understand Marissa and her practice is to recognize the influence of her sister Kaitlin. Kaitlin was born when Marissa was eight. "I was so excited to have a sister at age eight. That is what I wanted and I got my wish, and she was like my baby doll." But it was soon clear that Kaitlin had profound developmental disabilities. Marissa described her family life: "It's like a family affair when we would go from hospital to hospital,

and that was our big vacations where we would go to Johns Hopkins or Boston Children's." At about age eight Kaitlin was diagnosed with Rett Syndrome, a profound disability, often resulting from a spontaneous genetic mutation. About one in ten thousand female live births show some degree of Rett Syndrome, and, when the disability is severe, the child is unable to walk, hold objects, or talk. Marissa's mother, believing that Kaitlin was a gift, raised her at home and became a twenty-four-hour caregiver with Marissa as her helper, a task Marissa embraced, despite some resentment in high school. Marissa explained that "a lot of my childhood was watching her or taking her on walks or carrying her around because I thought she was literally my doll."

When Marissa arrived at Columbia College, she began to take documentary photographs of her sister. The images were clear and compelling. However, she was distraught over the advice of her instructors to choose another topic. "I was told not to make those because they were too personal. . . . I challenged it and they said that you couldn't do things that are so personal. So I literally just put it on the back burner. . . . I do think they were uncomfortable [with the subject matter]." Arriving at Illinois State, Marissa began taking photos of water towers, but her heart wasn't in it. She finally decided to photograph children with Rett Syndrome, and eventually settled on her sister, feeling that she needed that personal connection. As the project expanded, she felt a connection with documentary photographers, such as Mary Ellen Mark and Nicholas Nixon.

In time her project evolved, becoming more "conceptual." Marissa had given Kaitlin a "photobook" of her photos. Kaitlin in her excitement chewed and ripped the book, tearing it apart. Her mother advised Marissa to keep the book and reassemble it, and this proved an inspiration, an escape from documentary photography, more in the tradition of Robert Heinecken. She would reassemble the ripped books and then photograph them, leaving a memorial trace of her sister in the original images, in the destruction of the images, and in the photography of those destroyed images. Her work is respected by Illinois State faculty and has been included in a show at the Center for Family Photography in Fort Collins, Colorado.

Marissa was trained in art practices from her middle-class childhood in a small midwestern city, eventually committing to a specific genre of art production: photography. She then decided how her work could be consistent with canons of conceptual artistic practice, distinct from documentary photography. In this, she draws from personal experience. The work must engage several sets of viewers: a layering of audiences.

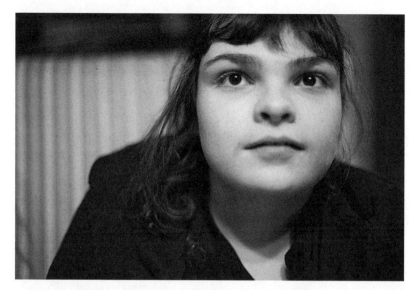

1 Marissa Webb, *Kaitlin, 2012* (photo by artist).

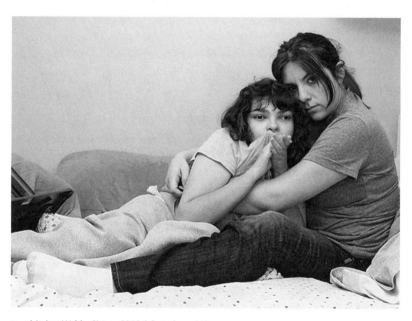

2 Marissa Webb, *Sisters*, 2013 (photo by artist).

3 Marissa Webb, *After Michelangelo (Bookwork)*, *2014* (photo by artist).

4 Marissa Webb, *Untitled (Bookwork)*, *2014* (photo by artist).

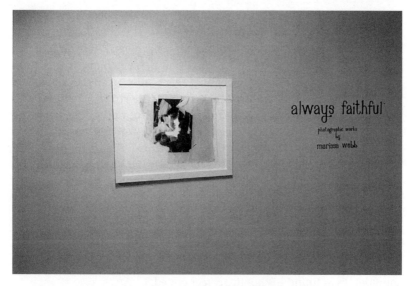

5 Marissa Webb's senior thesis show, 2014 (photo by author).

While she views herself as a sister with strong emotional attachments, Marissa hopes to appeal to a wider audience that must be convinced that her images are meaningful. The fact that Marissa works outside Chicago without links to galleries or residencies may make her career a greater challenge than those of artists with stronger networks.

Esau McGhee

Esau McGhee, a 2013 MFA graduate of Northwestern's Art Theory and Practice Department, also uses photographs in his work. At age thirty-seven, he finds his career is taking off. As I write this, I have just received an email announcing Esau's solo show at the elite Union League Club of Chicago, a short distance from the financial hub of the city. A show at the Union League Club might seem a long shot for a black kid who grew up on the gritty streets of North Philadelphia, a universe away from leafy lakeshore suburbs or from Chicago's Gold Coast. Esau explains, "[I was] born to a single mother, my father was already married to another lady at the time. He just wanted to spend some time with a young lady. . . . He was overall a standup guy. He did what he had to do in terms of taking care of a young child. . . . It was a really rough neighborhood during the eighties and especially the nineties. That was the crack era. . . . My mother, she linked up with my stepfather, who turned out

25

to be a horrible person. He was very abusive. . . . He was a drug user. He beat my mother, tried to molest my sister on several occasions. . . . There have been moments I would throw all [that I achieved] just for him not to breathe. . . . My stepfather ended up leaving us when my little brother was three or four. So the only father figure my little brother ever had was me. For all the shit I've done growing up in the street, like fights and shootouts and stabbings and stuff like that, I have never done anything in the vicinity of where I live because I have a little brother and I want to set an example." This is far from the imagined life of an artist. Like Marissa, Esau was shaped by familial history. Unlike his mother and strung-out stepfather, Esau himself was never involved with drugs. In his neighborhood, Esau was considered "soft," but he found "thugs" with whom to hang out. He was also saved by being a boxer: "For me [it was] the gym and Mr. Harold [the trainer] that was like my father figure and it was the first time I ever experienced love from a man, someone believing in me and totally having faith in me." But after dislocating his shoulder, Esau found his boxing career ended.

As Esau mentioned, the relationship with his brother, Steven, twelve years younger than Esau, has been a defining element: "It was always my brother and me." Esau speaks movingly about his brother, recalling their basketball adventures and how he taught Steven to navigate the streets of North Philadelphia. But once Esau reached adulthood, his mother demanded that he leave home after escalating arguments about the mother's choices. Steven felt betrayed by the loss of his brother and protector. In time, Steven was arrested, and during the period of my research he was in prison. Esau's written MFA thesis consisted of letters between the two brothers, contrasting two forms of institutional control.

Esau was not a "toddler artist." After dropping out of a small college, Esau returned to Philadelphia without a clear future. However, the friend whose apartment he shared owned a camera, and, "trying to be cool," the pair walked the night streets snapping photos, unaware of photographic practice or history. In time Esau received an Associate of Arts degree, making him the first in his family to embrace higher education. Esau specialized in photography, obtaining his degree from the Art Institute of Philadelphia, a for-profit art school. This was prior to digital photography—the days of wet photography—and Esau was influenced by the classic style of Irving Penn and Harry Callahan. His teachers— Howard Brunner, Jay Pastelak, and Phil Drucker—exposed him to the history of the field, and this local aesthetic culture constituted a turning point. Esau comments, "It changed my life. It changed how I see the world." But Esau was also accumulating debt. With his degree in

hand, Esau began working in a photo lab and stopped taking pictures, "decompressing" from an intense academic experience. In time he returned to photography, wandering North Philadelphia, creating images of objects—trash cans, gutter litter, dirty cars—that intrigued him. He felt he was becoming a "real artist."

But to attend graduate school, he needed a bachelor's degree. He attended a portfolio day with a representative of the School of the Art Institute of Chicago, and after some discussion, he was admitted on the spot. Esau suddenly found himself in one of America's most prestigious art schools. SAIC accepted credits from his associate's degree and expressed admiration for his photographs and his story, but provided no funding. More debt. Esau was so broke that he could no longer afford to take photographs. But his commitment was powerful. His courses in painting, printmaking, and collage influenced his photographic work with the inspiration of Henri Matisse and Romare Bearden. While occasionally he felt disrespected at SAIC, his work became more sophisticated and expanded beyond photography. Esau graduated in 2005 and chose social service employment and work as a bouncer at clubs, while still taking photographs. Esau's career has oscillated in and out of the art world. Eventually he realized that he was in a dead-end job and decided to obtain an MFA if he could gain funding. Esau was accepted into three strong schools, including Northwestern, which he accepted. Despite a spotty theoretical background, he now describes himself as a "conceptual formalist." Esau believed—correctly—that he could survive a theoretically demanding program. He commented on the posturing that occurred in critiques, a form of impression management not so different—and yet very different—from life on the streets. He needed to perform the role of artist to get respect. Although perhaps not as sophisticated as some colleagues, Esau believed in his own intense work ethic. For me, a memorable moment was listening to Esau talk with the well-to-do parents of a graduating senior, whom Esau had mentored. Esau explained that he himself often fell asleep on his studio floor when too tired to work or return home; he encouraged their son to do the same.

For his thesis show Esau created a set of dynamic, sculptural photo-collages, representing urban places with black-and-white photographs, and hanging long strips of paper on wooden structures. These works transcend the boundaries of sculpture, collage, and photography. They provide a political critique at the same time as they explore formal presentational qualities. Like Marissa, Esau transforms material objects into objects of thought: objects whose valuation depends on the imagination of strangers, including wealthy members of the Union League Club.

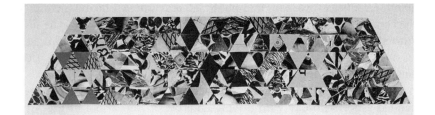

6 Esau McGhee, *Untitled Urban Landscape*, collage, 2013 (photo by artist).

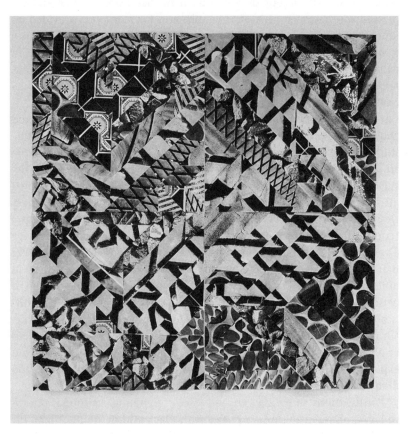

7 Esau McGhee, *Untitled Window Landscape*, collage, 2013 (photo by artist).

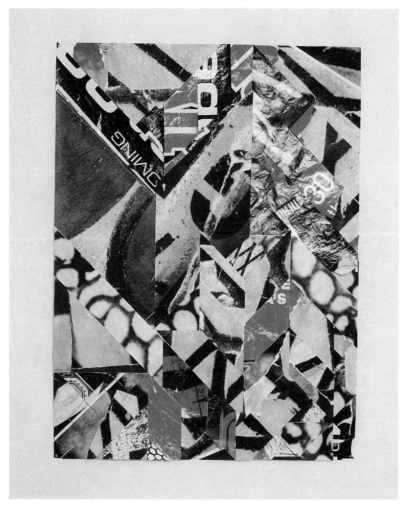

8 Esau McGhee, *Chicago Ave. and Pilsen*, collage, 2013 (photo by artist).

Hanna Owens

The date of 1 November 2015 was a turning point in the life of Hanna Owens, a 2014 MFA graduate of the University of Illinois at Chicago. She had already made her mark as an innovative performance artist, writer, painter, and videographer. She had been invited to perform in Mexico City, Baltimore, and New York, an impressive emerging career. But 1 November 2015 was her anniversary of ten years of sobriety, a date she referenced in her performances.

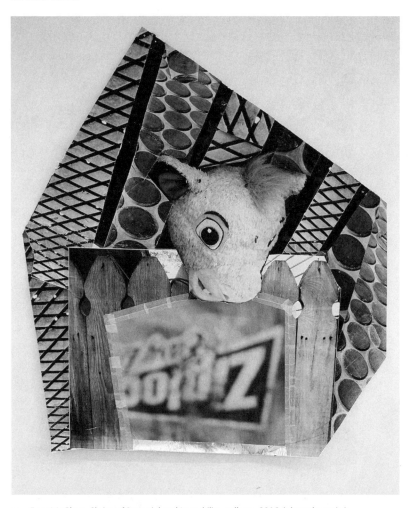

9 Esau McGhee, *Shrine of Potential and Immobility*, collage, 2012 (photo by artist).

Hanna was born in a small town in rural Vermont, exploring woods, wilderness, and snow. During her childhood, the family (Hanna, her parents, and her two siblings) moved to a wooded suburb in Maryland. She recalls her childhood as extremely happy and describes herself as a "total girl with traditional girlish tendencies, but covered in poison ivy." Both her parents were teachers, although not in the arts.

When Hanna was thirteen, her parents divorced. She says, "It was horrifying. I was heartbroken." Her father moved out. As an adolescent, Hanna was bitter toward both parents. By eighth grade she started to drink, eventually becoming addicted to prescription narcotics and il-

legal drugs, including hallucinogens. For Hanna this life fit her self-image—an image from age seven—of being an artist or writer. As she says of her parents, "They were so wrapped up in their own shit, they didn't notice me manipulating the different household regulations. They were in total denial." She suffered panic attacks and eventually was sent to a treatment center. She has not relapsed since age eighteen.

Graduating from high school, Hanna enrolled at Towson State University, double-majoring in fine arts and French literature, graduating summa cum laude—the product, she says, of a clear mind. She expresses gratitude for the years of addiction that eventually permitted her to be healthy, mentally and physically. As a college senior, she was admitted to the MFA program at the University of Chicago, but declined in order to spend a year in Europe. After college, she worked for the French ministry of education, teaching English and living in Calais. UIC proved to be the proper choice for her when she applied, because of its interdisciplinary emphasis. She desired a university art program that permitted her to take humanities courses. After graduation Hanna remained in Chicago, building a portfolio; her work has since been shown in Berlin, Singapore, and at the Museum of Contemporary Art in Chicago.

Being a sober artist is not easy, even though Hanna was a highly regarded member of the MFA community. To drink is to be. As Hanna points out, "I feel like it sets me apart, but also in a negative way. Adult

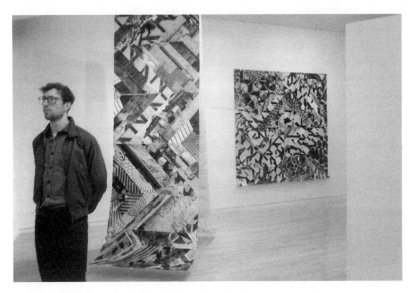

10 Esau McGhee's thesis show, 2013 (photo by author).

artists spend a lot of time hanging out drinking. It's a huge part of the socialization of artists and I'm excluded from that. I've made that commitment to myself, but sometimes I feel like I suffer from it. . . . That's where I come from as an adult artist. It plays out in the content of my work conceptually." Although Hanna's work does not directly address drugs or alcohol, issues of addiction are in the subtext. Like Marissa and Esau, Hanna integrates personal experience, conceptual expression, and political or aesthetic theory. Hanna puts her concerns this way: "I think it's related to addiction and recovery. For me, addiction is a 'disease of the feelings.' Drugs are just a symptom of addiction. When you get rid of drugs, you are going to cling to other things to replace them. I see the addictive behaviors I had as an adolescent that can be anything you choose to act out on: spending money, getting money, sex, the internet. I see these as ways to manipulate your feelings. As an addict then try to go and change those feelings. That's what addiction is about. We go get high so we don't feel this way. A lot of my work is about that. I talk about feelings, and feelings are most often associated with sex and intimacy. I often go towards that now because it's one of the few things I have left." As a woman with male and female partners, Hanna says her work deals with issues of gender, sexuality, and intimacy.

This concern included a project that followed but differed from Tracey Emin's list of all those she had *slept* with; Hanna compiled a list of those with whom she had had sexual relations: exploding the euphemism. Lists and audible memories have been central to her practice, which has extended to performances and videos. She reports, "The 2D surface was very slow and couldn't contain the information. . . . I started realizing my work was about feelings and connectivity and I could do so much more with moving image, performance with my body. I had no desire to depict on a two-dimensional surface." Hanna incorporates her dance background and her comfort at being publicly naked, evidenced by having worked five years as a nude figure model. In one collaborative piece, she danced in the nude, but in a space in which only female viewers could see. Of the students in this program that revered interdisciplinary work, Hanna might have been the most interdisciplinary of all. She creates scenes with music, dance, words, video, and objects, and she demands audience participation. She notes, "My art and my life very much blur, and I like to question the socially constructed notions of our sense of sex. I will blur my performances into things I'm doing in real life where there is no stage. . . . I want to do everything myself and make it messy and control the lights and audio. I wanted it to be a solo performance where only I knew what was going to happen. I wanted it to be messy

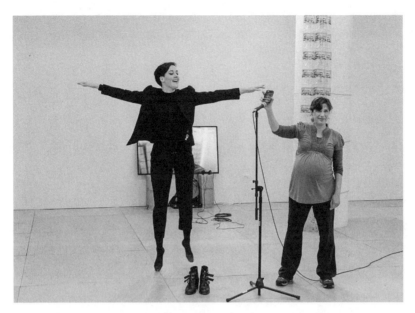

11 Hanna Owens, performance, 2014 (photo from artist, taken by Soohyun Kim).

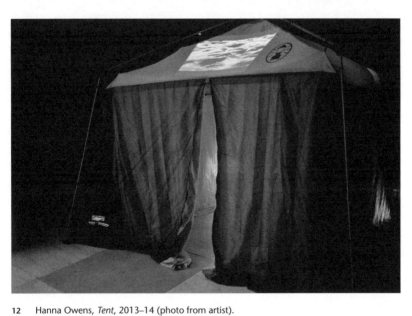

12 Hanna Owens, *Tent*, 2013–14 (photo from artist).

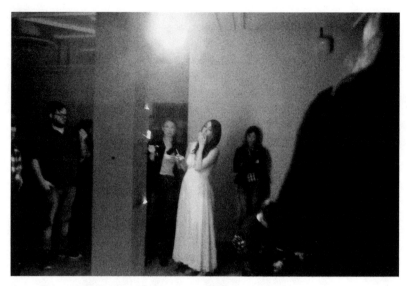

13 Hanna Owens, performance, 2013–14 (photo from artist).

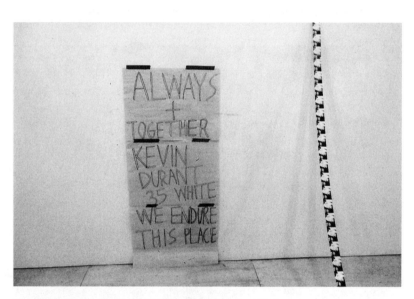

14 Hanna Owens, *Always and Together, 2014* (photo by author).

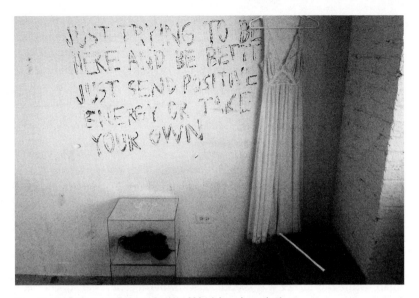

15 Hanna Owens, *Just Trying to Be Here*, 2014 (photo by author).

and sloppy. To me that speaks to body and emotions, especially to the feminine. The female body is so sloppy, messy, and blurry, and we can't even deal with it in contemporary society." In one memorable performance, she fed audience members brightly colored Jell-O and then had them spit it into a pair of pantyhose, referencing oral sex and ejaculation. Jell-O with its sloppy, kitschy, and sensual quality has been integral to her practice. For Hanna, Jell-O is a metaphor for the human body. At first I felt it peculiar, but it proved to be evocative and disturbing. Color, shape, sound, and movement within a community of viewers address the boundaries of intimacy and transform the private into the public, edging the artist from the center of the stage. Hanna explains:

Jell-O is hard but it's moving, wiggling. You can crush it. Suck it. It will melt. Cut it. It's become a metaphor for feelings. [By having people spit Jell-O into pantyhose] I wanted to display this forced intimacy with these people that were unsuspecting. Force you to get close to me. I was wearing those pantyhose all day. Took them off and hung them with the crotch at face level. . . . The act of oral sex. I asked you to put your head near the crotch of my pantyhose that didn't have my body in them anymore. I ask that you eat this Jell-O, squirt it through your teeth, and spit it into the pantyhose as a host of metaphors for sexual and emotional intimacy to create this thing with me. I then took off my panties, spit the Jell-O into them myself, and gifted them to someone. For me that was a gesture to fetish and how we fetishize these objects.

Many art publics are not ready for this level of intimacy, but Hanna admits that her work is evolving, and she hopes to develop a "mature" artistic practice in five years. The question is whether art audiences will embrace the investment that her practice demands. By integrating the personal, the political, the emotional, and the discursive, her work reveals how young artists conceive their creations and develop a personal style.

Soheila Azadi

In a global art world, choosing only American-born artists is inadequate. MFA programs increasingly embrace global culture.[62] I met art students from France, Germany, Colombia, and Iran. Soheila Azadi, in her early thirties, grew up in Isfahan, Iran, before attending UIC. Her practice, although originating in painting, now emphasizes performance. Her mother is a traditional middle-class Iranian woman, while she describes her father as more progressive. Her mother encouraged her to wear the hijab, while her father was skeptical. A former teacher, her mother is a housewife, and her father, formerly an army officer, owns a small real-estate company. Soheila recalls being fearful during the Iran-Iraq war, but also remembers the villa to which the family could escape. At age twelve, with the support of her father, Soheila began to paint, taking classes during the summer and after school. Instead of an academic high school, Soheila selected art school. However, because of bureaucratic problems, she could not enroll in a college design program, choosing early childhood education instead. She soon married. Her husband, a civil engineer, migrated to the United States and she followed, knowing no English (today Soheila is eloquent). She began to paint again. When her husband graduated, Soheila enrolled in an animation program at Edinboro University in northwestern Pennsylvania, where she learned about performance art. Her performances involved critiques of Islamic culture and gender politics, including tying a group of men together, and washing pages of poetry, hanging them like laundry on the ropes.

A more controversial performance, in rural Pennsylvania as in urban Iran, imagined an abortion:

I did this performance where I [appeared to drag] things out of me. So I had a bump here as if I was pregnant and it was stuffed with fabric that was white, and it was stained in parts. I was on the floor and I started pulling these out and as I was doing that I created an image of a womb. At the end of the performance I am lying down like a baby and this is connected to me. So I am the baby at the same time I am the mother. . . . I

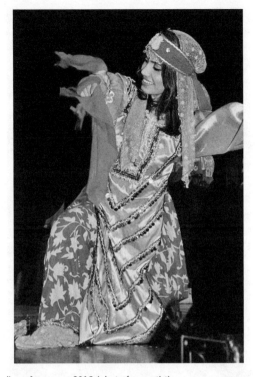

16 Soheila Azadi, performance, 2012 (photo from artist).

planned to perform this in a gallery setting, and they were really supportive of it. . . . Two hours before my performance, I was setting up, and one of the faculty saw me, and she said, "Are you setting up?" And I said yes, and she said, "Didn't you get the dean's email?" And I said, "No, what's up?" And she said, "They canceled it. They think it's too risky, and they don't want to risk anyone's health." They were afraid that there might be one or two Muslim students who would come here and bomb the gallery. [Soheila laughs.] And at the time I was so pissed because I thought it was pretty racist. Once they said, "No, you are not performing," I was so angry. I said, I will perform it. I remember texting my friends to come to the performance. It is not canceled, and please spread the word. So, fifty people showed up. I didn't do the performance that they were afraid of, which was the abortion one. But instead of that I printed out the email of the dean, which was very racist. I mounted it to a board, and I wrapped my mouth with my veil. And I held it in front of people's faces and that was my way of saying it is actually canceled. And then for the second one I said, Follow me. I texted a friend. He was living across the street, so we went there and I performed the abortion one in his backyard where fifty people were around me.

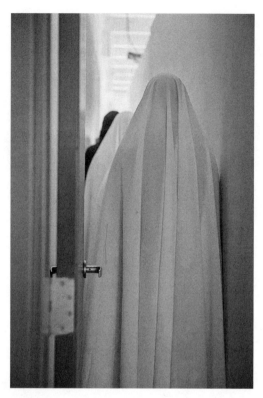

17 Soheila Azadi, *Climate of Fear*, 2013 (photo from artist, taken by Soohyun Kim).

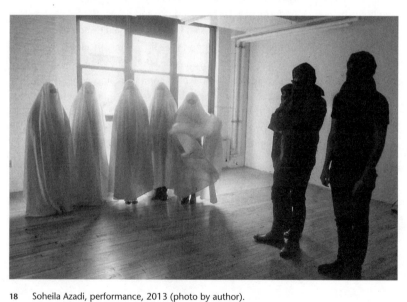

18 Soheila Azadi, performance, 2013 (photo by author).

19 Soheila Azadi's studio door, 2014 (photo by author).

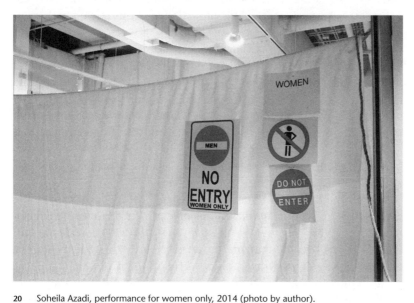

20 Soheila Azadi, performance for women only, 2014 (photo by author).

Soheila's artwork creates community. Eventually the dean apologized. With the support of a faculty mentor who had attended UIC, she applied and was accepted into UIC's MFA program. Her work has gained increased notice at artists' clubs, galleries, and museums. She has created works in narrow hallways in which audience members anxiously edge by and bump into Soheila's colleagues who are wearing full burkas. She continues to explore the relationship between gender and ethnicity as she defines herself as an interdisciplinary performance/installation artist, inviting her audience to question their cultural assumptions.

————

By presenting these four emerging creators from diverse backgrounds with different challenges, certain commonalities become evident. Each practice is shaped by the artist's history and relations, each depends upon the culture of colleagues and institutions, and each is linked to personal concerns. Yet each of these artists—and the seventy others I came to know—must develop an artistic self, begin to establish a recognizable, signature style, and share their work with a public. They are talkers as well as makers. The MFA program forces this role upon them in a world in which art no longer speaks for itself. Questions of intention and identity shape what is valued, linked to their discursive skills. Perhaps the wave of "high theory" from the 1990s has abated,[63] but ideas form the spine of the art world. Beauty is insufficient; work must exude meaning. Making, theorizing, evaluating, mobilizing, socializing, and being in the world are the actions of contemporary art. These artistic ideals connect to broader concepts of identity, discourse, socialization, and reputation. Each concept leads to a politics of valuation. That artists become students and then become artists again is central to participating in an art world.

I begin in chapter 1, "Producing Practice," with what was once the core of the art world, the making of objects. If art is meaning transmuted into form, the process of production is critical. Yet, while present, technique has become marginal in art schools. MFA students are not taught—at least in collective settings—the skills of production. Technique, if not already known, must be smuggled in through individual connections or explored privately. To be an artist is to be a maker, but what does this mean in a world in which students are *already* makers and in which conceptual practices are increasingly influential?

Chapter 2, "Sharp Genres and Blurred Boundaries," analyzes the distinct forms of production that characterize the forms and genres from

which students draw. I examine the types of artistic production in these three schools. In much of the art world, the late twentieth century was characterized by "the death of painting." While this slogan exaggerates, art practices evolve; some are embraced and others come to be considered passé. How do artists think about their practices, ignoring old domains and emphasizing new ones? Which are valued, and how? The artist produces not merely as an individual, but as part of a community of practice with a set of values establishing hierarchies of quality, leading to certain forms of production becoming venerated.

If art is not only about making, it is also about ideas: talk as enriched by theory. Art must be good to think, good to discuss, and, now, good to write. Drawing on Tom Wolfe, this is the topic of chapter 3, "Painted Words." In order to feel like artists and be treated like artists, students must master these skills. Like the standard, elite professions, contemporary art has a body of theory held by practitioners. This is revealed by the written thesis that art students must submit in addition to their artwork in order to graduate. Young artists are taught to be conceptual theorists, evocative talkers, eloquent writers, and aesthetic citizens. Displayed objects, performed actions, and social commitments exemplify their ideas. The need to draw upon a set of ideas produces art as an academic discipline, treating the university as its natural home.

Chapter 4, "The Reason of Pure Critique," explores the core instructional form of art school, the *critique*, and addresses the challenges and emotions of public evaluation. Young artists learn that they must explain their work if they hope for a career. These creators must be *fluent*. Faculty insist that students must be advocates for their own practice and must demonstrate that they stand apart from other artists but also have connections with them. Students must describe their intention, responding when challenged. They are expected to draw upon personal experience (often privileging trauma), the texts of others, and canonical forms of practice in a form of identity narrative that makes their choice of style meaningful to others.

In chapter 5, "Community as Praxis," I explore the formation of we-feeling within a set of art communities in which participants have very distinct styles of practice and of life. Social relations always shape belonging. I focus not on boundaries of objects, but boundaries of people. This issue is magnified by the diverse cultural expressions that are permitted to art students. I draw attention to the local culture of each program as a site of togetherness. In what ways do students create a group culture? An MFA program provides a two-year moment to create connections; it is an extended residency that depends on the creation of shared perspectives

among the participants. This leads to the question of location. How does being embedded within a research university—with its multiple disciplinary cultures—affect artistic practices and identities?

As I discuss in chapter 6, "Preparing for a Hostile World," preparation for the "external world" shapes art education.[64] While encouraged to face inward, students must prepare to face outward as well. The art school is a field that touches on other institutions: Schools and markets are not isolated, but overlap. I observed students while in school, but they discussed the world around them and speculated—fretted—about what would become of them after graduation. While students are protected from that world while in school, it is a topic of rapt fascination. It is made more challenging from the assumption that the school and the market constitute hostile worlds, so that the imagined transition is stressful, in terms not only of practical considerations, but also of ideological ones. What will one settle for? Whatever path they choose, students rely upon the development of a network, a network that begins in school, aided by faculty, and then expands. These links provide support in establishing a cache of social capital. Despite the ambiguity of career success and the lack of training in creating long-term opportunities, students recognize that they must find entry points to the wider art world.

Ethnographers describe their scene with analytic depth, but as a sociologist, and not an art historian or an amateur artist, I paint with broader brushstrokes. Chapter 7, "Disciplined Genius," the conclusion of this study, explores the implications of the changes in MFA education for artistic practice and links this to more extended sociological concerns about occupations and knowledge communities. In this chapter I address what this scene suggests about technique, talk, community, network, and discipline. While each of these concepts is connected to MFA training, they address other forms of occupational socialization. Practitioners in all fields must acquire skills in approved techniques, something that is as true for doctors as for sculptors. Knowing how to do—to perform—marks one as competent. But it is not only the how of doing, but the why of doing. This is the sanctioned engagement with an intellectual—a theoretical—tradition. Lack of awareness of the realm of ideas can diminish one's stature. Likewise, every domain is a field of talk. The ability to engage in proper discourse is a mark of inclusion, and an error-filled performance is a sure indicator of outsider status. This is true not only for young artists who must properly appreciate their revered elders, but also for those in all knowledge fields. Trainees must navigate a map of the field. Demonstrating this competence cements one into a community: visual art is merely one such, not so different from

my own home of sociology. Community assumes a secure boundary, but it is often the linkages beyond that boundary—a network—that permits individuals to have impact beyond a tightly knit locality. Students recognize that networks can transform those prominent in a group to those prominent in a society. Networks make lasting impacts and long-term careers possible. Finally, there are disciplines: knowledge realms. University-based art programs create a discipline, but what is the implication of this change for art production and presentation, and how is this parallel to other knowledge realms?

Ultimately I raise a question that is central to contemporary art: Are practitioners theorists or crafters of beauty? Do they belong behind ivied walls? Is Cultureburg, that sly term of disrepute coined by Tom Wolfe in *The Painted Word*, the community in which Marissa, Esau, Hanna, and Soheila reside? Can they escape, and should they want to?

Producing Practice

Although I hold a Master of Fine Arts degree in sculpture, I do not have the traditional skills of the sculptor; I cannot carve or cast or weld or model in clay. . . . Why not? HOWARD SINGERMAN[1]

To be an artist is to *make work*. Art demands production. As Bridget put it with a mix of pride and frustration, "We're artists, but we're actually students, so we are actually workers. We are working [even] in our sleep. That's kind of horrible, but it's also wonderful" (Field Notes). One student described the "artist's job": "My job is to make things and put them into the world." They select materials, transform them, and through the magic of transformation the result becomes theirs[2]—and then ours. Bridget works diligently, yet mastering a set of skills is not part of her education. As Howard Singerman noted almost twenty years ago, the graduate education of artists has turned away from production skills, as craft traditions have been shunted aside. Of his graduate days, Singerman recalls, "It was clear at the time that the craft practices of a particular métier were no longer central to my training; we learned to think, not inside a material tradition, but rather about it, along its frame."[3]

This is a story of materiality and the challenges to craft production: how the making of objects is treated in the world of contemporary art, and how the materials encourage and constrain certain forms of production. Students identify as object-makers for whom training in making is overwhelmed by training in thinking, talking, reading, and

writing. Recognizing the wide divergence in the forms of artistic practice, of course, what was true for Singerman remains true today. Traditional skills are acquired haphazardly and as part of a personal agenda, not collectively taught. Technique takes a backseat to theory. Meaning-making has priority over object-making.

This change in art education has been widely recognized, but less emphasized is that the change was not merely in preferences or aesthetic judgment, but resulted from the changed position of the trainee and the professor in an academic structure. Set within the university (and elite art schools that model themselves on universities), practitioner-educators judge competence in an institution in which theory and interpretation dominate. This is separate from valuation based on craft proficiency, economic exchange, or admired beauty. In a world of multiple evaluative systems, tied to fields of action, authorities create hierarchies of judgment,[4] which are sometimes in conflict.[5] For students, the embrace or rejection of these hierarchies owes much to the standards of universities. Works of art are claims about the world, moral and political stances, judged by the effectiveness of their argument for an audience of professors and their allies in critical and curatorial fields.

In examining the university-based art world, I focus on the local group–based system of evaluation. Evaluation occurs within sites of interaction and places of community. These judgments depend on social relations and micro-cultures. I subsequently address how student-artists are trained in talk, writing, and self-presentation, and how they respond in light of the organization of the world of contemporary art. I begin with the work itself and the creative process as a field of action.[6] Only after the work is produced can critique begin.

Students—including Marissa, Esau, Hanna, and Soheila—enter graduate school with a skill set. They know how to *do things*: painting, photographing, performing, or filming. For some these talents are sufficient for their career, while others desire more. But how do they expand their repertoire? Students take classes, requiring critiques, writing, knowledge of theory, or even, occasionally, of art history, but at these three schools, they do not take classes on technique. While workshops are scheduled, and staff and faculty share knowledge, students are expected to know how to "make art" before they enter. They are admitted as artists, not as novices.

These abilities, whether learned beforehand or gained on the fly, are what have come to be known through the writing of Pierre Bourdieu,[7] and with a more linguistic thrust by Ludwig Wittgenstein,[8] as a theory

of practice. Artists draw on a bundle of acquired competencies that constitutes *what they do*; material skills produce meaningful work and reveal belonging in a field of action. As a result, the form of objects can reveal their artistic intentions. Even if it is assumed that intentions produce objects, those intentions are always limited, channeled, and shaped by the capabilities of the artist and the possibilities of the material.

Even when artists expand their practice and experiment in different genres, as many do in school and beyond, they must develop technique on their own, albeit in a supportive environment. The artist becomes an entrepreneur and an advocate for her own production choices. The MFA, especially in small programs, is organized around *individual* needs of students. Students receive a studio as a site for making. As one who has trained sociology students for decades, I was puzzled. We insist on a sequence of methodology courses. Every student must learn statistical analysis, how to conduct a survey, and, at Northwestern University, how to accomplish ethnographic research. I assumed that art students would learn those skills that Howard Singerman never acquired. They would be taught to mix and apply paint ("mark-making," as it is called), and they would learn wet darkroom skills or their digital equivalent. This was not the case. I found that students learned on a "just in time" need basis, in contrast to the belief that a set of skills existed that were necessary for artistic competence (carving, casting, welding, or modeling for sculptors).

Still, much is to be learned, despite the skepticism over the existence of a consensual core of knowledge. The creation of work can be complex and multi-layered. Consider Ryan Shultz, a 2009 Northwestern MFA graduate. Ryan is a painter whose representational portraits reflect a "punk" reality. I use Ryan as an example because he is deliciously articulate about his practices:

I shot approximately 300 photographs in preparation for the painting, changing the camera angle and directing Jakub to make slight adjustments to the position of his body between each shot. The figure depicted in the painting is a composite of these images initially constructed digitally via Adobe Photoshop. I kept this composite image in several layers in this program so that I could adjust the color and value of each composite part independently. . . . I then purchased the stretcher bars and a yard of high quality Belgian linen. I like a medium texture because it shows just enough of the warp and the woof of the linen threads. I carefully stretched the linen and then applied the first coat of acrylic gesso. After this was dried I sanded the surface just enough to remove the roughness. If sanded too much, it would lose the beautiful quality of the linen, the uneven nature of the threads, the knots that randomly come about when the linen is made. [He chooses not to use cotton duck canvas.] The type of painterly

effect one is trying to achieve determines every aspect of the painting process, down to the actual support, be it wood, linen, or cotton. . . . After the first coat is applied and sanded, I repeated this process two more times, for a total of three sanded coats of gesso. Then, when dried, I applied an imprimatura which is a colored stain of paint that is applied to the surface. This kills the brightness of the canvas, allowing me to paint accurately, as it is nearly impossible to judge a color or value on a white surface. Once dry I started my drawing on the surface with charcoal. I slowly sketched out the entire image, starting with generic shapes and then slowly moved into detail. Then I drew the outlines with paint. . . . I then went in using Cremnitz white, burnt sienna, and raw umber, creating a sepia value structure. I use Cremnitz white, a thick ropey, lead based white that has a translucent nature to it. Skin is translucent so it makes sense to use Cremnitz white instead of titanium white . . . because it is so opaque it makes the skin look like plastic, like the skin of a Barbie doll. . . . As I continued developing the underpainting, I made more changes. . . . I then worked over a month and a half painting this underpainting, rendering the values, sculpting the form. The highlights must be the thickest and must have the most detail to attain this appearance of volumetric relief. I do this using small brushes, creating thick impastos with great nuance. Once the underpainting was done I glazed color over it. . . . I use about 12 colors in any given painting, employing not only transparent layers but translucent and opaque layers as well. By putting these colors down in succession, suspended in oil, they give the painting an incredible sense of volume. After the major color layers have been laid on the canvas, I do a series of touch up layers, slightly altering tones with subtle glazes.[9]

In this explicit consideration of his practice, Ryan Shultz is not a typical MFA artist. But finding a work process is central to any artist's career. Artists make choices, and this determines how they view themselves, with which artistic communities they will associate, and the style by which others will define their work.

One student, a printmaker, dragged a seven-sided printing plate as she walked from her home to her studio. Each day one side of the plate became scratched; upon arriving at her studio she printed the plate, creating seven prints that increasingly revealed the marks of her journey. Her process was deliberate, as what she termed the "plateness of the piece" was revealed (Field Notes). The doing of the work connected to how the often unnoticed urban environment reveals how we, like the plates, are marked by our experience. The mode of production is linked to the intention of the artist. This artist's "slow" process and that of Ryan Schultz emphasize the deliberation possible in artistic production.

In contrast, others work rapidly, incorporating speed into their practice.[10] The intentional thoughtlessness of production defines the work. In one research site this casual aesthetic production was labeled "slacker

minimalism."[11] These artists transform materials, but with less precision and, perhaps, more intuition. I have watched sculptors scavenge cardboard and other detritus from public streets and vacant lots, incorporating these found objects into seemingly casual assemblages.

But whether the process is deliberate or intuitive, one feature of graduate art education is the luxury of time. Time is what MFA students buy with their tuition and their commitment.[12] While the effort of students varies, a widely held belief is that the constant making of art is essential. The studio becomes both a home and a workplace: the site of creativity. The critique room is the discursive action space, but the studio is the production action space, less a public performance than the development of an artistic self. The work ethic enshrines busyness as morality. One art student, Terri, explained, "You work in your studio. You spend all of your time in your studio. You live in your studio and you work, work, work, and then if you work, work, work, you are going to make good work" (Interview). Still, she contrasts her ethic of production with those of some colleagues: "A lot of people sit at home and think, think, think, until they get that one idea that they really want to invest in and then they execute. And that is a very different model. My practice is not that way. My practice is try, try, try. Fail, fail, fail. Boom, find something new and exciting" (Interview). A senior faculty member explains similarly, "I would go over to the grad studios at ten o'clock in the morning. Nobody is there, and they come into critique with a flimsy drawing or they roll a marble on the floor. . . . Annoys me no end. When I went to graduate school, I was there seven days a week. I worked all the time and I loved every minute of it. . . . I tell the graduate students, look, this is like boot camp. It starts at 5:00 in the morning and it goes to 3:00 the next morning. This is your chance" (Interview). Another faculty member says, "You show up preferably everyday if you can. And you make stuff. That is your job" (Interview).

Despite its moral claim, this stance can produce anxiety, since it suggests that one should be working even if one doesn't feel creative.[13] Esau McGhee suggests that it is not that one has time, but rather one is *doing time*.[14] Time can be demanding as well as luxurious.[15] As one student explained, reflecting the concern of faculty: "I don't have a schedule. I come to the studio whether I'm working or not, listen to music. It's 8:00 and I've done nothing with the day. Most of the time I do nothing. I don't know why, but I've been avoiding the work. Last minute I make work, and it's done with a feeling of relief. Maybe it's a type of depression the way that I'm working, because I should come to my studio with full energy and work" (Interview). One faculty member com-

mented, "I have seen grad students get really lazy. I have seen them not do anything for ten weeks, and then throw something together for the critique at the end, and I feel like what a waste of resources. . . . In these economic times what a luxury to be able to step out and be given all the resources" (Interview). Student work is pressured by the institution's full schedule of courses, workshops, lectures, studio visits, critiques, and the final thesis show. Perhaps we still hold to the belief in genius—a lightning bolt to the brain—but the mundane reality is that if the artist continues to produce, good stuff will emerge. This pedagogy makes a virtue of busyness.

Meaning and Material

Although contemporary art is swaddled in talk and in ideas, most projects have a physical reality, shaped by tools that transform raw material into intentional form. To understand art is to appreciate its materiality, the limits placed by objects, and the meanings that result. However, perhaps elite materials provide less status than they once did. Marble, steel, and canvas have been replaced by cardboard, plastic, and soil. Casual materials challenge traditional forms of good work. Based on their abilities, their desires, and their local cultures, students select equipment for making: brushes, cameras, chisels, or pencils. Too often ignored, tools—the infrastructure of art—affect the look and longevity of the work.

While some tools are mundane objects, others are technological innovations, and institutions must keep pace. What an artist cannot afford, the organization should provide. As Steven Lavine, president of the elite CalArts, reported about the demand for equipment: "The ante keeps getting upped. . . . You don't have to have state-of-the-art technology, but it needs to be close enough."[16] In deciding on purchases, programs must balance desire for the cutting edge and recognition of rapid obsolescence, always determined in light of budgets, particularly challenging for public universities or those with tight budgets. How art is made is always in flux.[17] Today few artists require darkrooms, other than to make an aesthetic or political statement. At Northwestern, equipment for high-quality printmaking is no longer available, even though this was once what the department was known for. Debates about what equipment is necessary for film, video, or the always evolving new media reveal similar choices. These decisions are connected to institutional economies, program specialization, faculty interest, and the perceived direction of contemporary art. As a result, some programs deliberately

ignore equipment necessary for certain forms of artistic production (ceramics, glass, or video). This limits the aesthetic choices of students. Large private programs, such as the School of the Art Institute of Chicago, can afford the latest equipment, while a public university with a small program cannot. As one student who relies on video equipment pointed out, comparing the wealthy, private SAIC with his own public school: "Literally at one of SAIC's fire sales you could buy equipment for like $100, the same ones we have that are our good ones. . . . I think it can be positive in that people should be scrappy and not relying on institutions, but I see how that would be frustrating" (Interview). The availability of equipment shapes the art that students produce, and perhaps work-arounds are a goad to the creative mind.

Small programs, such as those I observed, face challenging decisions. One purchase means missing out on something else. With new technology, older techniques are forgotten and untaught. One faculty member explained that digital photography marginalized black-and-white photography as a "teachable technique." Something similar might be said of marble as a sculptural form. Faculties decide what equipment is essential, and these choices set the terms for instruction. While responsive to broader trends, programs have local cultures. A program with a faculty member who bases her career on wet (darkroom) photography may maintain that equipment, while a nearby school with different faculty goes fully digital. Schools with a large investment in certain equipment may hire professors and admit students based on material availability.

When faculty at UIC give potential applicants tours, they visit the wood shop, the metal studio, and the electronics lab. The tour demonstrates the program's *technological accessibility*. As sociologist Chandra Mukerji argues, access to machines—in film school and elsewhere—is a marker of status and a gateway to professional practice.[18] Although many artists are skeptical of institutions, the availability of equipment means that they are tethered to the very institution that they critique. As sociologist Judith Adler points out about the early years of CalArts, "Such artists can as little carry on in a one-man studio as a contemporary biochemist could set himself up at a work table in his basement, and their shifting relations to institutions become the most important contingencies of their careers."[19] Access to equipment shapes reputation and organizational success. Losing access marks the institutional vulnerability of the artist.[20] Painters, those who "sculpt" using cardboard or scrap wood, and performance artists have advantages in this institutionalized economy where their preferred materials decrease their institutional reliance.

Some students are technology mavens: Their practice depends on engagement with equipment. Holly was inspired by technology, even consulting for major tech companies. In one critique, she created a pair of machines—she called them "sensorial boxes"—that emitted smoke and fragrance in sequence. These objects were "in conversation with each other" (Field Notes). Wendi, interested in the world as an auditory stage, presented a fifteen-minute "sound" piece. Using a stereo boundary microphone and a contact microphone, she recorded the vibrations of computer servers in a large data center, collecting four frequencies on different channels. What might otherwise be mechanical hums became interesting sound through her technical inscriptions. We listened to whirring that would otherwise have been unheard. The audience pondered surprising technology and appreciated what one nonplussed listener described as "drone-music" (Field Notes). Obscure technology must be made legible if the work is to become meaningful.

Through technology, the question of agency emerges. Who is the creator: the maker or the machine? Nancy, a first-year student, was intrigued with an infrared (thermographic) camera that produced images based upon the traces of bodily heat. At her first critique she displayed brightly colored "portraits" of human bodies. Faculty were impressed by Nancy's technique, but demanded more. For several faculty members this seemed to be *only* a technical achievement, not an artistic one: meaningless. One faculty member suggested that she manipulate the *camera's images*, making the work her own. Another commented, "You may be relying too much on the conditions of the camera and not enough on your own agency" (Field Notes). Each wanted Nancy's intervention, not a mechanical inscription. In time Nancy altered her mode of work, inserting herself into the process, manipulating black-and-white images. Without the artist's agency, the equipment can be seen as "doing the work," and thus diminishing its value.

Technology can bleed into materials. The difference is between technological processes that stand outside the work, but make it possible, and those forms of technology that through the hand of the maker *constitute* the work. Hakim's practice reflects the latter. Hakim is a painter who adds materials to his canvases. At one critique, Hakim showed several paintings. One canvas was made three-dimensional by the addition of globs of transparent tape. The response was striking. Materials are not often discussed unless they create an immediate link to a theory of practice. In this case, the tape was treated as a theoretical intervention and not mere material. It provoked largely positive responses. Audience members remarked: "The tape shows the hand of the maker. The tape

is so playful for me"; "These are encouraging me to play and move and be active"; "I've been staring at this for the whole time we've been here. I can't take my eyes away from it"; and "I think the tape really binds these works together. What's so gratifying about the work is that whenever you need to find a way to solve a problem, you find a way. You very rarely see that in contemporary art" (Field Notes). The discussion of Hakim's materials consumed much of his forty-five-minute critique, revealing that materials can become foregrounded if considered part of the logic of practice. The everyday becomes extraordinary.

Material Politics

The choice of material is not merely a technical matter. Rather, it is—or can be—political. Material choices are easily transformed into the moral and the evaluative. As one faculty member expressed it, "Let the materials be the content" (Field Notes). In a world in which all can be theory, the choice of material can inform interpretation. I saw glass-making students confronted by critics who claimed that glass, polished and transparent, is "too formal" a material. Too lucid. Recognizing this, students may break, crack, roughen, or smudge the glass, hoping by altering the material to transform craft into art.[21] Faculty debate the use of oil paint (more canonical and thicker) versus acrylic (more contemporary and easier to apply), black-and-white versus color photography, or film versus video. Artists who work in wood are often challenged as to their craft, such as my friend Kevin. One faculty member comments, provoking laughter, "You're kind of a wood guy. Maybe it's craft. That may be a bad word." Kevin remarks, "People say why do you like wood so much? Nobody works with wood anymore. Then I say, 'I'm going to work with wood more. Fuck you.'" This response also provokes laughter. Kevin challenges orthodoxy, but the question is whether his choice is an attack or a retreat. Kevin's material locates him in the world of craft, with identity implications. He hopes to turn that claim to his advantage by constituting his work as transgressive. Students who sculpt bronze or glue cardboard have different identity challenges. They attempt to find a distinctive artistic voice through their material. They become known through their choice of material and of technique. Access to a range of material may be a distinctive benefit of MFA programs.[22] You are what you use.

In contemporary art, the poverty of materials is theoretically significant. Is it art, or is it trash? Or is the hierarchy so blurred as to make the question irrelevant? Consider UIC student Macon Reed (her actual

name, since I am quoting published material): "The piece I did in the fall was a set of megaphone sculptures. I like everything to look like it's made by hand and not look too slick and polished. It's that classic critique of going into galleries and having everything be so pristine and perfect. So I made these megaphones and they were made out of woven cardboard that was then covered with plaster and joint compound, and they almost look ceramic, and I had them all pointing down at a giant pile of pompoms that I had made. . . . I went and got a bunch of fireworks and set them off out of the megaphones into the pile of pompoms until they caught on fire."[23] Much can be said about the theory of this piece, including issues of gender display and sports culture, but here I note that, for Macon, the lack of pristine presentation (a DIY, or do-it-yourself, ethos) is crucial to her practice.

The blurred line of art or trash appears frequently. For instance, the sculptor Karla Black, a Turner Prize nominee, uses toiletries and cosmetics in her work, and highly regarded artist Gabriel Orozco uses caps from yogurt containers. Lena, a slacker minimalist using collected cardboard, is sometimes challenged, given the modest and found materials she incorporates in her sculpture. In a studio visit, one of her professors remarked, "It has materiality that is not polished. The problem is how are you going to present the work? It's like rubbish. . . . There is a challenge to cross over [to art] when they look too much like garbage. The poverty of materials is important. I want to know the *ideology* of how you are making the work. The works can get lost." She needs an ideology to justify her technique. The faculty member suggests that adding color can signal that her trash is legitimate artistic material. The issue is not that this ratty cardboard cannot be used for art—the casual materiality is intended—but that the goal must be clear. For good work, the material form must fit the conceptual intention. If not, the work is for the custodian and not the curator. Materials must be situated within an artistic conversation, and this is particularly true as students (and teachers) have moved away from canonical materials to challenge the basis of art, and especially sculpture. Artists make things, but the materiality of the object must be justified through discourse.

Tensions of Technique

Technique in graduate art education is often shunted aside as an end in itself. Given the technical sophistication of faculty members, why is that sophistication not central to a graduate program? How and when

does technique assert itself? To be made relevant, technique must contribute to meaning. Techniques have politics, whether recognized or not, and politics—economic privilege, for example—shapes evaluation. The thingness of art has become ancillary to its conception, and technique is not always salient. Being an artist involves situating meaning in form, as even (much) conceptual art leaves a trace. Art involves "the balance between percept and precept" (Field Notes). One makes and one thinks, and these cannot be separated.[24]

Bons mots assert the secondary role of technique.[25] It is claimed that traditional art academies teach *up* to the wrist (the skills of the hand), and contemporary MFA programs teach *down* to the wrist. The skills of the hand are replaced by the skills of the mind and the passion of the heart. Michael Asher, the charismatic teacher and leader of critiques at CalArts, has been quoted as advising "no knowledge before need," a mantra repeated by faculty that I observed. Technique does not stand apart from intention and vision. As a professor explained, "First you have to describe what you want the work to be, the need of the work, what you need the work to do, and then you figure out what you need, what is the best way to manifest that" (Interview). Of course, technique can create the idea for a work: "You don't think of things without having some recognition of the skill necessary to make them happen" (Interview). A toolkit allows the craftsman to imagine possibilities that those with an empty kit might miss. Mastery permits expression.

Technique was once central to art education. A 1951 essay in the *College Art Journal* argued that "all one can teach are techniques."[26] Of course, any number of things can be taught (for instance, witchcraft at CalArts, but not drawing);[27] the questions are what is defined as useful, and what will administrators permit. Today technical facility is old-fashioned. A senior faculty member scoffed that a course on drawing is like learning Latin. He quoted a student as saying that "the only time I draw is when I am doodling or on the phone" (Interview).

Howard Singerman recounts the emergence of this ideology: how skills became marginalized.[28] What happens in graduate school is that genius is uncovered. Art students are sorted as to who has "vision." Those whom faculty admire are welcomed into the profession and are awarded an esteemed identity.

Whether through genius or labor, the ultimate purpose of graduate visual arts education is to produce artists, rather than objects.[29] Given the diversity of artists, the goal is the production of *professional artists*, artists who fit a theoretically oriented, colleague-driven, academically based discipline. By making this claim, I am homogenizing MFA ideology and sug-

gesting perfect consensus. This is false, and I return later to the diversity of the faculty in art programs. Further, students are not trained by a department, but rather by a set of faculty members within that department. As a result, some students learn craft, and some faculty in their studio visits discuss how to draw, carve, or lay down paint. Still, the organizational structure of departments—at least these three departments—does not include courses in which students are taught technical skills. Perhaps the small size of the programs, coupled with the wide range of possible artistic expressions and student interest, renders such a strategy infeasible, although even larger programs, such as CalArts, downplay technique. The diversity of cohorts and their small size militate against explicit craft training. In the incoming, ten-member cohort at the University of Illinois at Chicago, only two students were primarily painters, three were photographers, one was a videographer, two were considered sculptors, one did installations, and one specialized in performances. Unless techniques could be defined as generally applicable or as required, courses would lack enrollment. As a result, students arranged their own workshops—for example, in photography—and the staff members who oversaw shops (electronics, metal, and wood) were available for informal guidance.

A fundamental division exists between novices (undergraduates) and colleagues (graduate students). MFAs typically acquire their skill set as undergraduates. Faculty do teach technique, just not to graduate students. One ceramicist explained that "there is an expectation that they can navigate a studio when they walk in the door" (Interview). A collegiate biologist or a sociologist who stumbled into art school would be lost.[30] One faculty member explained about two uses of paint—the undergraduate and the graduate: "When a student comes in at the graduate level, they have already been taught techniques hopefully in undergrad. So there are two forms to use paint. . . . You know how to mix paint and mix color and put it on a surface, or you know how to paint as a strategy of deploying painting in the world and that would be more of a theoretical position. How do you use painting versus how do you paint? [Graduate painting] is more about dissecting *who you are* than it is how to mix color" (Interview). The lack of training in MFA education motivates some graduate students to work as teaching assistants for a faculty member who instructs undergraduates in what graduates are assumed to know. As a teaching assistant, the MFA becomes a student as well as an instructor.

This distance from technique stands in sharp contrast to another set of institutions that appear to have similar goals. These are labeled art academies. Such for-profit schools, perhaps comparable to ateliers of the

past, include such institutions as the Chicago Academy for the Arts or the American Academy of the Arts. Focusing on post-secondary education, these schools teach those technical skills that are in short supply in more prestigious schools, such as drawing, especially from live models, and representational paintings and sculpture.[31] Yet within the elite art world, demands of the atelier are passé and graduates are not considered credentialed as "contemporary artists," even if the schools provide teaching opportunities for MFA graduates. Schools such as the Savannah College of Art and Design (SCAD), more ambitious than the art academy, are something of a hybrid, offering more traditional training, such as in graphic art or design, and providing students with employable skills. Institutions such as SCAD hold an ambiguous position in the contemporary art world. They serve as boundary markers, as faculty members at "serious" art programs emphasize that *their* programs are not "trade schools." As one faculty member put it, drawing a firm line between these two locations of art education: "We are not trying to churn out technicians, which is the difference with the [art] academy" (Interview).

In writing about "How to Succeed in Art" in 1999, Deborah Solomon emphasized the change in orientation. "It has been three decades since contemporary art acquired the look of the seminar room. . . . It was only in the 1960s that [these art programs] became lodged in universities—and critical theory was elevated above craftsmanship. Whereas once students attended life classes and learned skills by drawing from a model . . . today they sit in paint-free classrooms devising strategies for subverting the patriarchal order."[32] Transgression has replaced tradition. The MFA program, exemplified by CalArts, rejected consensual standards, and in the words of painter Eric Fischl, "focused on freeing up and redefining art."[33] Universities had the responsibility of solving a crisis in this perceived sclerotic domain, while art academies, scorned by leading critics, hoped to be bulwarks of the humanistic canon.

Marginalizing technique suggests that high-level artistic creation is theoretical and discursive, not the mere production of prettiness. As a result, a student confessed that she found "the non-materialism thing" a form of elitism, in contrast to technique that allows an artist to "captivate audiences": larger publics beyond the conceptual hothouse of the elite art world.

Skilling or Deskilling?

Although graduate art programs do not emphasize acquiring technique collectively, this does not necessarily mean that young artists in their own

practices have become deskilled. The decreased emphasis on teaching the craft of art-making is memorably captured in Daniel Clowes's wickedly satiric graphic novel, *Art School Confidential*, depicting a transition from "practical techniques" and a "demanding curriculum" to "vague pep talks."[34] In Clowes's view, echoing Tom Wolfe, craft skills have been replaced by discursive skills: an unexpected form of artistic identity. In their pedagogy, instructors separate their training from what might be viewed as vocational education, that form of socialization tied to a set of agreed-upon, essential practices. That is a boundary that should not be crossed if the artist is to be treated as a professional and not a laborer. Clowes might have been referring to the faculty member who explained to me, "I don't ever really teach the how-to. I don't mean this in a flighty way. I really think that it's the concern of a student. This is not a trade school. I am not trying to teach someone how to draw something. My job is to say, no matter how you draw something, each of those ways has conceptual, cultural differences, and therefore meaning" (Interview). One is unlikely to make a similar claim about an electrician whose wrong choices—and not only unexplained ones—have consequences.

Few faculty members argue that artists should be ignorant of the range of possible techniques, even if they focus on the solution of practical problems once a student's intentions are clear. Technique should follow vision, not precede it. Still, some argue that having a range of techniques at the ready can generate ideas. The technical toolbox extends an artist's vision in that it leads to imagining an expanded possibility of material expression. Painting professor Kit White says, "I still believe that technique has an important place in art education because artists are, at their core, makers. . . . Without the tools to fashion the form, it is like trying to capture air with a net—and often about as effective. Basic form-giving skills help the student make the bridge between thought and embodiment."[35] The emphasis on skill is expressed by the prominent painter Kerry James Marshall, as shared by an informant: "You have to master [the skills of] painting in order to express yourself" (Interview). Another informant also referenced Marshall's philosophy: "The more you know about how to paint, the more language you have, and you can refine that language to say what you want to say" (Interview). A third argued that technique and intention are inherently linked, despite the prestige of the latter: "If you don't know how to make something polished or realize it in a way you feel like it's come to fruition, then you'll never be able to get your intention across. Craft and technique are the elephant in the room. Acknowledging that you have a deficit in technical skills is not acceptable" (Interview). A student vented that despite her devotion to technique, "it bums

me out that no one will ever talk about my traditional skill in a critique" (Interview). Her efforts pass unnoticed in this rarefied community. Once I complimented Esau McGhee by saying that of all the students, he showed the most concern for technique, but I added that he might not see that as a compliment. He laughed: "Don't say it in crits [critiques]!" (Field Notes). As Esau recognized, to be known for technical proficiency is dangerous for one's reputation within this community. One must perform as an artist and not as a crafts worker.

In the schools I observed, a reverence for technique was a minority position, evident in the delicacy and humor with which it was mentioned. At one critique at Illinois State, faculty wanted to know about some of the color choices made by one of the painting students, but in prefacing their questions, they made clear that raising such issues stood outside usual custom. One began, "Maybe this is too much shop talk . . ." A second started with a compliment before asking about her brushstrokes: "Whatever happened to you this semester, it's really awesome, but what happened to your palette knife?" (Field Notes). Elsewhere an instructor asked similarly, "Could I just ask a couple of nerdy material questions. What kind of paint is it?" He explained in a self-effacing way: "I'm such a dork about it. I'm trying to figure out how her mark-making makes her tracing clear" (referring to the "anti-gestural" and the implication of building up volume on the canvas). The question was justified with an analytical claim. He suggested that it is *because of* the decline of technique that technique can be theory: "That's the great thing about painting right now. People have forgotten so much, so there is so much room to grow" (Field Notes). Questions of technique are justified within a conceptual discourse, different from those "technical questions" that might be raised in an art academy. Artists need the skills of making ("geeking out" on technique),[36] but they shouldn't proclaim that technique is crucial; ideas are.

This questioning of technique coupled with delegitimating expertise, while privileging the image of authenticity. While these students will never be outsider artists and by definition are not self-taught, colleagues demand that they speak from the heart if their practice is to be credible. They must present a personal vision, not the vision of others, facing inward, not outward. Fashioning an identity and expressing it in a signature style is crucial, allowing their work to be seen as belonging to an artistic argument. One faculty member spoke of his distrust of the proficiency involved in creating realistic, representative paintings, in which he finds "a kind of preciousness that is sort of magical in northern European paintings from the Renaissance. It is a style, but it is something

that takes a lot of training. . . . And I think we are at odds with that. I look at that and it strikes me as sort of academic and stuffy. When I look at a lot of that, even when it is impressive, it doesn't really get me going. Whereas I can look at something that is far less well handled, but seems to be coming from a place of genuine inspiration or desire to communicate or connect, which I think is really what is the value of art" (Interview). I was so impressed by his critique of northern European painting (what, for me, constituted "Art") that I began asking students: If by magic they could paint like Rembrandt, would they do so? The response from about a dozen students was a unanimous no. As Hanna Owens, the performance artist, explained: "I don't think I would be that excited. I would feel more productive with my time doing other things. It was really important for that time, and I don't think it's that important anymore. We have moved past that." Contemporary curators might agree, but scores of students in art academies dream of Rembrandt's skills.

In elite art programs the marginalization of skill in the name of selfhood is widely recognized. As one administrator emphasized: "Definitely in art school, we don't teach them skill sets in the MFA program. We haven't in a long time. What we do is we give them a studio and we kind of stand back and talk to them about what they are doing in their studio. And they kind of convince us that they really are artists and they have a practice and they can situate that practice within a discourse within the field of fellow practitioners" (Interview). This is a form of consecration of identity by those with the authority to validate: a view that assumes internal gifts, but judged through continual—and often routine—work outcomes.

The suspicion of traditional—or "thoughtless"—studio work helps justify a post-studio practice in which the controlled confines of the studio are replaced with a practice "in the world." Deskilling, in a world of theory, becomes not merely the absence of learning, but a critical category, tied to a contemporary approach to art-making.[37] As a faculty member asserted, "It is not like our practice has a notion to deskill artists, but that is what is happening in the academy. . . . One of the things that is very unfortunate about that is like watching civilizations become extinct. . . . People who are invested in craft feel like they are out of fashion" (Interview). What students are not taught becomes forgotten, only later uncovered as an act of discovery.

Under the Radar

Even though programs do not schedule courses that focus on technique, students may still find ways to acquire those skills they see as useful. As

with Michael Asher's exhortation of "no knowledge before need," faculty explain that students must first determine what they need and then find a means to acquire it. Students rely on a distributed availability of skills, a preserve of informal, networked socialization. If a student lacks knowledge, a colleague might share, and so one young photographer led workshops on editing and documentation for his peers. Departmental staff, artists themselves, offered workshops on computer editing, audio production, and metalwork. An occasional structure of workshops, not formally part of the program but essential to it, characterizes art education. A few students even attend life drawing class off campus, feeling that the extra effort has career benefits. Others connect with local artists who have the desired craft skills, such as a student at Northwestern who wished to learn lithography. These strategies, perhaps inconvenient, justify the beliefs of those who argue that pedagogy in technique is not warranted. When students bring sophisticated skills into their work, they are praised for their creativity, as in the case of Hakim and his tape, Holly with her "sensorial boxes," or Wendi using a stereo boundary microphone. As long as they avoid atheoretical "parlor tricks" (Field Notes), these self-taught technicians produce amazement that colleagues appreciate. The virtuosity of process, as one faculty member commended a student, is admired when justified by intention.

The Materiality of Space

Access to usable space is central to the materiality of art, as it limits and channels work practices, community feeling, and patterns of sociability. Both artists and scientists have spatial needs, but the scientists have theirs designed by leading architects, while artists make do with remnants of urban decay.[38] Artists find studio space by colonizing post-industrial landscapes of warehouses or factories. They make a virtue of standing outside sleek neoliberalism constructions. The location of production for some artists—particularly those whose works reference the authority of making—constitutes what the sociologist of science Thomas Gieryn speaks of as a "truth spot," a point of material production that gives meaning, veracity, and authenticity to the work produced.[39] Given the transformation of former manufacturing spaces, this constitutes the artistic-industrial complex.

Recently some universities, such as the University of Chicago and Dartmouth College, have built gleaming new state-of-the-art facilities

housing art studios. Columbia College in downtown Chicago was so proud of its newly redesigned building that it scheduled a session at the College Art Association meetings to show it off.[40] Hunter College in New York moved its studios from an expansive, but decrepit, warehouse west of the Port Authority terminal in the Hell's Kitchen slum to artsy Tribeca, preferable for "open studio" visits. Students missed their spaces where they could do what they wish and justify their gritty and critical work, although many appreciated the comfort of improved digs.

As universities have constructed new museums, perhaps art studios will be the next building mania, attracting wealthy donors.[41] Dartmouth's Black Family Visual Arts Center received a gift of nearly $50 million from private equity investor Leon Black. Today a commitment to the arts reveals a university's embrace of public culture, as well as constituting an institutional status symbol. The arts have found a new and (occasionally) supportive home.

In my research, studios for students were far from sparkling, and while these places generated complaints, they also produced community and the ability to create certain kinds of work.[42] Although artists are often first movers into scruffy industrial neighborhoods, the lack of amenities confirms the critical ethos of the contemporary artist and justifies resentment that the arts are not more valued. Ideally these spaces permit flexibility in object-making and allow equipment to be moved as necessary. Unlike science labs in which equipment is often permanent and the spaces controlled by faculty, in art school the spaces are student spaces (only at University of Chicago do faculty have studios on campus, although in a nearby building). In contrast to scientists, who negotiate for their laboratory facilities and demand institutionally awarded spaces, arts faculty are campus visitors with their production studios elsewhere, while students are residents.[43] In the sciences the presence of high-quality labs draws researchers, who, in turn, receive large grants, which bring in more researchers. The arts benefit from university largess, but don't directly contribute to it. Even leading artists, such as Northwestern's late art star Ed Paschke or its MacArthur Award winner Iñigo Manglano-Ovalle, do not contribute overhead on their commissions and sales. Arts programs rarely are supported by external funding.

The spatial heart of the art world is the studio, a site of living and a place of making: a state of mind as much as a location of labor. This is "owned space," serving as one's place in an institutional system. As Sarah Thornton points out, this may be a "post-studio" era, but the studio is private and insistent.[44] Perhaps, as critic Lane Relyea suggests, the

studio is too insular and too ruled by routine,[45] but for emerging artists that space and what they do with it reveals their occupational identity. Even on wealthy campuses, these spaces are often dilapidated. Northwestern has built a sleek museum, but student studios have moved several times, and are now located in the basement of a building (Locy Hall) scheduled for demolition, leading to the belief that the university cares little about the program. The basement floods, mold spreads, ceilings leak, and, I was told, there is asbestos in the walls. One student described her windowless studio as a "soul-suck" and another referred to his as "a dark and temperate storage unit."[46] A third described his cinderblock studio as "similar to a jail cell" (Interview). Studios lack high ceilings, ventilation, or natural light. At UIC a public meeting is held to distribute the studio space, with returning "object makers" assigned larger studios and entering students receiving the remains. Granted, the studio conditions create bonds, but they also generate a culture of complaint. Some students work at home, undercutting community. As one first-year student at Northwestern remarked, "The second-years are rarely in . . . At the beginning of the program I felt like I was the only one in the studio" (Interview). Soheila Azadi treats her small and windowless studio as a storage area, using it to dance, think, and rest, but she prefers communal spaces in which to create work.

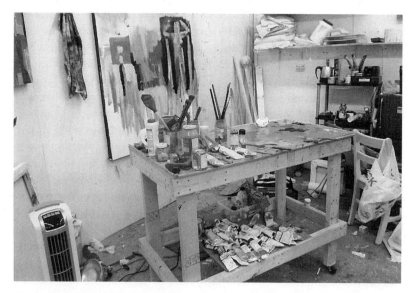

21 Studio, Illinois State University, 2013–14 (photo by author).

To receive a studio, Northwestern students sign a contract that sets the conditions under which they can use these decrepit spaces, despite the belief that their studio is personal to them. As one faculty member points out, "We rent that space to you. It's not yours." Still, a University of Chicago faculty member told me that he preferred the shabby spaces in Evanston's Locy Hall to the pristine Logan Center in Hyde Park. When Locy Hall is demolished, studios might move to a trailer on campus. Concern about environmental health is slight. One student made sculptures from resin, creating a "wanky" space that classmates refused to enter.

At UIC, during my research, the conditions were slightly better, even though asbestos had only recently been removed. The School of Art and Art History has studios in what used to be a bra factory on the industrial outskirts of downtown. At the end of my research, some of the space was closed for repairs due to the reconstruction of expressway overpasses. At Illinois State most students received studios in a building off campus in downtown Bloomington, an underheated, cinder-block structure that had been a garage, so chilly that students had to wear jackets while working.[47] They lacked private rooms, but each had a personal space, separated by sheets. Each program provided students with studios, which were identified with the resident. Students spoke of "Terrance's space," "Helga's studio," and "Clinton's dungeon." Some students slept or napped in their studios, and several purchased couches or coolers. Studios ranged from being spare to being "a landfill" (Field Notes). Sarah Thornton quotes a Cal Arts student: "'I live in mine [studio]. You're not supposed to, but a lot of us do,' she says as she points to a fridge, a hotplate and a couch that turns into a bed. 'There's a shower down by the workshop.'"[48] Students also stockpile materials that they plan to use in their artworks. Although some students work in their offices, UIC has some expansive spaces, including a large, open area on the top floor (the "Great Space"), more appealing than claustrophobic studios. Several students paint and sculpt there, creating an interactive atelier. As one administrator exhorted students, "This space, the Great Space, is your space. Make a mess of it. Bring your work here." She warned students that if they don't make a mess, the school might rent out the space for parties and public gatherings (Field Notes). Soheila Azadi, the socially minded Iranian performance artist, suggested purchasing a refrigerator, microwave, and coffeemaker to create community.[49] The Great Space is central to the local culture of the program, and is a selling point for prospective students on their campus visits.

Rooms of various sizes are set aside for critiques, locations in which student work is judged on these evaluative occasions. Often classrooms suffice, depending on the student's needs. In contrast to the studios, these

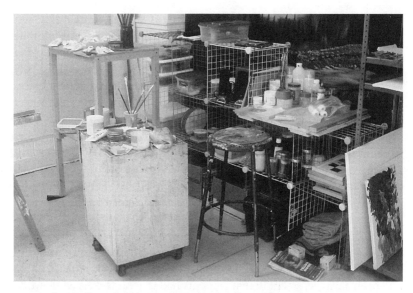

22 Studio, Northwestern University, 2013–14 (photo by author).

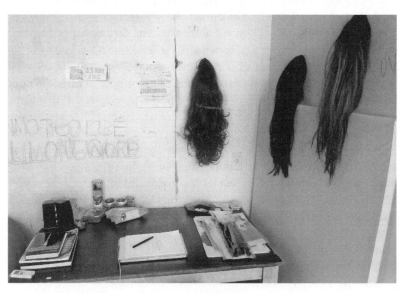

23 Studio, University of Illinois at Chicago, 2013–14 (photo by author).

mimic the white cube spaces of galleries, diminishing distractions. These rooms are known for their layers of paint ("about 9000-times painted white walls" [Field Notes]). Art educator James Elkins describes a "crit space" as "a dedicated room with sheet rock walls and metal frames for hanging things from the ceiling. Usually the floor is industrial hardened concrete, spattered and stained." Yet each room has its own character, and Elkins advises students to consider the space in which their work will be shown: "The room isn't irrelevant. In art, everything counts. Take note of the light in the room: see where it's coming from, and whether it is warm or cold. . . . A depressing room will affect your work and the critique. . . . An industrial-looking room will have a subtle effect on people's idea of your work, and so will a room that looks too domestic, or too capitalist, or too neat."[50] "An art space at rest" looks different depending on what is displayed (Field Notes); the space activates the art.[51] Recognizing this, students negotiate where they show their work, sometimes selecting their own studio, a squash court, or a school bus.

However, it is at the thesis show—the time when students about to graduate show their "mature" work to the general public—that the program provides museum-like spaces. Northwestern uses its Block Museum for the show, and UIC and Illinois State use public galleries (Gallery 400 and University Galleries). (I discuss the curation of MFA work in chapter 6.) As examinations of museum displays demonstrate, the placement of objects in a museum context affects how visitors respond to the works.[52] Sleek museum walls add dignity to the pieces. As French sociologist Pierre Bourdieu asserts, the field of art creates value through exhibiting objects in a location "both consecrated and consecrating."[53] A faculty member who teaches a critique class explained to a student during his thesis show: "There's a distinction about how we were talking about [your work] at the last critique and how we are talking about it now. The museum has for the past one hundred years added value to whatever was put in its precincts." Student work—such as Sidney's strands of brightly colored, hair-like filaments—that had seemed casual and wispy on a classroom wall gained gravitas when displayed in the museum. But the museum is not a given; it can be manipulated, providing the staff agrees. Janice installed grass in the main gallery, referencing outdoor spaces. Martin constructed a three-walled, eight-foot-high cloister in the gallery to reference the gallery's white cube and the closet for his work addressing sexual identity.

In the studio, in the academic spaces of the department, and in the gallery environment, place shapes the artistic imagination in light of the material limitations of that space. As is true for all occupations, space affects not only the content of work, but the identity of the worker.

Producing Practice

If art is ideas precipitated into form, the materiality of precipitation should have as much weight as the ideas. The absence of collective training in making is striking compared to much academic socialization. In the art world, socialization to method is proudly informal, recognizing a reality in which students begin as colleagues and not as innocent trainees.

Ultimately art is a domain of action. While producing work occurs in a field of expression, linked to a web of ideas, the doing—the practice—is channeled by materials, tools, and space. In this sense, the art world can never be merely thoughts and words; physical objects have power in shaping ideas. This is consistent with what the anthropologist of science Bruno Latour speaks of as "actants."[54] By this he means that the physical objects with which artists work have *agency* in shaping their makers and clients, encouraging some uses and constraining others. Ideas require materiality as the material placement of ideas affects their cultural reach.[55] As the anthropologist Arjun Appadurai emphasizes, objects have a "social life."[56] They are not only subjects, but shapers. Artists make choices from the opportunities that their materials allow. Wood, canvas, paint, even Hanna's pantyhose and Jell-O shape meaning. This is crucial to artistic socialization. Emerging artists learn what to do as well as what to think. The art process translates materials into commodities, making the common singular.[57] However much we wish for art to be in the air, it is always on the ground.

Spatial structures activate both materials and makers. Manhattan's SoHo and Chelsea are examples of places in which artists were early arrivals in a process that eventually led to hyper-gentrification.[58] I am not examining neighborhoods here, but rather smaller spaces, such as buildings, galleries, and studios. Artists often work in unappealing spaces, but sometimes these spaces permit art to become a form of production not seen in the humanities or social sciences, so tied to words. These spaces, shabby as they often are, are both treasured and resented by their inhabitants. Universities now promote well-designed new museums, but the gritty locales of aesthetic production remain as a monument to the industry of art and artists.

Sharp Genres and Blurred Boundaries

During my stay in Los Angeles, I asked all sorts of people, What is an artist? It's an irritatingly basic question, but reactions were so aggressive that I came to the conclusion that I must be violating some taboo. When I asked the students, they looked completely shocked. "That's not fair," said one. "You can't ask that!" said another. SARAH THORNTON[1]

For a visitor, to attend graduate critiques is to be thrown into confusion. How might a bucket of slithering eels reveal human nature? Is a student who excavates his studio, carving a screen door in the floor, a profound sculptor? What about a conceptual artist who scars herself, referencing the marks discovered on the earliest fossilized man in Europe? When does laughter overtake awe? Contemporary art leaves itself open to satire; perhaps it satirizes itself. Yet these are projects that well-regarded young artists presented in the programs that I observed, and the works and their creators were treated with respect. By the time of this publication those artists may have established firm careers. Some students produce "gallery ready" painting or photography as tightly focused as the work of the most established practitioners. Some will establish recognized styles by which they are known to critics, curators, and collectors.

Taken together, work produced in visual arts programs raises questions of how aesthetics, style, and genre are valued—and by whom. How do groups determine the boundaries and the evaluations of what they do? Whether art,

science, or labor, local communities must determine what counts as good work. In art, evaluation is particularly challenging in that it may conflict with the judgments of external publics.

Much work produced by MFA students is open to the complaints of Dave Hickey[2] or Tom Wolfe[3] that beauty, like technique, is unfashionable. If art remains the pinnacle of human achievement, it now does so in a different way from the eras of Da Vinci and Degas. What is art? I do not ask this as a mischievous and ironic gambit, but as a question of educational practice.

As discussed, in university settings, practitioners draw a bright line between art and commerce.[4] MFAs are not MBAs. Or so they claim. Some wealthy artists are charged with having sold out. As I discuss in chapter 6, the market does not receive much love, although the young artist newly acquiring gallery representation might rethink that position. In these cases, the artist acquires a reputational entrepreneur willing, at least for a time, to fight fiercely for the artist's reputation—with, of course, a 50 percent commission on work sold. Many MFA students, though not all, claim to reject the gallery-collector system, but it is hard to know whether they will be seduced by economic incentives and by the presence of someone who is literally invested in them. When such representation is productive, the emerging artist may move toward the center of an art world network.

Beyond the support of a gallerist, the location of one's network matters. As an example, four of the five graduates in one recent Northwestern cohort, all of them disdainful of the market, moved to New York shortly after graduation. This does not mean that they sold out—or would if given the opportunity—but that they wished to be where the action is.

Multiple systems of valuation compete within a social field, and such competing systems can easily become political—that is, come to be associated with different interest groups.[5] Systems of valuation serve different ends, emphasizing characteristics that benefit those who make the claim, and often serve as boundary markers with other groups. Multiple systems of judgment, existing simultaneously, are found throughout many social systems and constitute what economic sociologist David Stark speaks of as "heterarchies."[6] These valuations occur within local cultures, as particular models become salient (or not) to practitioners and consumers because of the pressures of the institutions that shape the conditions of judgment. As a result, different schools or artist communities embrace different ideologies, creating a differentiated—and sometimes contentious—field of social relations.[7] The possibility of am-

biguity or value compromises makes the bifurcation of value possible without rupturing the community.[8]

A problem with prettiness from the perspective of its critics is that "beauty sells." A division exists between those who care how things look and those who care what things mean: a divide between delight and insight. As Dave Hickey points out, this critique of the "big B word" is often swaddled in the language of artistic radicalism, linked to a haute-bourgeoisie antagonism toward financial success,[9] and so requires alternative sources of financial support. Hickey puts the division, past and present, starkly: "Paintings were primarily for people, not against them."[10] Ugly art is said to generate beautiful ideas.

To be sure, most of those in art school would take sharp exception to Hickey's formulation. No one expects sociology to be lovely or chemistry to be comely, so why should art practice be different? As in those fields, the criterion of worth should uncover unique and valuable contributions of whatever kind. Each auteur as knowledge-maker must find a niche, a point of distinctive creativity. I recounted in my introduction how I gave up being a serious artist when I learned that I couldn't be a modern Monet, but only a Monet-manqué. I desired to be derivative; perhaps, had I continued, I would have learned better. But I have created space for my individuality in sociology, a particular style of research and writing that I am known for; by the same token, my artist friends develop their own signature styles. Terry Smith warns, "Standardization means mediocrity; mediocrity is the enemy of art."[11] As a result, a young sculptor at Illinois State is criticized for her bronzes that seem too admiring of those of Henry Moore. As one professor phrased his concern: "These could be in a *New Yorker* cartoon about sculpture. [The audience laughs.] It becomes a watered-down, decorative version of modern sculpture. I know you don't want to be in that clichéd position of what an abstract sculpture is in a rich person's apartment" (Field Notes). This sculptor's work is too close to a canon that has become a cliché. While this is not precisely plagiarism, in that the admired work is not being copied, innovative creativity seems missing. Ideas trickle down, but in this process they need to be differentiated. The sweet spot is to show an awareness of art-historical connections without the work being derided as derivative.[12]

However, there is a paradox. While individuality is demanded, too much individuality—edging close to the honorific of genius—is suspect. Creativity is labeled as a "dirty word . . . it's almost as embarrassing as beautiful or sublime or masterpiece."[13] A professor explained, "There is kind of a resentment toward people who have a romantic self-vision and

self-assessments of themselves as artistes" (Interview). A work should not be *too unique* or *too similar*: identifiable as being located within a divided field and connected to (but not mimicking) a set of current practices.

These distinct perspectives may represent genuine disagreement, but they also rest on a troublesome dichotomy: Being imitative is undesirable, but so is creating *de novo*. What is left? Consistent with Michael Asher,[14] the answer is that art belongs within a relational space: a local world in which artists influence and are influenced by each other as colleagues. Art is a discipline consisting of competent professionals whose work is shaped by others and by a set of implicit standards, but ultimately differentiated, creating uniqueness as well as similarity. As Raphael Fleuriet writes in the catalog for his thesis show, echoing the classic sociologist Émile Durkheim: "Art creates aesthetic facts. Artworks are not the sole production of an author but aesthetic facts that are contingent upon one another, as well as upon larger sociocultural realities."[15] This supports the claim of critic Boris Groys that the artist supplies aesthetic experience, designed to modify or overturn the sensibility of viewers who stand within a larger aesthetic sphere.[16] Although the work is personal, it is situated in a nexus of value judgments.[17] Worth is to be debated convivially, embedded in a community of shared interest and recognized in the "social turn in art." Objects are not orphans, but members of extended families. This approach is labeled "relational aesthetics," a term created by the influential French critic Nicolas Bourriaud. Bourriaud defines the approach as "a set of artistic practices which take as their theoretical and practical point of departure the whole of human relations and their social context, rather than an independent and private space."[18] This domain sees the artwork as constituted by the artist *and* the audience. This suggests that the meaning of a work depends not on the object alone, but on the context of exhibit and consumption, made manifest through a social encounter.[19] While not every artist embraces this model, its interactive (and do-it-yourself) quality proved appealing. Practices that made this conviviality central to the work included karaoke as a relational exercise or the establishment of a pseudo-corporation to collect money to purchase artworks and to give grants to students. One student for his critique compiled a library of texts, creating a reading room for visitors.[20] The aesthetic significance of group singing or faux meetings is open to question, but the creation of community is a central feature of much contemporary art. While some works explicitly demand a relational response, for many the background of relations among artist, product, and audience has taken hold. The artist is to be not an oracle, but an interlocutor.

The Beauty Trap

An outsider to the professorial and professional world of art may share Tom Wolfe's and Dave Hickey's dismay at the disparagement of beauty. Who could dislike gorgeous objects—and why? Why would an art professor tell a student, "Let it be ugly, if it is ugly" (Field Notes). The problem is rarely beauty, per se, but rather beauty as the motivating force of a work that demands to be loved, creating a merchandising aesthetic. This is art that searches for a couch underneath. Art becomes an object for acquisition, serving, in effect, as exquisite wallpaper. An emphasis on the beautiful suggests an absence of critical content. Often artists who triumph in the reputational tournament of success are those who can produce works that collectors like to look at and critics like to think about. As Matti Bunzl argues in *In Search of a Lost Avant-Garde*, curators, especially those charged with selecting contemporary art, must juggle distinct audiences through a process of "managerial mediation."[21] However, in MFA programs, philistines are few, and the theoretically inclined professoriate dominates. Aesthetics is the A-word, Beauty the B-word, and Connoisseurship the C-word (Field Notes). Distant from the market and often lacking family entanglements, students have the luxury of scorning careerism. They can embrace voluntary poverty, able to live through the support of their friends.[22]

In practice, the skepticism of beauty shapes student choices and collegial evaluations. One student surprised me when he suddenly announced that his work did not need to "look pretty" (Interview). In this same vein, work that is deemed "formal" (concerned with form above content) is often derided, as in the case of one student, Devin, a glassmaker who strives to create "a perfect system" in precisely constructed rectangular forms. His work is viewed as sterile and rigid. Faculty, searching for meaning, admire the flaws in his production, about which he might have been embarrassed. One faculty member asks, "If I can be super-blunt, do you see these as a metaphor for something larger?" Others speak of the work as "very buttoned-up and very contained," and as "not much of an art of resistance." His strongest defender among the faculty recommends that he become even more contained and strict in his creations: "Just grab things and squeeze the shit out of them. . . . Maybe you do tight well, and you need to go down that road. The thing that shuts it down for most people could be your way to creativity" (Field Notes). This admirer suggests that Devin use his tight structure (work that otherwise is "boring and predictable") to critique other artists

for their looseness. Artists like Devin who make elegant objects are challenged in school in a way that they might not be in the market.

Devin's example reveals that aesthetic concerns are present, but must be treated gingerly. An embrace of the aesthetic remains possible as long as it is distinguished from beauty designed for elite patronage. Jane, a student friend, explained to me, as if to a foolish novice: "Gary, we are here at the school to make work that's challenging. I'm sure we could all make beautiful Monet paintings or Picasso paintings if we wanted to, and that's fine. I'm not opposed to that. There's a place for all art, but that's not what we want to do. What we want to do is make something more challenging and contemporary." Wick echoed Jane, referring to a colleague's film: "Moments of idiosyncrasy are more important than moments of beauty, because there are a lot of people in the room who can do that." A senior faculty member patted him on the shoulder, saying, "That is really good advice" (Field Notes). The irony is that elite collectors, as opposed to less wealthy and engaged buyers, often are so in-tune with art world conventions that they desire to own ugly art.

Some of those in MFA programs feel that "fine art" is a "snotty" term. It is considered too passive, too linked to an establishment that needs to be overthrown. As a professor explained: "Artists have cleaved open that idea space for redefining what is beauty. Our job is to continue to widen the definitions of what we understand as the world. So who is to say what beautiful is." His colleague added: "Something beautiful, there is a passivity in that that strikes a lot of artists. . . . Where they see the goal is to work against the grain to create conflict, to allow room for critical thinking, whereas sometimes if beauty is the only goal, and if it is a kind of canned beauty then it may not have enough" (Interview).

Perhaps we have arrived back at the provocation of fin de siècle modernist architect Adolf Loos, who asserted that "ornamentation is a crime." (Tattoos are the embodied exception that proves the rule.) If a work is called beautiful or decorative, the compliment must be offered delicately, as in this student comment: "Other places [in your work] seem like decoration. I don't mean that in a bad way" (Field Notes). The addendum would not be necessary unless the comment would otherwise be considered hostile. Today the category of beauty has been exploded: not in museums that seek visitors, but in art schools and critical journals. When one much admired student presented some elegant minimalist drawings on tracing paper, a faculty mentor admitted, "These are kind of heady art objects. I like this. They refer to other art objects. . . . These are really sincere." This faculty member admires these refined works, but admires them because of their references as "art objects," not as graceful drawings. Beauty

and ugliness are ideological and as such are capable of being smuggled into art school, but only to address something more consequential and critical. One instructor suggested that the idea of the counter-aesthetic, as described by theorists Fredric Jameson and Mike Davis, has overturned a dominant, uncritical view. The discourse that embraces ugly work suggests a fundamental disjunction between art within a market and art within an academic community.

Stylish Artistes

Think of style as sedimented aesthetics, tied to an artist's professional identity. To speak of an artist having a style—a signature style—suggests that there is a recognized linkage among her productions. This opens the body of work to the recognition of an artistic self. We think of a "Rembrandt," a "Monet," a "Koons," or a "Gonzales-Torres" as a category of objects with a recognizable creator.[23] Emerging artists are often told that they need a signature style, and that once they have one it is dangerous to change. Further, as sociologist of art Hannah Wohl points out,[24] artworks are typically made in series, even if the series only consists of the artist experimenting within a form, format, or medium. Art instructor James Elkins, surveying pedagogy, remarks: "It is hardly possible to imagine an art classroom at the beginning of the twenty-first century—at least in Europe and America—where students are encouraged *not* to try to find individual voices and styles."[25] *Consistent novelty* is linked to an artistic reputation.

Reputational danger exists in presenting work judged close to that of well-known artists. Too much influence, and the artist becomes an acolyte. This was evident when a student, Fred, placed sculptures on thin brass rods. One of his instructors remarked, "The rods are so Carol Bove. You have to wait ten years to do it" (Field Notes). Otherwise Fred's work might be seen as copying Bove or at best as homage, and not as personal choice. Even students who doubt the value of constructing a style or a "brand," as they dismissively term it, realize that works must be classified together. Most works look like those that the artist created just before. Wick notes, "I'm a little bit offended by the strategy of artists who make themselves into a brand, but no matter what you make looks like something you made" (Field Notes). Kerry Tribe, a visiting artist at Northwestern, cites her mentor John Baldassari, who told her that "nothing ever strays from the line. You think that you are here and here and here, but there's really a thin line between them" (Field Notes).

Despite the push to establish a distinct identity, style is problematic for two reasons. First, style can be perceived as strategic, leading to the work being seen as luxury home furnishings.[26] While serious collectors, in contrast to casual buyers, treat their purchases as economic or aesthetic assets and not as decor, the artist's style can be seen as a strategic attempt to find a niche and client base. Students recognize that style potentially involves the creation of a market persona. As Bridget explains, "Branding connects to commercialism because people want versions of the same thing" (Field Notes). Second, style emphasizes the physical appearance of the work (its surface), rather than its meaning (its intention). Jeffrey states the problem: "If you're an artist, you shouldn't be worried about style. I can't be wrapped up in originality. That's a dumb battle to wage" Yet, he explains, "I want to be acknowledged. I want to be validated" (Field Notes). How can an artist be validated without a creative self? If one isn't recognizable—labeled—one can be derided as derivative. The challenge is to develop an artistic identity, while not being tied to a narrow, repetitive, and imitative practice. Martin, a student who works in multiple styles and genres, jokes in a critique, after an instructor notes common elements in his work: "I have a lot of studio visits [of visiting artists] in which people say that this looks like a group show" (Field Notes). Because the intention of his work explicitly addresses the relationship of queerness to art history, Martin escapes criticism for a lack of visual style, being esteemed for the diversity of his practice and his theoretical intention.

Style creates identity so long as it is judged to be authentic and substantive: not refined or strategic. Slick is out, unless the slickness *critiques* the slickness of others. Yvonne Rainer, a prominent filmmaker and choreographer, told a young artist, "Art schools . . . tend to serve as launching pads for careers by fostering the same emphasis on polish and completion that one finds in the art world. Challenge yourself with what 'doesn't work.'"[27] As Fred explained, "Slop can be a style. Painting over the corners some could argue is slop. . . . The idea is to avoid your art becoming mechanistic. This active avoidance of technique is interesting" (Interview). Students are encouraged to reject hyper-professionalism, facilely embracing convention to mark competence. When members of the avant-garde break accepted rules, they must demonstrate that the choices are intended, rather than revealing incompetence.[28] Attending shows of undergraduate work, I often felt that they were more gallery-ready than the works of the advanced graduate students. Undergraduates had not yet learned the value of slop.

Genre Politics

Although genre often shapes the identity of artists, it was common at Northwestern and more particularly at University of Illinois at Chicago for faculty to encourage work labeled interdisciplinary. One student, defining himself as a multidisciplinary artist, explained that "I wanted to give myself the freedom to be as promiscuous as I wanted to be. I wanted to think of my practice as concept first and form later" (Interview). The mantra of Clement Greenberg in the 1960s, in describing medium specificity (features unique to a particular medium) suggests that significant art cannot sit between media.[29] As art critic Thierry de Duve wrote of Greenberg's perspective, "If something is neither painting nor sculpture, then it is not art."[30] Today art has transcended the Greenberg moment with site-specific installations, conceptual art, and relational aesthetics.[31] In the programs I observed, sometimes students sequentially explored different approaches. Several students who considered painting as their métier explored other genres with the encouragement of faculty mentors. One faculty member referred to painting as "a good gateway drug," leading to experimentation (Field Notes). Hanna Owens's practice was notable for her combination of performance, moving image, sculpture, sound, and occasionally drawing. As she explained, "I used to be a painter, and all I used to do was hang things on the wall" (Field Notes). Now she owns the space. The boundaries that separate the forms of art are blurred, intentionally, gloriously, and puzzlingly. Some art students even insert concepts or forms from other art worlds, such as film, theater, or music, into their production, raising the question of what characterizes a work as visual art.

I focus on two genres—or mediums—of practice, painting and performance, ignoring for the moment their fuzzy boundaries. To examine two genres is to remind us that even though we often casually refer to "art," the relational field that comprises the visual arts is highly differentiated. These cases could be multiplied, but presenting two distinct domains reveals the complications of an easy category of "art."

Every genre must confront its own culture. For instance, photography as a practice is fundamentally about editing a massive amount of product: many more photographs are taken than can be shown. Further, photographers must recognize a thin boundary with advertising or family snapshots. As a result, an artistic justification is critical. As one multidisciplinary artist, a former photographer, announced, "Straight photography

is not art. Straight photography is pretty dead for me as a practice" (Field Notes). A faculty member explained that photography involves "a great deal of curating, selecting work that best represents" the artist (Field Notes). How do you convince an audience that the work is a creation of the artist and not the camera?

In contrast, painters are limited in their production and tied to the politics of gallery representation and sales to elite purchasers. Paintings remain the most desired works at auction. Painting is not dead, even though students recite its obituary. It seemed to me that painters experienced more painful critiques than others. Perhaps faculty felt that they knew what painting was and what it shouldn't be. Sculptors have the problem of material. Marble and bronze, the materials of classical sculpture, are passé in contemporary art: How can modest materials be used to produce objects that last? Lacking plinths, sculptures squat, seeming still more casual than they once were.[32] The few students who show drawings have the problem of gravitas. As one occasional sketcher commented, "Nobody makes it as an artist as a color pencilist. You have to find a more serious medium" (Interview). Those in moving image work have a different challenge in that it is unclear if they belong in the visual arts or in film school. As one filmmaker shared, these artists are "too arty for the film crowd and too nerdy for the art crowd" (Interview). Ceramicists are treated as craft workers and printmakers as technicians. While performances may be rehearsed—and filmed—their wispy impermanence raises doubt. Each genre faces reputational challenges.

Old Paint

To discuss paint one must start with drawing, both crucial and inconsequential. Drawing is found in the backwaters and byways of museums. Few visit. Yet many children treasure pencils and markers. Give a child a crayon, and the house becomes her canvas. Drawing is like American soccer, engaged in by many, but observed by few. One young man, who has moved on, told me: "At the age of nine, in third grade, every day coming back from school, I would hide myself behind my bed and grab a piece of white plain paper. I was drawing these naked figures waiting in line to go to the bathroom. For about a year I did this every day" (Interview). Another nonathletic boy, often bullied, gained respect for skilled drawings of airplanes.

In time, the charms of drawing, inexpensive and open to all, grow faint. The next step—the first that requires a commitment in time, re-

sources, and identity—is painting. A painting is a drawing that demands preparation and materials that require purchase; unlike a draftsman, a painter embraces an occupationally distinct category as well as a door to high culture. Painting is so revered that during the nineteenth century mammoth cultural institutions were built to hold treasured canvases. The wealthy competed over who could gather the greatest collection, validated by donating their cache to the public. Once painting was the pinnacle of Western civilization, and it remains crucial to elite museums, the gallery-based art market, and competitive auctions. As a sociologist, I do not discuss the aesthetic complaints leveled, but rather examine how painting is treated as a career-based enterprise in art programs.

Even though the material forms and preferred techniques of painting have shifted over the past century—painting is not mere wet color on canvas[33]—the genre "painting" has survived. However, it has not been as successful within the rarefied critical discourse of the art world.[34] In 1935 Kenneth Clark, writing of the "future of painting," declared that "the art of painting has become not so much difficult as impossible."[35] Apocalyptic predictions have continued, including Ad Reinhardt's comment that his black canvases were the last paintings that anyone could make. In 1981 Douglas Crimp reiterated the claim in "The End of Painting."[36] Putting paint on canvas as an act is easy, but justifying painting as an art form is more difficult. As the young painter Jordan Anderson writes, thoughtful young painters create work in light of this "macabre discourse."[37] Some sneer that painting is merely illustration, kept afloat by the market. As one student maintained, gazing at a painting is like looking at the wall, a pleasant distraction in a restaurant or hotel (Interview). While most art schools hire prominent painters, such as Judy Ledgerwood at Northwestern or Julia Fish at University of Illinois at Chicago, it is common that, as at CalArts, many artists whose practices involve paint do not define themselves as painters.[38] These artists see an identity boundary. Says one: "I define myself as an artist who uses painting as a conceptual strategy. . . . To say I am a painter doesn't make sense because when I talk to all the painters they have fascinations and lusts for things I couldn't care less about. I don't care about certain types of finishes against other types of finishes" (Interview). This artist lusts after unvarnished meaning, not meaningless varnish. Another professor commented that "most artists don't want to show with a painting gallery. I don't even know if such a thing exists anymore. . . . So I think for a lot of artists they want to be able to test their work and have dialogue with artists working across disciplines" (Interview). Neither Northwestern nor UIC offers a graduate course on painting techniques. One senior

art professor, a sculptor, joked that when he was young, "We didn't know that in twenty-five years we would still be teaching painting."

Given how important painting is to me and to many cultured adults, I was surprised at its fraught politics. Young painters were seen as a distinct category, and faculty and students drew attention to the boundary. In contrast to other critiques in which all faculty participated, painting faculty felt that they should lead critiques of painters and that they had special expertise (Interview). Students referred to those who do "painting painting": those who were fully committed to the craft, rather than using it for another end. One described himself as a "painterly painter," meaning that he had faith in his mark-making, which has "expressive characteristics" and is a "major feeling device" (Interview). For him brushstrokes are essential, not invisible.

In contrast, others differentiate themselves from the painterly subculture. One student announced at a critique, "I'm not a painter. I don't know anything about painting." The student continued, "Maybe this is a non-painter question" (Field Notes). Comments like this were surprisingly common, and were rarely addressed to those working in other genres. I never heard a student claim not to be a performance artist, although many weren't. Students would make clear by their comments that they considered painters to be a separate community with its own forms of evaluation and practice. So when one of the classes I was attending decided to move to the painting studio, a student filmmaker announced humorously, "That would be great. I've never been there"— adding, "I've been there, but I've never been able to hang out" (Field Notes). Painting is threatened, but central; dismissed and revered.

In art school, painting is treated as a distinct world, a specialty with local traditions, social relations, economic structures, and action spaces, separate from other genres. Put another way, art-making, like other disciplines, is a set of communities of practices in which each community has a culture that binds members together.

Acting Out

We live in a world of performance. Many social scientists speak of a "performance turn."[39] With everyone acting in and acting out, what is the boundary between art and theater? Is a division noticeable between art as performance and other forms of performance? Artists think so because of their focus on the image. If painting exemplifies the flat and still, performance is the opposite: rough and quick. The boundary be-

tween art and performance was smudged by the social events of the Dadaists, the "happenings" of the 1960s, and the visibility of performance art in the 1970s. I have heard it said that we can date the break of modern art (Jackson Pollock, Mark Rothko) and contemporary art to 7:45 p.m., 19 November 1971, when the conceptual artist Chris Burden had himself shot in the arm by an assistant with a .22 rifle. Here was a performance, disquieting or disgusting, but one that emphasized that art was about ideas and not beauty.

Performance art flourished, a source of bemused public skepticism. No longer "my child could do that," but "my child wouldn't dare." How far is too far? When Hanna Owens had her audience spit Jell-O into her worn pantyhose, did she cross a line? Was Soheila Azadi making a profound political point in having audience members squeeze by collaborators wearing burkas? One recent Northwestern MFA student, Eric May, has made serving meals in a gallery and from a food truck part of his artistic practice. Do artists have the right—moral or pragmatic—to intimidate attendees into participating in their efforts?[40] Should art spaces, committed to relational art, become *Candid Camera*?[41]

With the desire to produce community coupled with the belief that artistic practice should be *embodied*, artists invite audiences to observe and, sometimes, to participate. Artists often assert that they find a personal imperative to perform. One student explained, "Being thrust into an art environment, I felt tense. I didn't feel liberated within art; I felt oppressed. This tension triggered an exploration in me that threw me into performance art. And then it was through performance art that it became a way to connect these aspects of myself that were polarized" (Interview). Another student, Julie Potratz, stated in her thesis that "the impermanent nature of performance is what I love about it." She described her practice in these terms: "During my first year of graduate school, I became interested in doing impersonations. The focus of these impersonations was women in positions of power—former secretary of state Hillary Clinton and the chancellor of Germany, Angela Merkel. The purpose of these impersonations was to analyze all the components that made up their public persons, and how gender affects the way they were perceived. It was also an act paying homage to two of my feminist heroes."[42] In a residency in New England a third student performed yoga in the nude while standing in a stream, in a performance entitled "What People Really Do in Vermont"—capturing, he felt, a dramatic spirit that was not possible otherwise. These works may have a certain piquant oddity to strangers (and, perhaps, to some insiders), but they are designed to reveal themes of gender and environmental politics.

Yet a performance is more than an artist expressing herself. It also involves viewers. If one is open to the experience, the performance expands one's awareness. Performance art requires an understanding audience, willing to extend the boundaries of appreciation in a way different from the appreciation of painting. As Pablo Helguera writes in *Art Scenes*, we now realize that *"we* are the art,"[43] and this allows artists to involve audiences, a relational view that many students embrace in their practices.

Painting is insistently material. It requires canvas (or its equivalent) and paint (or its equivalent); a wall would be nice. But performance is evanescent, and thus it must be documented. Material documentation permits performances to be inserted into art history as objects, and not just as memories. If a performance is not documented, will it vanish without a trace? Videography or photography of performances is common, and students depend on collegial helpers. The documentation, while crucial, is to be treated as invisible, not part of the work. This became evident in a performance organized by Soheila Azadi, in which Hanna Owens danced, that involved nudity designed to be viewed only by the female members of the audience (men and women were separated by a curtain). The student filming the performance was male, a fact noted by an audience member. Soheila explained that this documenter was not in the audience and so his gender was irrelevant. For purposes of the work, he did not exist.

Sometimes physical traces or objects from the performance remain. A case in point, revealing the perversities of collectors, has to do with the work of artist Rirkrit Tiravanija, who cooks Thai food for museum guests, hoping to create community through relational aesthetics. According to an informant, "collectors started buying his dirty woks and putting them in a vitrine. The point is anything can be commodified" (Interview).[44] One can imagine—with a shudder—that Hanna Owens's pantyhose might be monetized and displayed.[45] As Julie Potratz wrote in her MFA thesis, "These artifacts at least allow us to have a conversation about the ideas embedded in performance that don't exist anymore. Isn't half the experience better than none?"[46] But what about a student (at the University of Chicago) whose work consisted of telling faculty what he did, without showing any traces—a performance that led to a sharp division among the faculty (Field Notes).[47] As Potratz notes, performances are often recalled in narrative in a professional community: Chris Burden having himself shot, Rirkrit Tiravanija serving pad thai at MOMA, Julie Potratz impersonating Hillary Clinton, or Soheila Azadi simulating an abortion. These are moments that insinuate themselves into our memory, becoming a means by which we think about the world.

In many artistic performances, deviance is central. A thin line exists between acting and acting out. Performance is designed to shake an audience from its lethargy. As a result, some performers choose to be naked or to engage in erotic activities. Take the case of an early, university-based work of Paul McCarthy, now an art world darling: "In 1976, before a classroom of students at the University of California, San Diego, McCarthy performed 'Class Fool,' a shamanistic, quasi-sexual ritual with plastic dolls, in which he crawled around naked and smeared with ketchup, retching at the conclusion." The point was to understand the "absurdity of normality."[48] Other artists, Vito Acconci and Marina Abramović among them, have used their naked bodies in gallery spaces: respectively, masturbating beneath the floor and standing naked in a gallery door. I knew several art students who disrobed for their art. One student, Jeffrey, created a pitiful male character, often filmed in the nude, repeating sad pickup lines to reveal the comic pathos of unfulfilled male desire. As noted, Soheila Azadi uses nudity to critique gender binaries, contrasting Eastern feminism and Western feminism through bodily display. In one performance the nudity is revealed along with a soundtrack of an Islamic call to prayer. Nudity often is a trim young person's game, appealing to students and those who desire a reputation for provocation.

Sometimes, as in the case of Chris Burden, performance can involve danger. One student was so hyper-energetic at his critique performance that viewers worried that he might have a seizure. A faculty member described it as "being forced to have aphasia." Several faculty were acutely concerned, but did not interfere. As a visiting artist commented: "How can you do this thing without doing damage to your body? Doing that will lead to selling more. [Laughter.] You're going to get exhausted. Your voice is going to hurt. Your brain is telling you not to do it. Your art is telling you to do it" (Field Notes). Art world culture in school and beyond encourages performances that outsiders might find deviant, dangerous, or disgusting. While painting gazes backward, arising from and critiquing art history, performance art extends art practice forward into a world of sociality.

Where Does Art End?

Sociologists care a lot about boundaries. When and where does one thing become another? When does a meal become a snack, a test become a quiz, or intercourse become a quickie? How do we categorize things, and when do we separate them?[49] Sociologists of art wonder, Where does art end?

As art critic Barry Schwabsky asks, "Why does the seemingly kitschy work of Jeff Koons hang in great museums around the world while the equally cheesy paintings of Thomas Kinkade would never be considered?"[50] These references are particularly apt considering that, as its final show on the Upper East Side, New York's Whitney Museum gave five floors to a Koons retrospective. In turn, Derek, a student at UIC, wrote what I considered a brilliant paper imagining a career-spanning Thomas Kinkade museum exhibit with his artistic influences and stylistic choices delineated. The faculty, not composed of sociologists, was less impressed.

Boundaries are potentially confusing for audiences who spy a fire extinguisher in a casing on the wall. In a Jeff Koons show, an encased vacuum cleaner may be nearby. Even a couple locking lips might be not a public display of affection, but the provocation of German performance artist Tino Seghal.

The salience of artistic boundaries emerged from the practice of Marcel Duchamp. Perhaps he was not the most talented artist of the twentieth century, but he might be the most influential. For Duchamp art was about ideas translated into form. Consider his best known work, *Fountain. Fountain* is a white ceramic urinal submitted to an open show of the Society of Independent Artists (many urinals were later commissioned by Duchamp), signed by the "artist" R. Mutt. The materiality of the object, created through an industrial process, is less significant than the implication of Duchamp's submitting it to a show in which all submissions were to be accepted.[51] At first that so-called readymade was a scandal, rejected and leading to Duchamp's resignation from the board, but today it is an icon. Is art whatever artists do or whatever curators place in the museum, or does it demand more?[52] One student claimed, "The field is defined by those who occupy it" (Field Notes). Sarah Thornton quotes a major curator as saying, "For me, an artist is someone who makes art. It's circular. You tend to know one when you see one!"[53] As sociologist Howard Becker emphasizes in his influential *Art Worlds*, artists collectively develop conventions of what is to be treated as competent professional production: that is, art.[54]

French sociologist Nathalie Heinich argues that in the contemporary art world, the object itself is no longer crucial in contrast to the nexus in which it sits: "the whole set of operations, actions, interpretations."[55] These complexities, taken together, serve to differentiate, preventing everything that is produced by an "artist" from being embraced without qualms. In truth, anyone who has engaged with artists is aware that negative evaluations are rampant. Perhaps anything can be art, but certainly not everything is admired.

Consider Bridget, who, during her first year, produced texts having to do with imagined intimate relationships with iconic poets, work of which faculty members were critical, with one visitor suggesting that "it wasn't art because it was writing" (Interview).[56] This raised concern as to whether she really was a visual artist, who belonged in the program. (Her drawings are expert.) Bridget claimed that she was not worried about the perception of this work. She asserted the "edge [of art] is really slippery, but for me personally it is not a source of major anxiety because it is more about the feeling of personal imperative and that the work dictates its own trajectory. The title of artist is less important than the work being good" (Interview). In her thesis show Bridget incorporated drawing, printmaking, sculpture, and installation. She plays with boundaries, but she is fortunate in being sufficiently articulate to persuade the faculty that her multiple projects constitute a single practice. Her practice explores the intersection of identity, sexuality, and materiality through her multi-genre installations. Bridget is not alone in facing that boundary. Do composer John Cage, filmmaker Stan Brakhage, or singer Laurie Anderson count as "visual" artists? Each was claimed by my informants, perhaps legitimated by their celebrity, but also suggesting the potential intersection of art worlds. I was told that what makes these boundary-spanners artists is that professionals in their "home" disciplines reject their work; perhaps writers would reject Bridget, legitimating her texts to visual artists. Denise, who incorporates musical performance, emphasized, "I want to make work that musicologists won't like" (Field Notes). She recognizes that there are distinct *thought communities*,[57] and she chooses to stand on one side of the epistemic chasm between disciplines, not attempting to bridge them. To be treated as an outsider in one world may lead to being seen as an insider in another. Even though there are linkages, occasionally quite powerful, between distinct cultural fields, there are boundaries as well. Few creators are embraced by more than one cultural domain. Boundaries of belonging can be razor sharp, as these students recognize.

Related to the politics of making is the question of how and when artists must be involved with the creation of their own pieces. Some prominent artists (Jeff Koons, Damien Hirst) barely touch their own works; instead, they have expert fabricators follow their instructions. Artists may legitimately incorporate objects or performances produced by others *for different purposes*, akin to DJs' practice of "sampling." This is like Duchamp's *Fountain*: That work's distinctive form and industrial production insisted that it was not made by the artist's hand. In appropriation, objects and forms are gathered and combined, creating a collage. Vic presented a film providing a cracked reconsideration of the popular

movie *Home Alone*. The instructor was surprised to learn that he had filmed nothing, but had stitched together videos found on YouTube. (Many amateur filmmakers produce their own versions of *Home Alone*). Perhaps this edges toward copyright infringement (or even plagiarism), but I treasure his bricolage. The artist's combination of texts protects his work from the charge of academic dishonesty. The instructor praises Vic's work: "Creation is so prole now. You want to outsource that. Getting a multiplicity of voices was a kind of resistance" (Field Notes).

In a university setting, appropriation can be challenged, given standards of academic dishonesty. An instructor worried about plagiarism, an issue that occurred several times during her career, noting, "There is a fine line between appropriation and taking something that isn't yours" (Field Notes). Perhaps there is no line at all, only competing interests. Ideas inevitably trickle down. We should learn from others, but not steal from them, if we can find a line that divides the two. Often it is new words or old words arranged differently. The artist Richard Prince was recently sued for copyright infringement for using, without permission, the barely transformed photographs of Patrick Cariou. Eventually the U.S. Court of Appeals found for Prince, but it is easy to appreciate Cariou's resentment. Still, this is a world in which students are trained in plucking images. In one of her critiques Hanna Owens presented a camping tent onto which images were projected—an ocean, a snowy highway. In the background she played a slowed-down version of an Alicia Keys song. She explained, "That's really important to me. I didn't make anything myself, but I just selected things that mean a lot to me." Her hope was that this compilation—Hanna Owens as curator—would be treated as an act of creative inspiration.

What advice do we provide to ambitious graduate students? I am less concerned with what Jeff Koons or Chris Burden can get away with in their enshrined practices than what Marissa Webb and Esau McGhee must take into account in establishing their careers. Sociologist Judith Adler suggests that this makes the instructor into a stock market analyst or water witch.[58] The problem is that there are no fixed rules for borrowing. Appropriation is good, but copying is bad. What is the difference? The answer is a theory of the case. Students need to be recognized in light of their place in the field, but seen as distinctive from that place, as well. This is not an objective distance, but it comes clear when an artist like Hanna Owens justifies borrowing, while defining what separates her work from others. Faculty members, steeped in the Dadaist (Marcel Duchamp) and Situationist (Guy Debord) traditions, challenge students with the question of *why*—or *when* and *by whom*—a crumpled paper or

a path that an artist makes by walking in circles should be treated as an artwork. Particularly when working outside accepted genres, a student must justify her practice, avoiding charges of littering or loitering. The answer, as discussed in chapter 3, is developing a theory of the art that separates what is intended from what should be ignored.

Our Art

One of the most revered alternative galleries in the Chicago area is The Suburban, a micro artist-focused gallery located in Oak Park, a cinder-block building attached to a family garage. This artist space is co-curated by Michelle Grabner, a faculty member at the School of the Art Institute of Chicago and co-curator of the 2014 Whitney Biennial, and her husband, artist Brad Killem. During my research, I learned that an ex-student had deliberately crashed her car into the building. I was even more surprised that Grabner had taken the destruction with aplomb. Both the student and Grabner saw this damage as an art project, and not as a matter for police. An image of the damaged garage is on the gallery's homepage. Consider another case, one with a less happy ending, described by Judith Adler in her 1970s ethnography of CalArts:[59]

A student, whose short hair and checkered sports shirt make him an outsider in the prevalent hip subculture, presents a portrait of his wife executed in a "realistic" style. It is clear there is going to be some embarrassment in dealing with this work, less because it is bad than because it represents different aspirations. . . . He begins to talk about it as competently as any of the students who have gone before him . . . Soon he is forcefully interrupted by one of the teachers: "Why are people no longer paying attention!?" . . . Other students try obligingly to explain the "reality" that has been presented to them: "He doesn't seem to want to change—to learn from the group." In response to his defeated silence the teachers conspicuously withdraw their attention. One begins to read a book. . . . Finally the teacher begins again, "Do you feel close to who you really are?" [Although the student answers yes, the teacher rejects that answer.] "Now go back to the studio, pick up the goddam instrument and get back closer to what you are."

These are searing indictments of a claim that art can be anything or, just as important, that artists can be anything. This artist's colleagues would surely have been more admiring had it been clear that he was performing a nerdy persona. (He wasn't.) Contemporary art has boundaries that are field-specific and person-specific, linked to rhetorics of justification as well as to images of a disciplinary self. Loving portraits don't count;

automotive vandalism does. Students who work the border must carefully situate their work. David Boylan, a student "woodworker," demonstrates that a mask, with folk art reference, is embedded within contemporary artistic discourse. He writes: "The first significant piece I made in graduate school was a large mask titled *Summoning the Power of Warrior Gods*. Accompanying the mask were the remains of an old work that I had bought when I moved to chicago [*sic*] but would not fit in my studio. I had cut up much of the table to build the mask and what was left of the table stood intact nearby. By using the table as my material source I was destroying the work space and building a mask that embodied the table's spirit. It was intended to be a material embodiment for the transcendent experience of craft-work as a meditative pass-time. . . . By having the source of the material present, I was keeping the sculpture grounded in the realm of *objecthood*."[60] What might have otherwise been considered faux folk art becomes linked to contemporary discourse about materiality. Work must be situated within a domain of practice, demonstrating that the boundaries of art are collectively determined.

Everything Matters

These examples assume that what is relevant is clear and that boundaries are certain. As the phenomenologist Alfred Schutz points out, *relevance structures* shape our understandings of social worlds.[61] We must determine, personally and collectively, what matters and what is to be ignored. This might seem fairly simple. The painting is within the frame and the sculpture on the plinth. Even without frames and plinths, what is a painting and what is a sculpture should be evident, but when we view installations and performances, lines can blur.

I am standing in a studio where a young artist has removed wall plaster to demonstrate the salience of absence. Suddenly one of the critics notices a bandage on the floor and asks, "Can you talk about that Band-Aid over there." The student laughs with embarrassment and says, "It just fell off." (Field Notes). Another student has just completed his performance, and one of his professors asks him to talk about the significance of a splash of white paint by his feet. A colleague speaks up to apologize that she should have cleaned it up from her own installation (Field Notes). A third student brings a basket of bread for his critique, and the program director makes a point of telling those present that the bread is not to be critiqued, but merely something he baked for the group. A professor murmurs sarcasti-

24 Is this art? A task for the critic or for the custodian? 2013–14 (photo by author).

cally, "I like his bread better than his work" (Field Notes). During my research, questions were raised about cans, paper, and a ladder in critique rooms. As one student asked about some cardboard sheets, "Are those things [artworks]?" She was assured that they were not, and should be unseen (Field Notes). Instead of worlds that lack meaning, these worlds have—potentially—too much meaning. Intention can be assumed even in its absence.

On other occasions elements that do belong to the exhibit are seen as irrelevant. As cognitive sociologist Eviatar Zerubavel has emphasized,[62] what gets counted and what is unseen is a matter of communal preference. One student, Martin, installed pale diaphanous curtains in his critique room. It was only in the middle of the critique that the audience realized that the curtains were integral to the display. As one guest critic noted, "I didn't realize that the curtains were part of the work when I walked in the room." To her (and to me) the curtains were merely institutional drapery. This same student, on the opening night of his thesis show, had gallery attendants wear a specific perfume that spoke to the message of his installation, but one wondered how many attendees would have recognized that strategy if it had not been explained on the wall text. Another student, whose work involved gluing strands of synthetic hair to the gallery wall, also stained the floor. While the hair was recognized as

part of his work, the stains were treated as examples of poor building maintenance. A third example concerns a sculptor who embedded grains of rice in her sculpture. Over time the grains fell onto the gallery floor, as intended. As one faculty member commented about his revised understanding, "At first I was frustrated. I wanted the rice to stay in, and then I changed. I enjoyed watching it, and then I enjoyed watching people watch it." Another faculty member joked, "The museum guard will say, 'don't step on the rice'" (Field Notes). What is background, or even incompetence, becomes notable for the cued-in viewer, unless not-noticing is the point. While these issues of relevance affect the art world generally, they are particularly salient when evaluating student art, where producers lack full control over the space in which their work is displayed. Examining student critiques, Roger White refers to a gray-on-gray painting with a tiny piece of blue masking tape casually stuck to the center of the canvas. Was this part of the work or an error? White notes that such discussions were common: "We often spent a minute or two at the start of a session determining what was part of the art."[63]

Students must be aware of their choices: Everything might be deliberate, and students can be critiqued when they have not decided about even tiny components of their work. In a class on critique, Louis projects three colored rectangles on the classroom floor, coordinated with three colored canvases on the wall. However, the colors were set in a different order. The instructor questions that, and Louis shrugs, "Oh, that works," not wishing to change the order of the projections. The professor insists, "Do it the way you want to. We are spending an hour discussing it" (Field Notes). His point is that the class might choose to focus on the order of the colored rectangles as central to the work's meaning. Potentially, *everything matters*. While symbols might be found everywhere, we limit what we treat as meaningful based on our expectations. Our taken-for-granted reality is only rarely upended by reframings.[64]

These examples concern what is intended. But there are other instances in which the interpretation is constrained by technology. Austin shows a film that captures the beauty of flowing water. At the start there is a sudden flash of light, and a colleague asks if the flash was intended to gain our attention. Austin explains that it is a characteristic of 16 mm film. The same is true of the dust specks. He describes the "dirty, gritty" images as due to the film stock, not to his desires (Field Notes). On another occasion Jane hangs a rope sculpture from the ceiling of the critique room. She uses tape to hang it, but explains that the tape is not a part of the piece and shouldn't be evaluated. She claims there was no other means

of attaching the piece. The tape is to be ignored as an instrumental—not an expressive—gesture. These confusions reveal the fuzzy boundaries of contemporary art. As the boundaries of artistic practice are blurred,[65] the boundaries of what constitutes a work of art become blurred as well.

Their History

One might assume that the training of contemporary artists is tied to knowledge of art history. One might even imagine that art students, like music students—and like art students in the past—might be trained by copying or analyzing classic works.[66] Such a seemingly reasonable proposition is wrong. Do artists and art historians "belong together," or is what curator Bruce Ferguson terms the "almost complete break" justified?[67] Within the university, art practice and art history are separate disciplines, and despite a collegiate rhetoric of cooperation between the units, interdisciplinary work is precarious and often illusory.[68]

The structure of the College Art Association exemplifies this tension. This academic organization includes both art historians and university-based artists; it publishes two distinct journals but holds a single conference (or, perhaps, two conferences in one hotel) with academic paper sessions for the historians and more lively, if casual, discussions for the artists. When the conference was held in Chicago during my research, few art faculty presented, and many did not show up at the Chicago Hilton. Several made a point of telling me so. Tension flares on occasion. Art educator Pablo Helguera describes one such incident in *Art Scenes*, in which an artist assumed the identity of a living scholar and "performed" the role at a CAA panel. Helguera notes, "Conference representatives find themselves attempting to eradicate non-approved art from the confines of a conference of art." He contrasts the rebellion of the artist with the "order-seeking world of academia."[69] Can those who study and the objects of that study share a stage, or is this like having zoologists and rhinoceri in the same cage? As one art faculty member commented, channeling Barnett Newman: "Art historians talk about artists the way that ornithologists talk about birds" (Field Notes).[70]

To be sure, programs are organized differently, resulting from diverse modes of institutional support and patterns of social relations. Perhaps because administrators are uncertain whether art history and art practice belong together, these academic structures are unstable, subject to altered bureaucratic arrangements, depending on financial stress and

whether an academic entrepreneur promotes change. Given their spatial requirements, departments may be housed in different parts of campus, as at the University of Chicago. The School of Art in the College of Fine Arts at Illinois State offers an MFA for visual artists, but has no graduate program in art history.[71] Undergraduates can obtain a BFA or BA in art, but there is only a "sequence" in art history. Perhaps for this institutional reason, art history and visual culture are more integrated into the MFA program at Illinois State. In their three years, MFA students must take three courses in art history and visual culture; at Illinois State faculty in these areas routinely participate in graduate critiques. In contrast, Northwestern University has two departments: a Department of Art History, which offers a Ph.D., and a Department of Art Theory and Practice, which offers a two-year MFA. A faculty member explained that several decades before, they were in the same department, but split "because they hated each other so much."[72] I talked with Terri about this, remarking, "Here you have two groups of people who love art, who are consumed by art, and they share . . ." Terri loudly interjected, "An office. There is no overlap whatsoever" (Interview). As Terri emphasizes, the departments share space, but with different staff. To reach the program assistant in art history, one enters and turns left; for the program assistant in art theory and practice, right.

During my research the arts at University of Illinois at Chicago were restructured. In my first year of observation, UIC had a College of Art and Design, awarding two MFA degrees, in Art and in Design. Design, a larger program with more financial resources and a more direct link to a defined job market, wanted to separate. The second year, Design moved into its own school, and Art merged with Art History in a School of Art and Art History (with an MFA in art, an MA and Ph.D. in Art History, and an MA in Museum and Exhibition Studies). Structures vary according to bureaucratic cultures. Perhaps more striking is the fact that at UIC and Northwestern, MFA art students are not required to take art history classes, although they can choose them as electives.[73]

Relatively few personal connections exist between student artists and art historians, although the new structure at UIC, coupled with the interest of two art history students, helped promote some friendships, a shared graduate student lecture series,[74] and studio visits. At Northwestern, several art students told me that they did not know any art history students; as one student explained, "There's not much cross-pollination between the two. . . . There was never a sense of any of the faculty or departments organizing a gathering to meet one another. Either you had to seek that out yourself or just not even bother" (Interview). When I

asked, one faculty member answered, "What would we be reaching out to them for?" (Field Notes). Although there are exceptions, most MFA students at Northwestern and UIC do not take *any* art history classes, even in contemporary art. Students in art history are even less likely to take courses in art practice, and few of the art historians care about the practices of their studio colleagues.

Sociologists often listen to jokes, stories, and casual remarks as reflecting boundaries. I heard plenty. At a seminar taught by a curator—one of the few classes with students from both programs—the instructor questioned an art historian. He responded, "I'm coming to this seminar from the dark side" (Field Notes). On another occasion, an art student told how she and a colleague were taking a seminar on contemporary art history, noting, "We're the two outsiders in the class" (Field Notes). Louis's mother is an art historian who had recently published an important book, and it was suggested that she might give a lecture. Louis said, "I'm not sure that I would like that." I myself received a huge laugh when I joked, "She could give the talk in Art History, so none of you would go" (Field Notes).

Resentment narratives were common as well. A faculty member explained: "There is this notion that the art historians don't take living artists seriously. . . . I do remember once years ago giving a workshop and having some art historian grad students in the workshop, and one of them—or a group of them—saying, 'Look, we are artists,' and making like a big joke about it, which is so crazy because that's their profession, to study artists, but they were completely minimalizing and deriding the fact that there were actually artists in the school making art" (Interview). A student shared a story that addresses similar distance: "It seems like a while ago it was decided there was a distinction, and we don't really talk to each other. And you have to make a really clear effort to bridge that gap. It doesn't happen very fluidly. . . . Like I made an attempt to contact [an art history professor] last year. I was excited to talk to him, getting accepted to the program, because his writing has a lot to do with how I am framing my practice. And I met with him, and I invited him for a studio visit, and he got really freaked out that I wanted him to come to my studio. And he was, like, 'No, let's meet in my office.' I feel like the story of it is he has experienced some young artists trying to utilize him as a critic. 'Oh, you met with me. You are going to write a review of my show, right?'" (Interview). While this is not necessarily an accurate recounting of motivation, it is an account that this student felt was revealing. When art students feel disrespected or ignored, they attribute it to the differences between the two fields.

Beyond this perceived division, the temporal structure of their university experience differs: for art MFAs, two years; for the art history Ph.D. students, five to eight years. They embrace different disciplinary cultures. Art historians are trained in the technical and competitive discourse for which the academy is famed. Several of the art students, who spend most of their time in the studio and not the library, admitted that art historians intimidate them. Recognizing that students focus on their practices, instructors do not assign much reading. Esau McGhee said, "I haven't taken anything in the art history department. I wanted to play it safe while I was here. . . . It was stated, you are part of the family when you are in Art Theory and Practice. And there is an understanding that if something doesn't get done, it will get done eventually, and they will give you some leeway. You venture too far away from the ranch, you are taking your life into your own hands, and they might expect more of you" (Interview). These students work in a liminal zone between being students and being artists, a challenge that most graduate students outside the arts do not face.

Perhaps "art is a continuing dialogue that stretches back through thousands of years,"[75] but artists are often encouraged to leave that dialogue to others. It is not that contemporary art practice lacks a backstory—a set of meaningful objects and persons. It does have one. However, this backstory is "owned," defined, and represented by artistic practitioners, passed from artist to artist.[76] As one art professor, who used to teach the history of contemporary art, explained to me, "The art historians hate how I teach ["Survey of the Arts since 1960"], because I am teaching models of practice. I don't get into historical specifics as much, because I imagine that I am teaching artists who just want to take big chunks of examples and do something with it in their studio. . . . [Art historians] want specificity. That want when, exactly what was going on, and that can be obscuring for me. . . . They think it is a lot of difference between how they do it and how I do it" (Interview).

As James Elkins suggests, art instructors treat classical art in much the same way that science educators treat great scientists: interesting to know about, but more curiosities than immediately relevant. They illustrate a distant past.[77] Evan dramatically discounts art historians: "The canon is not something that's necessarily infallible. . . . There's a lot of art in the canon that's just bad art. All I mean to say is that it's political. The canon is not something that's necessarily instructive. That's not something you need to know" (Interview). Evan goes further than many art students, but there is sympathy for his view that what has been treasured may no longer be relevant. Artists create their own canon.

Recovering an artistic past is valuable, but it may also be limiting. As one faculty member claimed, "You can't invent hot water" (Interview). But the question is how history should be taught: as a set of objects and persons or as a set of inspirations and practices. For artists, more than for art historians, a narrative history of greatness is questionable. One student, recalling his days memorizing slides, said that he felt, as an artist, that history needed to be taught as a living text, relevant to art-making (Interview). As art theorist Hal Foster suggested, "Today the canon appears less a barricade to storm than a ruin to pick through."[78] One MFA student pointed out that it is important to realize "what one's work references and how it falls within a tradition of work" (Interview). How is the artistic past utilized to situate work and develop practice? Pierre Bourdieu asserts that the artistic eye is a product of history.[79] This claim is true, but history is made possible by a set of social relations, tied to institutions, technologies, and communities.

Our History

To suggest, as the previous section might imply, that there is no lineage of contemporary art is incorrect. Even if a detailed recounting of past traditions is marginal, strands of connection are important. In this, art practice does not differ from other domains of work, particularly those with institutional stature. Most domains of activity generate internal commitment and public esteem by the claim that they have heroes and historic moments. This is true for medicine, for religion, and even for chess. Trainees are encouraged to see themselves as part of a great chain that has shaped the world. Perhaps visual artists do not depend on a detailed knowledge of art history, but they must have a sense of a glorious past, if only to transcend it.

In the case of the visual arts, the discussion is not only—or primarily—about the unfurling of art history, but about an assessment of artistic influence. The admired professional must develop new modes of presentation. Yet the paradox is that these innovations are always inspired by the contributions of others. As a result, faculty often recount "family" influence when evaluating the work of students. To what and to whom is this project similar? Students' artworks are described in light of influential styles, theories, and techniques, suggesting that professional creativity is not individual and idiosyncratic, but linked to communities of practice, belonging to stylistic families, and connected to domains of ideas. While inspiration must be transcended or transformed, it provides a map and

genealogy. As is said, "Everybody looks like somebody." Perhaps the most common feature of a critique is to invoke skeins of influences, linking a student's uniqueness to an "invisible college."[80] Students are frequently told that their work is reminiscent of a prominent (or obscure) artist. At one student critique, the following artists were mentioned: Barnett Newman, Roberto Matta, Mark Rothko, Wade Guyton, Peter Halley, and Morris Louis. In the next critique it was Glenn Ligon, Rachel Harrison, Ed Ruscha, On Kawara, and Richard Artschwager. This was followed by references to Picasso, Donald Judd, Jo Baer, Cy Twombly, and Alexander Calder. There is a rolling and lengthy list of honors.

When I began to observe, I felt that I had a fairly deep knowledge of contemporary art. I could name perhaps fifty artists. Joseph Beuys, Sigmar Polke, Anselm Kiefer, and Gerhard Richter, just to name four Germans. Of course, my knowledge was an outsider's knowledge. What I knew depended on feature articles in the *New Yorker*, the *New York Times*, and *Time Magazine*. In contrast, I know many hundreds of sociologists by name, by work, and by reputation. They are my brethren and my cisterns, the sources from which I drink. Exposure to the extended community of art is gained in school. I learned that certain names were iconic: Robert Smithson, Bruce Nauman, Stan Brakhage, Christopher Williams, Cindy Sherman, Andrea Fraser, Joseph Beuys, and, of course, Marcel Duchamp. Barely a critique went by without one of them being invoked. They were referenced not as geniuses, but as inspirations. During this period, many references were made to Chicago residents Theaster Gates and Jessica Stockholder. Although they are artists with national (or global) reputations, they serve as touchstones for the local art world, demonstrating that powerful work is being produced in the city.

Some students enter the MFA program well-poised to drop names, the coin of the realm. Others feel like MFA Kenya Robinson, who remarked, "When I first got to Yale, I felt a little dismissed because of my academic background. . . . Much of the critical conversation was about adjectivising the work by using the name of other artists, and I wouldn't know who they were talking about. I would be Googling like: *Who dat?*"[81] Several students expressed their belief that they were rejected by MFA programs because they lacked the ability to provide artistic references: "I didn't know much about performance art, and I think that was one reason I didn't get into two universities that I wanted to, mainly because I did this performance and they liked it, but I didn't know enough artists to name during my interview. They asked me who were you influenced by, and I was like, 'no one really'" (Interview).

Names serve as teams, classifying work by placing it in a category rep-

resented by an archetypal artist. Some works are reminiscent of Judy Chicago, others remind the viewer of Lucien Freud, and still others have elements of Kara Walker. So a faculty member could say of a student's film, "The image in a Brakhage kind of way is on the surface of the film" (Field Notes). Whether or not the parallel to Brakhage's projects was justified, it made perfect sense to speak of "a Brakhage kind of way." Another spoke of photography in "a Christopher Williams way" or projects characterized by "Nauman jokiness." Critics might assert that the work was a marriage—or love-child—of a pair of distinct artists, such as "a combination of David Hockney and Karl Wirsum" (Field Notes). Grouped together, the references can be jarring. One student's work was linked to Giotto, Jan Vermeer, Richard Serra, and Félix Gonzáles-Torres. Although a few classical artists were invoked, most references begin with artists in the early twentieth century,[82] such as Malevich (or Malevichian) and Duchamp (or Duchampian), to reference shared understandings. These references were central to the socialization of students and mixed art history with praxis. As with all cultures, artists develop their own history and select their own heroes.

As part of the history of the profession, references to particular moments are taught. Chronology typifies forms of artistic production. Sociologist Fred Davis pointed to the use of decade-references to organize memory.[83] Despite the diversity of the art world at each moment, decades are awarded particular styles. One faculty member asked about a photographer, "Are we back in the work of making inscriptions? They look so much like the 1960s. They look so antique to me" (Field Notes). Another faculty member referred to a sculptor in these terms: "It seems like a primer of 1970s sculpture moves. This is kind of a Bruce Nauman, Richard Serra kind of move" (Field Notes). Another faculty member described a student installation: "This is like an Eighties show that's been hit by a Scud missile. The Eighties show was about the market, and this is like the after-market about repurposing" (Field Notes). In my observation these decade references did not go back to the 1950s or up to the 2000s (perhaps they have by now). There is a desire to tame a highly disparate field cognitively and socially, and with this mapping, to provide opportunities for students to present their artistic selves in light of the place on the disciplinary map with which they identify.

Inspiration

Why recall an institutional past? I mentioned inspiration and influence, but I wish to examine each more deeply. The former is conscious and

connects to how individual artists define themselves. Whom is one like? The latter may or may not be conscious and is not necessarily connected to identity. Inspiration is judged by the self, and influence by others. One can be influenced without being inspired, although much inspiration involves influence.

Rarely does one select a career without someone serving as a model. Although that person may be a personal acquaintance—a relative or a teacher—in our mediated age, we have access to many. A few shape us.

In the arts, a visit to a museum or an internet search provides a wealth of images. One student, Maxine, is explicit about the passion behind inspiration: "I always get these crushes on an artist and I really want to be them. I put [images of] their work on the wall" (Field Notes). Lena mentions an exhibition of Jessica Stockholder's sculptures at the New Museum and explains: "I saw that when I was an undergrad and it changed my life. I would say that when I saw this work, I felt a strong connection to it" (Interview). Another student explained that one of his works was a homage to Adrian Piper, not only because she shaped his aesthetic, but because of the inspiration he drew from her life. Bruce, a student who uses fabric and words in his work, told me that "William O'Brien, who has a show at the MCA right now, uses a lot of fabric, ceramics, drawing, and painting. When I see his work or Christopher Wool, what they're doing validates what I'm doing" (Interview). These students recognize that their identity as an artist is linked to affiliation with a corner of a highly differentiated field. Seeing work can be transformative, not only in becoming aware of styles, techniques, or content, but in defining oneself as an artist. The challenge for emerging artists is to recognize linkages to what has gone before as well as to differentiate their own practice. Artists serve as models of production, and these references serve as shorthand for where one would like to be placed by curators, collectors, critics, and dealers.

Influence

More common than inspiration is influence. As noted, I was told that everybody looks like someone. Our images of good art are shaped in the soup of visual culture. Although we may reject those models, the rejection shapes our choices. We decide to be the un-Monet. Even if contemporary artists are not indebted to canonical art history, they recognize that their signature style will be interpreted within a relational field in which their production will be likened to others, and that, as a result,

they must utilize this aesthetic mapping by drawing links themselves. A cognitive cartography comes to define all domains of practice.

In interviews and informal discussions, art students point to their influences, locating themselves in a fragmented field. In critiques, these influences serve as a shorthand for referencing complex styles or content. Richard Roth refers to these threads as genealogy, reference bundles, and, more cynically, as currency in an art world game.[84] Hanna Owens told me that she felt her performances were influenced by Ann Liv Young: "She's a performance artist who does these sloppy performances for audiences. They're calling it a 'drag of adolescence.' For the past few years, she's been doing performances with this character called Sherry who does therapy for people that she called Sherapy" (Interview). Sometimes presumed influence is discounted, as in the following examples: "This is a very poor cousin of Anish Kapoor." "It feels not akin to [Ellsworth] Kelly, but to a DIY." "It's more a Magritte moment, rather than a Robert Gober moment" (Field Notes). These assessments, from three different critiques, reflect that just as connection can be asserted, it can also be denied: pointing to ways in which the work differs in material, brushstroke, or emotional resonance. Students recognize this and strive for work that is not too similar to another's, hoping for a distinctive and resonant artistic identity. The failure of my Monet homage is a case in point. Jane is explicit about some of her sculptural forms: "The reason I would never show them is they are too close to a lot of work that's already happened in art history. Eva Hesse is a good example. . . . I'm not trying to have the same conversation as her" (Interview). Influence is the beginning, but differentiation must be the end.

On a visit to Illinois State, I was impressed by a faculty member who asked students to create three-generation genealogies for their work. He asked them to consider who influenced them, and by whom that person was influenced: referencing symbolic grandparents. He felt that the project was so successful that including another generation—great-grandparents—might be warranted. One student, a ceramic artist, was influenced by Louise Bourgeois who was influenced by Odilon Redon; another, by Hannah Wilke who was influenced by Arshile Gorky; and a third was influenced by Jenny Saville, who was influenced by Willem de Kooning. Perhaps these artists would deny their parentage, but this assignment made sense to the students, who were enthusiastic in discussing "where they came from." An aesthetic chain of being feels right. Artists should be aware of others within a stylistic domain, but not so shaped that their work is a mere palimpsest.

My History

Just as history can be institutional or local, it can also be personal. In contrast to much university-based research, art practice often emerges from autobiography. Of course, students of color, women, and LGBTQ students may select topics that address their own concerns. (The same may be true, less frequently, for whites, men, and the cishet).[85] However, in most academic writing a gap—perhaps a chasm—is expected between the details of one's life and what one researches.[86] The motivation for one's research question should matter less than what one finds. In contrast, in the world of art personal expression and the intentions of the artist are crucial. In the words of the prominent painter Eric Fischl, reflecting on his mother's alcoholism and suicide, "I vowed that I would never let the unspeakable also be unshowable. I would paint what could not be said."[87] A talented student painter, Maxine, addressed a similar issue: "I'm having difficulty thinking of something that originates art that's not a trauma" (Field Notes).

The line between work and life has increasingly been smeared.[88] As Wick, an artist who avidly incorporates many genres, explained: "The videos and performance I have done are all very different in some ways, but they all reflect my personality and interest in language or a compulsion to humor. . . . So even if I try to make something that looks like someone else's work, it will look like me" (Interview). Can a work ever be impersonal? For success, the personal—at least for those works placed in the world—must find an audience. Desire and trauma must resonate with others.

A student's imagined self can be a vivid part of her artistic identity. This is evident in an explicit description of sexual identity by installation artist Matt Morris, in which he asserts that as a "conscientious and fair minded queer," he operates *"from a point of view"* and inevitably one that is based on his identity and that shapes his practices, permitting appropriation of the objects to constitute drag as well as an institutional critique.[89] Hanna Owens capped a performance about being clean and sober with a deliberately casual and ineptly performed dance.

Perhaps most dramatic are the photographs of Marissa Webb, whose practice emerges from the relationship with her profoundly disabled sister Kaitlin (recall that Kaitlin has Rett Syndrome. As Marissa explained to me: "Imagine that a little girl has cerebral palsy, autism, anxiety, Parkinson's and epilepsy"). In her artist statement Marissa writes, "I have been trying to understand her view of the world and how she is per-

ceived through a photograph. Recently though I have realized that the bigger question I am after is trying to understand my purpose in her world and our relationship." By permitting Kaitlin to mutilate the photographic books that Marissa conscientiously crafted and then photographing the results, Marissa believes that "within these images both Kaitlin and myself are allowing chance to create an alternative narrative or conversation." She adds, "This collaboration allows for us to have some method of communication."[90] These examples reveal how the self can be inserted into a developing art practice. (See Marissa's images in the introduction.)

Rather than being an uncomfortable exposure, such personal inspirations are legitimate as long as they speak to the community. In the unsuccessful extreme this constitutes art as psychiatric remedy, but for institutionally engaged artists it points to analysis. A faculty member commented: "Most of making work is about confronting and grappling with the self, and therapy is also about that" (Interview). A gay student, Bruce, who had not used his sexuality as the basis of his work was advised by a faculty member to be more personal. Bruce struggled with his work during his first year until he had helpful conversations with a faculty mentor: "There were a few times when he said, 'Why aren't you doing any gay work?' After the fall critique, I started to think about it. I started to think about myself and the lack of communication I have with family about being gay. What I was trying to do was making work about my childhood: coming out, being gay, the struggles I've had" (Interview). With faculty support, Bruce realized that he could be a gay artist, and he began to use fabric to address sexuality.

As in Bruce's case, the self provides material from which to borrow, but rarely to cure. Advising art students, James Elkins asks, "Where is the line between a critique that is mostly therapy—for which no one on the faculty is trained—and one that has a lot of therapy in it—for which all the faculty think they're adequately trained?"[91]

The difficulties of this style of work are manifold, and many faculty are skeptical. In response to Carlotta's video installation and display of found objects that references her hybrid-ethnic background, faculty were dubious as to whether the work was persuasive. One professor asked, "What makes this more than a self-improvement project? What is at stake? What is the risk?" Another questioned her, "Does it become a metaphor for something bigger? I get what you want to do. I don't know what the viewer gets out of it unless you want us to know a little bit more about [your homeland]." Carlotta was presenting intimate work, but it was not seen as transcending the personal, and its impact was

questioned. Evaluations are more dicey on those occasions in which faculty attempt to psychoanalyze the work or the artist, as when works by heterosexual artists are claimed to have homoerotic themes. Of course, in art schools this is not necessarily an insult, although the implied lack of self-awareness might be. As one student complained, "My unconscious is nobody's business but my own" (Interview).

Further, while one's personal inspirations are legitimate, the standing belief that black artists will *always* address racial themes or that female artists inevitably are feminist artists leads artists to be stereotyped. The assumption is that work can be read through the artist's categorical identity; only rarely is that claim challenged. Identity gets read from the outside, whether or not it connects to one's self-image. While each artist is an individual, their work may be identified as a product of a category. Certainly, many students of color create work that addresses race, such as Esau McGhee, and many female artists, such as Hanna Owens or Soheila Azadi, speak to sexuality or gender in their work, but this is not always the case. Marissa Webb, especially in her photographs of water towers, would not find it so. Black artists such as Sidney with his wispy threads or Hakim and his experimental portraits created work that could not be necessarily be read as racial, although their audience found those readings apparent. Because of the large numbers of women in these MFA programs, their work was not always interpreted through the lens of gender, such as Michelle's religious installation, but that reading was always potentially available. However, artists in salient identity categories, such as Bruce, were *expected* and *encouraged* to have such intentions.

Just like paint and clay, the self shapes production. As material, it contributes to the technique of the artist as much as to the theory of the work. But given that it occurs within an academic discipline with standards of presentation, experience cannot be presented raw, but is transformed and mediated through institutional practices.

Genres and Boundaries

In this chapter I have focused on the meaning structure of an action field: contemporary art as known by MFA students. They attempt to find a space in which their mentors will recognize the value of their practices.

Every field develops common styles, standards, and references to which novices must be socialized. How is the field divided, and how is one placed within it? Fields inevitably are differentiated, and judgments are based on shared criteria of evaluation.

I began by examining what might seem to be the core question of any art world, at least as understood from the outside: the question of aesthetics. However, aesthetics, and its consort, beauty, now are challenged as to whether they define good work. Art as a discipline has moved from pleasing those outside to satisfying internal evaluators. The readily appreciated aspects of work have been marginalized in the face of the primacy of theoretical concerns, judged by credentialed specialists (discussed in chapter 3).

However, the visual arts, like other disciplines, are internally divided, and trainees must recognize these divisions. Genre is a means by which students place themselves into the field: Are they painters, photographers, sculptors, an interdisciplinary combination, or something else? Are they *merely* artists, or are they heroically so?

One form of the division involves types of material practices. I focused on two, located separately in the disciplinary space: painting and performance. Painting with its long and distinguished history is threatened by its traditions and by its market appeal. It stands as a consumer good, marketed to the haute bourgeoisie as a decorative enhancement, investment, or marker of cultural capital.[92] For nearly the last century obituaries have been written for painting, challenging its worth within the disciplinary field.[93] Performance, in contrast, is hot, linked to the DIY ethos of the arts and to relational aesthetics in which value arises from the privileging of interaction. Unlike the contained and decorous format of painting, performance, with its messy links to improvisation, is exuberantly unbounded and protean. Each genre poses questions of evaluation, and each depends upon distinct social relations and market connections. Together they reveal a broader discipline that is historically embedded and boundary-breaking.

Both cases reflect a more general concern with the edge of the *thing*. What counts as being relevant to interpretation?[94] Where does meaning end and irrelevance begin? What is detritus and what is intention? This is the puzzle in a field in which borders have weakened and in which previous boundaries—frames or plinths—are often absent. Student-practitioners must work those boundaries to their reputational benefit.

What about the past? Does it matter? Every established domain is grounded in memory of what has gone before: Collective memory is the glue that binds social fields.[95] These visual artists distance themselves from devotees of history. If art historians are ornithologists, and artists are birds, birds flock together, tweeting joyously. Artists do recognize history, based in references to admired artists. Their history is visual, visceral, and vital. Inspiration and influence link the field to its past: not

through biography, but through remembrance and recognition of community and its exemplars.

Finally, for artists, praxis is personal, but it is judged organizationally. The contemporary artist is a psychoanalyst manqué. Know yourself. Reveal yourself. Undress. Learn through your emotions.[96] The artist who excavates her past, an archaeologist of self, reveals proper professional practice.[97] One of the goals of graduate school is to provide a space in which this is recognized and facilitated, while simultaneously justified or criticized within a group context. The willing connection of self and field depends on a devotion to department and discipline.

Painted Words

I am a painter; I am not a lecturer about art nor a scholar of art. It is my chosen role to paint pictures, not to talk about them. . . . What can an audience gain from listening to an artist that it could not apprehend far more readily simply by looking at his pictures? BEN SHAHN[1]

Milton Babbitt is a titan of American music composition, a MacArthur award recipient for his contributions to electronic music. Yet he may be best remembered for a short essay published in February 1958 in *High Fidelity*.[2] The magazine provocatively titled his contribution, "Who Cares If You Listen?" He argued that music—or at least complex, contemporary music—was performed for specialists. Babbitt understood that adventurous music would have a small audience, and he felt that this was an advantage. Serious music demands serious listeners, an audience that can appreciate what is at stake. Cultural producers have this challenge; they must reach their primary audience. They speak to a community of interest, but this often excludes others. Few generalists are such committed omnivores that they would find works targeted to practitioners appealing. Cultural fields are often segmented, with some creators focusing on popular access and some on insider appreciation. For Babbitt's high art, discourse is essential, and could be threatened by middle-brow listeners who long for easy pleasure.[3]

Babbitt could easily be addressing the contemporary art world. In the visual arts, über-critic Clement Greenberg insisted that art should be treated as the equivalent of an academic discipline with standards for exclusion.[4] As a senior

faculty member explained, "[Greenberg] was the one who tended to focus . . . on a kind of inquiry or interrogation as to what belongs and what doesn't belong. These are the kinds of things that help us to distinguish one discipline from another. . . . They become interrelated, interdependent in such a way that while each has its own autonomy, they become necessary to one another. Tailor-made for the academy" (Interview). The tapestry of art is composed of interwoven threads, hard to untangle, but with recognizable borders.

Whether or not art practice is comparable to other academic disciplines, training in the visual arts has obtained a foothold in higher education. Instruction in painting, sculpture, and photography provides a taste of culture for undergraduates, but does this deserve the stature that a discipline provides? Should this lead to graduate training with gatekeeping, autonomy, and internal standards of evaluation? This question addresses Howard Singerman's account of the challenge of visual arts in the academy. He writes, "Among the tasks of the university program in art is to separate its artists and the art world in which they will operate from 'amateurs' . . . Art in a university must constitute itself as a department and a discipline separate from public 'lay' practices and equal to other studies on campus."[5] Members of an occupational domain must constitute their world as a *discipline* with boundaries, intellectual control, and legitimate expertise in order to deserve recognition by the mandarins of higher education.[6]

Who is the audience for the arts? Curators desire mass attendance. Gallerists prefer the well-heeled. Editors search for advertisers. But professors are sympathetic to Babbitt. In this they resemble practitioners of other academic disciplines: physics, philosophy, or sociology. Articles and books are typically read and judged by specialists. Our talk is our own; judgments, ours to make.

In the visual arts, contemporary works are not easily understood, and some are offensive to the suburban residents of Cultureburg. But who cares, while tenure remains? Granted, insularity does not generate financial support for emerging artists, even if it provides a steady stream of baristas and bartenders.

The contemporary art world, particularly that segment embedded in universities, has adopted modes of analysis and criteria of excellence. As members of a discipline, the faculty and students, not outsiders, have the authority to enforce these judgments.[7] As sociologist of science Stephen Turner suggests, the creation of disciplines is a protectionist strategy, and one that links to the establishment of a labor market—an employment cartel—based upon assumed competence.[8] The issue is not

simply their occupational status, but the existence of internal control in the face of external pressures to limit that control or to embrace other standards. To be sure, this is not limited to universities. Art worlds operate both within and outside of the academy. On rare occasions, as in the culture wars of the 1980s and early 1990s, moral entrepreneurs can encourage wider publics to treat the arts as a contentious—and political—domain.[9] Perhaps art world denizens are grateful that politicians largely ignore them, other than on ritual occasions in which the stature of art elevates elected officials, as at museum openings.

Professors and students circulate beyond college halls, and make up nearly 40 percent of attendees at art openings. In turn, critics and curators are invited to participate in student critiques, to make studio visits, or to give talks. Classrooms and academic lecture halls are not the only discursive spaces; journals, symposia, artist support groups, and museum panels serve as well. The art world extends beyond ivied halls, and the art market intrudes into collegiate campuses.

Further, in advanced, bureaucratic societies, internal control is never complete, but some vocations—those labeled professions—are more likely to claim the right to determine good work. Certain occupations (physicians or lawyers) have more power to do so, while others (cooks or beauticians) are typically judged by outsiders. Elite "professionals" speak of "having a practice," suggesting an entrepreneurial domain separate from external control. Artists, too, have practices. As Esau McGhee explains to his brother, "I want to tell you about my artwork or as they say, my 'art practice.' I feel like a doctor or a lawyer sometimes referring to what I do as a 'practice.'"[10] I discuss later how artists straddle university and public boundaries, a challenge shared with faculty and students in law and medicine.[11]

The goal of serious artists is to produce work that peers admire. Within a university system, insiders are influenced by colleagues, including those in other humanities departments. The university is a segmented bureaucracy—a network of disciplines—with department personnel having authority to determine competence (the awarding of tenure being a fraught exception). As a result, the world of contemporary art—the post-1960 MFA era—is defined by the institution. Mark McGurl[12] suggests in *The Program Era* that occupations compete with neighboring workforces that challenge their authority.[13] Understandably, in addition to the honorific involved, workers wish to determine the conditions of their labor. For artists this involves the question of who sets the terms of evaluation. Are they in charge, or are the crucial judges collectors, gallerists, curators, and critics? These multiple standards, involving beauty,

pricing, and political expression, reveal a field with a *heterarchy* of evaluation.[14] Creators in some corners of the art world have more authority than others. Consider portrait painters, whose clients often insist on the right to demand changes to the depicted physiognomy.[15] Beauty eclipses truth, and contracts trump verisimilitude. Portrait painters have traded authority for a ready market, but at the cost of disciplinary stature and personal vision. As a result, in the programs I observed, only one painting student (and none of the faculty) produced portraits, despite that genre's epic past. Aspiring portraitists attend art academies or ateliers, which are less tied to art world status structures: a world apart. With distant exceptions, their most distinguished works are found in the National *Portrait* Gallery and not the National Gallery of Art.

A parallel development occurred in creative writing, shaping the organizational forms in which internal hierarchies of value are established; a comparable cultural system develops in academic music conservatories with their own scales.[16] For their part, filmmaking and theater, and even screenwriting and viniculture, are moving into the academy, if somewhat less securely. Practitioners desire separation from the control of other institutions that might enforce worth through resource availability, while separating the sovereign evaluation of art content from public taste.[17] As French sociologist Nathalie Heinich argues, the harsh reality is that mediators attempt to control art practices against artists' demands for autonomy.[18]

The visual arts have become institutionalized. The College Art Association was founded in 1912, representing faculty in art and art history, suggesting by its name that art *belongs* in the university.[19] One faculty member explained, "Artists are now defined by the institution . . . art schools only exist in legitimate terms to the degree they imitate the university" (Interview). This trend, becoming ever stronger, has allowed Lane Relyea to write of an "educational turn" in contemporary art. By this he means not only that art training is embedded in the university, but equally important, that institutions such as museums and exhibition halls define themselves as schools, desiring collaboration with colleges.[20]

Even the discipline's label is instructive. One teacher explained that the change in usage from "fine arts" to "visual arts" reflected professionalization as well as a skepticism of elitism. He noted, "You get a move toward something that can sit more comfortably in the arts and sciences university or college, which is visual art rather than fine art. . . . The university as this place where art training is embedded as a way . . . to professionalize the artist on the model of other professions. As the liberal arts education changes, so does the art department and theory becomes

a bigger thing. You have got structuralism . . . starting in the Sixties, and then you have got post-structuralism, and these things really flood the art department" (Interview). Within the structure of a university, academic disciplines become aware of each other, and this potentially encourages theoretical exchanges, but does so in a context in which only some ideas are judged worthy. A second faculty member remarked that a shared space of conversation is crucial for a community: "If you are going to change the world . . . you need to be in a place where there is a very specific conversation on top of layers of organization" (Interview).

The value of trainees is evident, as students are the means by which occupational generations reproduce, creating newly accredited colleagues.[21] This is evident in the bureaucratic structure of the university, a topic to which I return in chapter 6.

Disciplines raise the stature of their practitioners, but at a cost. As the guild patrols its boundary and judges competence, strictures on good work are in place.[22] Gallerist Seth Siegelaub worries, "Unlike many fields of human endeavor where we can talk about professionalization— whether it be law, medicine, science or education, which are thoroughly professional—there still is a sense as an artist that you are doing something that nobody asked you to do. At the very least you still don't need a license as an artist." Not so far, but for leading galleries and in university hiring, the MFA comes close.

Meaningful Glances

As art training has become a discipline, the community defines meaning and shapes emotion. I do not assume that consensus will reign. That certainly is not the case in sociology or in any other vitally alive intellectual sphere or at any of the schools I observed. Debate is integral to belonging. Without dispute, a field is little more than routine knowledge-gathering. Art certainly does not lack for controversy.

Within a discipline, current work is expected to connect to what has gone before; sometimes the new work will be consistent with its predecessors, often it will be critical of them. As anthropologist Clifford Geertz has pointed out, disciplines have cultures.[23] Or, in the words of higher education scholar Tony Becher, they are tribes.[24] But how does this happen?

If art practice is to become a domain of knowledge, practitioners must answer the question of social theorist Jeffrey Alexander, exploring the sculpture of Alberto Giacometti: "Can art provide a window into social life?"[25] Approaches such as audience response theory, new criticism, or

social constructionism attempt to strip the judgment of intention from the maker, awarding it to the audience. Who has the power to determine a work's meaning?[26] Given that artworks are shown in particular places, meaning requires a politics of display.[27] Emphasizing those communities that negotiate, although they do not determine, relevant readings, Sophia Acord and Tia DeNora point out, "The arts are neither black boxes nor open books."[28] The artist provides material through which audiences collaborate in asserting what the artist is up to. These approaches agree that artworks convey meanings, whether in the object itself or in the mind of viewers or producers. Interpretations are routinely couched in ritual phrases of valuation, such as quality, originality, or authenticity, examples of what economist Hans Abbing[29] terms container words—words that, when shared, constitute conventions of judgment.

Art is not—should not be—"mere illustrations": colorful haystacks or evocative lily pads. As one faculty member remarked of a piece that he considered too aesthetic and not sufficiently content-laden, "I'm annoyed by the pleasure I'm getting from the piece" (Field Notes). Satisfaction is a challenge to a judgment of quality.

The Stakes

Why does this piece matter? Why am I viewing this? However formulated, the issue of *what is at stake* is critical. A student is taken to task when answering, "I think my response to all questions of what is at stake is life itself" (Field Notes). As an empty answer, the work is drained of meaning. Says an instructor, "I think the work almost always has to be explained. There is a discursive aspect of the work that has to go hand-in-hand with the visual work. It almost can't happen on its own" (Interview). Not every faculty member accepts this view, but visiting artist lectures, studio visits, critiques, and the MFA thesis emphasize the stakes in artistic production.

One afternoon in his studio Evan startled me with his current project. Those who fritter away the day surfing the internet might know that with the availability of 3-D printing, one can purchase a "potato chip Jesus": the savior's image on a rippled snack. (I've found it offered for $9.99). Evan purchased copies of the chip and, using crayons, disfigured them. Why? He wished to explore how society defaces cultural icons, and, for purposes of his project, the potato chip Jesus was such an icon. He explained, "Where the spectacle was once produced by the cultural industry, the spectacle is now produced by everyone. We all participate in producing images. This is me trying to think through what it means

to be an artist in the twenty-first century when images are made by everyone and not just an artist" (Interview). Perhaps Evan is not fully persuasive, but he does articulate his meaning.

Consider how Hanna Owens describes the meanings in the performance that I described in the introduction, dancing and asking her audience to spit Jell-O into her pantyhose. Although she describes the work as sloppy, her meanings are tidy. Hanna explains:

> My art and my life very much blur and I like to question the socially constructed notions of our sense of self. I will blur my performances into things I'm doing in real life where there is no stage . . . I wanted it to be messy and sloppy. To me that speaks to body and emotions, especially to the feminine. The female body is so sloppy, messy, and blurry, and we can't even deal with it in contemporary society. . . . When I think about the body, I think about Jell-O a lot . . . The body has this skin that is the boundary for everything inside it. It holds everything inside in and keeps everything outside out. I've been thinking about feelings . . . and if feelings were not intangible, but actually physical, they could bleed in and out of us. Wouldn't they stain everything? Jell-O is hard, but it's moving, wiggling, you can crush it, suck it, it will melt, cut it. It's become a metaphor for feelings." (Interview)

Hanna carefully considers how society fetishizes objects, imbuing them with power and emotion. Returning to the discussion in chapter 1, the materiality of her work is essential to its interpretation. Perhaps some in the audience—even an art world audience—might not transcend the erotics of gelatin, but she invites a deeper reflection on the mundane.

These works—especially those deemed successful—are richly textured through memory. In chapter 2 I described the work of David Boylan, who created a wooden sculpture from a cut-up table. Citing the Chicago-based artist William Pope.L, Boylan notes that objects never lack referents, always tainted by other objects in the world. He writes, "What started as a binary of symbolic functions and art historical references ended up as a synthesis of many associations. *Table* sits on the floor so it references minimalism and functionality and the unclear but very present nostalgic history of the wood makes the piece feel enigmatic."[30]

Multivalent meanings are often embraced. An African American student, Sidney, documented a performance at the entrance of the Art Institute of Chicago. He stood holding a placard, entirely black. Was he making a point that the Art Institute needed more artists of color, was he satirizing the fatuity of demonstrations, was he hoping for questions from puzzled tourists, or was he referring to Ad Reinhardt and the end of painting? He valued the "multiplicity of reads," including connecting

to an audience, "that was fairly successful in evoking a large kind of pan-
oramic of several different ideological, aesthetic, historical, social touch
points. . . . All of them could cross-read and inform one another" (Inter-
view). The multivocality of the work is its meaning.

Talking Art

While talk is central to the interpretation of practices, there are dan-
gers in relying too heavily on surface meanings. Too much clarity, often
viewed positively in an academic environment, receives the derogatory
label of *didactic*.[31] As one faculty member stated, "It's a good policy not
to think too much about what the audience will gain. You always have
an audience, but you don't direct that encounter" (Field Notes). Why create
a work if the argument is easily stated? Meaning must be unearthed. In
a critique, work is presented to colleagues: a group committed to shared
comprehension and to each other as colleagues and as members of a dis-
cipline. The work must be capable of being interpreted, but not so com-
prehensible that a mere glance will suffice. One faculty member said, "I
think of it as being in a dark room. After twenty minutes, you can see
everything [as your eyes get accustomed]" (Interview). The work must
whisper, not shout. Several students and faculty asserted that what was
crucial was neither history nor theory, but time for a slow unfolding of
a refined gaze.

Given shared exposure, how should meaning be communicated? Brid-
get's elegant and carefully considered installations, referencing poetry,
philosophy, chemistry, archaeology, and botany, are sophisticated and
complex. If I viewed them without Bridget's discussion, I would admire
them without understanding her aims. The weaving of references in her
work is impressive. By her second year as an MFA she was recognized
as an emerging star, so much so that her work was lionized as "museum
ready." But in works so dense with meaning, how much should she re-
veal? This became a central theme in one of her critiques. Responses
touched on the question of what to share: "There's a deliberate obfus-
cation going on, so it's appropriate to ask why." "I feel that I need the
originating poem or myth." "I don't think there should be a fear of being
generous to the viewer. Artists don't want to over-explain their work,
because why do it [if it is not explained]?" "One of the interesting ques-
tions is to figure out how does the audience get it." "The question is not
how you defend your work; the question is how the work has reached that
precision in how you as an artist deal with the information." These view-
ers needed keys to unlock her allusions. Bridget eventually responded,

"There is an enormous amount of information that will not be provided by me, but I hope I've provided enough doors into the work." Contemporary artists may produce conceptually deep work, but who should be responsible for providing meaning?

Hugh, who works with wood, is another student for whom blurred meaning is crucial. At the end of the year he created a large wooden sculpture, titled "Into the Abyss," a DIY version of a sculpture reminiscent of the work of Louise Nevelson. Over several months I watched the work evolve. Knowing Hugh's practice, I am confident now that he is still refining the object. The piece (illustrated here) is a six-foot tall maze, constructed from wood debris. The maze is filled with brownish goop that looks like excrement, as well as a chunky tan filler. Embedded in the filler are various found objects. What is it? At one critique Hugh referred to it as an "intestine." That was a misstep on his part, as the reference was too apparent, leading to a discussion of the body and its fluids. His friend Fred joked, "If you named it 'My GI Tract,' that would be a problem," suggesting that this reference would be even more explicit. The danger was that the piece could be seen as illustrative, rather than conceptual. Like Bridget, Hugh insists that he does not desire a singular reading, but that the multiple meanings can be captured by the committed viewer. He states: "I don't want any clear references. That would not be a success for me. . . . The intestine was my starting point, but only my starting point." The intention must be recognizable, but unfettered, built on relations among artist, audience, object, and context.[32]

The politics of meaning is exposed in what is termed a "cold read."[33] In contrast to the usual critique, in which a student speaks briefly about her work, setting the terms for discussion, students occasionally ask the faculty to respond without guidance. This is closer to the gallery experience. Programs have local standards as to how much explanation of the artist's intention is necessary. In some places the student can only listen, at least at first. At both University of Illinois at Chicago and Northwestern, students are invited to make an opening statement, and at UIC students are often asked for a title of the work. Students are questioned, while also receiving evaluative comments. In contrast, at Illinois State students provide a written one-page description of their practice, but they are questioned as well. These demands challenge the claim that the work speaks for itself. The artist, while having some authority, is also at the mercy of the object. Following the insight of Bruno Latour, a belief exists that the object—an actant—speaks, shaping the responses of human actors.[34] This role of the artwork as joining a conversation is evident in the comment of an instructor: "Some people know before

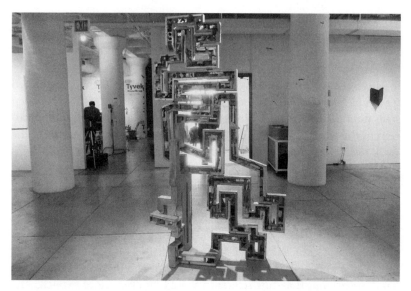

25 Thesis show, *Into the Abyss*, University of Illinois at Chicago, 2014 (photo by author).

26 *Into the Abyss*, in progress, University of Illinois at Chicago, 2014 (photo by author).

they begin the work what the work is about, and some people learn it on the way, and some people learn it after the fact. I am one in the third category. I work it out through the process. The words come really slowly to me" (Interview). The work tells the artist its meaning. Where I observed, students can request cold reads, but the faculty will eventually demand that the student will, in the words of one faculty member, "own your position whatever it is" (Field Notes). The art speaks, but so must the artist.

Feeling Special

MFA Affect

I describe the culture of young artists, their friendships, and mutual support in chapter 5, but here I analyze the intensity of graduate school. I focus on the emotional disruptions, recognizing that much friendship, even affection and intimacy, is also found. Relational ruptures are rare, but rarely absent among any cohort. This passion—a heated, lived moment—is part of what students pay for and what they treasure. This is a world in which their work really matters, to others and to themselves. Becoming artists, they develop an artistic self through the emotional intensity of schooling. In two years of observation I learned of three suicides (two of them at schools I studied, both prior to my research). Taking one's life is overdetermined: Too many causes exist for any death to be attributed to a cruel critique. Still, the fragile self rests on what one produces and how it is received. Enough celebrated artists have ended their lives to provide death with a dark glamour.

Eros and angst flourish in a world in which students are encouraged to be authentic and dramatic, and where deviance is tolerated. Art should be intense, and those who evince passion have advantages. But this produces a community in which consensus is fragile. One student commented on "extreme personalities" in the program, specifically a student judged too bubbly: "She is so 'history is beautiful and everything is lovely and butterflies and rainbows.' . . . To have her in my studio, that's not constructive. Her optimism, her love for everything, doesn't do anything for me" (Interview). This is a mild instance of anger, hatred, and "screaming arguments."[35] In one case hostility became so intense that a student was suspended from the program for a year. Even when comments are gloved, intensity is evident, as in a provocative critique by a student suggesting

that, although she had disliked a colleague's previous work, she liked his current work even less: "I want to say a few things and you can hit me afterwards. You know I've had a lot of problems with your old work, but I miss your old work which hit me in the stomach. This seems so watered down." Sometimes in damp relations, you can't win.

In MFA programs, the self is revealed through public displays. Fear and anxiety are magnified, more than in most graduate programs, especially given the public humiliation of critiques. "Some days it's 'Oh my God! I'm so bad at this. Why am I here?'" (Interview). A student remarked, "There's a huge amount of anxiety, a sort of paralyzing fear . . . The most surprising part is seeing how high the emotional stakes are in taking art classes at all. [A faculty member] frames the practice of making a painting with learning how to own up to your own failure" (Interview). Evaluations are everywhere, and few works are judged as reaching their potential. Given the absence of objective standards, one is haunted by failure, and some students are judged as failures, even if they do not lose funding as a result. Even praise is suspect as mere courtesy. Students refer to a "shit sandwich": polite compliments at the start and end of an evaluation and unpalatable criticism in between. These anxieties are intensified immediately before critiques and during the installation of the thesis show. Fred explained about critiques: "It feels as if you are under the microscope. Keep your voice down. Keep your blood pressure down" (Field Notes). Remarks about "panic attacks," "brains being jellied," or students as "nervous wrecks" are only half-joking. I listened sympathetically as students compared anxieties. One said, "I'm crit week fried"; a second added, "I hate those things. They are so painful"; a third worried, "I know I am going to get killed"; and a fourth told us, "I need to crash" (Field Notes). There was nothing particularly unusual about this session, surely recognizable by generations of MFAs. Stress is common when certification of competence is at stake. This is true not only in art school, but at all moments in which evaluation and its outcome are public. Smooth interaction, long central to the analysis of social life, is the default condition in which we pretend that all is well. However, on certain occasions, judgment is announced, and here (the ending of a relationship, the termination of employment, oral exams) the intensity is heightened in contrast to the usual politesse. As a result, failure is not merely technical, but a failure of self. And it must be admitted that there were students whose work was not admired by their faculty, often receiving perfunctory evaluations, because criticism was seen as not worth the bother.

The Politics of Excitement

Ethnographic insight often derives from small differences between one's site and one's home. When sociologists praise students' work, as we do, we refer to skill in data collection, concept, or presentation. Rarely do we claim that work excites us. But excitation is common in MFA critiques, and art students often suggest that they choose their projects based on what rouses them. To be sure, words have ritual meanings within communities, but "excitement" suggests the centrality of awakened emotion in assessment. Salient labels provoke response. As one student stated, "I think my work has a lot to do with creating exciting relations with the painting" (Interview). Another student said, "I'm trying to have a healthy relationship with desire" (Field Notes). In a published interview, Taiwanese American artist Jenyu Wang, a student at UIC, emphasized how embodied awareness shapes her work: "I am most concerned with the inter-relation of affect. . . . In such space, I feel connected to my humanity, yet it is where I allow myself to weep in front of a painting, to get angry while watching a video, to get encouraged by a photograph, and perhaps to feel profoundly cheerful by a performance."[36] She desires the passions in her work to be close to the surface, and objects to the work of colleagues that lacks her intensity.

Some art speaks to love and healing, some to sadness and trauma. As one curator told a group of students, "You live in the valley of tears. I hope you're happy. We need some healing. The purpose of art is healing" (Field Notes). One respected teacher advises students to "build a practice on pleasure" (Field Notes), but pain often has the upper hand in the field's thematic demography. The joyous gets crowded out by the traumatic, part of a politics that rejects contented privilege. Art student Ben Murray commented in a published interview, "I think that a lot of my images have a pathos to them. I mean they have a sad disposition to them, because there are a lot of things to be sad about in this world . . . being human, and especially being a middle class white male in America. I think there is a responsibility to not be glorifying in the imagery."[37]

Emotion is found not only in intention, but also in response. Viewers may react with anxiety, annoyance, or pleasure. In discussing performance in chapter 2, I described how a student wore a "fat suit" in portraying Hillary Clinton. The performance—a video—provoked debate about gender, politics, and power, but it also provoked uneasy emotions. One middle-aged female professor announced, "This piece is really freaking

me out and not in a good way . . . There's sort of a giggle in the room. It's sort of saying her face is saggy and her boobs are saggy. Maybe it's because you are a young woman with firm boobs. [Laughter.] I have to say that before my heart falls out of my chest." Another female faculty member agreed: "I just had such a sense of visceral protection. I think at some point of the film it shifted from being a representation of Hillary to a representation of you, and that's terrifying" (Field Notes). Damian forced viewers to wriggle through a large, casually built cardboard construction, angering some participants. Of all the critiques that I watched over two years, this one provoked the most severe responses. One faculty member described the work as "fascist and sadistic." Others claimed they felt like lab rats, and some expressed distress and claustrophobia.

Most works do not provoke these intense reactions. However, faculty draw on their feelings in their judgments. Works can generate ecstasy or distress, but they should produce an embodied experience.

Talk as Practice

As I argued in chapter 1, technique is often secondary in graduate socialization. However, technique can be a platform for explanation. As students build, they must persuade. Talk is central to the training of young artists. As the College Art Association states, "Verbal skills must not be ignored."[38] A work requires a narrative to become the basis of discussion.[39] Contemporary art involves conceptualizing the world, not merely illustrating it. This change has defined the transition from modern art to contemporary art: from the artist as sphinx to the artist as chatterbox. While buyers may prefer bright illustrations above the sofa, professional practice demands more: a disciplinary conversation. Following Pierre Bourdieu, emerging artists must learn the codes that secure a position within their cultural field. Even if talking about art is rougher, looser, and less gnomic than writing,[40] it requires an awareness of the proper forms of persuasion. Once learned, the codes become tacit representations of how the field operates and what are the relations with other networks.[41] Shared codes permit a smooth interaction order.

Within any well-functioning community much goes unspoken: Norms depend on assumed consensus. This is what management scholar Michel Anteby, examining business school education, terms a "vocal silence."[42] Cultures of orientation create moral orders, exerting normative control through what is said and what cannot be said.[43] This Foucauldian formulation finds power in the implicit structure of institutions, whether or

not this is recognized by the participants. But to point to the existence of "vocal silences" does not mean that there is less to say: on the contrary. Learning the rules of talk is crucial to the successful MFA. This is nicely put by Pablo Helguera:

The fact is that when one first enters the art world, it is no different than entering a party in the middle of the event. People are already in conversation groups, and a group dynamic has been set. As newcomers, our best option is to integrate ourselves into one of the groups and start following the tenor of the discussion, with the hope that we can at some point enter into the conversation. When we are in that situation, we are enacting an interpretive performance—we assess what is going on, follow cues as to what kind of comments are appropriate, and then enter, hoping to contribute in some way to what is being discussed.[44]

Helguera makes several important points through the metaphor of graduate education as cocktail party. First, there is the process of socialization. One must recognize local norms. In the graduate art program, norms are continually on display in studio visits and critiques. Second, Helguera speaks to the local context of one's involvement. There are many small groups within the art world. One chooses which knot to join and which not to join. But learning local norms is rarely sufficient. One must talk through them: entering a community involves skill in performance. One needs awareness of norms, commitment to a local culture, and the ability to perform. Students display these skills in their critiques and at their thesis show. After graduation, they may have further opportunities in teaching and in artist lectures. While some successful artists remain mute, discourse contributes to career advancement. One professor asserted that the belief that work can "speak for itself" is "incredibly naïve," adding "For the work to have a bigger impact, then you have to engage in the discursive aspect of it, which means you have to talk about what it really means, what you really want it to do" (Interview). As a student stated, more candidly, "Those artists who are successful are those that can critically talk about their work. . . . At the very basic level to do PR for their work. I think it's entirely necessary if you want to monetize your work" (Interview). The artist must be MFA and MBA.

The centrality of discourse in the art world is emphasized by Nathalie Heinich: "The extension of the artwork beyond the materiality of the object produced or presented by the artist also includes the *discourse* on the work. A work of contemporary art almost never exists without a text. . . . Just as the context has become part of the work, the discourse on the work has become part of the artistic proposal. This is why today's

art schools . . . include in their pedagogical agenda the mastery of discourse such as 'Being able to speak of one's work and to develop a text on it.'"[45] Art world professionals explain to students that "what you learn in art school is that you learn how to talk . . . as opposed to particular skills that were part of traditional art schools" or that "being able to talk about your career is crucial" (Field Notes). To be productive, hiding in one's studio, is important, but participating in a visible world matters as well. According to sociologist Priscilla Adipa, many art gatherings are "talking events."[46] As one administrator explained, the art world is awash in talk, and this shapes what happens within the artist's studio:

Your MFA student gets a studio. They make work. I started teaching at the college level in the early Eighties. [Studios] were messier because there was less talk. . . . Now that there is so much one-on-one discussion and critique in the studio, the studios get cleaner because they become little galleries. Much of what goes on in the studios is presentation of the work and less making. . . . So there is a lot of talking and a lot of talking one-on-one in the studio. And that talking is about building interpretive structures around the work. (Interview)

Students vary in how they think of spaces of production and spaces of display, but today's student has had to be more interpersonally engaged in constructing a career.

In any occupational world discursive norms are linked to sociality, marking one's belonging and status. Publics are often skeptical of what is labeled jargon or shop talk.[47] As Elizabeth Mertz points out in *The Language of Law School*, learning to *think* like a lawyer results from learning to *talk* (and to *write*) like one.[48] Faculty cannot easily control the brain, but they can control the tongue and the pen.

Sociology has not been immune to the amused skepticism of insider talk.[49] The art world is not the first or last domain to have an equivalent to the "Instant Art Critique Phrase Generator" with such chestnuts as "It's difficult to enter into this work because of how the reductive quality of the Egyptian motifs contextualize the remarkable handling of light."[50] Out of context the phrase is satirical, but one could imagine it being said and, more important, being perceived as meaningful. Echoing Tom Wolfe's *The Painted Word*, Alex Rule and David Levine point to the growth of "International Art English," a contained and technical discourse.[51] One needs commitment to the form of communication. As one MFA student remarked about her pre-graduate days, "Most of my residency mates had been to graduate school, and there was just something about the way they spoke about that work. It wasn't just about confidence—they

knew the vocabulary. Beyond the jargon (although they could get into that, too), but the lexicon—how you might communicate about your work to create understanding . . . I liked the camaraderie of the experience, and I wanted more of that."[52] While discourses vary widely and not all students are fluent, being able to converse opens opportunities for participating in journals and symposia. Some students never pick up the lingo, but reading and discussion in the first year—and the modeling of advanced students who can talk cogently—motivates some students to become more verbal. Observing at Northwestern, I wondered whether the first-year students would ever become as proficient in critiquing work as the more advanced students. That second year, some of the quieter students became leaders in analyzing works from a theoretical standpoint. In each cohort of five students there were some theorists and there were distinct cohort cultures, but in a culture in which heightened discourse is valued and in which students come to feel comfortable and expert, talk emerges. Faculty worry that incoming students will not acquire the depth and panache of their seniors, but they always do. Students mature in graduate school.

When effective, graduate schools make talk transparent. Carol Becker, dean of the faculty at the Columbia University School of the Arts, emphasizes the importance of a common language. "Art students, like other anthropological sub-groups, together share knowledge of the hidden signifiers—the references to which the work alludes—and rarely notice that these signifiers are unknown to those on the outside."[53] Fish, it is said, never realize that they swim in water.

Palaver and Panache: The Politics of Eloquence

Critique is built on challenge. While praise is desired, criticism comes with the territory, referenced in the event's label. To deflect attack, the maker must justify her work. As Terri explained, "I am very much required to write and talk about my work . . . If you aren't able to talk about [your work], someone is going to put words to it that may not be what you intend. So it is really staking a position and then occupying that territory. And that territory, at least the emphasis today, in art is a linguistic one. It is so much about language" (Interview). In the words of a faculty member, "Everybody knows that grad school is based on critiques, and if you can't talk in your own critiques, people would probably say you are sunk. But there is an expectation that you learn to talk better" (Interview). The critique becomes a linguistic battle in which faculty have the upper hand, and students struggle to articulate a defense.

I present two critiques that depend as much on linguistic facility as on the work displayed:

Crystal is a well-regarded young painter who presents three canvases. She says of her previous work, "It felt too much like illustration for me. This is abstracting of representation." This begins a conversation with the faculty: "Are these referencing particular points of remembering?" "Without this conversation, does memory ever occur?" "Thinking of the artist's memory is a dead end. Where is the productive aspect of memory?" "Is there content you want to discuss other than memory?" The group continues to challenge her on how memory is implicated in her canvases. After a series of false starts and brief responses by Crystal, a faculty member asks, "How are you talking about your decisions with paint? I wonder if you can state what's at stake for you." Crystal finally responds, "I'm having difficulty connecting these things [image and memory] and maybe it never will. I don't know I have a really good reason." Because her practice is seen as sound and the work as compelling, the discussion is focused on her intentions. The session is critical, although faculty members admire her technique. One says privately, "I think she's one of the strongest painters we have had in a long time," but adds that in responding, she seems like "a deer in the headlights." (Field Notes)

———————

Esau McGhee presents compelling photo collages of urban, impoverished scenes. At one point in his critique he explains to the faculty, "The work implicates you" [presumably the white faculty in the creation of urban poverty]. This provokes a lengthy and intense discussion of Esau's language.

Professor One: Implicates me in what?
Esau: In the landscape.
Professor One: But how? Implicated means implicated in a crime.
Esau: That's good. The piece is looking back at you.
Professor Two: I don't understand. The artwork looks back?
Esau: That's why I think the piece is making you work . . . I'm trying to figure out how to implicate the viewer to not let them off the hook.
Professor Three: I really would encourage you, Esau, to get more control over your language. You tend to use language in ways that are not effective.
Professor Four: Does it have implications or confrontations?
Professor Five: There is something about confrontation as an assault without it implicating me. (Field Notes)

In both cases what is at issue is not the work itself, which is admired, but the discussion: pinning the student to a wall of words. Partly this is a lux-

ury of an evaluation in which competency of technique and elegance of production are not at issue. The faculty concern is that the young artists are not able to articulate intention in light of disciplinary expectations. With a two- or three-year training regimen, the faculty does not allow talk to grow by accretion, but rather expects it to grow through challenges.

This threatens a student who has artistic vision, but is inarticulate. An artist who channels Ben Shahn—"Shut up and paint!"—is disadvantaged. Several students in each program had considerable difficulty describing their practices, perhaps a function of their education, ethnicity, social class, or gender. Making work was their goal; talking about it was not. One young artist told me, using the favored metaphor of the Occupy Movement, that the talkers were the "one percent." An articulate faculty member referred to another student who had been criticized by colleagues for her silences: "I don't think that's a criterion that I want to base her success in the program on. She is present for the other students, but when it comes to her work, if she is speechless on the spot, I think that's OK. She is absorbing what we are saying, and some people just can't answer on the spot" (Interview). One of most reticent students commented in an interview: "[As an undergraduate] I pushed myself to talk about [my] work in front of people. This year I've struggled with that. I feel like I don't want to make work I can just sum up in language. I really feel like I've been hitting a breaking point with that, so I have a really difficult time talking about what I'm doing. . . . I don't know if I feel artists have to" (Interview). Both of these women suffer because of their inability to converse with panache, despite their ability to create objects. They need others—critics or gallerists, if they can find them—to place their work in a wordy context. In a world that is often—on the surface—exquisitely sensitive to identity politics, treating verbal fluency as a mark of intelligence or ability is a political stance.

Given that art talk is taken by many as a defining characteristic of MFA education, some go further than Ben Shahn and discuss the hazard of eloquence. Henri Matisse is said to have remarked that "a painter ought to have his tongue cut out."[54] Robert Storr, dean of the Yale School of Art, phrased the matter pungently: "The intellectual tyranny of glibness is as damaging to art as that of dogma—and the two combined are lethal to both art and ideas."[55] In a similar vein, Jane Chafin, a Los Angeles gallery director, asserted, "We're teaching artists to *talk* about art. Anything is art as long as you can justify it using the codified language of academia. As my friend Ted says, there's no good art, no bad art, just an endless dialog about art."[56] In an email a senior colleague shared that he had lost patience with what he termed "the verbal mania of the art

world." He noted, following Tom Wolfe, that once "there were artists and critics: those who do and those who explain. Now it's artists as critics who first explain and then illustrate their explanation." In the extreme, poorly presented talk can transform an admired work into one scorned. As a student explains, "I've actually seen some really nice work, and then when the artist opens their damn mouth, it can make you not like it. For me, something visually compelling will drop in my opinion [based on an artist's commentary]." While talk cannot erase marks on canvas or chips on stone, in the MFA world objects require justification.

Write Turns

Successful artists have many talents, just like lawyers who are prodigious researchers and smooth talkers, or surgeons who can cut carefully and sympathize lovingly. Some artistic skills involve technique: mark-making, carving, arranging, and dramatizing. But increasingly writing is one of those skills. As one faculty member expressed it, "writing is an externalization of one's practice" (Field Notes). Each of the three programs has a written thesis requirement.[57] These projects vary in length and in academic content. Not counting the images that are included, most theses are about ten to fifteen pages long, but some are as long as forty pages.[58] While the thesis might be expected to be an exegesis of their practice, given the importance of concept and theory in contemporary art, engagement with ideas varies widely.

At first I was puzzled as to why visual arts programs demanded a written document. Part of the answer is that the programs are housed in research universities, and these documents are counted as research, even if they consist of poetry, memoir, or a footnoted, scholarly text. In practice, a thesis is whatever a student chooses to write and whatever her advisers choose to accept. Esau McGhee presented a moving series of letters to and from his imprisoned brother. The thesis addressed Esau's work, but not through art history. He explained the basis of his practice and his self-conception as an artist. I was told of "an MFA candidate [who] had someone else write his thesis for him, because his practice was so related in conceptualism and appropriation that it was a credible argument to the department that he could . . . outsource it" (Interview). Perhaps this *was* academic integrity. Plagiarism as deviance depends on an ideology of creativity in production, rather than creativity in selection.

Several students presented artwork (although with some textual explication), such as a student who submitted a thirteen-foot-long scroll

with "a timeline of curiosities" (Interview). In contrast, one of Esau's colleagues wrote a thirty-page document examining the linkages between his own work and larger political and cultural paradigms, with references and footnotes in Modern Language Association format (Interview).

This diversity of theses, each accepted as fulfilling the task, poses a problem in the absence of definitive demands. A faculty member admitted, "I tend to be very forgiving, flexible, liberal. I think it is a really useful kind of engagement, but I am not that committed to what the product of it is" (Interview). A director of graduate studies told students that their thesis is not a research-based master's thesis. "There is a written component [including the thesis show exhibition catalog]. It can be a set of poems, but words have to play a role. . . . How do you contextualize your work in the conversations about art?" (Field Notes). Students in this program work with an adviser and choose two other readers, but for students who do not feel comfortable with the written form, an emphasis on "rigor" provokes anxiety. Many high school students choose a career in art precisely because they are uncomfortable with academic standards in other classes. They find an alternative community in which they thrive. Now they must face their demons. Illinois State instituted a writing course because, in the words of one faculty member, "Our students don't know how to write well, so we can't let them write a thesis without training" (Field Notes). Some, such as photographer Marissa Webb, find writing a chore, and she worried about writing twelve pages on her practice. Others describe writing as a "slog" or as "torturous."

The ambiguity of thesis form is different in kind from the ambiguity of the artworks. In the latter, much is judged. However, writing is assessed with a light touch. I attended a series of sessions in a thesis practicum. As someone who has taught a writing seminar for sociologists, I was startled that the instructor did not discuss argumentation, writing for an audience, or the process of editing. We discussed student drafts (although not writing by other artists) without analyzing what constitutes an appropriate thesis. Students benefited from the feedback, but did not learn about constructing genres of writing. In contrast to their work as artists, students lack well-defined models of writing, and despite claims that writing matters, the thesis is secondary to the artwork itself. Of course, for some artists, texts are central to their practice and constitute what Andreas Fischer, an artist and professor, labeled a "culture of writing." The rise of so-called "artist's books," incorporating the visual and the textual, exemplifies this trend. Writing in a poetic or nonlinear fashion, students hope to generate an experience of reading that mirrors the experience of the work. Some succeed.

Ideally, the thesis helps students fashion an artist statement, now essential, even if some consider these documents as "the dentistry of the art world."[59] While the thesis as an extended document is not crucial to graduate success and lacks the gravitas of a master's thesis, an effective artist statement is significant as a practical skill. Artist statements announce intention. These statements have a long history, dating back at least as far as Dürer, and constitute an expected feature of exhibitions, providing "insider knowledge."[60] Artists also must prepare grant proposals and applications for fellowships and residencies: Drawing will not suffice.

Institutionally the thesis suggests that art programs, like other departments, are aligned with the university's research goals, but they struggle to make that happen, given the goals of artists and the skills of students. Still, most students accept that writing belongs in university-based visual arts education. The thesis fits not only the colonization of the arts by a research institution, but also the art world as a discursive space.

Writing belongs in the training of MFA students, but, unlike talk, its centrality is uncertain. When writing is salient, it advantages some students at the expense of others.[61] In this, art is not so different from other professions, in which sermonizers differ from pastors or medical researchers from doctors recognized for their bedside manner.

The Theory of the Aesthetic Class

Visual art as produced by elite, revered artists is not now and for a long time has not been centered on the production of beautiful objects, however much Dave Hickey and Tom Wolfe might despair. Once Marcel Duchamp placed plumbing in the gallery, the exquisite went down the drain. Art is about ideas, a perspective rarely absent, but more recently encouraged by a political context that challenged fealty to the market. Here is a world of theory:[62] a world that art school pedagogy encourages and that universities demand. But theory means many things. In the 1970s art educators discovered French high theory. I suggested 1971 as the year that contemporary art was born, when Chris Burden had himself shot, but perhaps we must wait five years for the carnal embrace of theory. It was in 1976 that *October*, the journal of contemporary art, politics, theory, and criticism, was founded by Rosalind Krauss and Anne Michelson. The journal was influential in transporting French poststructuralist theory to American shores. *October* was not alone, and its

founding responded to emerging trends, but it provided a space in which high theory contributed to the academicization of art. The 1980s witnessed the enthusiastic embrace of theory in art schools and in art criticism.[63] Philosopher Arthur Danto suggested that "in turning into philosophy, art had come to an end." In other words, Danto wrote, "progress could only be enacted on a level of abstract self-consciousness of the kind which philosophy alone must consist in."[64] Contemporary art required a theory—or at least a conceptual infrastructure—as justification. Heroes of theory had a Gallic accent, and included such writers as Gilles Deleuze, Guy Debord, Georges Bataille, Jean-François Lyotard, but also the American theorist Fredric Jameson. Recent figures in the same high (critical) theory tradition include Catherine Malabou, Boris Groys, Alain Badiou, and Jacques Rancière. All were respected by my informants. Groys suggests that students are "infected" by critical theory.[65] Quelle horreur! Although not all professors agree, theoretical engagement supports a university-based art. Timothy Jackson asserted that "a curriculum centered on ideas rather than technique is beginning to emerge, owing, in part, to the ideas and concerns that have grown out of critical theory."[66] While all art derives from beliefs about society, artists are encouraged to be self-conscious of how their intentions fit a wider matrix.

With its impact on art education, particularly in the 1980s and 1990s, high theory continues to reverberate in the academy.[67] This provided a pedagogic allegiance between faculty in the arts and colleagues in philosophically oriented humanities departments, including comparative literature and gender studies.

Whether or not embrace of the nuances of French theory has moderated, conceptual discourse in the arts has broadened. The relevance of these canny and subversive thinkers was always somewhat problematic. Students admitted into MFA programs were selected not because of their skills in unpacking texts, but because they could make marks on canvas or build objects. Some students, skilled artisans, even claimed not to know what theory was. Lena, once an undergraduate at an art school, said that she rejected her work being "based on theory." She explained, "I feel like 'theory' has been a word that I've been introduced to since entering the program. I'm sure I read articles [as an undergraduate] that were considered theory, but that wasn't a term that was used. I've been learning what that word means." Not only must Lena learn how to speak of critical theory in a seminar, but also she must identify it in the wild. As art historian Alexander Potts[68] suggests, theory becomes influential as part of the vernacular spread of ideas.

Critical theory is tamed and simplified as ideas reach artists and collectors. The cutting edge of ideas is dulled in the process. One faculty member described the change to a group of students, describing the "hardcore" of theory: "Fifteen or twenty years ago you would have had to have a theoretical backbone for your thesis, but [high] theory has sort of gone out of style. . . . In the Nineties, you had to get your Lacan right. Today it doesn't matter" (Field Notes). The embrace of high theory demanded too much, and, in truth, many artists did not value such esoterica.

How did theory and production join? One answer is through what art historian W. J. T. Mitchell labeled "medium theory," a compelling term that plays off images of artistic mediums and differentiation with high theory—rejecting unifying principles—and off low theory, mere opinions about particular works. Mitchell writes, "I mean to suggest a picture of theory in the middle instead of on top. I locate theory somewhere between the general and the particular. . . . Medium theory would thus stand in contrast to what has been called high theory, the aspiration to total mastery, coherence, explanatory power associated with metaphysics and . . . most notably with structuralism."[69] This is a theory that emphasizes the local, embedded forms of practice and is linked to the exploration of particular bodies of work. As Lane Relyea[70] emphasizes about young artists—applicable to graduate students—praxis develops from the open-ended conversations that artists have in their studios, apartments, and bars. Talk is found in the Rue des Batignolles, the Cedar Tavern, and UIC's Great Space.

We should not overgeneralize the responses of art departments. Programs and faculty embrace "theory cultures" in different ways. Among schools, the role, form, and content of theory depend on local traditions and local faculties.[71] As one professor explained, "Discourse is the kind of thing that attests to the seriousness of the program." This does not mean that most students as they apply for admission look beyond the school's reputation, its leading faculty, or its location (Field Notes). But faculty members and programs gain reputations for the intensity of their theoretical embrace. As one faculty member warned students about a colleague, "I bet she would give you a big pile of readings. She's that kind of person" (Field Notes). The speaker made clear that, in contrast, she herself was not "that kind of person." In responding to the work of a highly conceptual student, a classmate noted "how theoretical her work is. Only Louis [another student] and I get it" (Field Notes). Theory talk (and theory appreciation) becomes a skill to be claimed. Others, not conceiving themselves as "intellectuals," "writers," or "thinkers," are only

modestly interested. In one class a text by Fredric Jameson was assigned. About half the students claimed to have done more than skim the reading, perhaps an inflated percentage, and discussion was desultory. When the topic turned to objects and films, the group became energized. Placing a text on the syllabus does not make it transparent. As one student pointed out, sitting in classes, discussing unknown references, limited her participation. She said, "It ended up making me a lot more reserved because it felt like I was in territory I wasn't supposed to be in. I feel like I am so far behind. A lot of the names and ideas that come with it were completely foreign" (Interview). Assigning Foucault is a Foucauldian expression of institutional control. Another student felt that his work was not well received because he was unable to cast it in a theoretical light, and despite his personal vision, the work was derided as "formalist . . . devoid of concept and theory" (Interview).

Students self-select into programs. Those who attend UCLA have different agendas from those at the Savannah College of Art and Design in more than their ambitions and backgrounds. Those who apply to CalArts think differently about theory than those who select a craft-oriented program like Indiana University, or they will by graduation. This permits the development of local cultures such as those I discuss in chapter 5. The conceptual emphasis at Northwestern differs from the more political approach at University of Illinois at Chicago and the pragmatic stress at Illinois State. UIC signals the importance of theory by offering several classes each semester labeled "theory courses," such as a seminar on intentionality.

At certain times and places theory becomes a slogan to raise the status of art practice and create intra-university alliances as well as being valued for its pedagogical virtues.[72] Institutional placement is central, making art an intellectually engaged discipline, rather than a craft practice. As most contemporary theorists would agree, theory is a form of academic practice used in multiple ways, operating on different levels of generality, and having variable connections to material objects.[73] It can be a comfortable home for the conceptual artist.

Unlike inspiration that cannot be taught, theory can be—and is. James Elkins provides an account of how students deploy the work of Jacques Lacan as they become more sophisticated: "One BA student began her critique by saying, 'I have just been reading the psychoanalyst Jacques Lacan. I am especially interested in a concept of his, called in French the *objet petit a'* . . . At the MFA level, the same student might say something even more fancy, like 'My work interrogates the Lacanian *objet petit a*.'"[74]

Elkins's humorous remark suggests not that the second student understands more about Lacan, but that she can frame her interest professionally, claiming an embrace of unattainable objects of desire.[75]

In many schools, particularly those deemed elite, a student's ability to deploy conceptual explanations is a status marker. As Leslie Dick at CalArts remarked, "the prevailing belief is that any artist whose work fails to display some conceptual rigor is little more than a pretender, illustrator, or designer."[76] CalArts graduate artist Mike Kelley agreed: "You can't not have theory. I have no tolerance for the idea that artists are idiot savants who make their art by going into a room and squeezing their souls out. That's Hollywood's version of art! Artists need theory. . . . We're not going back to learn from plaster casts."[77] Wendi, a philosophy major in college, found reading theory "inspiring," shaping her practice. She claimed to read theory every day, just as she works out daily. She said, "If you don't do daily exercise, in a few days you lose it" (Field Notes). Louis, well trained in French theory, explained that "[theory] is fundamental. . . . It is a perpetual work of interpretation. . . . [I had] insomnia that came from . . . excitement of working through ideas in a way that felt good" (Interview). In their theoretical confidence these students embraced what many faculty desired. Here I quote from published materials of two students (respectively Jenyu Wang at UIC and Raphael Fleuriet at Northwestern) that represent emerging artists articulating how theoretical models influence their material practices:

I question modernity, while constantly interrogating Cartesian duality, the gap between thinking and feeling, mind and the body. Sometimes I hope to bridge this gap, while sometimes I hope to stretch it or simply close it. Projections, sculptures, and sound, often used in the same space at the same time are my tools to approach this gap. In pursuit of this gap, I concentrate on the moments that show the vulnerable body, the traumatic body in the psychology of the "everyday." Aspiring to go beyond Lefebvre's "everyday" of the Western experience, I introduce the cross-cultural experience. . . . I have made it my mission to dismantle the dialectical relation of intellect and emotions.[78]

Not just abstract plastic paintings, but fine granules of pigment suspended in acrylic polymer emulsion squeezed between two sheets of polymethyl methacrylate, a transparent thermoplastic alternative to glass. . . . These abstract plastic paintings are historical landscapes, layered with facticity, entangled with artificiality. They are multisided, point to no singular meaning, and have less to do with presentation than with plastic-

ity; this capacity of being formed while resisting deformation. . . . These plastic objects result from an on-going artistic research project into the material origins of acrylic, an investigation into the various currencies of plastic, and a reflection upon the term, and concept, of plasticity.[79]

Tom Wolfe would grimace. These statements—incisive, forced, or comic, depending on one's critical attitude toward critical theory—are treated as legitimate, and admired, discourse in the academy. As Milton Babbitt asserted, esoteric talk is not necessarily esoteric within a local community, where words and ideas gain collective meaning. And, of course, drawing boundaries with outsiders validates internal expertise. Still, this language does not come naturally, and not all are equally facile. In classes, some students talk in a heightened theoretical register, and others, comfortable in plain speak, resent the "bullshit," struggling to keep up or daydreaming. This is part of the performative expectation of art students. While not so evident in seminars, the pejorative assessment of theory mavens is common at bars. One student considered leaving graduate school because she was disappointed in the rarity of these theoretical discussions. She expected that "we would all be engaged in this dialogue that everybody was going to be reading as much as I was. . . . You could be like, 'have you read this book?' . . . and that person would actually read that book and you could have a discussion about it later" (Interview). This student found little overt interest in theory among fellow students and felt more at home in departments of comparative literature, philosophy, or gender studies. That some faculty desire to infect students with theory does not mean that all will come down with the disease.

Students are at the mercy of the faculty, and many accept the veneration of conceptual development, at least publicly. For art historian Howard Singerman, reminiscing about his MFA experiences, art education "stresses theorization and a verbal reenactment of the practices of and the role of the artist."[80] This is more than talk about the aesthetic and meaningful qualities of particular objects, but fits those objects into a larger structure.

The Fangs of Theory

Theory? What's not to like? This is what really, really smart people care about. At a university, smarts are a virtue, except when they become "over-academicized." As Wick recognized, theory ("with a capital T") "feels like it is posing to be scientific" (Interview). Theory sometimes

feels as if it will continually advance to truth, like science. This excises feeling or vision that can be appreciated, but not described. For some artists, theory, borrowing ideas from others, diminishes creativity and marginalizes intuition. As Hanna Owens explained, "I believe I should be making work that's coming from a real, raw place" (Interview). Archie Rand, a painter and professor of art at Brooklyn College, speaks of MFA programs as "idea monopolies."[81] A one-sentence artist statement said simply, "Look, Don't Think."[82] A student remarked provocatively, "I think artists should think as little as possible" (Field Notes). Another student suggested that theory talk as performance was used to maintain reputations while directing attention away from their work. These students may have been as sophisticated in their images, but had difficulty framing their practice, struggling to find the right words to lull others into docility because of their "obvious" insight. Speaking of a professor, Denise, a student who emphasized the visual, complained, "You got ripped in pieces if you didn't have a huge backing of theory in your work. The second years [students] are used to spouting off and talking out of their ass so they could defend themselves and had this authority; we didn't. The first years are of a different culture: more seeing, more doing, less yapping" (Interview). For Denise, "yapping" was a means of gaining authority, in contrast to producing art. Students like Denise found theoretical discussions off-putting and resented that they could not talk about art without jargon, sometimes denigrating student-theorists as full of themselves. The bullshit artist has a genre all her own, at least according to those more comfortable with plain speak. Within all graduate programs, and nowhere more than art school, students attempt to justify their presence and relieve their insecurities through a culture of posturing and competing. These are rarely explicit, but competing students know they exist, as certain members of the cohort are treated as real artists, however hard that is to admit. Even if a cohort is idealized as a community, it may be riven. Theory is one of the lines on which it is fractured.

Peter Plagens, the former art critic at *Newsweek*, suggests that theory diminished the work ethic of artists. "The schools have taught a generation of artists how to make art without laboring in their studios. It's all about intellectual strategy. You just assemble found objects into an installation, say the word 'gender' and you're done."[83] A New York dealer describes much of the work she sees as school projects: "When I go to the New York galleries, all I see is art-school art. The art is either feminist or deconstructionist, and basically it looks like homework."[84] Students

are overwhelmed with the pressure to keep producing: There is little room for the slow artist. This is compounded by the fact that the more time devoted to reading, the less time for making. The real test, as at medical school,[85] is to figure out how to meet faculty expectations while acquiring skills that serve well in the profession.

As is often the case, these anxieties are revealed through joking. At a critique, a student is asked a lengthy and dense question about the theory behind her practice. The student receives a loud laugh when she responds, "Could you repeat that?" (Field Notes). Heavy theory is inconsistent with light comprehension, reflecting the conflict between slow and fast cognition.

What emerges are competing models of art education and effective praxis. To make this point, Damian shared a dramatic story from his undergraduate education: "I had a studio visit once when I was an undergrad, probably more when I was making more formal [and less theoretically informed] work. It was from a critic . . . he was established and older and very confident in himself and very proper. He was even English, maybe. And he comes in and I am an undergraduate sculpture major making some cool looking things. . . . [He says} 'The work you are making, I am not on your team. I am rooting for the other team, and good luck to you.' . . . I read it as a more conceptually minded artist team" (Interview). Perhaps memory sharpened the story, but it suggests that theory is both a game and a marker of identity.

Aesthetic Citizens

Artists are citizens: aesthetic citizens. But should art, as disciplinary practice, encourage civic virtue, incorporating political debates and the theory of activism? Should art shape society, or is beautifying it sufficient? Increasingly artistic theory makes this former commitment central.

Politics has long shaped art practice, in the depiction of scenes of religious devotion, court figures, or bourgeois comfort, but in contemporary art the recognition of engagement derives from a set of theories about art, embedded in the approach labeled social practice, and, according to some, one cannot escape political choices. One faculty member explained that "no politics is political," adding, using my preferred apolitical art, that "the idea of painting water lilies is very much taking a position." Monet decided what to aestheticize, and this choice affected how the work enters a market or museum.[86] This is one reason why the

label "fine arts" is increasingly replaced by "visual arts," avoiding a hierarchical connotation that some deem offensive. (Still, the MFA degree has yet to be replaced with the MVA.)

Politics and aesthetic theory are not *inherently* in conflict, as both connect artists to their spectators.[87] In the past, few artists imagined themselves primarily to be change agents; rather, they tried to fit into markets and patronage systems. However, with the growth of the twentieth-century avant-garde, and spurred by theorists such as Walter Benjamin and his critique of diminished artistic authority in mass-produced art as constituting the "aestheticization of politics,"[88] artists began to define themselves as political actors, challenging the status quo.

This choice can be problematic. Writing about social practice, the critic Randy Kennedy asks in what way it reflects art: "Its practitioners freely blur the lines among object making, performance, political activism, community organizing, environmentalism, and investigative journalism, creating a deeply participatory art that often flourishes outside the gallery and museum system."[89] As Kennedy emphasizes, this is art that is embedded within the halls of universities by professors with secure careers and by students insulated from the market. For these academics, a political voice suggests power, even if frequently muffled. As one faculty member told her students, echoing Boris Groys, "The worst thing that can be said about an artist is that his art is harmless" (Field Notes). For art to be meaningful, it must not only be politically aware, but be aware in the right way. Art should, in this view commonly heard on campus, struggle with oppressive forces, including neoliberalism, rape culture, heteronormativity, white privilege, and narco-capitalism. One professor critiqued a display by an Iranian student that he considered insufficiently aware: "This is very sterile. It's so polite. You have the responsibility to steal power. . . . It's very Republican." A colleague added, "Don't be too political in a conservative way" (Field Notes). Better was the student who, as an undergraduate, was asked to participate in a competition sponsored by a powerful corporation to paint a portrait of its CEO. Casey, wishing a political edge, painted the CEO's head cut off (Field Notes). His work was not selected, but he was admired by colleagues. Contemporary art has become part of the armature of progressivism, encouraged, for good or ill, by political movements.[90]

While we can accept the perspective that all art is political *in some sense*, many artists who explicitly and self-consciously create works that engage the need for an activist community embrace social practice in their work. They commit themselves to aesthetic citizenship, merging

the civic and the visual. The challenge for activist artists is to avoid having their work become a screed and themselves a scold.

To find a space for aesthetic citizenship without losing their audience is the goal of engaged artists who use form to raise consciousness. Louis worried about his work becoming too explicit. In his videos and constructions, he hoped to theorize oppression without the work itself being oppressive: "I want to think my art is political. Now I want to make sure my art is political in a way that my civic duty should find its way to my art. I found myself moving from an approach to political art that is very legible, very didactic, very obvious, pedantic . . . to something a lot more fleeting, a lot less identifiable and hence perhaps a lot less political" (Interview). His art should captivate without become a pamphlet. As Janice shared, "Even if there's a political agenda behind [your work], you can still approach it on a sensory level" (Interview). The challenge is that some viewers might recognize only the aesthetic surface, ignoring the provocative depths.

Several faculty members described their own work as political, at least in the broad sense. These artists spoke of incorporating "research" (that is, acquiring expert knowledge) into their practice.[91] Art critic Hal Foster refers to the artist as ethnographer, mapping and archiving sites of oppression and using this information to revive traditional forms of artistic production.[92] This strategy depends on the resources and the protections that the academy provides, even if research, like technique, is not explicitly taught in art programs. The university becomes a safe space for society's condemnation. With library access, computer technology, and support for activism, the political artist can thrive. Given the rare discussions of research methodologies, I sometimes felt that research constituted theory bolstered by anecdote, an unsystematic body of narrative to be marshaled for a cause.

I admired their desire to go beyond the personal, but recognized that research had a different meaning in art practice than in sociology. Carol Becker, dean of the Columbia School of the Arts, made a similar point: "Student artists are often ill-equipped to research their subject matter thoroughly enough so that they can integrate what may be a sincere outrage at the world in which they live, with the objective facts that can infuse their critique with meaning and credibility. The work may therefore have a confrontational or heavy-handed feeling, assaulting the viewer with its lack of subtlety and generosity to the audience it supposedly wishes to influence."[93] As Becker warns, art programs desire public art, but they lack the ability to teach best practices—experiments, survey

research, or ethnography—to examine those beliefs that they hold inchoately or reject with passion.

Still, some art faculty and students collaborate with participants in other programs, including medicine, engineering, philosophy, comparative literature, and sociology, and this justifies their commitment to research. One faculty member, who emphasized documentation, asserted that his practice had "a huge research component," so much so that he felt it justified a lower teaching load. The documentary approach trickles down to the critique room[94] as some students present archives of texts, including an extensive "library" about alternatives to factory farming.[95] One course I attended examined "The City of Chicago." The class visited intermodal rail transfer yards, downtown financial institutions, and art centers throughout the city. Each student had to create a project that combined artistic practice with knowledge of the city (for instance, the siting of honorary street names). While the title of the course might suggest political science or sociology, attendees were art students, who valued the exposure to the city, finding much material to transform visually. Nevertheless, one apolitical student skeptically suggested, "One of the things I have been struck by in this program is how much focus on some type of social activism a lot of the teaching is. . . . There is certainly a leftist leaning that certain kind of ideology is definitely promoted. . . . I don't feel the personal mandate to have my art be connected with those same ideas" (Interview). Research can be used to support theoretical perspectives.

The importance of research—or politics or theory, for the three are often joined—was evident when one school decided that a rare opening be used to hire a professor who specialized in social engagement. The program invited four candidates to present their projects. One talked about water policy in Latin America, and a second discussed hacktivism and opposition to drone technology. The one who was hired produced films, created documents, and aided movements opposing the supermaximum security prison system, which her activism helped modify. She was treated as an important artist, because of her involvement in the public sphere. Yet my friend Evan was skeptical. "Is a graduate MFA program a place where a radical practice can be developed, deployed or incubated? Or is it a place where a radical practice really goes to die? . . . Her work is bureaucratic and dry" (Interview). Although the work was not stirring for Evan, it was for his teachers, and the candidate joined the faculty. But if Evan is correct, the university may create a space for dissent, while making that dissent impotent by forcing it through a theoretical grinder.

One can see the effects of a limiting institutional discourse in examin-

ing religion and politics. As I noted previously, expressions of faith are problematic, even when the student is exploring *loss* of faith. Religion is off-limits unless "framed correctly."[96] Politics is even more one-sided. I met several students who I felt might have admitted to being conservatives in more supportive environments, but no one exited that partisan closet. As Steven Lavine, president of CalArts, noted of his faculty and students, "Everyone talks a pretty good left game."[97] In this, progressivism is often seen as in sharp opposition to capitalism and, in particular, the art market. One art teacher admitted, "I'm always trying to teach against economics." As it is often used, that talk can involve describing dispreferred perspectives as "fascist," a term that typically means status quo, traditional, materialistic, or simply dumb. In this light a student's work, a sculpture incorporating water bottles and grocery bags, was described as "a manifesto for thingness. It's not fascist, but it's a little fascist." It seemed too close to an embrace of materialism, rather than a critique of it (Field Notes). One school administrator emphasizes the sensitivity to anything that strays outside progressive lines: "There are students who come here with great politics, but there are students who come who are sexist and racist" (Field Notes). When I talked with students privately, they recognized that while allegedly anything goes, taboos exist (opposition to affirmative action, skepticism about climate change, or a rejection of marriage equality). As a faculty member admitted, "There has rarely been a counterpoint to the progressive by the absolutely conservative student" (Interview).[98] To stand athwart progressive politics is to tarnish one's reputation. The academy is a cultural field with a truncated politics.

In contemporary art education, with its political commitments, theoretical engagements, and identity politics, the artist confronts her fragment of the world. This is as true for students who wish to engage as for those who turn away. To the extent that faculty believe that practice and praxis must be joined, the content, form, and place of artworks are shaped. The image of an ivied ivory tower is challenged by those who wish to raze the walls.

Painted Words

Art embraces the visual, not the aural or linguistic, and yet it has become a world of arguments. In a field of flowery words, can a landscape survive? It is difficult. Art-making is found within an institution. Placement in this institution, the university or the proto-university (the art school), is relatively new. Art was once taught in the atelier. This was a world in

which artists trained artists, fulfilling commissions from other institutions: palaces and churches. Beginning in the early twentieth century, the belief emerged that art—high art—must be about ideas and not about what is pleasing in the chapel or the ballroom, distinguishing the artist's vision from the ideology of sponsoring institutions. As this was prior to the growth of art school training, one wonders about cause and effect. Is the MFA program the cause of a growing embrace of theory or its result? For artists in universities, does the emphasis on the verbal result from a desire for institutional legitimacy? Does theory marginalize other forms of appreciation? Recalling Tom Wolfe, does theory make the artist its victim?

But theory means more than the dispassionate consideration of aesthetics. Much art carries with it a theoretical commitment that is steeped in politics. In this sense, these artists as thinkers of the world are aesthetic citizens, and this identity justifies a school-based autonomous practice. Intentions can include both visual form and a responsibility to promote change. Change rarely happens quickly, but these students attempt to engage, merging pure theory with praxis, and linking to other forms of activism on campus, embracing the civic engagement of social practice. In this, the artist is not only an object-maker, but a society-maker.

In the university with its systems of evaluation, professors judge students, and professors are judged by tenure committees, composed of those in disciplines in which texts are the primary form of valuation. Art instructors attend lectures, serve on committees, and befriend colleagues. Artists increasingly are workers who are trained and who are granted degrees that certify that training.

Crucial to this training is not only the object, judged through multiple criteria (the *heterarchy* of evaluation), but talk and text, each with standards. The idea of good work increasingly depends upon these verbal and textual domains of judgment, rather than direct sensory appeal. This system determines who is hired and tenured, along with other reputational indicators leading to the placement of works.

Even if art cannot be taught and imagination cannot not be tamed, theory can be, and professions are skilled at laying down lines of what is moral, political, and generalizable. Ideas of what constitutes respectable theory change, but inevitably, if communities belong together, they depend on generalized criteria. Even when fields are diverse in their practices, as contemporary art famously is, practitioners understand that collective criteria create competence. Despite heated conflicts, an imperfect sense exists of which artists are producing outstanding work. Judgments are diverse, but never random.

The Reason of Pure Critique

It's true of families, and equally true of workshops: you meet people there you'd never meet otherwise, much less show your work to, and you listen to them talk about your story or your novel. These are not your ideal readers—they are the readers you happen to have. Listening to their critiques forces you past the limit of what you can reach for in your work on your own. A fiction writer's work is limited by his sense of reality, and workshop after workshop blows that open by injecting the fact of other people's realities. ALEXANDER CHEE[1]

Every domain of graduate education has its iconic format: the Socratic dialogue in law school, grand rounds in medical school, and the case study method in business school. Each discipline treasures its best practices. For artists, that tradition is the critique—or group crit. These are sessions in which faculty and graduate students, along with some advanced undergraduates, visitors, and guests, gather to evaluate a student's work.

There are several justifications for the critique that, taken together, render the system nearly universal. Some of these are recognized by the community, and others are recognizable by those outside. First, the critique is designed to uphold the standards of "good art," however that slippery and provocative term is locally defined. In a field that lacks "objective" standards, the voices of the community, although fragmented, recognize the autonomy of the school-based art world in creating standards. Second, the critique, as usually organized, forces students to defend their art, justifying their intentions, whether aesthetic, political, social, or otherwise.

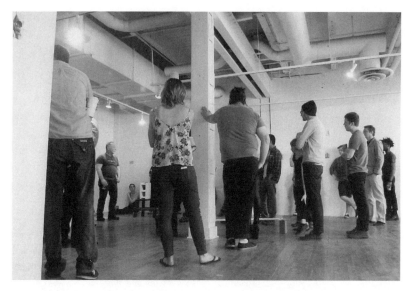

27 Critique, University of Illinois at Chicago, 2013–14 (photo by author).

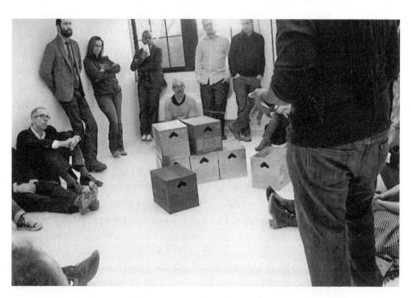

28 Critique, Northwestern University, 2012 (photo by Art Theory and Practice Department, Northwestern University).

Each must answer the question, "Why?" Third, the very existence of the critique as a collective gathering creates a community of interest and, as a result, models the larger art world as a networked world and a space of social practice. Fourth, the critique is a spiky context is which students must deal with the possibility and, sometimes, the reality of failure. It models a world of rejection, creating implicit (and sometimes explicit) hierarchies. Finally, the fact that students and faculty are willing to gather for days to discuss artworks asserts that something important is at stake in their activity. The *game of art* is more than play; it is a civic culture that shapes the world. The struggles in critiques constitute the belief that art is worth the fight. These themes justify a system of interaction that may appear odd or perverse. Elements of these justifications appear throughout this chapter.

Critiques are typically held near the end of term, and constitute a capstone exercise. As pedagogic rituals, they have detractors; for example, at the University of Illinois at Chicago during my research, the department discussed how to make critiques more humane, less boisterous battles. But for some of those involved, it is precisely the conflict in valuation that justifies the worth of art. Antagonistic struggles may contribute to the production of belief.[2] Consensus of judgment is not the only process through which valuations are established; as the social theorists Luc Boltanski and Lucien Thévenot[3] emphasize, what may be more important is a consensus on how criticism is voiced and justified as fair.

In addition to the group crit common in MFA programs, departments may organize studio visits by faculty and guest artists, or critiques with one student and a panel of faculty. These structures tend to be less contentious than the large evaluative performances. After the group critiques, faculty meet to evaluate students, allowing them to proceed or awarding a grade,[4] and students are encouraged to meet with their adviser to process the outcome of the critique.

These public conclaves can be brutal in a way that, under other circumstances, might be labeled a hostile learning environment. Some students find their work sharply and personally slammed, something unthinkable in most academic departments, but expected in art education. In this respect, these occasions stand apart from gallery openings, in which praise and Chablis are poured generously. That academic critiques are set apart from the market means that criticism must be treated as helpful in sharpening ideas and not as destructive of financial worth. No matter how hostile the words, the mantra is that the critique is constructive.

I have taught sociology for more than four decades and have led many graduate seminars. In that time, I have never caused a student to dissolve into tears. I doubt it is because I am such a nice person. Rather,

harsh public evaluations are rarely found in most academic disciplines in the United States.[5] Perhaps less is at stake in sociology.

As a sociologist who has emphasized the importance of group cultures, I argue that programs have local patterns of critique: West Coast programs are said to be more laid back than East Coast programs;[6] schools near concentrations of galleries are more market-oriented; craft-oriented programs push theory less. By observing three schools, I have some basis for generalization, even if the programs are not representative (as described earlier, all three are small programs, located in the Chicago area).

Discipline and Critique

The heart—perhaps the broken heart—of MFA education is the critique. This pedagogic tool has its roots in the 1960s, but is now nearly universal in graduate art training.[7] The critique forces the students to place their work into a world, an academic world, not a market. Like a school of sharks, some have said, faculty and students circle a series of artworks and sometimes, sensing blood, rip them apart. But as noted, it is this conflict that establishes the value of this academic practice: These events are *critiques*. Accounts of crits focus on the drama, the emotion, and even the terror. As artist Roger White writes about a critique at the Rhode Island School of Design: "The reviews are operatic: they reach soaring heights and plummeting depths. Of emotion, with booming ensembles and sustained arias of enthusiasm or doubt, approval or invective."[8] Given the salience of critiques and the anxiety they evoke, manuals provide strategies of how novices can cope.[9] Evaluations range from "This work is really gallery-ready" to "This is a pathetic attempt at art" (Field Notes). Critics of crits, such as James Elkins, provide Grand Guignol examples, such as "If the teacher thought the work was particularly bad, he would just hand the student a book of matches, with one match bent forward."[10] At each school where I observed, faculty recognized that a critique can become a stylized performance: Kabuki condemnation.

Generalizing from extreme examples, perhaps not entirely fictional, is unfair. Such accounts, like horrific anecdotes of Little League parents, transform the rare into the routine. Most critiques, though occasionally faulting the student's work, are more sedate, a stew of praise, disapproval, and questions from those who care about the work and the student. Faculty have been initiated themselves, and most strive to be candid and balanced in their remarks. Despite the criticism, students' efforts are often admired. These students can be ecstatic—and surprised!

The critique is central to how faculty and students feel that art evaluation should be taught. It exemplifies that a community exists, an art world, and that collective engagement is crucial in establishing the right for academics to make judgments that might otherwise be left to gallerists, collectors, journalists, and curators. A recurrent metaphor is that crits are like boot camp; artists must prepare for condemnation and humiliation to survive a world of rejection. But boot camp also produces a "band of brothers." When students grumble, they are told that they must be tougher and develop "thick skin," because the critical world can be harsh. The irony is that at openings, shows, and other post-MFA venues, one is likely to be praised, patted on the shoulder, and often politely ignored.[11] The studio is secure, and the gallery is genteel; the critique is dangerous, but vital. Admired students are particularly at risk, as those with little promise may receive gentle chiding on the grounds that a lacerating appraisal is not worth the bother.

While some members of the art world contend that most comments at a critique are positive,[12] questioning, or descriptive, mundane remarks are rarely recalled. Dramatic anecdotes demonstrate that one has survived the scrum. The crit, privileging sharp elbows, feels like a masculine initiation rite or, perhaps, women's roller derby. Certainly, styles of interaction are always embedded in gender politics and then help build those politics. This is true even if the student cohort and the program's faculty (to a lesser extent) are relatively gender-balanced. One female faculty member at UIC insisted that she saw the critique as masculine, despite the leading female artists in her program. She explained that subsequent to my observation, the feminist approach had consciously become "sharper." Perhaps this changed the gender dynamics or simply allowed female faculty to use their elbows like their male colleagues. Does this affect the evaluation of female students? My data, limited to the students observed, are ambiguous on this point. Some female students, like Bridget and Janice, were widely respected, others less so, but the same was true of males. Although gender and race shape interaction and art schools are affected by societal attitudes to race and class, no formal structure or explicit hierarchy exists within critiques.[13] Still, senior faculty—often white men—are expected to direct discussion.

In analyzing the critique, I hope to avoid over-emphasizing its drama, seeing the crit as *both* routine and explosive. My discussion draws on the critique mosaic I described in the prologue and many others I observed. The critique is an integral part of the socialization of young artists in local institutions that claim the right to establish shared valuation of good work. We find a community of artists: a space, distant from the market,

in which dealers and collectors do not belong.[14] I begin by discussing the critique as a form of communal culture, then I address the emotional intensity of critiques, the critique as a performance space, how critiques might be bettered, and how intention is publicly displayed.

Crit Culture

I speak of a *crit culture*, recognizing elements that critiques have in common: an offering of food (coffee, fruit, pastries, and snacks),[15] communion provided by the supplicants who will be critiqued; an assigned timekeeper who starts the discussion and, with the help of an alarm, ends it; a collective milling about; an opening statement; questioning and evaluations; and concluding applause (a healing ritual found no matter how critical the session). Institutions also have local traditions, and these may change over time.

The famous (or infamous) twelve-hour critique class led by Michael Asher at CalArts has properly been described as "not a class but a culture": a culture that depends on the institutional arrangements, including those of teacher and student, sponsored by an art school. As described by Sarah Thornton,[16] students arrive at the critique room in the morning, prepared to spend the day discussing the work of a few colleagues. As students, they understand that their work is open for critique, an event that rarely happens after graduation when their work has become "mature" and is judged by those with other institutional concerns, such as dealers, critics, and collectors. Students revel in their roles as artists-to-be. On those days nothing matters more than the artwork and the art self. The event is not routine and replicable (a class), but distinct and unique (a culture).

Each school organizes critiques in its own fashion. At Northwestern, open critiques are held after the fall and winter quarter on a Thursday and Friday afternoon with a social gathering on Friday evening. Five students are reviewed each day for forty-five minutes each, which makes the schedule less arduous than programs with full-day schedules. Two guests from the Chicago art world are invited. At the end of the spring quarter, faculty as a group meet with each student for a private critique. Local culture includes the public announcement of cigarette breaks, part of a culture of institutional challenge.

University of Illinois at Chicago, a larger program, holds critiques four times a year: at the middle and the end of each semester. The mid-semester critiques, scheduled over three days in the morning and afternoon, last thirty minutes each and are attended by students, a critique

committee of four faculty members, and the student's adviser. The end-of-semester critiques, which all should attend, run for forty-five minutes and go on for five days with a different guest critic each day. Lunch is often integral to the critiques, as faculty and some students drift to a local restaurant. One day students provide lunch. On the evening marking the end of the final end-of-year critiques, the first-year students organize a joyous party in their expansive Great Space.

Illinois State holds a three-day critique in the fall and a two-day critique in the spring near the end of each semester. (This program also has critiques in mid-semester with the faculty in the group—painting, printmaking, and so on—with which the student is affiliated.) Students at Illinois State prepare an artist's statement that is distributed to faculty prior to the discussion; the statement generally becomes longer as the student progresses toward graduation. Each critique lasts forty minutes, and for second-year students who need to be evaluated for their progress, the faculty hold brief meetings immediately afterward.[17] Snacks are provided for everyone during the morning, but lunch at a nearby restaurant is for the faculty. Unlike at the other schools, chairs are provided for faculty and students in the two critique rooms. At UIC and Northwestern, participants stand, squat, or sit on the floor (at the University of Chicago portable stools are provided). Illinois State does not hold a departmental party after critiques.

In addition to these formal structures, each program has its own style[18] or *idioculture*.[19] The critiques at Illinois State, although not without intense evaluation, are gentler in tone ("This is not a criticism, but a question" [Field Notes]). Even though faculty differ in their orientation to global art worlds and emphasis on theory, in the critiques faculty are markedly deferential to each other. During my observation, when disagreements occurred, faculty joked about their differences or made a point of giving what one student termed the "crit nod," an exaggerated head waggle that indicated that one aligned oneself with the speaker, visually constructing consensus. One faculty member with personal connections to the other programs told me that he found the ISU critiques far less contentious than others.[20] At Northwestern faculty treated the critique as a forum to argue for their vision of proper art practice, a strategy that was engaging but caused some students to feel that they were pawns being used to make a point. Students felt that they had supporters (or detractors) on the faculty, as a function of their aesthetic position. However, there was enough deference that this did not affect students getting through the program. At UIC, there was harsh criticism, along with strong personalities, but these were less grounded in firm theoretical positions than they might

have been elsewhere. While student participation varies, some students actively participated in discussions at UIC and Northwestern with faculty encouragement. At Illinois State the line between expert and novice was more strongly drawn. Conceived broadly, Northwestern emphasizes the conceptual, UIC the political, and Illinois State the aesthetic. While the kinder and gentler critiques at Illinois State have appeal, the generosity suggests in part that less is at stake in a program distant from an urban art world. These are not students who, for the most part, will enter elite markets, and many lack the background to appreciate the conceptual debates elsewhere. Boot camp can feel more like summer camp.

Putting aside local styles, for better and for worse the art school critique is distinct from talks in galleries or museums. At those sites, little attention is given to each object. The critique may be the only time in an artist's career in which her work is closely examined. This critical focus is also not evident at the more polite thesis show, closer to a stylish gallery opening. Even though what the artist presents is visual (and occasionally aural), the critique is a talking event.[21] It is never merely the viewer and the work; rather, the viewer, the artist, and the work are shaped by the spatial configuration of discussion.

Although the critique is supposed to be about the art, sometimes it becomes a discussion of the artist. In a critique of a comic video that examined contemporary entertainment culture through a process of sampling, Wick, a respected student who often incorporates humor in his works, became the target. One faculty member commented, "The theme of the work is very smartass. You're smart, but I just don't like it . . . It's not the work of a serious artist" (Field Notes). I choose a mild example—most explicitly personal assessments are mild—but discourse about student intentions easily bleeds into claims that only particular kinds of students would have those intentions. Their work became identity art. Who but a sadist would create a sadistic work? Who but a voyeur would have a voyeuristic practice? Given that work is an expression of the artist—a personal expression—the critique is, as Howard Singerman suggests, always ad hominem.[22] The topic always includes both the artist and the object.

To give a detailed sense of what a critique sounds like, I use Esau McGhee's critique at the end of the fall quarter during his second year. This is a fairly typical critique in its tough questioning, but without strong emotional drama. By this time Esau has developed a respected practice. He displays five works that are collages of photographs with some painting of the collage. The works, predominantly in black and white, capture inner-city environments. Like much work produced at Northwestern, his constructions have a DIY quality as the pieces are stuck together, with

the tape evident on the front of the pieces. Esau explains that his goal is to find "surreal moments. . . . I try to elicit moments of excitement and judgment." His brief remarks set the direction for the critique. One faculty member, known for surreal images, challenges Esau, "Why do you suggest surreal moments? That surprises me." A painter reflects, "The top [which includes images of urban barbed wire] bears such a structural, formalist quality. They seem like formalist collage." In this context, to describe a work as formalist is potentially insulting, as it may excise political meaning. Esau recognizes this, responding cleverly, "I don't know if it is a slap in the face, a punch in the gut, or a handshake." The conversation continues, with another faculty member inquiring, "Did you intend to make collages that someone would define as formal? Is formal good?" A third faculty member, a sculptor, pushes further on the formal quality versus its embedded meaning: "Is the work moving away from the street? They are not of the street anymore. They are part of their own iconography. . . . The urban architecture is not just any urban architecture, but it is the urban architecture of your work." The painter adds, "Why is the work in black and white, or putting it another way, why is it not in color?" A fourth faculty member, a critic, comments, "It depletes it of the there-ness of the here-ness" [the there-ness being an urban place]. The first artist chimes in, "I think I might be going out on a limb a little bit. They are not enough for me. To what ends are the works, and that's what I want to ask about here. I think you are pulling your punches, and I want more." Finally, a fifth faculty member chides Esau by suggesting that "you haven't introduced the work in a way that it can be understood" (Field Notes). In forty-five minutes there is much more discourse, but the thrust of the comments attempts to provide a context for the work. When Esau responds, he links the formal features of the work with the urban references: "It's all about perceived urban space that is assumed to be useless, but is not." A set of themes develop that are extended and transformed in the discussion. Critiques are collaborative attempts to unearth meaning that hides behind ambiguous intention. Through the verbal interpretations, the participants provide Esau with insight. However, the discussion is not just individual responses, but a set of responses, taken together, that depend on a hook provided by the artist, the work itself, or an early speaker. Another early comment might lead a critique in different directions. At this critique the central element is the relationship of the formal structure of the collage and its politics with regard to scenes of urban devastation.

Faculty often feel that the best critiques are the ones in which the work is neither hopeless nor polished. As one sculptor explained, "It's a great work, and I only feel sorry in that these are the worst critiques

in that I really want something wrong, rather than patting you on the back" (Field Notes). The hope is that the critique provides constructive feedback that helps the student refine, rethink, or reorient her work with renewed resolve to return to the studio. Even a contentious critique may be successful if it provides paths forward, as opposed to merely stating what is disliked. The best critiques are those in which all are engaged and in which—the faculty hope—the student will "listen to what we're saying" (Interview). A senior painter suggests, "I think it is a great critique when the conversation allows the student, the individual maker, to come to their own recognition of something they could never have gotten to on their own. To me it's not about whether any one of us is the correct voice. It's frequently the case that things are slow to rise to consciousness of what is the crux of what I think of as the question" (Interview). This instructor raises the challenges of the critique: multiple voices, emotion work, floating interpretations, and gut reactions.

Students find a discordant chorus of voices and must decide which to hear. The solution may be subtraction. Dane, the young abstract painter, explains that critiques "get me to get rid of things that were unnecessary. [If] people want to talk about some one thing and you don't . . . take it out . . . If I did something in a painting and it caused a certain conversation that I didn't like, then I would change the painting so that it would hopefully stir a different conversation" (Interview). This process was revealed humorously in a critique of a ceramics student. This student presented a headless woman with a separate head placed nearby. One faculty member suggested that this piece reflected violence to women. In response, the student pocketed the head, an act met by much laughter and applause (Field Notes),[23] revealing in its immediacy a common desire to defuse criticism. The student recognized a well-understood wish to make everything right.

Break a Leg

The critique is theater:[24] a performative display. Treating the gathering as talk is a true representation, but insufficient. It has plot, character, and scene. Crits may themselves be considered performance art, and some MFAs use the occasion as the setting for drama.[25] While students are not forced to participate, each faculty member and visitor is expected to have a say but not dominate. At one critique, the visitor was notably silent, and this absence was noted. The following day the director of graduate studies announced that the guest would supply written comments. This guest violated the rules: Every player has lines.

For students, vigorous differences of opinion may seem like faculty members settling scores. In the words of Louis, a conceptual artist with a patina of cynicism, critiques reveal personal fault lines: "That's where shit becomes malicious." He asserted that students judge the words based on who said them and why (Field Notes). Hanna Owens points out, "It's often faculty members arguing with each other. . . . It's kind of cut-throat" (Interview). Esau McGhee, from a different program, responds similarly: "It's like they are playing a Game of Thrones. . . . Sometimes a critique can become such a waste of time, and the language becomes so lofty" (Interview). Professors with strong opinions may overwhelm critiques. As a recent graduate explained, one should be fair, shun counter-factuals, and avoid rhetorical questions.[26]

The most memorable instance of a battle for dominance, one that students discussed afterward, was a loud and testy exchange between two faculty members. The pair disagreed over an esoteric question of whether the work was sculpture or performance. When one interrupted the other, tempers flared. Interruptions are common, but on this occasion, it was treated as an offense. The absence of deference was notable, but even more notable was that public repair was necessary. Students claimed that "they nearly came to blows" (doubtful), and the interrupter spent the rest of the day apologizing ("I don't mean to interrupt . . .", "I'll say this and then I'll shut up"). He made a point of telling me, "Wasn't that a good critique? We're great friends." Another faculty member said to me, "I wanted to let you know, in sixty graduate critiques this has never happened before. It happens at other places" (Field Notes). I did not notice any long-standing animosity, but the event was treated as something that needed to be quarantined or it might be generalized as *typical* critique drama.

If the critique is improvisational drama, who is the director? Each program assigns a faculty member, often the director of graduate studies or the head of the critique committee, to be a timekeeper, but not a mediator. However, the belief exists among the faculty that, given the different perspectives of professors, the student should direct the critique by an opening statement, responses to feedback, and questions to those assembled. One instructor advised students to use theory to their advantage, "There is a notion of Foucault to reverse the position of power." He suggested that students could gain power by explicitly describing their vulnerability, rather than taking hostile criticism as a transparent assessment (Field Notes). While students claim to desire to tape their critique in order to review the comments, the recording limits hostility and, like police body cameras, may be used by subalterns to control authorities. This may explain the ire of University of Chicago faculty when they

learned that a student had taped his critique without permission. The critique is an archetypal Foucauldian space with dominance, discipline, surveillance, penalties, and opportunities for subversion: an opening for high theory jujitsu.

Hearts Apart

For all the talk about critiques as intellectual spaces, awash with talk, it is hard to miss their emotional punch, and in this regard gender expression plays a role in self-display. In addition to Michelle's experience, described in the prologue, I heard many accounts of female students tearing up or weeping in their studios.[27] Men rarely do the same, at least publicly, although one male student shared that he felt like crying, and one faculty member claimed to have seen male students cry, but these stories are less frequent (and perhaps less plausible) than those of women crying, which fits cultural narratives. In addition, for men and some women, fury, controlled in the critique space, burns later. Whether rage is directed inward or outward, the disparaged student must process the comments. For many, intellectual consideration of the advice comes later. The critique can be a "painful ritual . . . [presenting] a flurry of half-baked opinions that leaves [students] torn apart."[28] Howard Singerman memorably refers to "the everyday cruelty of the crit."[29] One faculty member likens critiques to the "Stockholm syndrome"—the recognition that by the end of the session, the young artist may affiliate with her tormentors (Field Notes). Perhaps intensity is a better metaphor, but, for some, cruelty feels right. Students do not sleep easily prior to their critique. Louis shared that before critiques he only gets three hours of sleep. But if the critique as an institution can be cruel, it can also be wise. Students do learn. Student work and defenses at final critiques are typically more confident and compelling than those before. Michelle is an example, given the drama of her critique. Later in the year she began to photograph and display images of graveyard crosses, a change in strategy that allowed her concerns to be expressed without a facile reading. Likewise, Bridget, who in an early critique shared an obscure written drama, later moved to more admired installations with her words integrated with the display of objects.

When I asked students what surprised them most about graduate school, many referred to the combativeness of the critique. Students are not socialized to this interactional style, as undergraduate critiques often emphasize the objects, not the maker. As Ted, a sound artist, explained, "I think probably the most surprising thing when I came here was the intensity of the crit because I had never envisioned being in a room with

twenty faculty members and all of my peers and thrust into a situation in which I had to answer for my work. So in my first critique I became a bit defensive, because I didn't know how to handle myself in a critique formally. I didn't know I wasn't just supposed to defend the work. I was supposed to really listen. What I ended up doing was getting my back up a little bit, and that actually affected how I was received from that point on" (Interview). Ted is convinced that because he was not socialized to the intensity of the critique, his reputation was set. He was seen as un-teachable, as someone who would not own up to his work. How can a student avoid the traps of muteness and belligerence, showing that they can respond, even without time to process what is said, and in a situation in which returning fire is judged a failure?

Whether because of student growth or audience politeness, second-year critiques, particularly final critiques, seem more generous.[30] That is the last chance to bid farewell and demonstrate that advice was con-structive and that the program had value. This contrasts with earlier critiques, in which improvement is possible. One faculty member sug-gested that "we try to push our students who are in their third semester. I'm glad I'm not on the receiving end" (Field Notes).

Students must be prepared for these shocks, as programs do not al-ways clarify the boundaries of critiques and how to respond. When a first-year student's work is called "lame" by a senior faculty member, the student might be shaken, confused, or depressed. But an entering stu-dent can improve. Respect is not inevitable, but if students incorporate feedback, a rough critique need not lead to a sullied reputation. Faculty often discuss students who have changed their practices for the better (or at least who follow their advice).

Using feedback to improve is a challenge, particularly when the self is on the line. Although faculty describe critiques as constructive, with mul-tiple voices confusion may reign. A damning critique, of which there were several, provokes no understanding and no change. In addition, some positive critiques were seen (by faculty, at least) as unsuccessful. No understanding, no change.

Esau McGhee explained that he was challenged in deciphering feed-back. "It's the most frustrating thing ever. Every doggone crit I have had here. The first one I felt confident about stating what the work was about. After that my confidence dwindled more and more and more because it was always what you are saying is wrong, and I am waiting for someone to tell me when I am saying something right or how do I say it right. It's like this building tidal wave of you're not worthy" (Interview). Less critical, Marissa Webb had a similar perspective: "I became friends

with a first-year this year and helped her through a lot of her struggles. She was beating herself up going into her first grad review, and I said, 'It is what it is. You're not going to have all your answers,' I said. Your professors might tell you, you need an answer for this. It's your first big review, you will be fine. They are going to say things. They are going to challenge you. You can be upset, but know they are just trying to help you in the end. They are trying to push you to the next level' . . . She has her moments every so often where she is freaking out. I was, 'look, just ground yourself'" (Interview). Marissa confessed that after one critique, she was upset for a week. Despite the sensitivity to gender, toughness is venerated. Only a masculine culture would routinely be caustic to these vulnerable young adults who are looking for role models.

A New Critique?

Over two years, Jeffrey, a performance artist, became a treasured informant. At one point we started talking about how students conceive critiques. By that time it was clear that many students were deeply troubled by the tone of these occasions, fundamental to their education and critical to their reputation. We met at a gallery party for one of his professors, and, as we sipped wine, Jeffrey described his theory of evaluation. He explained that central to the critique is the faculty role that he labeled "The Asshole."[31] If nothing else, antics of The Asshole are a font of stories, suggesting trauma in common. For Jeffrey, The Asshole is a critic who judges without humor or without appreciation and understanding, and whose comments are not modulated by affection or respect. For Jeffrey, art should be a source of joy and selfhood, but "The Asshole gets rid of the romance" (Field Notes).

During my research, and as I describe in the prologue, some students believed that they had an "Asshole" in their midst. Some faculty agreed. Other students felt that this faculty member, Paul, a widely admired artist, was their salvation. They explained that they would not have survived without his guidance, support, friendship, and wisdom. They appreciated the parties where he invited students to meet prominent visiting artists. Their affection was genuine.

Paul had opinions: ornery and expressed with verve and vitriol. He never seemed so alive as in critique, wielding judgments like a rapier. He could be relentless. Unlike those of Jeffrey's Asshole, Paul's assessments could be sweet and enthusiastic. However, when they were negative, they could be eviscerating, whether focused on altering the work

or the student. Michelle's experience, as I described in the prologue, was dramatic because it was so personal, but she was not alone. Another student told me that Paul told her in her first critique, "If this is the type of work you're making, then I don't think you belong here." When she discussed this with other students, she said, "They brushed it off. . . . You got Pauled. It was almost like an initiation." Her adviser was sympathetic, but no one intervened. Tough love or tough luck. This student felt abused.[32] When she later confronted Paul, he could not recall the incident and complimented her recent work, but the sting never left (Interview). Realizing that they were dealing with a tenured faculty member, students discussed the appropriate response. One student, Evan, a conceptual artist, baited Paul in a memorable confrontation. Evan displayed a set of slogans made of vinyl letters that he paid a fabricator to produce, provoking the following dialogue:

Paul: What do you get from that?

Evan: I was interested in this idea of shared authorship. No offense.

Paul (sarcastically): No offense to you. I withdraw the question.

Evan: The individual lone artist is not something I believe in.

Paul: Does anyone? . . . I want to get into what you intend in your practice.

Evan: You could think of this as a potential work in a Thomas Hirschhorn way . . .
I knew you were going to hate the work.

Paul: I do. Congratulations.

Evan: Another time we can discuss why you don't like it. I wish I had a more cutting
answer for you.

Paul: It's a question of honesty. I think that you just discussed the artist as a straw man.
There is nobody who thinks of an artist like that anymore. (Field Notes)

While some students enjoyed the debate, it is unclear if Evan got the best of it, and if his response was productive. Students debate whether to hold their ground. As one student explained, Paul was harsh, but some faculty were too mild, making his criticism seem worse by comparison.

One faculty member, admitting that some comments are inappropriate, asserted that Paul never acts with malice, that students are thrilled when he is positive, and that "some students say later how grateful that they are that something is at stake" (Field Notes). I was also told that he was the designated clown or Shakespearean fool. Paul's role in the culture is such that when he had to leave a critique early for another engagement, a faculty member joked, "Someone has to play Paul," a remark that received a huge laugh and suggestions for who might fill the role.

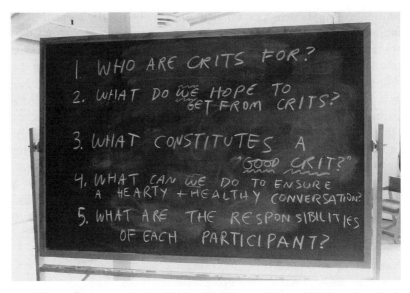

1. WHO ARE CRITS FOR?
2. WHAT DO WE HOPE TO GET FROM CRITS?
3. WHAT CONSTITUTES A "GOOD CRIT?"
4. WHAT CAN WE DO TO ENSURE A HEARTY + HEALTHY CONVERSATION?
5. WHAT ARE THE RESPONSIBILITIES OF EACH PARTICIPANT?

29 What constitutes a good critique? University of Illinois at Chicago, 2013 (photo by author).

Still, weeping focuses the academic mind. Michelle's tears raised a communal problem. As a result, the program, at the request of MFA candidates, held a meeting in which the community reflected on the role of critiques. The critique was defined as "such a fundamental component of the MFA program that it can be hard to wrap one's head around it." Its institutional centrality is such that the announcement of the meeting made the point that "the MFAs are not proposing any radical shift in how the critiques are conducted nor want to open up a complaint session, rather they want all to be mindful of having (and giving, and being inside of) the best crits we can."[33] In other words, the assumption was that the critiques would remain much the same. And they did. The problem was defined as how the department could set norms that would prevent the critique from "crossing the line," while not questioning the approved disciplinary format. The crit is not merely something that students must suffer, but something that makes them artists in the disciplinary imaginary, much like fieldwork in anthropology. As Wick admitted to the group, "The critique is a fundamental aspect of our pedagogy. I love critiques and I expect that most of you do. Think of it as personal, but not personalized" (Field Notes).

The meeting was convened to explore a set of questions, but these were so general that they were unlikely to lead to specific changes: Who are crits for? What are we hoping to get from crits? What constitutes a good

crit? What can we do to ensure a hearty and healthy conversation? What are the responsibilities of each participant? Eventually two meetings were held. The first, official meeting was dominated by faculty, including Paul, who insisted that the critiques were crucial to graduate education and had been successfully practiced for a quarter-century. Students felt that they needed to engage with each other, and held a second, all-student discussion on a Saturday. This, while filled with complaint, also accepted the basic critique structure. Suggestions focused on creation of a culture of respect, the responsibility for intervention when necessary, and the ability of concerned students to select a "faculty buddy" and/or "student buddy." Participants were sensitized to the danger of hostile critiques, while allowing critiques to continue without question. The three subsequent critique sessions I attended were, perhaps, slightly less contentious, but their form remained unchanged. They were a kinder and gentler boot camp, but a boot camp all the same. For the critique structure to change, a consensus must emerge that such tense and competitive evaluations are misguided. That disciplinary consensus does not exist.

Kind Intentions

What makes critiques possible as a form of pedagogy is the belief that intentions are at the core of artwork, and that these intentions must be explored and challenged. This is central to the critique, and it is what makes the critique distinct from other forms of artistic evaluation.

Entering a museum or gallery, the visitor faces a mute object. Perhaps there is a wall text, but rarely is the artist present to respond and to defend. For some critics, a work of art in a silent room is all they need. As Dave Hickey remarked, "I don't care about an artist's intentions, I care if the work looks like it might have some consequences."[34] Theorist Boris Groys says similarly, about the artist's authority in determining the selection and representation of works, that these are "personal sovereign decisions that are not in need of any further explanations or justification."[35] It is not only prominent artists who refuse the invitation to explain, but also some students. Dominick, a committed painter who produced off-centered florals in a quasi-realistic style, was asked: "I don't think this is about plants. What are the plants a vehicle [of] for you?" The artist, half-joking, replied, "I don't have to tell you" (Field Notes). In this humorous assertion, he threatened something basic, the linkage of intention and form.

As I discussed in chapter 3, the artist must speak, but in a way that

demonstrates artistic intent: The desire to receive a grade, meet an assignment, or, worse, make a sale doesn't count, even if accurate. Intentions must support the self-presentation of the artist as a truth-teller within a professional world. The artist must share her identity with others in a self-enhancing way. The art world as a theoretical discipline, and moral enterprise excludes claims of self-interest. Intentions are to be framed as forms of commitment.

Often explanations are encouraged with a simple question: "What is the title?" When students do not spontaneously give a title, they will be asked. The title is a gateway to intent, and artists must decide how to approach this reveal: Do they wish to give away the game? Is the title to be denied ("Untitled"), descriptive ("Reflections of Clouds in the Water-Lily Pond"), or esoteric (Damien Hirst's stuffed shark is named "The Physical Impossibility of Death in the Mind of Someone Living")?[36] That titles are seen as weighty is evident in the comment of a teacher addressing a student painter ("Skeleton of Trust," "Loose Translation"): "I don't really care about titles, but it clarifies what you're working through as an abstract artist" (Field Notes). Another professor tells a photographer, "Maybe a title would help people who start from scratch" (Field Notes). Jordan Anderson emphasizes the fetishizing of titles (and untitles) in his MFA thesis at UIC, noting cogently, "When you title a work 'Untitled,' what you mean most of the time is that this work has no title, so why not just resort to 'no title.' . . . Calling a work untitled sounds as if it had a title and you took it away, that the work is now an orphan. . . . Are you hiding something? Do you not want to give away your 'Big Secret'?" In response he provides a list of sixty titles that he might give his work: Oranges + Sardines, Old Man Denouncing a Staircase, The Distance between Them and Them, Chicago Still Life, and Untitled (Record).[37] Titles are institutionally demanded, and so with regard to the title of a thesis show, *Archipelago*, one student explained, "No one liked it. . . . It really was an institutional thing. The [gallery] needed it" (Field Notes). These students denied a shared intention and selected a title that indicated that the show did not cohere and that they were islands lacking bridges, critiquing a museum system where exhibition titles indicate unity.

The standing belief is that intentions should be meaningful, that they should persuade an audience that the intention is expressed in the work, and that everything in the work is intended by the artist. A discourse of intentionality downplays intuition, a point of objection by those artists who suggest that they only know what they intended after the work is completed. A skeptical professor commented, "What the meaning is is a construction that comes after the fact. And the conversation tends to

be about your intention not being fulfilled, or it is or it isn't. Usually it isn't" (Interview). This suggests that these are only retrospective claims designed to pacify a panting audience.[38] Whether works arise from intentions or intentions arise from works, their presence exposes a scholarly yearning for a linking of self and object. As sociologist Nathalie Heinich writes, viewers assume a bond between the work and the interiority of the artist.[39] This is reflected in a critique by a visiting artist, who remarked, "Anything an artist puts out in front of us, you [the artist] should own it" (Field Notes). Students are sometimes challenged, as one was in his critique: "What do you want for us to get from this? What are your goals? What is the reveal? What do you want for us to see?" (Field Notes).

The discussion of intentions suggests the centrality of vision[40] (perhaps a theory or even a hypothesis) that the work itself exposes. This exemplifies *reflection-in-action*.[41] However, the adept artist will coordinate her intentions with the audience response. Further, the artist must allow the audience to collaborate in the process. As one student noted, "intention and didaction are different things" (Field Notes). When the point is too obvious, the painting becomes a lecture.

When attendees provide a student with alternative explanations, she can assess whether her intentions were clear or decide if the miscommunication is productive. Consider a young gay artist's thesis show: Bruce embroiders. He displayed a photograph from his senior prom, a standard prom photo with him standing next to an overweight young woman. Much of her body was obscured by his stitches, leading the audience to assume that the work erased her in order to refer to his coming out. This, Bruce claimed, was not his intention. He was already secure in his sexuality and the date was a close friend whose boyfriend had been taken ill. Bruce claimed that the image beautified his life as a gay man, but not at the expense of his friend. That the work was the center of discussion suggests that intention and interpretation need not synchronize. The audience was drawn to the work, perhaps more than to anything else in the room, but its meaning was up for grabs.

Learning Intention

If the presentation of intention can be taught, how is it done? Through the MFA program, students must come to show themselves as "real artists," speaking their lines in a convincing fashion, persuasive in posturing and in sincerity. As with talk generally, as discussed in chapter 3, some students are glib and others stammer. However, it is not just the words, but connecting words to artistic goals. When an intuitive artist

is also an inarticulate one, the presentation of intentionality becomes a profound challenge. Some students talk fluently about their intentions, whether they believe fully or desire to sway an audience. Often the motives are mixed.

Consider two students. The first describes a performance with audio feedback; the second refers to an installation pairing two photographs: the young artist's photo of a drag queen, and Man Ray's image of Marcel Duchamp. Says the first, "I feel that a lot of my work is tightly controlled, so I wanted a performance that is out of my control. I wanted something that is out of my comfort zone. I was playing with taking back a certain amount of control. I was really fascinated by how you take sentences and create meaning." The second: "There is this thing of pairing work by a young emerging artist with historical heavy hitters, and this is something I am very interested in. I am thinking that ready-made and drag are really interconnected. It undermines the claim that I'm really like Man Ray because it's all drag" (Field Notes). These two artists—Carlos and Martin—describe what they intend and how they construct their practices, but not all students have such clarity. These men are secure in their performances. Even if they don't boast, they argue that their choices are well considered. Some students either do not wish to examine their motivation, or they produce work that lacks a conscious justification. The faculty must guide them to verbal praxis through modeling and encouragement, suitable for a community of colleagues. As one professor explained, "What I try to help the [student] to articulate is what is the subject of the work? What is the territory? . . . What have you made that is interesting to you?" (Interview).

Consider Lena, a vibrant young sculptor and musician, graduated from a well-recognized art school, but not given to self-reflection. In her critique at the end of her first year, she presents several sculptural objects made of found wood and tarpaper, telling the faculty, "This really feels dark and empty. I'm really interested in hearing people's really honest feedback because I don't think there's anything here." This unexpected, if depressive, candor sparks a discussion in which the faculty attempt to lead Lena to explain her motivation. This is to be a teaching moment. One faculty member inquires, "What were the really deliberate decisions you made about this form?" Lena struggles to respond: "I knew it would be sort of impoverished. I didn't have a clear intention. These aren't what I intended them to be. I didn't have time." Here, at the end of the year, Lena claims a lack of time for what appeared to be casually constructed objects, a candid reflection that did not impress her mentors. Another

30 Slacker minimalism: sculpture, University of Illinois at Chicago, 2013 (photo by author).

31 Slacker minimalism: sculpture, University of Illinois at Chicago, 2013 (photo by author).

student might have made the case that her choices were deliberate and constituted an institutional critique or political provocation aimed at sculptures in bronze or marble, but not Lena. The objects squat, mute. In their questions, the faculty point to paths that she might take to appear to be a confident, knowing artist, whatever her internal doubts. As one exhorts, "I wish you would just take ownership of the work here. I'm much more interested in talk about the work, and not the backstory of doubt. There's really an opening for a narrative. Let's figure out the narrative. The decision of tarpaper. It makes me go to a tarpaper shack. It's a placement like Robert Morris, really a gesture of casual presentation. There's a place that the work is generating that you should take ownership of." Other faculty add: "There is a unity in your work that should communicate something." "I think the work is so much better than the way you are talking about it. You need a ghostwriter or an actor." "What are the things that you would dream us to feel when we see it? Are you interested in having them be a conduit for me having the same reaction as you? What do you want, whether it's happening or not?" "You are already taking it boldly through the world. We could end up taking up so many meanings that are irrelevant to your work. I would like some measure of cue." "Artists tell people what to think all the time, and we do. Otherwise it's all about taste" (Field Notes). Lena struggles to meet her audience's expectations, never providing an answer, admitting, "I don't know if I can answer that. It's hard to speak of my own subjectivity . . . I know you want to know what I want."

I present this not for purposes of dissection, but to show how faculty work jointly to shape ways of being. They desire a professional who can securely proclaim her intentions. Lena is a maker, but not yet an artist. While dramatic, her pathos is not unique. The artist's voice allows her audience to see the project as having impact in the world outside the studio; the artist is the work's defender in the rough scrum that is the critique.

These demands appear regularly. As a UIC faculty member advises a diffident young photographer, "If we are all projecting our perspectives on the form, that is an abdication on your part" (Field Notes). To a student at Illinois State, faculty comment that although as a ceramicist her technique has improved, she shows an absence of intellectual framework: "She needs to find a language" (Field Notes). A printmaker is told, "I think that we're all sitting here thinking, why are we sitting here looking at this?" (Field Notes). Questions like "What does the image do?" "What is at stake?" "What is the payoff?" and, most directly, "What is your intention?" are common. Passive work can be made compelling by the right narrative.

Students benefit if they can talk a good line as well as draw one. As noted in chapter 3, faculty take inarticulateness into account, recognizing the merits of poorly defended work. In such cases, faculty provide interpretations, hoping that students will learn how to talk. Still, in the context of the active critique, where the performance of self matters, the eloquent student is advantaged. Over time, many students develop confidence, learning the lingo and the rules of debate, but inevitably the world is divided between talkers and those who believe the work speaks for itself.

Knowing Good, Breaking Bad

Every social system develops criteria of excellence. What constitutes good work?[42] One dealer looks for work that is "honest, creative, original, skillfully executed and intensively visual."[43] That is comforting, but how can one distinguish honest, original, skillful, and visual work from work that lacks these qualities? Is great art like pornography, known when seen? And whose knowing matters? That artworks lack measurable outcomes, in contrast to medicine, clouds how they are evaluated. Evidence-based art is hard to imagine. To be sure, judgments are *always* difficult, and often are political, but in art consensual standards are vague. Who would have imagined that paint drips, monochrome canvases, a mound of candy, a romantic encounter, or Thai cooking would be museum-worthy? As Howard Becker emphasized, art worlds, like all communities, depend on conventions that set the criteria for competence, even when such evaluations are contested.[44] These conventions are enforced by curators, gallerists, critics, collectors, and professors. Work must do more than repeat the past (my desire to paint like Monet) or reject all current standards.[45] Students integrate their imagination and that of the field through controlled novelty.[46] They must please themselves and satisfy their instructors.[47]

Philosopher George Dickie[48] once suggested that art is the stuff that one finds on museum walls, a view that enshrines curators as the gatekeepers of aesthetics. But today art may be what justifies a degree. It is the faculty who hope to be the gatekeepers, gaining disciplinary authority, even if the criteria are uncertain. One student, referring to the four-person evaluation committee at UIC, admitted that she had no idea by what criteria she was being judged. She assumed that she would not flunk and, as a result, did not look at her grades. She was correct; students rarely fail, perhaps because of the uncertain and diverse standards

of evaluation. While some students struggled with their theses, being forced to revise, I know of no student among those I met who was forced to leave the program.[49] A student suggested that this system of evaluation "can really breed a strong sense of insecurity, because everything is so questioned." He wondered whether, if he went unchallenged, "they are just brushing you off," because the work is mundane (Interview). However, this ambiguity also means that it is difficult to determine incompetence, protecting students whose work does not appeal.

Still, a reputational hierarchy was evident and shared. This status ladder combined evaluation of motivation, judgment of the work, and the student's ability to explain intention.[50] Some students are judged at the bottom of the hierarchy, but these students are passed through, perhaps with less attention given to their work, out of a feeling that the art market will weed out the less interesting, aided by the likelihood that these students will have weaker or less supportive networks. While I do not follow these students after graduation, I know that some students find their postgraduate artistic life difficult, leaving them no option but to find other occupations. In contrast, stories are told about one modestly regarded student who quickly received elite gallery representation. His story was told to indicate the unpredictability of a market dominated by outsiders.

As sociologist Erik Nylander argues for jazz education, a gap exists between what is said and what is done: between verbal claims and artistic outcomes.[51] It is not only that evaluations differ, but so does the process of evaluation.[52] Faculty spoke of a dichotomy between works that were quick and those that were slow. Some works are quickly appreciated, their qualities are on the surface; others reveal themselves slowly. As Dominick, a representational painter, reflected on his own work: "I would like my paintings to be richer and deeper. It's like an addiction to be making quick painting" (Field Notes). It's not that Dominick makes paintings rapidly—he doesn't—it is just that he worries that his goals are easily recognized. Most florals, for instance, are readily appreciated. Other works must be gradually unpacked, difficult for evaluation at a critique. Slow works are not necessarily *better* than fast works, but they are evaluated differently. For instance, a young photographer who captured images of small-town residents was creating quick work, as viewers rapidly imagined the character of those photographed, but an image of a flag reflected in the window of a house was judged to be a slower work, more grounded in a discourse of community.

What—and who—establishes the criteria of worth? How do we judge what is in front of us?[53] Who draws circles of evaluation?[54] These circles

often overlap, but sometimes are distinct, potentially leading to widely different appraisals of particular objects. Judgments are subjective by necessity, but for a discipline to stabilize, they must be treated as fixed: based on communal preferences.[55] As painter Laurie Fendrich points out, "The notorious Q-word (for those of you born since 1990, I mean *quality*) has been banned from official art discourse since about 1975. Even so, it hovers backstage during every critique. Good students and reasonable teachers still know the good stuff when they see it, although they'll only say so with a faux-blue-collar spin: 'Hey, that works.'"[56] A second metaphor is quite different. This is the claim, noted above, that the work "excites me." What is at issue is emotion. This does not require happy or soothing sentiments, as powerful and influential works can be vicious, cringe-worthy, or embarrassing, all terms that were shared as compliments. Each type of work makes the viewer feel alive, perhaps thrilled. As Dane, the abstract painter, explained: "If the painting is sup-posed to look crappy, that's fine. It's actually quite hard to make a suc-cessful, loose, ugly painting" (Interview). Students receive few kudos for lovely work that lacks a "deeper" text. Commercial appeal is deadly.[57] Crappy may be a better career move.

Evaluations are situated within fields. The MFA program is a site of power, separate from the power of the market, but not from the power of the faculty. The critique is the forum in which debates about "good art" get played out, and this debate is essential. Assessments may be in the mind, they may pay heed to local epistemic cultures, they may re-spond to institutional demands, but they are presented in the round: a space where communities battle over meanings.

The Reason of Pure Critique

Whatever art may be in the marketplace—in sleek galleries and klieg-lighted shows—graduate school stands apart from this market, glorying in its bifurcated field. The academy requires the assessment of intention. This evaluation is not personally selected, but an institutional demand. It serves organizational needs by creating a form of evaluation that mod-els how art should be validated and by creating a community in which artists defend their sense of self and their sense of art.

Few fail graduate school—in any discipline—but hierarchies matter. Stories are told, often with glee, of students who are roughed up only to be snapped up by elite galleries. The absence of consensual valuations,

notably the decline of beauty as the gauge of worth, poses a fundamental problem for organizing the discipline and contesting school-based evaluations.

Perhaps the critique is not the ideal setting for education, but it is what art schools esteem: a confused, contentious, and cordial scrum that confronts a student's offerings, looking for love and smelling blood. The university demands evaluation, and the critique provides it with zeal. Despite what philistines say, art really matters. It matters enough to fight about.

Is the critique the best means to produce talented young artists? Artists are shaped in many ways in and out of school. Perhaps young artists should forget the MFA and move to Brooklyn. Some argue this would be an improvement, but that ignores the demand for credentials and the mark of legitimacy, the time and space that a graduate program provides, and the presence of a caring community. The critique is the central pedagogical event, a means of turning students into artists, with spiky edges and thorny words. Establishing standards of competence, discursive styles, intense community, and emotional toughness, the critique demonstrates that art really, truly is vital and deserves the battle.

Community as Praxis

If we are going to build a sociology of the contemporary art world, it can't be centered on objects, but on people and their social rituals around these objects. . . . If the art object has been slowly dematerializing, what takes its place is the social context around it. PABLO HELGUERA[1]

Careers depend on identities; occupational subcultures shape the self. As Howard Singerman emphasizes, the goal of art school is to create artists,[2] the objects that are created are secondary. Artists in their performance of self must embody the role,[3] acting in a way that persuades others that they are committed to the trade. But surface acting is not sufficient; real artists must feel their role and must believe that they are part of a community. This identity work is crucial for aspiring doctors and lawyers as well, but at least these trainees are provided with a core of occupational knowledge, a set of recognizable skills, and an expected career path. As individuals, artists develop the ability to produce, but as a domain of work, contemporary art is known for its malleability, rejection of convention, and diversity of practices.

Just as restaurant cooks can be variously considered artists, professionals, business executives, or manual laborers,[4] so can artists be viewed as artisans, designers, entrepreneurs, social critics, or healers.[5] As Singerman learned,[6] and, as was even more dramatically true fifteen years later, it is unclear whether painters, sculptors, photographers, or videographers are distinct categories. Are they all *artists*? Perhaps because of their toolkit and their traditions, photographers

and painters are most willing to claim specialized titles. Sculptors, who have put down their chisel, polish, and molds, are more likely to call themselves artists or object-makers. These material resources provide identities grounded in genre. However, not everyone needs a genre label. Wick explained that he does not define himself as a filmmaker, although his films are admired; the label might suggest he belongs in film school. He considers himself an artist. "I feel like 'artist' is a broad enough term and describes an approach to doing things, so that I am not limited by material. So [I am] just an artist who does a variety of different things" (Interview).

With the erosion of a recognizable craft tradition, it is unclear what contemporary artists *do*. As one CalArts instructor explained to sociologist Judith Adler, "It's one thing to whisper behind one's hand that someone isn't a real artist . . . but to be so sure of the definition of a real one that one could actually point a finger and state the case in a very loud voice?! . . . If someone claims to be a tap dancer you can at least ask him to dance. But if he claims to be an artist, who knows what to ask him to do!!"[7] In *Your Everyday Art World*, Lane Relyea, examining our trendy DIY culture, claims that many young makers and performers do not even claim the title of artist, preferring to say, "I do stuff."[8] I did not find this casual selfhood among these students. As with Wick's comment, "artist" was the identity du jour. It was the basis of building a community that transcended genre, while embracing an honored label.

Color Theory

We find artists, but wonder if—and when—a subcultural adjective is required to separate and emphasize the artist's selfhood. We don't think about Methodist ceramicists or Republican photographers, but what about black painters or female sculptors? At one time those latter labels were common.[9]

Art schools are still largely white spaces. Of course, the programs I observed are small, and their demography depends on who applies, who is admitted, and who accepts. During one year at Northwestern, two of ten students (20 percent) were African American. For bean-counters, African Americans were overrepresented in those cohorts. Then both graduated. The following year two Latina students enrolled, and one from Iran. In general, minorities are underrepresented in art schools, both as students and on the faculty.

One faculty member at Northwestern explained that, given the small

numbers, the only thing the department wants to make sure of is "that it's not all guys" (of the fifteen students during my research, six were female). He added that in each cohort "it would be nice if we had a minority [student]" (Field Notes).

Numbers alone do not tell the story. Attitudes matter. Several students expressed the need for greater inclusion. Esau McGhee claimed that as an African American he felt welcome in the department, but he considered himself an outsider at the university. "I am a nice jovial person, and I will speak to people, 'Hey, how are you' or 'good morning,' and people will look at you and say nothing. Like you don't even exist. . . . They will not say a word to you, so you start to feel invisible" (Interview). He speculates that as a middle-aged, casually dressed, large black male the issue is not only black and white, but one of privilege. He feels that he doesn't quite belong, even as judged by younger African American students. How does race affect the interpretation of the practice of a student of color? In a critique of a black student's work, a professor notes, "The work links you to African American culture and thus a very different discourse [from the immersive photographs of Chicagoan Jason Lazarus]. What if a different body did the work, would we see any differences in the work. If it was Jason Lazarus, would we suddenly hate it? Would we hate it because it was an adolescent white guy?" The discussion continues on this theme with Sidney, a black student, concluding, "It's performing for an audience [of whites] and then you're living with it. It's like a minstrel show performer who comes home with you" (Field Notes). Are Sidney's objects, black foam in phallic and excremental shapes, about blackness or about repulsion? Is this an object that carries the same meaning no matter the maker, or is it contextualized by the artist's identity? Artists must decide this in their statements of intention. Consider the dilemma of one young African American sculptor. As a faculty member explained in her critique, "You said [in your statement] that you were trying to get us to feel what it's like to be a black woman." Responding to the artist's claim that "I want these works to speak to the younger black kids," another faculty member suggested: "Your work may not be political at all, but the fact of your identity [as an African American artist] may be" (Field Notes). These are the challenges that artists of color face: how much of their work is racial? Can they ever escape a racial identity and embrace a nonhyphenated artistic self? Critics have this problem as well. Must they use a racial adjective to describe this work? What does it take for an African American artist to be an artist?

Girly Art in a Bro World

Gender politics raises related issues, even if the demography is different. In these programs, the gender balance is relatively equal: more women at Illinois State, a few more men at Northwestern. But does it mean anything to be a female artist in a world in which women are underrepresented and find their works valued less?

Despite significant numbers of female students and faculty, some women find continued discrimination. The Guerrilla Girls are a cohort of anonymous feminist artists dedicated to fighting art world sexism. In their words: "The majority of art students have been female for decades. Get ready to work harder and for fewer rewards than the guys next to you."[10] Some female students argue that female faculty members adopt the persona of a "straight white male" and worry that successful female artists are merely tokens. I do not address the accuracy of this perception, but it is heard.

Today many young female artists build on what was once described as feminist art, a label with many virtues and some sins. A young sculptor photographs her fingers with long pink acrylic nails, commenting, "I want to dress the way I want to dress and look the way I want to look and also be considered a legitimate sculptor. . . . It's kind of my little feminist 'fuck you' in some way."[11] She wants it all, and why not? One artist presents a ceramic tower composed of female lips and vaginas. As she responds when questioned, "For me the vagina is the solution" (Field Notes). In a seminar, three women, chosen to work together, decorate the room with clotheslines on which they hang bras, panties, and camisoles (Field Notes).

Women are permitted these challenges to male hegemony, but for men, depicting sexuality is more problematic unless in a same-sex context. As one female faculty member commented about a male student's video: "In videos guys are getting shit-faced or jacking off, and girls get in the bathtub. I tell my undergraduates that I won't allow it." In another video by a male student, a young woman, wearing brief panties, gives herself a "vagina rub." (To be precise—and I can't believe that I am writing this—it is a clitoris rub.) He is asked whether the scene means that he hates women. Watching the video, a female colleague announces, "At one time, I called you a feminist, and I'm going to retract that now. . . . This piece has opened out a lot of triggers for me that you're not taking responsibility for." A faculty member, speaking of this "pervy attitude,"

describes the work by saying, "This seems like a misogynist Jeff Koons" (Field Notes). In today's art schools, different rules exist for the display of sexuality of (straight) men and women. Artists examining LGBTQ sexuality typically have more leeway. Discursive rights link to a sense of entitlement, institutional policies, and politics.

Aesthetic Scenes

Social scenes are crucial to any ethnographic account: a place where people talk and act and argue and love. These scenes are localized arenas of exchange, creating a social field.[12] This is true of street gangs, surgical teams, and art schools. For the last, schools constitute local aesthetic communities.[13] When culture producers share a vision or a goal, they become a collaborative circle.[14] Recognizing the power of togetherness does not suggest that all is bliss, but group focus derives from shared presence and common interactional styles.[15] A claimed virtue of MFA programs is that a community of friends, collaborators, and mentors share struggles and confront obstacles.[16] The idea of an art scene, a concept developed in the 1960s,[17] emphasizes a joint commitment to creating cultural objects,[18] relying on available resources or amenities.[19] We find these art gangs—to use critic Peter Schjeldahl's term[20]—from the Impressionists onward, the building blocks of a social history of the arts. This community is central in producing, promoting, and distributing artworks.[21] As Pablo Helguera notes in his book *Art Scenes*, "We are left to construct representative 'art scenes'—small, collective projects that are nothing but our performed, provisional, and interpretive reading of what is happening."[22] It takes a village, or at least a program.

Some observers discern a social turn in art, a perspective consistent with relational aesthetics. That approach suggests that the art is in the gathering, not just in the object.[23] The studio becomes a site for socializing. The party is the practice. As critic Lane Relyea emphasizes in *Your Everyday Art World*, "It seems impossible to flip open an art magazine or catalog these days without running into photographs of artists socializing. . . . These are handheld snapshots taken with automatic flash, seemingly private tokens not suspecting that they would someday end up as glossy art world publicity. . . . the artist as lone individual has been replaced by a more social, extroverted figure, by a milieu."[24] The artist's identity shifts by emphasizing communal relations. Community is more than a space, more than a network. It reveals commitment to a project,

a group, and a practice. As sociologist Alison Gerber points out, artists invest locally: renting studios in certain neighborhoods and volunteering in the community.[25]

Chicago is known for "apartment galleries." These tiny spaces (often living rooms) display the power of a small group in a local art world. At the same time, art collectives have formed in modest neighborhoods. Of those connected to my informants, several stood out: Roots and Culture, a grassroots, nonprofit art center that hosted gallery shows as well as occasional parties, organized by a former Northwestern MFA; an alternative film society, Nightingale Cinema, at which several MFA students showed their work; and Bad at Sports, a collective that produced podcasts of weekly interviews with people within the art world. These art gangs permit newly minted artists to find a community. A dinner that I attended at Roots and Culture—recapturing classical Roman recipes from Apicius—served forty people, mostly local artists, including several from the schools that I was observing.

While these gathering points matter, the school is the central site that fosters intense interaction, describes ideals, and provides resources. Within the school it is the cohort that counts. These are friends, rivals, and a few frenemies. The artist Ben Shahn, recalling his experiences in the 1950s, before the rise of the MFA, refers to sociability, but is skeptical of a shared artistic vision. "One of the great virtues of the university lies in its being a community in the fullest sense of the word, a place of residence, and at the same time one of personal affirmation and intellectual rapport. The young artist-to-be in the university, while he may share so many of the intellectual interests of his associates, and has a community in that respect, is likely to be alone artistically. In that interest he is without community."[26] Today a greater sense of aesthetic community exists, even as each artist struggles to find her own niche. Yale's Robert Storr points out, "The two or three years spent [in graduate school] will be almost the only time in the lives of young artists when their primary audience is people as informed, as driven and as committed to the long haul as they are. The dialogue that can only take place among peers or with older artists with whom the students have chosen to work is crucial to the roller-coaster ride of doubt and confidence."[27] Dialogue is key, not consensus.

The size of the program and the absence of firm career paths lead art students to maintain their ties, perhaps more necessary than those in other professional programs, such as law or medicine, where different post-graduate communities (hospital residents, law firm associates) replace the university cohort.

Art matters, because one is in a scene. Evan explained, "Everyone re-

sponds to you as an artist. The expectation is that they take you seriously. That positive social pressure is one that would motivate you to keep moving, to keep making. It can be isolating to be an artist. If we don't have a supportive community and no one's pressuring you to be an artist, no one's regarding you as an artist, are you an artist?" (Interview). The emphasis on social relations is such that deciding whom to admit is linked to those students who are currently enrolled. A former administrator discussed his institution's admissions waiting list: "Who should be next? Part of my response has been [that] this second-year student needs to have a first-year student to have a conversation with. They need a partnership to talk about ideas. I want to protect the second-year student from feeling isolated, and I don't want the first-year student to come into an isolated context" (Interview). Programs establish skeins of students, not only within cohorts but linking them, supported by faculty mentors.

Building a culture of commitment is central to graduate student life, and, as a result, art school permits many forms of intimacy. Martin, known for being gregarious, pointed out, "We know a lot about each other's lives. . . . We see each other constantly. There is an intensity to just seeing each other all the time, so we are very, very clear on each other's basic positions on the world, and that creates tension. It can create productive and unproductive tension" (Interview). At Northwestern, students have studios along the same basement corridor, and, as a department of ten students, their classes are seminars. Friendships are magnified, but so are enmities. As one student admitted, in contrast to classes outside her department, "These are my people." Students organized social events where several played the board game Risk or sang karaoke. The ISU painters and sculptors share a small building off campus and see each other constantly. Students at UIC held film nights to show classic 16 mm art films, and organized studio visits (throw-downs) and photo workshops. Attending gallery openings, listening to lectures, or a sharing a meal after class were common.

Students often work late, hanging out together and commiserating. Each program organized trips (to Chicago; Marfa, Texas; and Mexico City), and these were important bonding experiences, fueled by talk and beer. As I discuss, some cohorts have sharp conflicts, and not everyone is well integrated, but a sense exists that students share a common fate. The year before I observed, one student at UIC committed suicide, with the body found in the art building. This shook the entire cohort, but "it brought the community close." In referring to the death, the director of graduate studies exhorted new students, "Please reach out. Don't be isolated" (Field Notes). During my research, one student was seriously

injured. Fellow students supported their colleague, delighted when he re-
turned to classes. One student's conceptual practice involved creating a
company (Supporting Artists with Children and Kids: S.A.C.K.); he pro-
vided sack lunches for sale at critiques, and used the proceeds to purchase
a painting from a student-mom (Field Notes). Photographers and video
artists documented the work of object-makers and performance artists
gratis. Perhaps the most powerful show of communal commitment was
the spring equinox performance at 6:45 a.m. outside the art building, at
which nearly two-thirds of the students showed up. Given the schedules
of students, the turnout revealed the depths of community.

The Place of Art

Community implies spatial proximity: a protected place provided by the
university within its expansive campus and satellite neighborhoods. In
chapter 1, I discussed the physical environment in the making of art. Here
I discuss place in the making of an aesthetic community.[28] One writer
describes collegiate space as "a cloister."[29] A second metaphor, less sacred,
but with the same theme, imagines a crack den: "While inside, the envi-
ronment feels cozy, everything there seems remarkable because you're all
smoking from the same pipe."[30] Others, more sober, refer to Alcoholics
Anonymous.[31] Both Northwestern and UIC set aside spaces for talk and
play. In the building where students have studios, Northwestern provides
a "break room," a small kitchen and dining area with microwave and re-
frigerator. The previous studio building, delightfully decrepit, had a porch
on which students gathered. UIC provides graduate students with a large
area, the Great Space, on the top floor of the building. As one faculty
member explained, "It is just this big open space, and if you walk in there
in the middle of the week, you will see five, ten people in there with
projects that they are working on. They come in there and build together
and they have conversations" (Interview). As noted, Soheila Azadi, one
of the more sociable students, arranged for the purchase of a refrigera-
tor, coffee maker, and microwave, making the space a gathering point for
art-making, informal chats, and student-organized critiques (Field Notes).
When I would arrive, I often headed to the Great Space, where I often
found students hanging out. Students (sometimes with faculty) also go
out to restaurants, pizzerias, and taverns after class or critiques to socialize
and debate. Some bars, such as the Skylark in Chicago's Pilsen neighbor-
hood, are known for the young artists who gather: a local Cedar Tav-
ern.[32] These dialogues, fueled by alcohol, continue past midnight. Such
mingling reflects the reality that studios, when not shared, can be lonely,

depressing places.[33] Universities insulate students from the outside,[34] but may isolate them within.

Describing the contemporary art scenes in Glasgow and Los Angeles, Lane Relyea emphasizes that art spaces—apartments, houses, storefronts— are the basis of post-studio practice, encouraging socializing that has long characterized art worlds, but now has come to define them.[35] What had been tangential to art production now is central to what art *is* in its emphasis on relational aesthetics.

How to be a community with common interests, while establishing a unique artistic self? This is the challenge of collaborative circles.[36] Mutual support should shape a local tradition—the Impressionists, Dadaists, or Abstract Expressionists—while not smothering individual creativity. Belonging to a tight-knit artistic movement may benefit early creativity[37] and, through publicity, one's reputation, but it can potentially pigeonhole one's work.

Balancing group influence and personal inspiration is crucial. As noted, the five members of one graduate cohort deliberately chose the title *Archipelago* for their joint thesis show to demonstrate that, although they were colleagues, they defined their practices as distinct, worrying that being labeled together would dilute their identities (Field Notes). One student explained, "It relates to islands. It was more about us being individual artists" (Field Notes). Another student commented, after emphasizing their personal support, "We all do different work, which also means we aren't too interested in each other's work" (Interview). Perhaps this overstates the case as their work, as a group, was recognized as differing from the more conventional practices of the next cohort. This title was indirectly plucked from the remarks of a guest instructor who recommended that students collaborate: "I suggest that in the crits . . . each artist does something to the artwork of another. It would be so much fun. You won't do it, but it would be a beautiful thing." She added, "The biggest weakness is that you are thinking of yourself as a single artist. No one is an island in themselves" (Field Notes). As a cohort, they clung to the metaphor of aesthetic islands: lapped by the same waves, but lacking bridges. The group had intense conversations about their projects, organized a day-long symposium on theory, and spent a weekend together at a resort. They mattered to each other, but the metaphor of an archipelago was salient precisely because a disciplinary cartographer might otherwise map them together. After graduation four of the five moved to New York City, where they maintain social ties, separate practices, and aesthetic distance.[38] A sociable site is not necessarily a collaborative community.

As Lane Relyea argues, community can create a thriving post-studio

practice, but it can also encourage a monotonous vision. Recognizing the power of group culture, some argue that a "program aesthetic" develops: a CalArts vision, a Northwestern style, or a UIC character. As one faculty member explained, standards of competence can truncate personal development (Interview).

Thorny Edges

Although "community" has a cheery ring, vestiges of dispute remain, even if these vestiges are not inevitably harmful. Each cohort develops a distinct culture—a culture that may conflict with that of the faculty. One senior professor pointed to three twined rings: first-years, second-years, and faculty, noting that each student cohort will be surrounded by two others—the year ahead and the one behind (Interview). Cohorts often establish social boundaries and claimed virtues. One student contrasted her cohort with the second-year students: "I don't think anyone that's a first-year reads poetry on weekends. I know everyone that's a first-year could whistle a song in the top twenty. . . . They [the second-years] all come from parents who have Ph.D.'s and that shapes them" (Interview).[39]

As cohorts rise in the program, they find academic hurdles and personal differences. The first-year students develop cohesion as strangers while defining artistic personas; the second-years are stressed by creating mature work and imagining life after graduation. A group of thirty can divide into art gangs,[40] but this is less readily achieved among ten. A nondrinker like Hanna Owens must find spaces to socialize; an outgoing artist like Soheila Azadi must find fast friends; and an artist from the inner city like Esau McGhee must collaborate with suburban colleagues.

When differences spark public conflict, life becomes less secure. Distinct moral visions, family histories, or firm beliefs may disrupt personal comity. One senior faculty member explained, "There have been years where the chemistry and the dynamic among a group of students or between the first and second-year group has been really difficult, and cliques that have been very exclusive and unkind have formed, and that has been incredibly troubling" (Interview). One student was skeptical: "I know that the faculty don't give a damn about group dynamics. They don't care about that when they put a group of people together. They just want to get the best artists individually they can get. . . . If you don't get along as a collective, you just don't get the fuck along" (Interview). Despite his profane candor, this is unfair: Would he wish for a program that selected students on their congeniality or on the sameness of their goals? Perhaps faculty should be more present in graduate student life,

but running a matchmaking service has problems of its own in a world that values diversity. Students who imagine that in graduate school they will find a happy family are often rudely awakened.

On several occasions dislikes were clear. In one instance, these animosities led a student to be forced to take a leave of absence after a series of public disputes with another student. Ostensibly the triggering issue was about the organization of the thesis show, but the conflicts were more personal. Students took sides, with some finding the conflict "very frightening" and others angered at a "post-modern sacrifice" (Interviews). A fellow student found this student "creepy," but another described him as "a great artist and a great person" (Interviews). The division could not have been any more sharply drawn. In the end, the decision was made by the faculty with their own personal divisions, solving the problem by delaying his return until his foe had graduated. A classmate contended that the department had pretended ignorance until the hostility became too obvious to ignore, hoping that the dislike was merely gossip (Interview). Bridget, the conceptual installation artist, remarked hopefully about social rifts: "Sometimes I think this sort of unfriendly and difficult environment is actually really a good training ground in life in contemporary art: that no one is going to give you anything you don't earn" (Interview). The next year another animosity, attributed to sexual identity, emerged. This hostility erupted in class, allegedly leading to tears, but it was ignored institutionally (Field Notes). Small programs can develop tight networks and strong cultures, or they can fall apart, as the disputants have nowhere to hide.

Add to these cultural stressors the reality that programs are reputational tournaments. Within a program, status is distributed, leading to student competition. Professors suspect, perhaps from their own experience in graduate school, that students may be saying what they think their mentors wish to hear. Certainly this is true at times. Each student wants to be seen as one who will bring institutional credit, receiving faculty love. The extent of rivalry is hard to gauge, but some students liken art school to pre-med, a battle for selfhood. Although some students claim that others have big egos, this is questionable. Big insecurities couple with big dreams, creating, in the words of one student, "a stew pot of paranoia" (Interview). Some hide career opportunities, cadge dinner invitations with visiting artists, or are privately critical of the works of colleagues. One student admitted that "bitchiness comes out every now and then" (Interview). These behaviors merge competition and jealousy, the result of a shared hierarchy and sharp reputational politics.

Art school has a distinct dynamic, in contrast to graduate programs

where the status division between student and faculty is clear. As noted, in contrast to medical school, students who are admitted into an MFA program are already artists. Within the program a hierarchy of teacher and student exists, but in the larger art world the hierarchy may be up-ended. Janice, a talented and politically minded artist, explained: "Some-times there is a faculty member and student in the room who have re-ceived the same award or are in the same fellowship program. . . . I know that [a faculty member] and Cher were both chosen by the Artist Coali-tion for the year [as artist residents]. . . . I feel faculty realize that they are vying with students for the same type of opportunity. . . . It's an age-positioning rivalry that festers in a critique environment" (Interview). More pungently, Dave Hickey agrees: "Only saints can nurture real talent. I am a writer, not even an artist, and even I can't avoid feeling a twinge of resentment when a pimple-faced twerp with a skateboard under his arm shows me a mature and persuasive work of art. I can see, much more clearly than the twerp, the road opening before him, the obstacles falling away, and it's all I can do not to stick out my foot and trip him. If I were an artist, with a stake in the game, I would probably trip him, and tell myself that it's for his own good."[41] This competition is found when the community is seen as divided (as between students and faculty), but in the larger reputational bazaar it becomes a single hierarchy.

All students desire community, but on their own terms: a world cov-eted but fragile. Do closed studio doors reveal an absence of community, or does this simply mean that students wish to hammer or play music? Is choosing not to socialize in a pub a communal rejection or a sober desire to spend time with family? Whether collegiality exists depends on whom one asks. Some see it ("we're a tight-knit community"); others do not ("it is profoundly unfuzzy") (Interviews). Everyone believes in com-munity, but how it is judged varies widely.

Amoral Orders

Of all our admired social institutions, few have the same capacious em-brace of *deviance* as the art world. Artists define themselves as mavericks.[42] Sometimes it seems that anything goes: anything except conventional morality, traditional religion, and conservative politics. The avant-garde becomes the rear guard, as young artists push boundaries. Good taste is in short supply.

This claim should not be pushed too far. Many artists have stable mar-riages, raise children, and maintain suburban homes, and even a few Re-publicans hide in the closet. Still, much tolerance is shown to behaviors

that the psychiatrically minded might label "acting out." The core of the discipline may be talk, theory, and object-making, but the periphery is expansive. As the goal of art school is symbolic production, artists are conscious of cultural symbols—tattoos, black sweaters, cigarettes—that mark the boundaries of their world. Students learn to perform the artist role, looking and acting the part.

These markers are not only local, reflecting a close-knit community, but they also situate art gangs in romantic resistance to established standards. The centrality of oppositional identity is depicted by journalist Larry Witham, who spent a year at the Maryland Institute College of Art (MICA) and speaks of art's "amoral subculture." "Art schools, like the art world, do not pass judgment on whatever subculture, or 'scene,' an artist will call her own. The naughty and subversive subcultures are fairly common, and for very good reason—some of the most famous artists of the twentieth century created those subcultures."[43] Consider Still & Chew/Art and Culture, from the late 1960s: "John Latham and his student Barry Flanagan organized a party at which guests chewed up pages from the library copy of Clement Greenberg's *Art and Culture* at Saint Martins College of Art and Design in London. . . . Latham was fired after he attempted to return a liquid made of the fermented paper and saliva to the library in place of the book."[44] Thirty years later, artists at UCLA were "wrestling in a kiddie pool filled with fake blood."[45] Carol Becker, now dean of faculty at Columbia University's School of the Arts, explains:

The way in which we educate artists in art school is better suited to a romantic paradigm. We unconsciously continue to envision the artist as a marginalized figure, cut off from the mainstream of society—operating out of what Freud calls the Pleasure Principle while the rest of us struggle within the Reality Principle . . . We even tend to be suspicious, as Arthur Danto notes, of those artists who survive too well within the "straight world." We wonder about their creative credentials. . . . The implications for the art school are that it is forced into the role of permissive parent, while its students play out their respective parts as precocious and at times unruly children.[46]

Those who see artists (at least certain elite ones) as operating from a business model—the MBA model of art history[47]—might claim that art school constitutes the moment before artists "grow up."[48]

Misbehavior defines these students. For some, art school life is awash with drugs, alcohol, and bodily fluids. Perhaps artists and writers are better behaved than in the 1970s,[49] but their domestication is hardly complete.[50] At evening gatherings some students and faculty drink heavily

and joke about it, referring to their "bar brain." Students, like Hanna Owens, who maintain a clean and sober lifestyle, must establish community elsewhere; she believes that she suffers from her commitment as bars are where much socializing and social critiques occur. Drugs, if not as common as drink, are also endemic to artistic communities, found in studios and at departmental parties. Marijuana use was so accepted that an instructor, musing on snacks students brought to class, joked, "Did someone put pot in the hummus?" (Field Notes). It was unclear if this was a warning or a request. Soheila Azadi shared how she naively attempted to support a colleague: "There was a girl in our program who was looking really tired. She is actually my friend or I thought she's my friend, and I said 'Are you tired?' And she said, 'I did cocaine. That's why I am so tired'" (Interview).

Sexual exploits are also recounted. It is not surprising that students embrace, but I was told about several student-faculty liaisons, arrangements less accepted elsewhere in the university, linked to gender and power. One student suggested, implausibly to my naïveté, that two-thirds of the faculty had sexual relations with students (Field Notes).[51]

I am often asked what surprised me most in my research as I contrasted art departments with my home in sociology. The answer was clear but mundane. Cigarettes.[52] Students in sociology rarely smoke in public, but at each art school, smoking was assumed. During my research, smoking was not permitted indoors, but devout smokers gathered outside even in winter. One student asserted, "I can do what I want. It won't kill me." Another, celebrating her birthday, explained that she was considering stopping smoking, "so today I've been smoking as much as possible" (Field Notes). At Northwestern "smoking breaks" were built into the critique: "We have a ten-minute smoking break scheduled" and "Things are starting late because people like to smoke." These comments were from two different faculty members. When the university threatened to ban cigarettes from campus, several members of the department claimed that they would violate the rules as a form of civil disobedience.

Aside from smoking, discussions permitted in graduate seminars differed from those in sociology (readings—such as the Marquis de Sade—differed as well). What is accepted in art programs would be considered unprofessional in medicine, law, or public policy. Students use obscenities casually, and profane terms of intensification are common ("it sucks ass;" "this is the most important thing I've read in five fucking years") (Field Notes). Some domains within the university (including other arts) have equally broad moral margins, but a program in the visual arts is an *obscenity factory*.[53]

However, the cultural challenge is not the "bad boy" and "tough girl"

mystique, but whether admired art emerges. As writer Kristin McGo-nigle said of her experience at New York's New School, "MFA programs are just like big social meet-ups. At mine, a lot of people made friends and started sleeping with each other and everybody went out and got drunk every Wednesday, but nobody produced any great art in the end. You could tell who serious people were, who was actually going to suc-ceed. . . . I used to say that MFA stood for Mostly Fucked Around, which was often true."[54] Sometimes MFA stands for "Mother-Fucking Artist."[55]

Acting out may shape careers. Although my research did not have a large enough sample to verify or disprove the conjecture, it is possible that a swaggering culture may disadvantage women, a reality noticed in the busi-ness world. To the extent that female artists are more conventional than male counterparts and are less likely to party or socialize, making career-advancing connections, they may be disadvantaged in a reputational mar-ket.[56] Female students participated in cohort and art world culture, but it is hard to judge if they did so at the same rate or with the same verve as their male colleagues. This may be a mechanism that helps explain the persisting gender differences in the art world. In a similar way, if racial minorities, of-ten a small and visible group, feel excluded from social events at which con-nections are made and deals brokered, they, too, will be disadvantaged.[57]

All communities set criteria of belonging and pressure those who should be inside but who reject local standards. Art programs do not dif-fer in setting conditions of acceptance, but here those who flout exter-nal authority and spurn cultural control may be venerated. How serious need one be about one's practice? How playful? In art school this strug-gle is contentious, because some of those with the highest reputational capital are those who least accept conventional behaviors or aesthetic conventions. Living fast, dying young, painting hard, and changing the world might be the mantra for icons such as Van Gogh, Pollock, and Basquiat. As art becomes a discipline, evaluated by its own standards at least in school, its permissiveness is notable.

Local Cultures

Throughout my ethnographies I point to the diverse institutional forms that result from local traditions, depicting how these cultures create community. Group cultures channel individuals, providing a model of being and working. These tiny publics create *idiocultures*, small group cultures that characterize interaction.[58] While idiocultures intersect with

each other and have parallels among them[59]—creating a subculture that provides a template for local cultures[60]—every group has its own distinct character. The salience of locality, social relations, and shared vision is emphasized in Lane Relyea's[61] *Your Everyday Art World*. Part of the everyday is due to the fact that it is "your" world—a recognizable pattern of relations and meaning found in particular sites. As Relyea argues, community flows from the school into post-graduate scenes: apartments and galleries where artists create and display work together.

This becomes evident when programs are defined by their character, often through the stereotypes of graduating students, coupled with awareness of a few exemplary faculty members who serve as mentors or inspirations. For a time these programs gain prominence as distinctive,[62] although eventually their distinction fades because others mimic their culture or because administrators broaden their mission. Even ways of laying paint on canvas provide a local *look*.[63] At times, an art program becomes such a compelling scene that students are drawn to apply because they share the aesthetic or, perhaps more likely, they wish to be where the action is:[64] a hot spot of creativity.

Artists who attended the School of the Art Institute in the 1960s, such as Jim Nutt, Ed Paschke, or Roger Brown, creating the ethos of the Chicago Imagists, are a well-known example of how a school produces a movement. On the East Coast, the Yale School of Art was consequential in producing a style of masculine and dramatic painting.[65] In the 1970s, much attention was paid to CalArts, which for a few glorious years was transformed from a provincial, Disney-inspired technical school to an academic atelier where anything was possible.[66] As the CalArts culture dissipated, UCLA became the place to be: the power art school of the 1990s.[67] Even Northwestern and UIC have distinguishing features. Northwestern, once a painting and printmaking program under the triumvirate of Ed Paschke, William Conger, and James Valerio, by the late 1990s became known for its conceptual art practice. One current faculty member, recalling that earlier program, sniffed that "it was totally a backwater. We were not serving [students] well. They could not understand a contemporary art museum" (Field Notes). In a few years the program changed radically. A student explained that "they prefer work that doesn't fit comfortably in the gallery context" (Field Notes). Once I purchased a self-published book from a student for ten dollars. She joked that this transaction made her "a commercial artist" (Field Notes). While culture varies by cohort, students at Northwestern are less known for traditional thing-making.

UIC has a more political, engaged, edgy reputation, although in the 1990s it also was oriented to painting, sculpture, and printmaking. Today the program defines itself as proudly interdisciplinary, both in encouraging students to use different genres during their training and in combining genres in individual works. Several students explained that they selected UIC over more prestigious programs precisely because of its ethos. As one faculty member explained to new students, "If you're a painter, you're not just talking with painters. If you're a photographer, you are not just talking with photographers. That is part of the program" (Field Notes). She defines the program culture as promoting the making of *art*, not painting, photography, and the like. The downside is that in a small program, sculpture students, for instance, may find few other sculptors with whom to talk. The community is constituted broadly, but intense debates of technique may be lost. The program prides itself on an imagined culture in which anything might be an art object. One faculty member said, "The joke about this program is that you can drag in a crushed can and we would critique it for an hour" (Field Notes). Indeed, one of the works being critiqued during my observation included a crushed can, although the critique lasted only forty-five minutes! Illinois State has a less sharply delineated aesthetic culture, including craft and representational painting, although much work references the body. A noticeable division among the faculty exists as to whether the program should be training contemporary artists, familiar with theory and conceptual work, or training teachers who can impart technique to undergraduates.[68]

Each school has stories, often about faculty but also about student projects: the student whose project involved apricots coated with lotion, the student who carved her studio wall, the project of an a capella group singing in a school bus, the display of a bucket of live eels, or the ceramic casting of young girls' panties. Recall of these creations forms part of the group's collective memory. These cultures may not be fully applicable to larger programs, to programs located in art schools, or even to these same programs today. The University of Chicago is a revealing case. A few years ago, its MFA program was judged highly contentious and a marginal academic unit. However, the university invested in upgrading the program, erecting a sleek new building and hiring several prominent faculty. The reputation of the program has been on the rise.[69] While art is a professional discipline, the structure, training, theory, and interpersonal dynamics of every program is shaped by local conditions and microcultures. Art programs share a disciplinary perspective, but the particular culture shapes the experience, aspirations, and identity of their enrollees.

Finding One's Way

Within the context of community, individual reputations are built. A student is, say, a Yale painter or a CalArts performance artist, but she is also an individual, honored, accepted, or dismissed. Within each program, I learned which students were widely admired by faculty members and which were marginal. Even though there were no departmental awards, some students were encouraged to apply for fellowships or residencies. Others were felt to have a cloudy future. As one faculty member explained, instructors gravitate to those students whom they feel are excelling, providing more feedback (Interviews). I did not learn how many students recognized the hierarchy: Some did, others not. Certain students are seen as more diligent, more theoretically sophisticated, more ambitious, more technically able, and more likely to create admired practices within the contemporary art world. But even those students who are generally considered less talented receive their degree. Their work, technically competent, does not excite others, and little seems at stake in their practice. Some of them survive in the market, despite the skepticism of faculty, but others find a career impossible. As I noted in chapter 4, in describing the hierarchies in critiques, their evaluations are often routine, not worth a vigorous debate, and they are rarely mentioned or recommended for fellowships or residencies. Given the uncertainty of faculty sponsorship and the ambiguity of hierarchy in most locations, these orphans of art school may have only a vague sense that others are regarded more positively. Few fail (none in my research) and all consider themselves artists, but conceiving oneself as an integrated, professional artist becomes less plausible. Unable to find post-graduate opportunities, some students treat art-making as secondary to a primary career. Perhaps they hope for an eventual break, but they are forgotten by those whose career lines are brighter.

Despite the importance of community, the desire to be part of a movement, and the social turn in contemporary art, artists value what sociologist Nathalie Heinich terms a "singularity realm."[70] As Michael Farrell emphasizes in his analysis of culture groups,[71] groups nurture creativity, but circles dissipate as individual participants refine their style and as reputations diverge. Reputation is a mix of persona, network, and the work itself.[72]

The demand for singularity is powerful,[73] and art school should help a student determine her unique practice, even when artists work and show together. Of course, the presence of mundanity must be taken into account: Not everyone will be, in James Elkins's words, "astonishingly

original . . . it is common to be a little behind the times: not everyone is bleeding-edge avant-garde."[74]

The desire to find a distinctive artistic identity is particularly salient given the oversupply of practitioners and the uncertainty of success.[75] Just as chess players fantasize about finding the next Bobby Fischer,[76] the denizens of the art world look for the "next Warhol." Pablo Helguera in *Art Scenes* details the consecration of video artist Matthew Barney through the intersection of dealers, curators, and critics.[77] Such a structure permitted UCLA graduate Delia Brown to claim, "We each nurture the delusion that we'll be the one artist to make it."[78] Further, reputations are not stable, particularly for those in the second tier. Reputations expand at an opening of a gallery show, held perhaps once every two years, and shrink as the show closes and is forgotten.[79]

The art school is a well-stocked pond. If one wants a fish, this is where one throws a line. Programs located near contemporary art galleries have an advantage in this regard, well recognized by students in New York or Los Angeles. Chicago programs have advantages over more peripheral schools, such as Illinois State in small-town Normal, Illinois. These strategically located schools use their market centrality to their advantage. While young artists worry about how their reputations will fare in this competitive tournament, gallerists have the same fear. Young artists interested in market success wish to climb the gallery food chain.[80] At one lecture about career options, a prominent curator advised students not to show everywhere: "You don't want your work in a place where it doesn't fit in terms of the gallery. . . . It means something, where you show." This curator was candid in saying that she cared not only about the content of the work, but whether it had been shown and by whom. For her, these artists were "serious about their career" (Field Notes). In practice, this combined institutional linkages and the ability to talk about one's work so as to have the work be favorably situated within art world discourse.

Dealers search for the next star, to be presented to curators and elite collectors. Sociologist Natalie Heinich suggests that this requires actors who shape the reputation of emerging artists: "Intermediaries are in competition for the discovery of artists who have not yet been noticed, or who have not yet even really entered the art world. Consequently, they tend to orientate their choice toward the youngest artists, who they are sure to be the first to discover."[81] Mike Kelley of CalArts was quoted as saying, "The rise of the Eighties art star changed everything, and changed it for the worse."[82] It made Kelley a celebrity until his apparent suicide in 2012. One faculty member described the Los Angeles scene this way:

There are always three to five hot graduate schools, where collectors and dealers are going to the studios and striking professional deals with people before they are even out of school. . . . I have a friend who went to UCLA and now he is making a living as a painter and by the second semester he was selling work out of his studio as he was finishing it in graduate school to huge collectors, already had a very big career-making gallery before he graduated. More recently, [at] Columbia University, there was a wave of artists who came out of there into the gallery system and just exploded. And so [dealers and collectors] started going to Columbia . . . I heard they had to exclude their first-year grad students from open studio [nights] because dealers were coming in and making deals with people in the middle of school and that is often irritating to faculty. (Interview)

This did not occur frequently at the schools I observed, because students at the two Chicago programs did not emphasize "object-making" and scorned the market, while the program at Illinois State, where objects and canvases were produced, was too distant and lacking in reputational capital. Still, reputations develop through residencies, performance venues, and teaching opportunities, even if market-makers are less evident.

The University and the Art World

Judith Adler, examining the early days of the California Institute of the Arts, titles her account *Artists in Offices*. By this she stresses that CalArts was a bureaucracy, and organizational and financial necessities challenged the ideals of a bohemian subculture.[83] Artists were given offices, but had to find their own studios. However, CalArts is not a university. It began as, and remained, an art school. Artists were in charge, recognizing, as Adler does, that artists could also be bureaucrats. When the arts move into a university, things change, not only because institutional leaders may have little familiarity with the needs of arts faculties and students. The arts may add cachet, but rarely do they generate funding.

Artists belong to a social system that stretches beyond their purview. As Judith Kirshner, former dean of the College of Arts and Architecture at UIC, put it, "Charged interactions occur in the university where the artist has no special status but is part of a complex community composed of biologists, engineers and historians."[84] Artists are one group of many, but, given that their output is not in the form of articles, books, or research reports, their status is insecure.

The movement of artists into the university has benefits and strains. In many locations, particularly outside of New York City, the university,

along with the museum, is the center of the local art world. Degrees are the credentials that mark an artist's seriousness. Within these communities, faculty are treated as artists in full.[85] Yet, located in a routinized and bureaucratic structure,[86] the self-image of the creative, subversive, outsider self may be challenged. The university artist must discard what literary critic Fredric Jameson describes as a "matter of shame," that they have failed the test: "Those who can, do: those who can't, teach."[87] Both routine and bureaucracy threaten the image of the avant-garde artist. Perhaps for this reason the label "avant-garde" has fallen from favor. In a thoroughly professional world, everything is judged though jaded communal standards.

The tension between the mundane and the transgressive is central to what Mark McGurl speaks of as the program era in creative writing, but this can easily be extended to visual arts. In the words of Chad Harbach, "the program writer . . . always wants to assume and is to some extent granted, outsider status by the university; he's always lobbing his flaming bags of prose over the ivied gate late at night. Then in the morning he puts on a tie and walks through the gate and goes to his office."[88] Judith Adler quotes a CalArts teacher who explained, thinking back to his student days, " 'If I had known what I know now at the time I chose to become an artist, I wouldn't have *had* to fight with my parents about it. I could have joked with them instead.' The 'joke' consists of the incongruity between the image of the artists' marginality and the growing reality of their social integration—of the fact that the mature and successful art academic finds himself in a social position not very far from that of the lawyer his parents had wanted him to be."[89] This is less about professors than about all those in work domains who seek to control their own standards and evaluations. Throughout the twentieth century we have witnessed attempts by communities of workers to gain the right to call themselves "professional." Sociologist Harold Wilensky terms this the "professionalization of everyone."[90] Artists do not fit the professional model as defined by sociologists in many ways, but they, like those in traditional professions, seek disciplinary autonomy, in this case from university administrators, gallerists, and collectors. Artists and art teachers wish to set the terms for valuation, even though they must compete with others with different values and more resources. In creating sites of evaluation, the university with its authority and prestige confers both faculty and student identities.[91] Disciplines provide this control through organizing knowledge, theory, method, technique, and subcultural traditions. Departments make these controls local.

Whether the primary virtue of graduate education is credentialing or

the ability to talk (or think) like an artist, the lack of an agreed-upon set of technical skills challenges disciplinary authority. Educators argue for their own worth, but others, both artists outside the academy and administrators within, question the cherished autonomy of the programs.

Within the university, art practice—in contrast to art history—is disadvantaged, as faculty and students do not publish papers judged by blind review or conduct detailed analysis of empirical material, labeled research, capable of replication. Even theory is borrowed from other disciplines, including philosophy, gender studies, art history, and literary analysis. As a result, some promote (with envy?) the creation of a research-based Ph.D. degree to justify the artist in a university. As art educator Timothy Emlyn Jones points out, "the introduction of studio-art doctorates in many countries . . . had brought fine-art education to its coming of age, on a par with and different from other university-level disciplines."[92] Likewise Al Landa, vice president of the New School for Social Research, remarks, "There is a tendency to honor Ph.D.'s and the studio artist is, in the hierarchy of education, lower on the totem pole than any Ph.D."[93] Serving on a university tenure committee, I once had to evaluate a member of the art faculty. The process was challenging, although with a happy outcome. Standard metrics for other disciplines did not apply. Without a Ph.D. and without reviewed articles, are these teachers "scholars"? How should one evaluate a gallery show or a work selected for a museum exhibit? One faculty member was frustrated that he was turned down for tenure by the university even after he had been invited to contribute work to the Whitney Biennial. He explained that "they didn't understand what that was. That is a perfect example of not understanding as an academic versus a nonacademic setting" (Interview). In his view, being selected for the Whitney did not count for colleagues outside his department. A second faculty member makes a similar point: "I don't feel terribly connected to the university. . . . Art schools feel separated, a little bit of a token school. We had at one point two MacArthur winners on the faculty, but we never felt there was much of a sense from the university that it mattered that much" (Interview). Perhaps they were overly sensitive to disciplinary affronts, but their feeling of distance was common. Within the university, research-based disciplines, bolstered by the Ph.D. as the terminal degree, serve as a model of a research community. Art practice does not fit comfortably. What the faculty feel as a matter of institutional insecurity gets passed on to their students.

But how does the placement of art worlds in a university change what is being produced? Howard Singerman argues that the technological ac-

cess and economic security of faculty produce certain types of art.[94] Faculty are shielded from market vagaries and the need to satisfy gallerists or collectors. They can produce objects that are not salable. This encourages conceptual, performance, and post-studio art. The university also trains curators, critics, and artists who see in these nonmaterial forms a legitimate practice. Both politics and philosophy, often yoked together in critical theory, have propelled institutional critique and social practice. Artists have found their provocations accepted in a domain of ideas, difficult in a market. Nonmaterial art—an art of ideas—has flourished. Could the German conceptual artist Joseph Beuys have thrived without his professorship at Dusseldorf in the 1960s and his subsequent visiting positions? Beyond its separation from the market, the university promotes a hierarchy of theory over applied practice.[95] As a result, it creates autonomy for the field of visual art in the contemporary scene, despite the frequent grumbles about the power of the market.[96] The diversity of activities in a university provides inspiration. As John Barth remarked about writing *Giles Goat-Boy* at Penn State, he taught classes "not far from an experimental nuclear reactor, a water tunnel for testing the hull forms of missile submarines, laboratories for ice cream research and mushroom development, a lavishly produced football program . . . a barn-size computer with elaborate cooling systems . . . and the literal and splendid barns of the animal husbandry department."[97] Visual artists, like novelists, are inspired by the worlds that surround them. In its personnel, the university is an archive of knowledge.

Given the reality of the university as a space for faculty engagement, how does this affect MFA students? I distinguish art colleges from art departments in universities. Art colleges (as opposed to more traditional art academies) have upgraded course offerings since the 1960s to become accredited colleges, even though their "non-art" courses are typically those in the humanities. Yet, even though art colleges sometimes wish to be considered liberal arts colleges, the claim rings hollow, as the school may feel like a small art academy on steroids.[98] When the university art department is set alongside sociology, history, or English departments, cross-disciplinary linkages are possible.

Even absent degree requirements, a push exists for students to connect to the rest of the university, not necessarily from a desire to broaden them as persons, but in an effort to increase the scope of their practice, much as John Barth's writing was expanded at Penn State. A director of graduate studies encouraged students to take courses outside of the art program, exhorting: "You're in a university and so you might wish to take courses

in philosophy or astrophysics" (Field Notes). Of course, such options are unavailable to their art college peers. In turn, students from other departments can select courses in the art department, although this is rare. Only a few design, art history, and philosophy students enrolled.

Many MFA students affirmed that taking an array of nondepartmental courses was in their interest. Several explained that they selected the program because of its location in a large university. As Martin, the LGBTQ installation artist, explained, "I chose [my university] specifically so I would have the flexibility and the latitude in the way I craft my degree to take a lot of coursework outside the department. So I am working most of the time in gender and sexuality studies, but I have also done work in English and philosophy, and that is incredibly important to the way I have developed" (Interview). Unsurprisingly, art history is the most common choice, but during my observation, students also selected courses in music theory, African American studies, gender studies, film, and comparative literature. In addition to classes, students meet with faculty in other programs, including English, sociology, women's studies, and even biology. Belonging to a university allows students to meet and befriend colleagues in other programs. Bridget, who incorporates Walt Whitman's poetry into her work, participated in a cross-disciplinary Whitman study group and helped to organize a national conference (Interview). Martin was deeply involved in the queer theory group on campus. He explained that he asked a sociology graduate student to advise him on how to conduct research about how gay and lesbian students and faculty had been treated at the university so that he could incorporate this information into his practice (Interview).

Students find opportunities, even if structural encouragements to enroll in courses outside of the department are lacking. However, constraints exist as well. Even when students make efforts to reach out, the skills of artists—or their absence—may limit success. Michelle, the student interested in family and faith, contacted a sociology faculty member. The professor, a friend of mine, enjoyed talking with Michelle, but found her naïve in sociological terms (perhaps my friend was equally naïve in artistic terms). Michelle wanted to know, reasonably, what the *typical* American family was like. Sociologists emphasize the diversity of family structures. Only someone naïve would ask about a typical family. This incident reveals how distant some art students are from discourse in the social sciences. Lena, the young sculptor, trained at a reputable art school, hoped to take a course in philosophy, but felt that she did not belong. "I was excited I was going to be at a university where I could take other classes. I had a rude awakening [when I] enrolled in a [gradu-

ate level] philosophy class. I had never taken philosophy, only an ethics course. I just really struggled with it. . . . I'm really struggling with writing papers, academic work. . . . I feel like what I am here to do is to be an artist and make art. That is my top priority. . . . I've really come to think of art as its own language and something different than writing a paper" (Interview). Students with a BFA in art, and particularly those admitted from an art school, find that enrolling in a research university requires a foreign set of skills that their graduate program is not invested in teaching. The word "theory" is an honorific, suggesting that one is sophisticated and knowing. However, rarely evident is the complex analysis—and the associated writing—that permits young artists to survive in programs in which deep reading is essential. Art students feel more secure in their departmental homes where theory is linked to the visual.

Community as Praxis

Disciplines depend on community: central spaces cosseted by boundaries. Like all disciplines, art worlds are segmented. As artists, practitioners do many things: painting, sculpture, performance, video, and photography. They embrace various approaches, each with its own politics: social practice, institutional critique, or relational aesthetics. They belong to different demographic/political groupings: queer, feminist, African American, or their intersections. And they have distinct stylistic preferences: slacker minimalism, photorealism, or sloppy performance. Each generates its own conversations and controversies, even if in a tight-knit place like graduate school, it is hoped that many can engage. These artists have, not the problem of too much information to master, but the challenge of sufficient time to produce a body of work. As noted, some genres produce a great deal of product, needing much culling (photography), while others (painting) produce only a few, treasured objects. Art school is, in this sense, many schools in one, just as the art world is many markets in one. The faculty and students must persuade each other, given all these differences of practice and of demography, that they belong together, morally and not only institutionally.

Art programs do not have a single culture. My three Illinois schools differ in important ways, and see themselves as distinct. Each has a program culture that, while it does not eliminate the similarities that permit us to speak of art school education, reminds us that all communities are locally constituted with group cultures and collective histories.

At the same time, internal hierarchies emerge: Reputational politics

and rivalries are inevitable, whether or not they are publicly recognized. The multiple approaches of artists persuade many that no one should be compared with anyone else. This is a promising line, but it is never fully persuasive when resources, grants, and awards are at stake. The illusion is of equality; the reality is that equality only exists on ritualized and rhetorical occasions.

Finally these programs are situated in universities with their multiple disciplines. Not every student utilizes the resources of the university, but they are aware of options and models. The problem is how to address the differences in forms of education that allow the absence of extended writing and systematic research to be considered good practice. Over the past century, graduate arts education has been fitted into the university system, but this fit, while providing status and resources, always recognizes difference and distinction.

Preparing for a
Hostile World

There are few modern relationships as fraught as the one between art and
money. Are they mortal enemies, secret lovers or perfect soul mates? Is the bond
between them a source of pride or shame, a marriage of convenience or some-
thing tawdrier? A. O. SCOTT[1]

To students and staff alike, as well as to its public, art school
feels like a place apart, a monastic, inward-looking arbiter of
taste and competence with distinct customs and standards.
Sometimes it seems to be a castle surrounded by a moat,
keeping the barbarians out—and the select within. The sys-
tem of critique, the emphasis on the artist's intention, the
focus on talk, and the desire to make a political statement
are found in classrooms, collegiate studies, and lecture halls.
These make the academic art program distinct from the pub-
lic art world. But so, too, does the frequent emphasis that
outside lies a hostile world: the polluting market. The uni-
versity becomes a safe space for artistic production, separat-
ing the pure and the profane.

For a student, to be credentialed as an artist is to be
trained by instructors who emphasize theories of art, if not
always professional practice or technical skills.[2] This em-
phasizes an inward focus—a social envelope that is often
sealed—distancing students from the mercantile world that,
as graduates, they will eventually encounter. While there is
much to recommend an intense disciplinary gaze, it sepa-
rates art in the academy from evaluation by wider publics,
creating a bifurcated cultural field.

Initiates expend much time and acquire debt in this closed world, per-
haps expecting that a payoff will result in reputation or in resources. In
time, they learn that these are uncertain, unlikely, and even undesirable.
How do they cope? Many accept the belief of their mentors that the purity
of the work—its remove from the market—is what matters. Artists are in-
tellectuals of the object. Their return on investment will not be in dollars.

The faculty, who serve as guides to a career, may be of modest help
in linking to audiences. While professors are supposed to be the key to
professionalization, not all are embedded in the market, and few be-
lieve that developing contacts between students and gallerists or cura-
tors should be their prime concern. Through the university, these men-
tors are protected from the vagaries of the market, and they often have
an antagonistic attitude to this world, whether from theory, politics, or
grievance. Their perspective makes it hard to engage fully with a neolib-
eral, capitalist, materialist institution.

The hostile world dilemma, the strain between art and commerce, is
that while students need the support that a market might bring, they are
discouraged from making this connection for fear of being discredited.
If an ivory tower lacks windows, how do students imagine their post-
tower life?

In exploring how art students think about their post-school lives, I
address how conceptions of the art world shape students' out-facing ac-
tivities as they consider their careers.[3] I emphasize two critical aspects of
training: the development of an artistic identity, shaped through men-
torship of artist-teachers and curators, and the development of a social
network that, it is hoped, provides footholds in the art world.

To make this argument, I begin by describing how students think
about the contours of their careers. These students balance whether they
see their lives as artists as constituting a calling, a form of the sacred,
or as work lives with the need for strategic planning. In this, students
might take into account their debt load. Without a firm path, the ques-
tion of the next step produces anxiety and uncertainty. To gain footing,
students rely on the networks that colleagues and faculty provide, hop-
ing that these connections, even if unpredictable, are sufficient to bridge
school and life.

Ultimately, emerging artists must consider those to whom their work
speaks and those who have the power over their reputations. To this end,
I examine the relations between students and those around them: their
mentors, the curators who shape their work in their capstone thesis show,
and finally, the shadowy market that, whether embraced or disdained,

captures their attention. Together, these topics paint an Impressionist landscape of the awakening of the young artist as an aesthetic citizen.

Careers and Callings

Occupational socialization is more than learning skills; it involves acquiring and asserting an identity. This identity consists of what one's occupational role means in the development of a personal self and a presentation of that self. Students not only create art in the studio, they also learn to be artists in the world. The creation of an artistic identity is a central outcome of art school: what they do, who they are, and how others should respond. However, given the multiple images of an artistic career—pecuniary, credentialed, vocational, or relational[4]—emerging artists recognize fault lines. Whether we brand them as sellouts, professionals, visionaries, or colleagues, students' selves shape their lifeworlds.

Should the goal of MFA education be to produce lasting art or sustainable careers?[5] The conflict is evident in the tension between art and commerce. Economic sociologist Viviana Zelizer describes this tension as "hostile worlds," referring to alternative judgments that are in fundamental conflict.[6] As economists of culture recognize, artists are embedded in dual evaluative systems, judged by external, resource-rich publics and by their theory-rich colleagues.[7] As Pierre Bourdieu asks, is art autonomous (art for art's sake) or heteronomous (a hierarchy determined by systems of power that surround the field)?[8] Absent consensual agreement over quality, evaluation in either world is unpredictable and unstable.

Further, becoming too immersed in talk and too tied to the autonomy of academic judgment, artists risk losing their public audience. They may be seen as little more than intellectuals who play with paint, video, and marble. Despite an anti-market mentality, most students hope to balance the approval of their peers with a measure of economic success. The goal of participants in the field of art is to gain the authority to establish the criteria—feeling excited by ideas—through which their publics judge them.[9] However, despite this fizzy dream, many artists find their careers fuzzy. The dilemma goes beyond the division of art and commerce as two legitimate, but competing, spheres. As I observed, some instructors attempt to persuade students that professionalization and market awareness are in themselves stigmatizing, and that those skills are not worth having. Imagining and navigating a post-college career involves overcoming ideology and institutional barriers.

This strain is a puzzle, given how hard it is to succeed as an artist. Why are professors so willing to push their students into a lottery in which there are so few winners? Why is the hostile worlds perspective so dominant that career skills are not treated as a legitimate and necessary part of the curriculum? The system as developed, tied to the dominance of critical theory, politics, and social engagement, is more suited for a discipline in which the university is the primary job market, rather than a scrappy world of gallery representation and collector appeals.

The romantic perspective, sharply cleaving aesthetic identity from market persona, ignores the artist's role within an urban cultural economy,[10] leaving graduates unprepared for the rigors of a post-school practice. Students must transition from paying tuition to being compensated by collectors. The uncertainty of "discovery" allows young artists to believe that reputation is chance, anonymity is temporary, and success may arrive after they "pay their dues."[11]

For a nervous careerist, enrolling in an MFA program is not a secure option. Some suggest cynically that an MFA degree prepares the graduate to be underemployed, even if applying for welfare is not in the curriculum. Perhaps MFA programs are a training ground for Starbucks. There has long been an oversupply of artists, given their limited opportunities.[12] Despite the progressive politics of artists-as-makers, no ethos of sharing commissions exists, the way that artists-as-servers share tips. Political groups, such as Working Artists in the Greater Economy (WAGE), a New York activist group that desires nonprofits to pay artists whose work they exhibit, while viewed sympathetically, have had little effect.

Art is not simply shown, but known. Given this reality, how does one situate oneself in these competing evaluative communities? Students are socialized to a collegiate world in which art should be prized for its insight, not its decorative appeal, and yet they must confront the challenge of supporting themselves after graduation in a world in which too few buyers share this perspective. How can these strains be managed to craft a career that is esteemed by their publics and their colleagues?

It is here that networks matter. The ability to establish oneself through a set of relations with colleagues and supporters is crucial. This depends on displaying one's artistic self in ways that are persuasive and that generate meaningful linkages to one's chosen community. These social relations are essential within art worlds and, if handled well, allow artists to escape the stigma of careerism.[13] Internships can be productive for networking, as long as they are not seen as diminishing the artist's authentic vision.[14] Is the artist merely a follower, or is the artist a creator?

Networks have long shaped the art market,[15] so much so that one teacher suggested that the art world "governs by network." Despite dangers of insularity and homogeneity, using friendships and affiliations for access and advancement is valued.

Ultimately, art students recognize an intense market interest and its seductive power, but also respond to alternative career valuations, based on collegial judgments. Which values permit a sense of distinction in establishing a lifeworld and participating in a social field? As the Dutch economic sociologist Olav Velthuis demonstrates, value never depends on the desires of the artist alone, but rather on a network of institutions that collectively determines how to price the priceless.[16]

In Debt to Art

Despite the scorn for the gallery market, the university is itself a consumer market, part of the neoliberal economy. To be an art student is to choose debt, at least at most schools. One gives one's life over to a sense of precarity, a feeling of existential uncertainty. Although many young artists reject the neoliberal economy, when they consider their financial prospects, they know that they will be hobbled by debt. The MFA degree comes at a cost. Is it worth the creative autonomy that a degree supposedly provides?

Attending art school can cost more than attending an Ivy League college. Seven of the ten most expensive institutions of higher education in the United States, after financial aid is considered, are art schools; the proportion of student loans is higher and career security is lower.[17] In 2014, the cost of tuition and expenses to receive a two-year MFA degree at the Rhode Island School of Design was $253,000, while at the School of the Art Institute of Chicago the cost was a mere $204,000.[18] The Strategic National Arts Alumni Project, a survey of art education outcomes, found that most graduates left school with debt; more than 40 percent of respondents claimed the debt had some or major impact on their careers or educational decisions.[19] In speaking of MFA education in creative writing, literary agent Noah Lukeman advises students: "Take the $35,000–$50,000 you're going to spend on the degree, buy yourself a good laptop and a printer and a bundle of paper, and go off to a cabin and write. At the end of two years, the worst that can happen is you have nothing. Less than nothing is what you'll almost certainly have at the end of your MFA program, because, besides nothing, you'll also have a mountain of debt."[20] In a similar vein, artist Noah Bradley has created "the $10k Ultimate Art Education," asserting that "I will no longer encourage aspiring

artists to attend art school . . . attending art school is a *waste of your money*. . . . I am saddened and ashamed at art schools and their blatant exploitation of students. Graduates are woefully ill-prepared for the realities of being professional artists and racked with obscene amounts of debt. . . . That any art school should deceive its students into believing that this is a smart decision is cruel and unusual. . . . Not once have I needed my diploma to get a job. Nobody cares."[21] For these critics the university system is a scam built on government loans, no better than the gallery system. As Fred wondered, "Since they are insulated from that risk [of financial strain] by us idiots, is that driving the growth of MFA programs?" (Interview). As MFA programs grew in number and popularity, students naïvely believed that art market success would be waiting. An overpopulated field serves some well, creating a ravenous market for adjuncts, artists who will do the gallery's bidding, and a thriving housing market in hot urban neighborhoods. One socially engaged student wondered, "Am I worth the investment?" The better question is, Who profits? The impropriety of sharing personal financial circumstances prevents students from engaging in discussions that might lead to activism. At one school students talked of unionization, and a grievance was filed about the improper use of teaching assistantships. The faculty, normally reliably progressive, were not supportive. While the university gave in on the grievance, no structural changes occurred.

Simply pointing to the "obscene" cost of tuition—the rack rate—is misleading. The university provides a cushion, protecting students from the excesses of the educational marketplace. While college tuition continues to rise, few pay the full amount. Northwestern, an extreme and happy case, provides a full fellowship (now $30,000 per year) and tuition waiver for the five students that they admit. The other schools, less generous, also provide tuition waivers and some fellowship or assistantship support. As a result, universities have a different financial structure than free-standing art schools,[22] in part a result of vastly different endowments. (In 2016, Northwestern had an endowment of over $10 billion; SAIC, under $200 million.)[23] But debt remains a recurrent topic. Costs exclude some students, limiting diversity, leaving the art world to what one professor labeled "trust fund kids." Although few students are from truly wealthy backgrounds, most are children of professionals. The reference to trust funds (as opposed to cultural elites) places the onus on money, rather than on social and cultural capital that may be more relevant. Many of my informants were children of teachers; only one, a foreign student, came from a highly privileged home. The image of the trust fund kid grated on those who hoped to upend economic inequality, intensifying art school's

oppositional culture.[24] But just as there are few students from affluent families, few come from impoverished backgrounds. The university is a class system that favors children of the comfortable.[25]

The Next Step

Having received the degree, graduates face uncertainty. Students scramble to find adjunct teaching positions or short-term residencies. As Austin sighed, "I'm feeling separation anxiety. What am I going to do next?" (Field Notes). Most students speak anxiously of their post-graduation fears in interviews and informal discussions. This becomes a recurrent topic before commencement, more salient than fears of the thesis show. To graduate is to lose a safety net, however harsh collegiate critiques may be. Yale School of Art dean Robert Storr reflected that it was not until he was thirty-nine that he received his first tenure-track teaching job, reporting that he, like many of his current students, operated on a basis of "catch-as-catch-can."[26]

Of the students I met, many found positions in the *penumbra* of the art world. Several were hired as studio assistants by established artists. After graduating, they wound up in what might qualify as an apprenticeship, perhaps not so different from the pre-MFA classical workshop model, gaining an additional credential and a mentor and sponsor.[27] Others found work as photo assistants, art preparers, documenters, adjunct teachers, accountants in the arts, or gallery assistants. One parlayed her skills into becoming an aerialist and circus artist. With this employment, they hoped to sustain a practice. Absent that commitment, many drift away. As one recent graduate told me, "It's kind of like having a full-time job and a half. Being an artist is a job and earning money is a job" (Field Notes). Survey data from the Strategic National Arts Alumni Project (SNAAP), examining all arts graduates, indicate that nearly 40 percent work more than one job.[28] Beyond the penumbra, students find work doing construction, mixing drinks, selling suits, or, in one case, modeling underwear, a brief career. Most survive in the neoliberal market economy while continuing to produce work.[29]

Finding an economic perch, while establishing a career, is crucial. Given the hostility to the market, success has multiple meanings in an arts economy of galleries, grants, collaborative projects, and residencies. Not every student wishes to become "a million dollar artist" (Interview), but for what would one settle? Janice, working in multiple media, explained, "I feel like my work doesn't fit in a gallery and part of me is excited by that, but part of me wonders, well, if I don't fit in the gallery

space and that's the option for longevity in this type of career, what does that mean for me?" (Interview). Janice hopes for residencies and projects, but she is unsure if that will suffice. Sidney wants a gallery to provide a platform: a base of support for work that will be thoughtful, but salable. He is willing to have some paintings commodified, while creating work that is conceptual and of the moment, not easily fitting into a gallery setting. Each desires a life and a practice.

How long to wait? Few students find rapid critical esteem, a golden gallery ticket, or a museum show. Many suggest that the true indicator of success is whether, three to five years after graduation, the artist has an expanding resume or gallery representation: a career, and not merely a dream. But many leave the art world soon after the degree, in contrast to students in other fields,[30] perhaps with art as a sideline or a hobby. A faculty member explained: "Eventually, after two or three years with students out of school, that's when the art world weeds. . . . I was always told in graduate school that the toughest time is three years out. It's hard to get shows; it's hard to get known; it's hard to get a job. You have to negotiate a lot, but slowly, if you are working for three years and you are doing studio visits, shows will start to happen" (Interview). As Esau Mc-Ghee pointed out, "You have to do a lot of leg work. You need to go to a lot of galleries. See what they are showing. See how you fit in. You need to make your presence known. Meeting a gallerist, they know what you want. It's like asking a girl out on a date. She eventually knows where this is going. The gallerist knows the same thing. It's like, 'you are trying to get with me; it's cool'" (Interview).[31] Unlike medical school, where one becomes an intern, or law school, where one becomes an associate, the artist lacks an institutionalized next step.

A few students succeed immediately, such as UIC student Paul Cowan, who shortly after graduation had a solo show at Chicago's Museum of Contemporary Art and has gallery representation at the Clifton Bene-vento Gallery in Manhattan. Thanks to the eye of an important critic, curator, or gallerist, some artists are established quickly. As prominent Chicago-based artist Theaster Gates pointed out, "Galleries are search-ing for nested chickies to hatch." This is more likely in those locations (Manhattan, Los Angeles, and New Haven) in which gallerists trawl the halls[32] than in Evanston, Illinois, where gallery-friendly objects are treated skeptically. Few dealers visit the basement studios in Locy Hall. Still, within a few months after graduation, several MFAs had studio visits from gallerists, even if these did not result in major connections. Oth-ers, including Esau McGhee, Soheila Azadi, Hanna Owens, and Marissa Webb, were invited to show their work or to perform. Ultimately, MFA

students recognize the uncertainty and instability of their career paths. The school turns its back on the market, and the market averts its eyes from the school.

Knit Worlds

Networks provide social capital essential for career advancement; placement in these networks creates linkages to those outside one's close community. In practice, it is hard to disentangle evaluations of quality from what one owes an associate.

Perhaps I shouldn't have been surprised to learn how major shows are assembled, such as the Whitney Biennial or the international Documenta in Kassel, Germany. I had naïvely assumed that curators would visit artist studios, talk with respected dealers, recall previously displayed works that had made an impression, or rummage the internet to find appealing objects to select. In fact, many curators do not select a full roster of works; rather, they select artists and ask them to create. Typically these are artists whom the curator knows personally, admires, or has previously shown.[33] This is particularly true early in an artist's career, when strong ties matter, before they become widely known and commercially successful, and selection becomes less personal, based on communal reputation.[34]

One prominent curator explained to students, emphasizing the importance of social connections and collaboration, that she knew the artists she selected for a major show. "I've worked with most of the artists. Trust is hugely important. I looked for artists who influenced me" (Field Notes). She assumes that they will produce suitable work on time. Sometimes they don't. One faculty member whose video was selected for a prestigious national exhibit did not complete it until two weeks before the opening (Field Notes). Students learn that their connections, and the respect that results, affect their opportunities. Curators are brokers, not of objects, but of persons within a reputational field. Artist Howardena Pindell speaks of close connections in the art world as a form of "insider trading."[35] In a similar vein, a faculty member spoke of an elite network—in this case that of mega-collector Charles Saatchi—as constituting a "cabal" (Field Notes). Artists who are sociable, attend gallery openings, have "good politics," share resources, create loyalty, and talk fluently have a reputational advantage.[36] One faculty member put the case: "If you're a hermit, you are never going to make it. . . . When you are out there networking and somebody says, 'Oh, What do you do? You are an artist?' you can answer with a generic answer or you can answer with something that is

really well crafted that automatically says, 'Damn, I really want to get to know that person. I want to see that work'" (Interview). Young artists, such as Wick and Martin, skilled at self-presentation, enacting the artist role, have thriving careers. Wick connects his networking with his sense of self: "I think it is just who I am as a person that I like having a lot of people around. I like involving people in things. I like making people do things. I like being part of a lot of stuff" (Interview). Although he is troubled by the idea of a careerist network, his artistic lifeworld is a social space.

Networks have long been influential in the art market, including Renaissance Italy,[37] Golden Age Netherlands,[38] and nineteenth-century Paris.[39] Today networking is embraced in the "social turn" in art.[40] Despite dangers of insularity and "social incest,"[41] using friendships to open doors for art practice is common. Wick describes the thin line between socializing and careerism: "Part of what I was doing was with [a junior faculty member], talking to her [and saying] that I want her to be part of this show I am doing. It was the first half of the conversation, and the second half was her wanting me to do a show she is doing. . . . We have been at each other's shows. . . . Either of them won't pay any money and there is a tiny amount of glory involved so that is a way I can personally defend my level of community/nepotism. . . . Cultural capital is a nice way to talk about it" (Interview).

Within art school, networks are justified in disciplinary terms, not as mercenary strategy: Social relations are integral to the art, enshrined through the stance of "relational aesthetics." Lane Relyea is a leading advocate of this approach. Relyea writes of a network paradigm, pointing to "the rise to dominance of network structures and behaviors and their enabling manifestations . . . describing the kind of dynamic landscape it envisions in its turn toward an art of performativity, sociality, and eventfulness."[42] How do networks of socialization relate to the education of students? Relyea argues, "Art schools, for example, are often portrayed as protean networking scenes. And yet schools are also the places where artists usually confront their first set of jurors . . . [Students] form networks that spread after graduation through postgraduate residencies or adjunct teaching jobs, and also as some students get picked up by galleries or included in museum group shows. These are all opportunities for the network to make connections with other networks, but also for the data within networks to get picked through, refined, and thinned down."[43] Schools are a platform for the ambitious artist, assembling groups interested in similar projects.

As a result, some students select a school with advantages in what Louis described as "networking potentialities" (Interview). For Fred, it's about "casting your net, and ending up at the right house party" (Field Notes). Some kids receive all the cool invitations. Showing one's work depends on showing one's self. Thus, students at Illinois State, two hours distant from the galleries of Chicago, find themselves at a spatial disadvantage, and students at Columbia University, UCLA, or Chicago's downtown School of the Art Institute benefit from the nearby social ties that they can mobilize.[44] As one recent graduate remarked, "Maybe you can get a teaching position in the middle of nowhere, but do you want that? Location is important" (Field Notes). This is evident in the extensive visiting artist programs that wealthier and more centrally located schools organize, but also in that students in cities have contacts across schools. During my research, students from SAIC and UIC traded studio visits, as did students at Northwestern, University of Chicago, and SAIC in round-robin visits, sharing theory, career advice, gossip, and beer (Field Notes). These connections provide supportive relations. Illinois State handles its isolation by inviting admired artists for extended visits of up to six weeks. Marissa Webb worked closely with a Chicago-based photographer who was invited to campus.

Martin, not only a talented conceptual artist but also an articulate arts writer, explained: "Specifically the person who put me in touch with writing for this piece is [a well-known teacher/curator], who I had actually worked with before I came to Northwestern. I curated a show of her work, and so we had this connection before I got here. We have gotten closer since I have been in Chicago, because she went to Northwestern for grad school as well. . . . I do feel that I am being situated in a specific corner of the art world . . . and it is the corner of the art world I want to be in" (Interview). These informal networks permit students to enhance their careers without believing that they have sold out or given in.[45]

Sociologists find linkages crucial to most things, a driving force in interaction regimes. Theorist Robert Witkin emphasizes that social relations can drive aesthetic strategies and promote outcomes, even if artists are not conscious of how networks matter.[46] Likewise, sociologist Samuel Shaw finds that "local scenes sort into larger assemblages that may be called cliques. . . . Unlike collectives, their borders are porous. . . . Their formation is the result of repeated interaction and exchange, through which particular aesthetic concerns and problems are worked out, dispositions practiced and performed, and local-centrality is generated."[47] With open boundaries, networks expand and group members work together.

Collaborative circles merge. While quality always matters, it results from preferences arising from a field of social relations.

Like the decision of whether art school is a sound investment, time budgeting matters. Should one attend museum or gallery openings? Sociologist Alison Gerber finds that artists deliberately invest in their practice, committing scarce resources to network-building. An informant explains, "We have to go to this bar for this afterparty and the drinks are $24, but I'm going to go . . . because I need to be around these people."[48] Students differ in their involvement in the art scene, but some, like Vincent, go to gallery openings each Friday, learning of current trends, making connections, trading favors, and building networks. Partners of art students can be used for networking purposes if they are integrated in the art world. One partner was an arts administrator, another a curator, and a third an arts writer. I was told (with lush gossipy details) that the choice of one's partner may result from a desire for advancement. Not just sleeping around, some artists sleep ahead.[49]

The school becomes what one faculty member termed "the first network": a web of classmates and instructors who pen letters of reference or provide connections with dealers or curators. "That first network that you come out with is really vital for the rest of your networking" (Interview). As Esau McGhee reflects, "Once you [graduate] you still have to work at developing your art world. The community is your art world. The art world is not just one universal bubble that everyone operates in. Everyone's art world is different, and you can jump into other people's bubbles, but then you are operating in their own little art world . . . I have the fourteen people I have met [as fellow students]. Now I have to work at developing some sense of community with them once we leave here" (Field Notes). A recent Northwestern graduate described his first post-school network:

It is kind of neighborhood-based now. But there is a friend who is a musician and was formerly associated with this gallery called Incubate. And I met him when he was working in the art history office at Northwestern. Sidney and his wife live around the corner from [me and my partner], and then Bridget and her partner, they live just a mile away [Sidney and Bridget were students at Northwestern]. So that is kind of what my community is right now, and then Carl and Charlotte. Carl went to UIC and Charlotte is there currently as a student. And then Nancy, who was in my year, she and her partner. She lives in Logan Square, and so I still stay in touch with her. . . . There is something about being an artist today and being part of an art scene; that having an affiliation with an institution, like a grad program, kind of helps people take a temperature of

what kind of artist you may or may not be. I found that moving to Chicago and being a part of Northwestern, and saying I went to grad school at Northwestern, people knew the faculty that were there and the reputation of the program, and that helped me gain visibility in the Chicago art scene. . . . I started to make more of a name for myself in Chicago and network a lot more . . . Through the Midway Fair I got connected with Aaron Gent, who runs the Document space, and I met him actually at a fundraiser for this organization I am a board member of called Summer Forum. It is a residency program basically for discussion and conversation around contemporary texts, and we were doing an art auction and Aaron was there at the art auction, and both Nancy and I introduced ourselves and he gave us his card, and we did a studio visit with him. . . . We each met with him and then he offered us a show at the Midway Fair a couple of months after that visit. (Interview)

This lengthy extract suggests how in a robust urban art community young artists advance their careers, linking to those with other institutional standing. Post-school networks build on peer connections from classes and critiques, adding friends of friends. Learning what and whom dealers and other artists admire can make building a network a form of market research.[50]

Faculty Brokers

The student community is important as the first network, but faculty also provide links to career-advancing institutions. In some instances, faculty are brokers for their students. For disciplines like sociology, this mentorship is vital and expected. I write many letters, promoting students that I admire. The rules are less certain in the visual arts, where faculty have limited powers of sponsorship[51] in a market in which university hiring is rare, in which museums show artists with established reputations, and in which gallerists gauge the preferences of collectors. Further, as Judith Adler points out, faculty may treat their students as competitors rather than protégés.[52] I heard varied opinions of the propriety of faculty promotion of students. A faculty member noted, "When my gallerist comes to town, I try to arrange studio visits with alums that I think she will be interested in, and that has been really effective. So last summer there was a show in New York with maybe three alums from our program" (Interview). A second recalled his own student days: "The faculty were known to be people who could make those connections . . . when I was a student a certain professor took some of the work and showed it to a friend who used to have a major gallery, and people get sort of plucked

out of the general population of students. We expected that would be one of the features of the school, but nobody talked about it officially" (Interview). A third faculty member said, "I always am keeping students in mind about things that I am thinking about doing, and if there is a place for them." I asked if he would introduce students to his gallerist, and he replied, "I would introduce them as in 'hey, you should really look at this person's work because I think they are doing great work,' but on a very, very selective and careful basis" (Interview).

These claims of support were, on occasion, matched by actions. A faculty member said that he once took a curator for the Whitney Biennial to the studios of recent graduates he admired. In another case, a professor invited Soheila Azadi to participate on a panel on race and gender sponsored by an informal group of feminist artists that the professor organizes. Soheila said with gratitude, "It was such an excellent experience for me, because it opened every door to a huge community that appreciated having me. Now strangers come up to me and say, 'I saw you in the panel discussion and I agree with what you said'" (Interview). Most dramatically, given that the incident was mentioned by several students: "Out of the blue [a faculty member's] gallery contacted a recent graduate and said that [the faculty member] had suggested her for a show, and the gallerist came to Chicago and visited the studio, and now she is exhibiting with this New York gallery in a very visible gallery space. So clearly there are network potentials, but it came as a great surprise to [the student]. She had no idea [the faculty member] felt strongly enough about her work to stake her own reputation on it" (Interview). While discouraging a focus on the market, faculty do provide entrée on occasion, even if they do not consider this part of their responsibility. The last comment is revealing in suggesting that the recommender is at reputational risk through the gallerist's evaluation of the student, a problematic matter when hierarchies of good work are uncertain and unstable.

As a result, some faculty explained that they were unlikely to make connections. Yale's Robert Storr remarked with some asperity, "Art schools should not be a dating service that matches the young and the restless with avid art lovers."[53] Faculty, even those who will pass on a name or express admiration, avoid extensive networking. Galleries, operating outside disciplinary control, base their decisions on financial constraints of which artists may have little awareness. As one faculty member noted, promoting a student can be a delicate matter: "It's not a network in the sense that we just get on the phone and say, 'I have a good student. They deserve a show.' . . . I work with a gallery in New York, and it's not very likely I would grab a student and walk in and say, 'You need to meet

[this person].' . . . Part of it is just understanding how much is at stake for the gallery that I would feel presuming a little too much, but I would certainly bring up [the student's name] in conversation with a curator that I am having coffee with" (Interview). A second faculty member commented: "There have certainly been instances where I have been able to make some introductions and be helpful. But . . . I try not to be viewed as the one that's going to get them the teaching spot or get them the exhibition. . . . I figured out early on that wasn't my responsibility; that they needed to be independent of us and find their way" (Interview). Understandably, students, having invested time, money, and emotion, feel that faculty should do more. However, given the belief that the artist must advocate for her own work, and given the idea of personal creativity, the faculty-student linkage lacks the expectation of sponsorship found in other disciplines with more organized job markets and institutional relations. Within the art world, recognition exists that your network defines you, and, as a result, promoting a student or a colleague can have consequences for one's own position, both positive and negative.

Imagined Audiences

While the artist's ability and the work's content combine to create an artistic reputation, audience response is vital. Art is not simply displayed, but viewed. As James Elkins perceptively points out, an artist's stature depends, in part, on chance.[54] A thunderstorm on the night of a show's opening, mislaid publicity postcards, or a single negative review might strangle a career. In contrast, an important opening in the gallery next door, or the presence of an influential acquaintance or a motivated critic might prove crucial. Often, in what is termed the Matthew Effect, positive publicity generates additional notice through a process of accumulated advantage.[55] Without good fortune, a career can reach a dead end.

Emerging artists are fortunate in that museums have become more willing to show contemporary art, and audiences are increasingly likely to appreciate this work, whether they understand the artist's intention or not. Lane Relyea points out, "Museums are attracting ever larger crowds by embracing contemporary art with . . . its motley barrage of readymade and everyday materials."[56] Still, acceptance takes time. Just as modern art was transformed from once being the butt of jokes about the ability of babes into a major and extremely popular art movement, transgressive or casually made contemporary art can seem risible or repulsive. Museums might find a place for Lena's minimalist cardboard

constructions, gathered from streets and closets, but some viewers will be skeptical. Knowledgeable audiences in global cities—those who understand the artist's impulse or who claim to do so—flock to displays of leading contemporary artists, vouched for by trusted reviewers. This legitimates the visions of emerging artists, permitting them to display their works, receive grants and residencies, and gain gallery representation. Of course, given that thesis shows are held on campus and some exhibitions hide in apartment galleries—even using a student's car trunk or an artist's clutch purse as a gallery space[57]—the audience for the work may be narrow, but the hope is wide. Can they attract the gaze of "civilians" or "normal people" (Field Notes)? How can the work "circulate in the world"? This desire, tainted with ambivalence, is reflected in comments by two young installation artists, respectively, Evan and Martin:

I definitely strive to make work that addresses everyone. That may be a crazy thing to say, but my hope is that. Maybe another way of saying that is to say I don't want to make work for a niche. I want to make works that have the ability to resonate not only with someone who is familiar with the discourse of art, but someone who pumps gas.

I always say I am interested in cultivating an audience of curious viewers. . . . The only baseline expectation for who could appreciate the work . . . was curiosity. (Interviews).

As I asked in chapter 3, should art be made widely readable or specialized for colleagues as Milton Babbitt suggests? Like sociologists who attempt public sociology versus those who write for peers, practitioners consider their audience. Given the craving for broad impact, *Nation* art critic Barry Schwabsky writes, "The people who make up the art world often wonder if their culture is really central at all. Undoubtedly they believe that it ought to be, but they are deeply aware that there is something eccentric about their relation to the culture at large, something fragile. . . . The art world doesn't know whether it is a subculture pretending to be a culture or a culture pretending to be a subculture."[58] By gaining authority over its criteria of judgment, art as an autonomous discipline separates criteria of judgment from those of wider publics. A creative writer, perhaps echoing Babbitt's concerns, spoke of a colleague, a former poet laureate of the United States: "He feels people won't take him seriously because he is too accessible" (Field Notes). If an artist becomes too celebrated and too separated from the arts community—and Thomas Kinkade is the poster child for this in the visual arts—she may lose the commendation of the profession.[59] One art student, Casey, an

expressionist painter, explained that both his mother and sister encourage him to produce works that are less esoteric. He told me, "My mom wanted me to be a landscape painter. Whenever she comes to a show, she asks where the landscapes are." He sighs, "Ninety-nine point nine percent of the world doesn't care about what I'm doing in my studio and never will, but I feel obligated to do something to speak to social issues" (Interview). His family desires work that they can hang above their couch, while he hopes that his work will disturb those on the settee below. Sidney, an African American conceptual art student, comments similarly: "Who is your audience? How are you communicating with them? I think I am communicating with several different audiences that exist in different registers. There is an audience that will come in that is maybe a lay audience and can only just respond to what you put in front of them in the most naïve and open, unpredetermined way . . . and then there is another audience that will look at the catalog and try to find out about me and have touch points in contemporary art and identity politics, and they will get their own content from it" (Interview).

A chasm may exist between the profession and the public, assuming that a public can be found. In talking of his own work that he claims is "appealing to a populist kind of positionality," Sidney notes that such a public stance is controversial within his program that emphasizes the disciplinary response to the work (Interview). The artist wants to be in the world and in the discipline. She hopes to reach across the boundaries of social fields, but the fences are high. Through the critique and studio visit, a young artist learns what colleagues feel about the work, but public judgment is less certain, as most responses are polite and are judged through sale prices. In open venues, or quasi-open ones such as the thesis show, the artist looks for unmediated responses: smiling, conversing, grimacing, or turning away. Casual audience members rarely respond directly, so indirect cues are all there is. In reality, only a specialized audience lays eyes on the artist's work; most of the population has little desire to do so.

The Teaching Artist

Given the actors in the art world, the greatest influence on students is their instructors—men and women who model what it means to be a successful artist and, for some students, model what they hope their career will entail. Art education is not simply gabbing, but an educational

forum in which teacher-artists are expected to be guides, even if this guiding is couched in words. The hyphen is deliberate. They work the line between pedagogy and criticism: advice, friendship, appraisal, collaboration, and competition. Educators should be caring mentors and candid critics. But given their personal histories, instructors will have different emphases. Some desire to be artists with a teaching sideline; others wish to train a new generation. The strains are inherent in the role.

Institutionally the university is a mechanism of transmission; the minders of that machine are professors. Even in fields—and art is one—where education may seem hopeless, even irrational,[60] someone must instruct as long as there are students who pay for the privilege.

With the growth of university-based art programs, teachers became role models. Undergraduates learn that artists belong in the university, that an advanced degree is valuable, and that, if they wish to be real artists, the path is through the MFA. Although many students see teaching as a means to survive an uncertain market, a few desire these positions as ends in themselves. Evan, an installation artist with an interest in social science, explained: "Teaching could be a great component of being an artist. It could pull you out of your studio, out of your head, out of yourself. You could really be challenged by your students. I also think that teaching art is a way to keep your practice fresh. Teaching art is also learning how to make art" (Interview). For Evan, to be a teacher is to be a student. This is a happy vision, but it is notable for the vitriol of those who dissent. Consider the remarks of Dave Hickey: "Art schools are unhappy, ugly places. They tend to inculcate philistine, institutional habits of mind and to teach young artists more about teaching than about art. Since teaching art has been destructive to the practice of every artist I know who teaches, I try never to forget that the few good, serious teachers of art pay a price that's way too high for the privilege of doing it."[61] Hickey's claim is unfair. Many students revere their mentors, because of either pedagogy or talent, and, as is true elsewhere in the academy, an array of students find an array of mentors. At UIC, almost all of the instructors were revered by some students, grateful for the inspiration that these men and women provided.

Perhaps the most powerful effect of the growth of MFA programs is the creation of a job market. As of 2017, Esau had taught at the Milwaukee Institute of Art and Design, Soheila at SAIC, and Marissa at Lincoln College. Being a practicing artist provides little in the way of security, except for the most fortunate practitioners. As the late Chris Burden, formerly a tenured professor, opined, "People think collectors support artists, but it's universities that support artists."[62] Many artists have day-

time careers and work on their art evenings and weekends, but teachers are artists throughout the day. It is not that those who cannot do, teach. Rather, those who desire security find the academy appealing. Some artists value teaching as part of their practice, while others lecture until a big (or small) break. Some faculty oscillate through the academic membrane: teaching, then choosing a full-time practice, then returning to the classroom. Others teach and also sell their work. These realities emphasize the danger of a too sharp division between academy and market.

Becoming a teacher, while embedding oneself in an institution, provides a financial haven, permitting a measure of autonomy.[63] This is particularly true for artists outside the New York City orbit. Los Angeles is known for a culture of education, and students benefit from these artists who are part of their social world. As New York gallerist Andrea Rosen reflected, "A big part of being in the art community in L.A. is being a teacher."[64] One prominent faculty member suggested that, as a result of a series of articles on Los Angeles, "it became kind of glamorous to be an artist who also taught. . . . Now you get people who really don't need to teach who have a kind of nominal teaching job at some of the glamorous departments [such as] Columbia and Yale" (Interview). He speaks of this as the "pedagogic turn in art," an orientation that depends not only on academic hiring but also on visiting artists. Still, New York's art world is not primarily an educational culture. Chicago, culturally as well as geographically distant, is in between, with some prominent artists having teaching responsibilities. As is true of creative writing, academic positions are patronage: cash subsidies and academic sinecures.[65]

The institutional pressure within universities is to gain a reputation: to become known, not to become rich. Engaging with the gallery system is only one way; appearing in major shows, receiving awards, or being the subject of critical notice also builds one's resume and one's cachet. Being an artist brings one into collegial contact with others who share an interest, even when they maintain different styles of work or systems of worth. But when market valuation contrasts with academic valuation, a bifurcated reputation market emerges. As with all disciplines, an art department is a world of specialists (a slot for a sculptor, video artist, performance artist, theorist, photographer, social practice artist, and the like). As a result, departments hope for diversity, collegiality, and shared commitment to building a local culture.[66]

Among the professors I met, most felt that hiring depended on the quality of the work, not the ability to transmit skills.[67] A prominent art educator made the startling claim that his *lack* of teaching experience was crucial: "I was not in the adjunct pool, no one knew me, they only

knew the work."[68] One faculty member remarked tartly, "I argued vo-ciferously that what we needed to do is to train artists and not to train teachers. Doing this [hiring teachers] won't get you attention in the art world. You need to hire people who will give you attention in the field. You can't get jobs without having a significant career" (Field Notes). Ex-hibitions are privileged; teaching skills are barely considered. Educators may be considered "failed artists" by their museum-oriented colleagues, described as "hating" the art world because they couldn't "hack it." Such snarky views are heard when artists who participate in the gallery scene consider less prominent colleagues.

In my observations, even though many classes were inspiring, most were not primarily concerned with transmitting a body of material, but rather aimed to weave webs of interpretation or promote dialogic encoun-ters. Lecturing from notes was rare, and discussions were semi-improvised. With reference to Dave Hickey's assertion that MFA students learn little but how to teach, I found scant evidence of his claim. Little systematic instruction in pedagogy is evident, no evaluation is based on teaching (at least none that mattered), and there is no recognition of the best teachers. What made a "teacher" was a diploma and a portfolio.

In this sense, one cannot properly suggest that MFA programs train teachers, even though some students are assigned as classroom assistants. One school offers a course on art instruction, but it lacked practical tips. A student reflected, "I took a seminar on pedagogy. It was pedagogy and contemporary art, and we rarely talked about practical things on how to teach or modes of teaching. It just felt like three hours of being talked at about an article, and not tying it back into today" (Interview). Marginal-izing teaching may happen in other disciplines, but the absence of lectur-ing in art programs, as opposed to hands-on instruction, suggests that teaching is an esoteric art form. Further, cycling in and out of adjunct and visiting faculty positions is common. Robert Storr, dean of the Yale School of Art, noted acerbically, "The allocation of labor in the educational sys-tem resembles migrant farm labor in far too many respects, and it's been that way for a long time."[69]

Buddies and Mentors

If the teaching enterprise is ambiguous, the relationship between pro-fessor and student can be intense. Prominent artists often point to their mentors as inspiring. At its best, a bond is simultaneously collegial and instructive. Recalling his days at CalArts, Eric Fischl remarked, "We were treated with the same respect as our teachers. In fact, we weren't even re-

ferred to as students but as young artists or artists in training. The school expected its professors to teach by engagement, suggestion, and example, not by rote or coercion."[70] This shared fate applies to the art schools that I examined: Students and faculty were in the trenches together.

A collegial structure was the model. Some faculty members asked students to critique their work, although the responses were rarely as critical as what students received in return (Interview). Students and faculty collaborated on projects, such as a visual investigation of the environmental impact on the Venus Flytrap. They occasionally presented their work in the same shows or applied for grants together. Unlike the case in many disciplines, a belief exists that the work of a student should not mirror that of the faculty mentor. There should be no "departmental style" (Field Notes), even if that style is noted by those outside the precincts.

This can be a challenge for students who enter a program without a firm artistic identity. Esau McGhee was such a student. He said, "Northwestern was very integral in changing how I see things. When I came here, I just wanted to be a sponge and be moldable. Some people come to grad school because they want to refine what it is that they are already doing, so therefore their approach is you are looking basically at a two-year residency. [I felt] you are my professor. I am the pupil, and I am here to do better. I am your disciple. Lead me" (Interview). In time, Esau developed his own style, and now, after graduation, he has an artistic identity and signature style.

In contrast to other departments, close personal connections exist between faculty and student. This includes a drinking culture and stories about intimate relations. One faculty member meets with her students at their studios on Saturday. Daylong critiques, such as Michael Asher's twelve-hour critiques, while not duplicated at these schools, reflect a profound commitment by art faculty and an equally profound informality. In addition, departments invite visiting artists to pay studio visits, linking the university and an external art world by creating collegial spaces.

However, the spatial realities of the university militate against frequent access of students and faculty. When faculty and students meet, the relations are intense, but their lives do not always intersect. At all three schools, faculty studios are off campus. These schools do not provide faculty with the equivalent of labs, and many faculty members rent space in urban industrial corridors. As a result, some faculty are known for their absence from campus.

The three schools handle the relationship between student and adviser differently. Northwestern assigns advisers to students on a rotating quarterly basis, so that a student will have six advisers over two years. At UIC

a student is assigned an adviser on entrance, although the student can change advisers; each semester the department appoints a four-person critique committee, composed of three faculty and an outside member, that visits each student's studio and evaluates them, in addition to the critique encounter. At Illinois State, the students choose a committee, a decision based on their genre of choice. With a single adviser, the UIC system produces more intense relations; ISU provides a strong community; and Northwestern builds a wider network. In some critiques, faculty "defend their students," while on other occasions they remain silent, waiting for post-critique meetings to express their candid opinions and to process those of their colleagues. When the advising relationship sours, the reality that the adviser is the face of the institution leads to trauma, anger, or grief. Trainees are not judged by "the field," but by hired representatives of that field. The closeness of the advising relation allows some students to feel "jealous that some faculty and students are buds" (Interview). Although teaching can be passive, mentoring is intense. The academic intimacy that may characterize faculty-student relations in other departments is amplified in the hothouse of contemporary art.

Curator Culture

While the artist's name is on the marquee, audiences, whatever their motive for attendance, respond to objects in place. Boris Groys provocatively writes of "the space of an artistic installation [as] the symbolic private property of the artist."[71] However, he misses the curator who often has the last word. The artwork must be sited to gain meaning, placed in context. The exhibit, not the individual object, becomes crucial. As individual works matter less, curators matter more in arranging temporary shows of artist collectives, choosing conceptual art, organizing multi-object projects, and devising career retrospectives. Although people pay to see the actors, the director defines the experience. In contemporary art, the assembly of objects—the installation—has gained significance.[72] Some in the art world suggest that curators, as selectors of the excellent, rival faculty artists in being integral to art education.[73]

For many MFA students, the first formal connection that they have with the world outside the program is with the curator who is assigned to arrange the capstone thesis show. This may be the only time that the presentation of their work is targeted beyond friends and colleagues.[74] This is a simulation of market and public presence, potentially showing

the work to a wider audience, not only one's friends and colleagues. Students tiptoe into the market with the curator as a guide.

The curator may be a staff member at the university museum or gallery (as at Northwestern or Illinois State) or an independent contractor hired for the purpose (as at UIC). Protected by university practice, the curator is less swayed by the conservative impulses of donors and gifters who constrain the museum, but the curator still provides a taste of the museum world, giving practical insight into how works are transformed from university-worthy to public-worthy. The larger audience of the thesis show might include critics, gallerists, museum donors, or simply art lovers.

In a formal space, work that once seemed casual appears carefully considered, thoughtful, and even elegant. The museum provides the context for interpretation. For the thesis shows at University of Illinois at Chicago, the guest curator worked with five groups of four students in creating a week-long display for each group. Each group was required to provide a common statement explaining how they conceptualized their show; this document shaped the installation. Like all professional curators, Mary Jo hoped to present the works in their best light, but also to have the works "in conversation with each other." She frequently referred to sight lines as a means of sparking this conversation. Her point was that she was not displaying pieces, but rather forming a show. Curators often treat their choices as intuitive, based on "feeling right": where everything comes together.[75] I watched as Mary Jo delicately worked with a group of students, determining how to arrange their work. She persuaded Hugh, the wood artist, that his pieces should not be placed parallel to the wall, but rotated to give them greater presence, and advised Janice that her photographs would have increased effect if grouped together. She even suggested that wall labels not be placed too low, so viewers would not have to bend down or else ignore the texts. Mary Jo saw her work as educational, but told me that students should have the final say. She tried not to overwhelm them with choices (Field Notes). While students at UIC were enthusiastic in creating a group show, the problem at Northwestern was that students demanded their own turf, worrying about their own voices being muffled (as mentioned, they titled their show *Archipelago*). The museum space was arranged to create five visually distinct areas. In a previous thesis show, Martin convinced museum employees to wear a selected perfume subtly to convey a message about "queering the gallery," a fragrant institutional critique.

But tensions emerged as well, as students began to find the limits of institutions that they did not control. Jeffrey, the video performance artist,

32 Thesis show, *Sod in the Gallery*, University of Illinois at Chicago, 2014 (photo by author).

explained that he was frustrated that the museum demanded specifications months before the opening, while he was still deciding what to display. He griped, "Everything has to be premeditated. The gallery is given a plan and there is no going back" (Field Notes). Flexibility is frozen. In another instance, Janice wished to install a carpet of sod in the gallery for her environmental project. Although this was permitted, she groused, "When I get multiple emails showing that someone hasn't read my proposal and [they] are asking the exact questions that are answered in the proposal and then when I say I will use whatever cleaning products are recommended by the gallery . . . and they ask what kind of products are you going to use. . . . I feel like I'm not being treated as if I were an artist" (Interview). She felt that she was seen as a student and not as a professional. Of course, a visiting artist would not clean the floor or patch nail holes after a show. These negotiations reflect policies about the gallery space: Could sod be laid (yes), walls built (yes), or holes cut in the walls (no)? Institutional decisions affect how the public will find the work.

The Shadow of Markets

Do the protected precincts of school adequately prepare students to emerge in a gallery-oriented art world?[76] Thorny words in a university

critique do not provide market skills, where both overt criticism and open checkbooks are rare. As sociologist Judith Adler recognized, "The school setting itself may be perceived as dangerous in its failure to stimulate the skill of sharp hustling which will be required for survival in the outside professional world. Easy access to valued equipment or valued attention is seen as a threat which can lull students into a softness which will do them little good when they suddenly have to be warriors to survive [in] a Hobbesian real world."[77] Who will help? How collaborative is the art world, post-schooling? Vincent, a conceptual artist, put it forcefully: "You get out and you are drowning. You are alone. Your community is gone. You don't have any access to all your labs. You don't have any equipment, and you are just totally screwed, and that's not something they prep you for. There's not an exit class" (Interview).

Many professors with their secure positions attack market logics and encourage students to select practices that distance them from dealers and buyers. Students, concerned about the future, are ambivalent. Many students wonder if gallery representation is essential for their practices. They often discuss how—and whether—they can monetize their practice, a persistent challenge for those who are conceptual or performance-oriented. As Pierre Bourdieu writes in his magnum opus, *Distinction*, art demands a distance from necessity.[78] *Real* art cannot be motivated by profit, or so it is said. As one student at the University of Chicago noted, a strong ideology exists of "Don't be a professional. Don't sell your wares." Avoid being a peddler. This student explained that a student who focused on showing at an elite River North gallery in Chicago would be scorned by colleagues.

The ambivalence of desiring to be represented by an elite gallery is palpable. Hakim, committed to selling paintings, commented: "There's a notion of purity in what the production of art offers to society, that it should not be sullied by the concerns of commercial interest and that you somehow taint the maximum potential for artwork or performance to be catalysts for real long-term transformation in society. . . . Somehow these things become tainted when you talk about making a living and the exchange of those things in a market" (Interview). Hakim wants a strong reputation and a comfortable life, and painting, perhaps more than other genres, will permit that to happen. He hopes to find a middle ground between these hostile worlds. Another student dismissed a colleague, saying, "I really have trouble listening to someone like Brock talking about the game and making it. . . . It seems he would stop making work if he didn't have anyone to sell it to" (Interview). This anti-market perspective was pervasive, but I also knew of students who secretly hoped for a big break. As with Hakim, these two perspectives may be joined in the same

artist: desiring sales, but fearing that embracing the market is discrediting. This privileges conceptual art: art that rejects traditional gallery spaces.

The reality that "the art market simmers under all of these schools"[79] forces students to consider how to build a career that incorporates disparate values. Students must face an art world split between allegiance to competing institutional structures—galleries[80] and universities—each with its own preferred form of valuation: The former values market investment/beauty and the latter occupational identity/activism.

Whichever path is chosen, art programs do little to train students in marketing, negotiating with galleries, or building a stable career. The division between art and commerce is powerful in designing the curriculum. This absence is caustically underscored by critic Dave Hickey: "Teachers of art practice have one overriding obligation to their students: to be intimately familiar with the contemporary standards of art practice, discourse, trade and exhibition against which their students' work will be measured—so their students will know the unspoken rules they are choosing to break or not break."[81] As UCLA's Charles Ray recognized, a fundamental difference exists between art students and young artists: "Young artists get galleries. Students study. Simple as that."[82] Perhaps Ray might have noted that both make things, but one audience is teachers and the other is dealers and collectors.

Northwestern once offered a course on career development: "professional practice." As a faculty member described it, "There was a point up until recently where there was a practical course that had to do with how to write grants and how to get shows and who to contact, and the kind of logistical stuff that artists need to know." However, departmental faculty felt that this pragmatic training was not what a serious program should offer, and the course was dropped. The professor continued, "Some of the complaints I have heard coming through MFA programs is that [students] come out with no practical skills. How do you make networks? How do you find connections? That is something that is so taboo to talk about. That means you are being careerist and selling out" (Interview). In a world that disdains market logics, this training is rare. According to data from the Strategic National Arts Alumni Project (SNAAP) survey, most MFA graduates are dissatisfied with the career advice that they receive. While 84 percent are very or somewhat satisfied with their art instruction, only 44 percent are satisfied with their career advice.[83]

Programs differ, and some schools do teach professional practice, but these courses are rare, so much so that a session at the College Art Association meetings attempted to persuade faculty that they should do more to train students to establish careers. The chair of the well-attended ses-

sion emphasized the marginality of the topic by joking, "I'm glad to see all of you geeking out on professional practice" (Field Notes). Nothing similar was said in sessions that dealt with art-making. In lieu of courses, schools offer workshops, inviting curators, gallerists, or artists, sketchily mapping the field that students will soon enter. Faculty members seemed uneasy talking about their own gallery representation, and uncertain if they wished to divert students from an artistic vision in the name of market forces.

In the Market

Unlike chemistry, philosophy, or sociology, a large audience cares about art, travels to appreciate it, supports institutions that display it, and willingly spends considerable sums to possess admired objects. Art enhances our homes, as each collector is the curator of her own museum.[84] Stuff on the wall makes a house a home. Buying art is not a cold transaction, but a warm one. It is an act of love, or at least of like.

In order to survive financially, students must be persuaded that these transactions are not stigmatizing, and faculty and colleagues are not always supportive of this. As painter Elizabeth Murray explained in a letter to a young art school graduate, "Showing your work—eventually selling work—is not evil, and it is a natural process. You are not selling your soul, you are earning a living. . . . If you make some money and get attention for what you have done, your friends may be envious. Forgive them—you'll have those feelings, too."[85] We have not yet reached the point that Lane Relyea suggests is coming, in which patronage is replacing purchase and in which museums underwrite research.[86] Patronage has its own problems, creating a hierarchical market that demands personal deference from artist to funder.

The debate as to whether artists have "sold out," a phrase that sounds precise but may be anything but, must consider present and future alternatives.[87] Self-interest and selfless devotion may be impossible to disentangle. One can convince oneself that what is best for one's career is best for the art world.[88]

Money is so tempting that metaphors warn of the eager embrace of mammon. Some students claim to find the market "kind of dirty," feeling that openings are like "a convention-center trade show," something to avoid (Interview). Others are offended by artists becoming "brands," recognized and comfortable styles that are strategically useful in that collectors may want works that are easy to live with and radiate "refinement," a skill that Thomas Kinkade perfected, to his reputational discredit. This

was clear when a fellow student told Sidney, "I'm always troubled by your work. It's like Miley Cyrus selling her jeans at Walmart." Sidney, less offended by the market, retorts, "I think selling a part of yourself at Walmart is part of the point" (Field Notes). As the Walmart references suggest, students worry about an art world ruled by fashion, sales, and greed.[89] Students talked of the "whorishness of the market." One sells part of oneself that should be sacred.

At one of the few critiques in which the issue was raised, a faculty member told a young painter that he should not obsess about the market: "The market will find you if the work is good enough." Another faculty member reacted dramatically: "We don't want to talk about market conditions. It's making me a little nauseated" (Field Notes). On another occasion, in a workshop on career opportunities, a professor announced: "There are some of us who are not in the market. I don't have a gallery. I had a gallery for three years. I might have been more prominent if I made work for a market" (Field Notes). At one point in this session, designed to describe life after graduate school, a department administrator added, "You don't have to show in every gallery. You don't have to eat shit. It tastes bad. [A big laugh followed.] Put that in your book, Gary" (Field Notes). Filthy lucre, indeed. The session provided a tocsin about a toxic market. This constitutes an identity hedge against artistic failure, constituting an academic position as the sign of success in part because it does not require a market embrace. Identity is important in the arts, as in all occupations, and by rejecting commercial success, young artists can preserve their self-esteem by claiming that continuing financial struggle equals moral worth.

This occasion was one of the few times that pricing of artworks was mentioned—a deviant topic of rapt fascination for students, approached gingerly or with horrified disdain. A gallery director explained, "The pricing is the value you see in your work. If you price your work too low, it seems that you don't believe in your work. If it's too high, you believe in it too much, but you want to get your work sold. The art market is kind of like the Old West," unregulated and brutal (Field Notes). I wondered how I might monetize my faux Monets. An hourly rate in a wage economy doesn't figure in to market valuation. More to the point is the faculty member who, in speaking of environmental artist Robert Smithson, emphasized that "Smithson says that few people are able to control what they are paid. Consecration in a museum really puts the value up, but Smithson says that an artist alone can't create his own monetary value" (Field Notes). In this view, artists are dupes in a world that they do not control.

Faculty emphasized how much the art world had changed (for the worse) in the last decade, becoming more commercial and more tied to seeing art as investment. To be sure, this has been said for decades, as the world always is in decline from a Golden Age, but it was no less believed for that. Multiple systems of valuation are available,[90] but some hierarchical judgment is always present.

Preparing for a Hostile World

Art students need audiences, but how to reach them? How does one access the world, or at least the art world? Virtually or physically, emerging artists wish their works to circulate, but wishing has its limits. Museums trade in established names, even if these grand institutions are now more open to contemporary creators and challenging forms. Rarely is a young artist plucked out of obscurity by an ambitious curator or inspired gallerist, but lotteries do have winners. More often, the young artist finds smaller spaces, such as apartment galleries or local art centers, often managed by colleagues and friends. One might imagine that students could look to their schools for career advice, but this is, like learning technique, hard to come by.

How do young artists, anxious as they proceed through their MFA training, think of their efforts and their debt? Can they reach their desired audience, and gain appreciation? Can they be strategic, while avoiding the stain of careerism? They pay their dues until success and market embrace, or until despair, giving up the dream, satisfied with being a teacher, working in the penumbra of the art world, or treating art as avocation. The crucial issue is how, considering their present, artists conceptualize their future, facing a world that they see as uncertain and perhaps as hostile to their most tightly held values.

Despite the image of the isolated creator, strategizing alone, art careers build on collective action.[91] This village, Cultureburg, is a space of networking. Contemporary art as a field of practice requires mediators: curators who figure out how to display works to their greatest effect; gallerists who believe that they can find appreciative moneyed publics; critics who discover new truth; and instructors who know the way. Each provides linkages between the students and the world, even if faculty mentors post warning signs.

The relationship between mentor and student is often crucial: The former are present for the long haul and the latter, as trainees, for the short. Mentoring is built on relations of friendship, advice, advocacy,

and power. But wait. Given that training is less about the transmission of technical knowledge—or technique—and given that theory may not be of much concern to collectors, some students outpace their instructors, with all the oedipal threats that this reversal entails.

The competition between faculty and student is moderated by the fact that faculty are hired because of their work's renown and their reputation. Having esteemed teachers is crucial, and stature, not skills in pedagogy, is the basis of employment, especially in elite institutions. Perhaps the best that can be expected is that instructors—individually and collectively—are aware of the mapping of the art world and will share their wisdom, not hide it discreetly.[92]

Curators and dealers pose other challenges: looking out, not in. These colleagues are rarely seen on campus, but they are often dreamed of. Curators help to prepare the thesis shows of graduating students, and this may be the first time that students have the experience of a museum-like (or museum-lite) context. This is a socializing experience, forcing students to face the world, even if they may not have a similar experience for several years. The gallerist, at least at these protected midwestern schools, is typically a campus guest, invited for words of wisdom at workshops or words of critique at evaluations. A few students arrange meetings with gallerists, but I am not aware of any who came to be represented by a major gallery, although perhaps that had happened several years out. In each case, these relations force the young artists to consider their goals and their identities, the desire to "make it" and the fear of "selling out."

For any professional world, the work itself is not all; participants must find ways of being through identity work. Identity develops from the world that surrounds them. By adjusting to an obdurate economic order and navigating a complex network, art students can think of themselves as professionals. Emerging artists must break open the university's cocoon if they hope to have a stable professional and personal future. Given suspicion of a too-direct involvement in a materialist, monetized world, the process is often fraught. Students are torn between hostile worlds of valuation: art and commerce. Is it more virtuous to be starving and devoted or secure and recognized? These alternatives channel how MFAs imagine their future. Drawing on advice, support, and commitments, students get by with the help of their friends. Will they reject the lifeworld of a celebrity artist if offered?

Career outcomes are built both on structures within the institution (the university) and structures beyond (the art world). Finding a secure place within an art world is validating, but depends on overcoming the absence of occupational tracks. Lacking these recognized paths, evident

in law, medicine, and academe, the future is hazy. Should we be surprised that within five years many artists put aside the dreams that graduate education provides? This chill reality is to be expected, given the over-supply of artists, but that does not make it easier to accept. Succeeding as an integrated professional depends on imagining a future and working to achieve it: becoming an artist respected by peers, while navigating a rough and moneyed world.

Disciplined Genius

The belief that artists tap into a pool of inexplicable creativity—genius—is long-standing, and reflects how we see cultural production. We revere Da Vinci, Rembrandt, Monet, Duchamp, and Rothko, believing that they stood outside convention, relying on an individual vision. And, of course, none of them received an MFA.

The examination of artistic socialization questions the belief in independent, idiosyncratic, unpredictable genius.[1] Groups, networks, organizations, and institutions shape how creativity is defined, how objects and performances are produced, and how workers come to think of themselves as creative. Genius emerges not from the soul, but from a community, depending on local traditions, shared vision, collective work, informal collaboration, and institutional structures. We require a meso-level sociology of inspiration. Creativity results from the commitments that emerge from a world of action. This was true even before the explosion of graduate university-based art education. Of course, this holds not only for visual artists but for all whom we venerate for their creativity: writers, playwrights, architects, medical researchers, even sociologists.

Becoming an artist is a social process, something that happens not in a garret, but in a village or, perhaps now, on a campus. A world not of silence, but of laughter, toasts, praise, and insults. Worldviews are shifted and styles developed along with like-minded others. In today's art world with its relational turn, its emphasis on shared projects, and its institutionalized centers of training, the salience of the social

has become ever more apparent, but all domains of creativity have similar structures. Sociologists insist that every world must be understood in light of how it is organized through interpersonal ties, organizational demands, linked social fields, and communal appraisals. Today art schools are key institutional players in creating the disciplinary autonomy on which creativity depends. Suspicion of the market is insufficient, one needs an embrace of commitments of the academy. Given that they do not teach technique, career skills, or even research, what programs do offer instruction in is the authority of art practitioners as determinants of quality. True, artists may feel that they are controlled by market forces, but schools have considerable influence in this battle.

A view that enshrines an influential community does not suggest that everything that is produced will look like everything else. Quite the contrary. While there may be family resemblances in creative products, each auteur—whether writer, architect, filmmaker, or philosopher—requires a distinct personal vision. This constitutes a "signature style," permitting the recognition of a connection between the maker and the made. Creative products reveal singularity, but also similarity. This establishes a market niche, but it may typecast makers if they move in new directions, unless they can utilize their community and a logic of personal growth to support the change. Audiences expect a certain kind of product, and may be disconcerted if the new series is too dissimilar in appearance, meaning, or intention. Creations must be recognizably similar to the greatest hits or must find supportive reputational entrepreneurs that vouch for the new creative vision.

I am an ethnographer who over the course of an academic life has examined many scenes: from Little League baseball teams to restaurant kitchens, from meteorological offices to chess tournaments. Building on my research in the world of self-taught art, I spent two years considering how artists are trained in university-based MFA programs. Although my account is larded with interviews and observations at three schools in the Chicago area, I do not claim that they are *typical*. No school is. Rather, they reflect some characteristics of small, university-based programs, outside the art centers of New York and Los Angeles, and part of a regional art world. Despite certain skepticism, I was permitted to share moments of students' lives and fragments of their activities.

We must see the production of artists—the training of MFA students in the visual arts—not only in light of their particular circumstances, but in how occupations shape the selves and the activities of trainees and how reputations are formed. This occurs in the context of local beliefs,

conflicts, and resources, influenced by understandings of the broader oc-
cupation order and organizations that surround it. I begin with specific
persons, cultures, and institutional arrangements. However, local insti-
tutions inevitably imagine themselves as part of something larger, more
consequential.

To engage with the contemporary art world is to be embedded in a dis-
cipline, an approach to knowledge that depends on academic authority
and group influence. In this art is not so different from other disciplines.
As the art world is increasingly linked to university settings, its disciplin-
ary contours arise from a body of knowledge that is expressed in particu-
lar ways, establishing forms of authority that shape those who hope to
belong to the guild. While the university is not the only place where the
field of art is preserved, it has increasingly become crucial, a key site for
the generation of ideas (and not only of beauty). As is true of science, the
art program is a truth spot.[2] It is a site of judgment. Professors are makers
of art and artists. Along with fellow travelers, such as critics and curators
who participate in academically informed debates, the art world is linked
through graduate education to a domain of ideas as well as craft practices.

In this final chapter I return to my central organizing themes to ex-
amine how each provides the basis for understanding disciplinary so-
cialization, using visual art practice as my example, although the themes
connect to other worlds. I focus on *technique, theory, talk, community, net-
work*, and *discipline* as core concepts in this project.

Technique

One might imagine that in attending graduate school as an emerging art-
ist, the primary goal would be to learn how to produce objects. The "how"
of producing good work seems central to any form of group-based occu-
pational socialization. Indeed, artists today are routinely labeled "mak-
ers." However, technology is not an end in itself: the question is whether
the trainee has the tools to succeed. In many disciplines—sociology is
one—the assumption is no, and students have to take a set of required
methods courses to become certified as competent practitioners. How-
ever, because students enter MFA visual arts programs as artists, typically
trained as makers in undergraduate programs, and because there is no
consensus on the range of techniques that an artist will find necessary,
communal training is rarely found, at least in small, university-based MFA
programs. For training in technique to be adopted as part of graduate edu-

cation, a consensus must exist on what tools are essential, and a general belief that students lack those tools and will not acquire them on their own. This is not the case.

As a result, craft skill is treated as background, not a topic of required course work in art school, but essential for career success as a set of personal abilities. This contrasts with medical school, law school, divinity school, architectural school, and most academic Ph.D. programs.[3] When students enter MFA programs, they are assumed to be knowledgeable makers. To be sure, they must learn to think and act like *artists*, but they are already painters, sculptors, printmakers, or video artists. School demands that they refine, rethink, and reconsider their practice, and also conceptualize what it means to be an artist in today's art world. In contrast, systematic, classroom instruction does not occur in how to make marks, craft objects, film videos, or stage performances. Ignoring technique as a topic of instruction reflects the breadth and divisions of art practice, coupled with small cohorts. So many techniques, so few students.

Any line of work requires skilled performance—surgery, statistical analysis, legal research, or composition of homilies—to demonstrate that one is competent. While conventions in the art world are notably diverse, there are still recognizable styles of work. Individual trainees have specialized talents, even if these are not learned in school. This is most evident among painters, where there are consequential decisions about which materials to use, how to prepare canvases, how to mix paint and make marks, and how to preserve the final product. These are taught in high schools and in undergraduate classes, but not to these graduate students in collective settings.

The downplaying of technique reveals that the movement of art education into colleges, as connected to the humanities, is consistent with a movement from craft to concept: from labor to philosophy. Over time art has been colonized by the university in its role as an idea factory: the educational turn. This is similar to the incorporation of other arts—theater, music, dance—as well. In disciplinary terms, the skill of the contemporary artist involves turning ideas into form. Technique becomes the means by which this occurs, but it is secondary to ideas. Craftwork is often treated by the individual artist as a *tool*, but seems—in critiques and classwork—less central as a *topic*. The maker's skill is typically not considered of central interest in critical discourse. Technique is treated as background noise. It is what library research is for the humanities scholar: necessary to make an argument, but rarely, in itself, part of training. Technique is individually chosen, perhaps in conjunction with mentors, rather than being a standard disciplinary methodology.

Theory

Given the absence of collective focus on technique, what replaces it? What happens in seminars? The location of art training in graduate education suggests that learning to think takes priority over learning to make. Theory is characteristic of so much of the university in its current form. To be welcomed, a new discipline needs this theoretical commitment. This is the cultural logic of an academic department. Discourse becomes crucial. Craft requires conceptual justification;[4] borrowing and extending theory—high- and medium-range—serves this end. The university makes the demand for discourse insistent. This emphasis, growing from an institutional demand, is the engine by which Tom Wolfe's distress about the "painted word" becomes manifest.

Theory has many meanings as the term is used in practice.[5] It can refer to a set of ideas that provide a generalized intellectual structure for social relations and institutional order (high theory or critical theory); it can focus on the conceptualization of particular objects (local theory); or it can examine the implications of types of practice as forms of intention. This last is what W. J. T. Mitchell refers to as medium theory. During the 1980s and 1990s art professors, particularly those who were newly minted, embraced high theory, seeing it as a gateway to university credibility. But often the arguments were only loosely connected to specific objects and blurry in their connections to what artists did in their studios. While this built bridges to other corners of the academy—comparative literature, gender studies, or philosophy—too great an emphasis on abstract theoretical models, at least in teaching, proved challenging for students, many of whom entered MFA programs through a commitment to thing-making and performance. These texts were too demanding for students, and even for those faculty not trained in close textual readings. Theoretical accounts frequently proved irrelevant for practice, even if enhancing for academic renown. Further, some rejected the theoretical emphasis as treating the object as a mere illustration of an idea.

In the early years of the expansion of MFA programs in the 1970s and 1980s, a tight embrace of theory might have been a mark of status for these entrants into university-based graduate education, but broad theoretical commitments proved hard to sustain. By the dawn of the millennium, observers noted that "theory" (that is, high theory) had subsided. Greater attention was given to artistic genres and their position in society. Faculty emphasized the conceptual, but these discussions were more closely tied to the object. The linkage of ideas and material forms (or per-

formances) provides the basis for current graduate art education. Perhaps the artist lacks full authority to define the work, but the artist should be able to address those concepts that are activated by the practice.

Even with decline in high theory, meaning has replaced making as the central MFA topic. This is a movement from how to why, suggesting that an artwork constitutes a form of social analysis. Art practice allies with the humanities, aiding its fit in the university. As discourse is privileged, visual art belongs to a knowledge factory. The ability to recognize and respond to arguments creates what the sociologist of science Ludwig Fleck referred to as a "thought community."[6] Art practice is but one thought community in the university.

Talk

Central to chapters 3 and 4 is the form of disciplinary practice known as the critique. It depends on a tight-knit community defining value. Of course, talk is central in all disciplines when making a case for insight is at issue. However, the critique is an odd and spiky shard of education, a way in which art programs stand apart from decorum and politesse found in the rest of the university: an intellectual scrum.

Most disciplines rely on evaluation, but typically this occurs in private spaces. Judgments may be rough, but they are rarely public. Dissertation defenses are not, in practice, public venues.[7] But in art programs, it is expected—desired—for the entire community to gather for several days to view and comment on the work that students have produced. In finding a common space, MFA education permits—even insists—that social relations be displayed though talk. The critique allows a dialogue not just of ideas, but of persons with histories, friendships, passions, resentments, and beliefs. What is hidden elsewhere is evident in visual arts programs, where all are encouraged to say their piece.

As is now well recognized, sociability depends upon performance, and the critique with its focus on communal action is such a space, transforming private reputations into public ones. It builds on the concepts, ideas, and theories within the discipline, but shared in light of local standards. The community explores the ambiguous in a forum in which consensus is not demanded and is rarely achieved. Participants monitor each other, and earlier comments set the direction and tone for those later. The conceptual and the personal, the political and the aesthetic are in the toolkit from which attendees draw.

As my examples demonstrate, critiques can become heated and can

trade in matters that relate as much to the person as to the work. This is consistent with the claim that an art school shapes artists as it shapes art. That race, politics, faith, or sexuality can enter the conversation suggests that the imagined self of the artist is decisive.

The critique brings the art world into the academy: The range of critical interpretations, as well as the presence of external guests, makes the event a cross between a colloquium and an art unveiling. Even the opportunity to cruise the room before the start of discussion mimics gallery openings. All that is lacking is wine and cheese. The discourse connects the event to the academy, but does so in a white-walled, furniture-free space akin to clichéd gallery decor.

The thesis show models the gallery or museum opening still further, with friends gathering to celebrate. This culminates a student's education, but at the same time—with presentations and seminars that surround the show and with some schools publishing a catalogue—merges college and museum.

The location of artistic practice within an academy demands a form of material presentation that depends on a public accounting. The critique is a talking cure, mediated through a thorny group therapy.

Community

Worlds of common fate organize themselves though personal relations and group culture, demonstrating commitment. Young artists depend on the social capital that togetherness provides. We should not think of an overarching, undifferentiated art world, but granulated, local sites in which meaning and relations are built. The program, the cohort, and the clique are, for students, nodes of attachment.

Community is essential everywhere, but universities, with their offices, faculties, classes, admission procedures, and educational rituals, excel in producing a desire to belong. Departments provide resources, limits, and boundaries. As small groups, they build intense cultures that shape the lives of those they admit.

Art programs differ in size, and some art schools unaffiliated with universities, such as the School of the Art Institute of Chicago or Maryland Institute College of Art, admit large cohorts. However, the schools that I examine, and most university-based art programs, are selective, with few trainees. For two or three years, students confront each other and their faculty, a group comparable in size to the small number of graduate students in other departments—or of players on a basketball

team. These programs generate close relationships, supportive acquain-
tanceships, and occasional rancor. But these colleagues face common
challenges, even when outcomes differ. They judge each other, and they
are judged as members of the same field of practice.

To get along, students must develop shared perspectives. These are
shaped by their placement within a university, a department, and a
broader, linked world of social media, public attention, and critical writ-
ing. Their culture results from the vitality of sociability and shared experi-
ence. Being "where the action is" is to participate in a local site: Chicago,
Evanston, or Normal, Illinois.

Cultural themes are mediated through the institutions that make up
the student world, and include attitudes toward good work and displays
of identity. Given the diversity in practices, art programs encourage a
range of styles and mediums. More than this, given political prefer-
ences, a program must embrace various forms of diversity. The idea of
an avant-avant-garde transcends what is widely accepted, even if that is
the established avant-garde. Perhaps because of the continuing produc-
tion of the new, the term "avant-garde" is increasingly old-fashioned.
Academic culture is a rolling search for novel ideas, embracing the dif-
ferent and the difficult.

Along with the rejection of conventional styles—and more problem-
atic from an institutional perspective—is the rejection of organizational
norms and moral boundaries. I remarked on the desire of students (and
faculty) to smoke in a tobacco-hostile world. Smoking may be a per-
sonal pleasure, but it is also accepted as a group pleasure that serves
to differentiate. Nudity and gender expression, drug and alcohol use,
and elaborate tattoos reveal similar dynamics. Each must be negotiated
in light of community expectations, sometimes producing contention.
Only with progressive political and social attitudes does one find firm
accord, reminding us that even diverse communities have their police,
producing a measure of disciplinary control.

Network

Sites of socialization not only depend upon internal commitment, but also
develop relations with other institutional sites. The university provides
a platform for engagement with a wider field. Most studies of graduate
education take the school as the world—the fishbowl—in which students
swim. Yet, even medical or law school, with their summer internships
and relations with hospitals and law firms, are not self-contained. For

art programs, such a model that separates the school from the world is inadequate. Students enroll with a provisional artistic identity, an awareness of current conventions of influential work, and with linkages to art communities, centers, and galleries. They belong to the art world in larger or smaller ways, and they think about their future roles in that world. During school they attend events and shows, feeling this attendance is essential. Few law students spend Friday evenings at night court. This, in effect, is what emerging artists are exhorted to do and what many treasure. Their mentors emphasize that they are part of a glorious mosaic. The more embedded, the better.

Part of this exhortation derives from the reality that—in contrast to law and medicine with firms and hospitals that need a continual stream of new staff—artists are on their own to make their way. Suppose all MBAs were start-up entrepreneurs, scrambling for ideas and resources. Networks prove valuable in establishing paths to the penumbra of the art world, providing opportunities for the emerging artist as studio assistant, gallery greeter, or art documenter. These assignments may lead to the artist's first show or residency.

The network, perhaps even more than the school, drives careers and shapes occupational practice. While these social relations are built upon a common, if generous, perspective on art practice, they also provide support, whatever the quality of the work.

In a world as economically precarious as art, networks provide a safety net that allows artists to cope with strategic poverty until they "make it"[8]—or give up. One relies not only on close, strong connections, but also on acquaintanceships that provide information and opportunities for survival. Subcultures are built on interlinked groups, connected by weak ties. With common foci and organizations that promote gatherings, artists constitute themselves as a field of action. Social events allow for the expansion of the network.[9] What is true for art worlds in New York, Los Angeles, or Chicago is also true for political subcultures in Washington, music subcultures in Nashville, or tech subcultures in San Francisco. Digital worlds, such as Facebook, Tumblr, and Instagram, serve similar purposes, creating virtual neighborhoods.

Discipline

Socialization results from the reality that these sites of training treat the world of art as a field of shared knowledge: a discipline. It is, and should be, a place of ideas. This counters the easy claim that the art world is

directed and controlled by the market: that art production is dominated by wealthy collectors and elite galleries. A struggle exists between alternative sources of valuation as they are situated institutionally. One can see art through the lens of meaning or through that of finance. I focus on the former, but the latter is always in the background, at least as artists see the matter.

For young artists and for their teachers—at least at these small, midwestern, university-based MFA programs—art as finance runs counter to their self-identities. Perhaps several will win the arts lottery, but most claim not to care. They assert that they wish to follow their vision, even if they are not the next Jeff Koons or Damien Hirst. These names are, in fact, rarely mentioned in class or critiques, except occasionally as dire warnings.

In such a setting, what is important is that artists control their own judgments. Collectors rarely visit art programs. Gallerists, curators, and even critics[10] do not quite belong, except when invited to run a workshop or to serve as a guest instructor. Art programs are composed of bubbles of artists who attempt to define the virtues of newly esteemed art.

In this, the MFA art world serves as a model of how a discipline operates. The goal is to set the terms of good work. Critiques make this process apparent. Of course, as emerging artists graduate, they find alternate places of judgment. This success may inspire others to follow their model. In the field, external to disciplinary control, artists can no longer so easily regulate evaluations. To the extent that Lane Relyea is correct in emphasizing the project-based and social turn in art, treating collaboration as central, the control of art judgment by artists is increasing. Still, whether or not this is true, it certainly applies within the program era in which shared talk is privileged. In contrast, external mercantile worlds are not primarily worlds of talk, except when they incorporate the mediating evaluations of the critic and the curator, two positions that can bridge the discipline and the marketplace. Art teachers talk constantly with their students, in contrast to collectors whose voices echo from their wallets.

This returns us to talk. Ultimately occupations must consider what constitutes good work, and who has the power to define it. For the emerging artist, this is the teacher and the program, a moment prior to control of the market, the dealer, and the auction. Of course, artists once affiliated with an academic program world can, if the opportunity arises, change their allegiance. Still, as sources of identity, disciplinary spaces demand precedence at least while students are under their control. The belief in a core of knowledge—theory, however we label it—depends on an institutional world of professors, students, and occasionally critics

and curators. This permits the university to direct art world practices, using poison ivy–covered walls to discomfit the heathens.

The intriguing aspect of the art world is how, through its placement over the past half-century in the expanding university and through the increasing credentialing power of the MFA degree, art has gained autonomy, with practitioners justifying their intentions, no longer mute targets of interpretation. In this they are increasingly like those in other academic disciplines and protected from the incursions of the market.

Culture U?

What does it mean that over the past half-century the arts (visual arts and other forms) have been embraced by the university? Are the arts better off from the clasp? Opinions differ. Those who treasure beauty and craftsmanship argue that the hug is poisoned. Canvases, not words, should be painted. Jazz compositions are messages from the heart, not texts to decipher. But increasingly artists produce for other artists, just as scholars write for peers. Judgments can be esoteric, and some audiences consider them puzzling or perverse. Given their contentious politics, artists might, ironically, be grateful that many viewers will not get the point. The plaint of Tom Wolfe has power if we find splendor slipping from our grasp.

Yet, while the training of art students has changed, this is not the whole picture. Who can argue that the market has disappeared, auctions lack bidders, or museums are empty? It is not only that the domain of art is fragmented, but products are as well. Much beautiful art is produced, and collectors understand this. Artists are still venerated, even if the more provocative are scorned, as they long have been. This is a change that Claude Monet, condemned for painting *mere impressions*, would have understood. Monet was no Rembrandt. Hanna Owens is no Monet.

I do not argue for *one best art*. Art students are taught within the frame of a discipline, a community of beliefs and evaluations that involves the performance and acceptance of identities. These beliefs have enough leeway to consecrate numerous styles in the name of excellence, permitting many ways of being an artist. That theories matter no more produces a sameness in art than it produces a sameness in philosophy or sociology.

I still admire works that I find gorgeous, but I now revere works that challenge me with their insight. I have come to treasure what I see in the contemporary wing, just as I once toured the grand salons.

Training in art has changed over the decades, but astute makers always transform their lessons, creating works that seem odd today but tomorrow may yield euphoria. This is a lesson of sociology. Seemingly objective hierarchies of value are always unstable, because the institutions and social relations through which they are produced change, embracing new values and new audiences. Today colleges have allied with artists. The contemporary art world could not survive without Culture U.

All ethnography focuses on a scene: a specific world. However, my argument goes beyond this case. I analyze how universities create academic disciplines from arts occupations. By building a program—the program era in all spheres of cultural production—creators assert a measure of control over their activities through institutional authority, credentialed mentors, and elaborated ideas. The development and deployment of theory justifies aesthetic practices. Over the past fifty years multiple creative worlds have been incorporated into the university—theater, dance, poetry, fiction, cooking, wine-making, couture, filmmaking, and the visual arts. Cultural production has been welcomed into the ivory tower. While this has not occurred at the same speed in each field or equally persuasively, a dramatic expansion of graduate-level arts education has occurred over the past half-century. The arts once polished collegians as urbane young adults; today universities not only teach the arts, but also create aesthetic citizens, challengers of the status quo. While the availability of government loans and grants spurred this process, it could not have occurred until the disciplinary training of aesthetic citizens was seen as belonging in a research university, not only in private academies or trade schools. The arts were ready to be sponsored, colonized, and patrolled by professors.

I emphasize the local basis for all forms of socialization. Parallels exist among schools, and occupations have cultures made possible by mass-mediated discourse and national institutions. However, it is in the local environment that good work is defined and students' practices and identities are shaped. Each of these three schools, located in the midwestern heartland, depends on the particular character of its institution. But this is true of all schools in all settings. Community connects the individual and the world, creating local sites of commitment. All social worlds ultimately depend upon group cultures, specific personnel, spatial contexts, and resulting opportunities. The art world demonstrates how the local develops from individual action and how it responds to pressures of the broader world.

The art world is ever changing, buffeted from within and from without,

constrained and buoyed by surrounding institutions. But at its heart it consists of artists working together, claiming meaning, finding opportunity, and developing friendship. In this, schools play a crucial role in bringing artists together in worlds in which they talk, think, make, and judge. The university has a special role in creating a center where the autonomy of contemporary art is created. Schools do not erase the market, but rather compete for authority. In their success, they become the core of disciplinary power.

Ultimately, whatever medium students choose and whatever their intentions, these efforts, channeled, challenged, and critiqued by colleagues and mentors, build our culture. In this, their work is both miraculous and rare.

Notes

1. In writing on competitive chess, I used the masculine pronoun to reveal the dominant gender composition of the field. In the MFA programs I observed, there was more gender balance (one of the three had significantly more women than men). In this manuscript when I refer to a generic art student, I use the female pronoun.
2. Hannah Wohl, "Branding Creativity: Consistency in Artistic Production," paper presented at the American Sociological Association meetings, Chicago, 2015.
3. Al Muniz, Toby Norris, and Gary Alan Fine, "Marketing Artistic Careers: Pablo Picasso as Brand Manager," *European Journal of Marketing* 48 (2014): 68–88.
4. Many programs, including the two Chicago programs I observed, invite guests from the local art world to participate in their critiques, and these guests are expected to provide feedback. I was the rare outsider present.
5. The specific critiques, selected to underline general issues of evaluation, occurred in a different order from how I present them.
6. Following ethnographic tradition, I use pseudonyms to refer to students and faculty members. The only exceptions are when I cite published texts or when I discuss the careers of four students, who gave me permission. These students are described in the introduction. I name the MFA programs when appropriate. Since my focus is on students, with a few exceptions I do not refer to particular faculty members by name, but when I do, these names are pseudonyms.
7. Neil Gross, *Why Are Professors Liberal and Why Do Conservatives Care?* (Cambridge, MA: Harvard University Press, 2013).

8. Other, external issues affected this critique, such as a petition about the un-fulfilled promises that some students felt the program had made to them and the faculty's resentment of these complaints. Michelle explained to me that she had felt ahead of time that she was going to have a rough critique. She knew Paul, having worked with him as a teaching assistant, and she worried that he took the petition personally. Later, the program administrators were concerned that she would file a grievance, something that she asserted she had no intention of doing, but which led her to feel institutional pressure. Michelle reported that her adviser subsequently apologized to her for not speaking up on her behalf in the critique. Faculty mentors often serve as protectors, redirecting discussion if it becomes too contentious.

INTRODUCTION

1. I thank Andreas Fischer for this insight.
2. Paul DiMaggio and Toqir Mukhtar, "Arts Participation as Cultural Capital in the U.S.," *Poetics* 32 (2004): 169–94.
3. For discussion of the debate over the Ph.D. in studio art, see Timothy Emlyn Jones, "The Studio-Art Doctorate in America," *Art Journal* 65, no. 2 (2006): 124–27; James Elkins, ed., *Artists with PhDs: On the New Doctoral Degree in Studio Art* (Washington, DC: New Academia Publishing, 2009). If there is to be a Ph.D. in studio art, will it be more of the same, or will it demand a new set of skills, emphasizing research?
4. These data cover artists in a range of fields, including writers, visual artists, actors, musicians, dancers, and other entertainers. The data also reveal, given this wide definition of the arts, that approximately 2 million arts graduates live in the United States. About 27 percent of artists with bachelor's degrees listed the fine arts as their degree field, and 10 percent of graduates with art degrees defined themselves as working artists. Data are reported in Susan Jahoda, Blair Murphy, Vicky Virgin, and Caroline Woolard, "Artists Report Back: A National Study on the Lives of Arts Graduates and Working Artists" (2014), 3, 6, 7; available online at http://BFAMFAPHD.com/#artists-report -back (retrieved 17 November 2014).
5. Academicization has also shaped training in cooking, viniculture, fiction, filmmaking, dance, music, theater, and couture. All can be found in in-stitutions of higher education, although some have a more secure perch than others.
6. Tom Wolfe, *The Painted Word* (New York: Farrar, Straus, Giroux, 1975), 5.
7. Ibid., 105.
8. Harold Rosenberg, *The De-definition of Art: Action Art to Pop to Earthworks* (New York: Horizon Press, 1972); Sophia Krzys Acord, "Learning How to Think, and Feel about Contemporary Art," in Laurie Hanquinet and Mike Savage, eds., *Routledge International Handbook of the Sociology of Art and Culture* (New York: Routledge, 2015), 219–31.

9. Arthur Danto, *After the End of Art* (Princeton: Princeton University Press), 1996.

10. C. Clayton Childress and Alison Gerber, "The MFA in Creative Writing: The Uses of a 'Useless' Credential," *Professions and Professionalism* 5 (2015): 1–16.

11. Alexandre Frenette. "Making the Intern Economy: Role and Career Challenges of the Music Industry Intern," *Work & Occupations* 40 (2013): 364–97.

12. Childress and Gerber, "The MFA in Creative Writing," 3; Magali Sarfatti Larson, *The Rise of Professionalism* (Berkeley: University of California Press, 1979).

13. See Jane Chafin, "MFA: Is It Necessary?—The Debate," 12 July 2011, http:// janechafinsofframpgalleryblg.blogspot.com/2011/07/mfa-is-it-necessary -debate.html (accessed 7 July 2014).

14. My primary source materials—field notes and interviews—will be cited parenthetically in the text throughout.

15. Sarah Thornton, *Seven Days in the Art World* (New York: W. W. Norton, 2008), 46. In an earlier era, the degree in question was the BA (Bachelor of Arts) or BFA. In 1969, Harold Rosenberg, an arts critic for the *New Yorker*, reported: "Only one of ten leading artists of the generation of Pollock and de Kooning had a degree (and not in art), while of 'thirty artists under thirty-five' shown in 'Young America 1965' at the Whitney Museum the majority had B.A.s or B.F.A.s. . . . 'Academic' is still a bad word, even though no one knows any longer exactly what it means." See Barry Schwabsky, "Permission to Fail: MFAs Aren't a Problem: It's Artists Being Content with What They Know," *The Nation* (21 January 2014); available online at http://www.thenation.com /article/178023/permission-fail?page=full (accessed 2 February 2014).

16. D. G. Myers, *The Elephants Teach: Creative Writing since 1880* (Englewood Cliffs, NJ: Prentice-Hall, 1996).

17. The famed Iowa Writers' Workshop was founded in 1936, and still sets the standard for writers' workshops based in university settings.

18. Mitchell Stevens, personal communication, 2011.

19. Jason Owen-Smith, personal communication, 2014; Mitchell Stevens, Elizabeth Armstrong, and Richard Arum, "Sieve, Incubator, Temple, Hub: Empirical and Theoretical Advances in the Sociology of Higher Education," *Annual Review of Sociology* 34 (2008): 127–51.

20. The same is true for MFA degrees in other creative fields, notably creative writing, which has seen an explosion of programs, many found in English departments. See Myers, *The Elephants Teach*. According to Chad Harbach, "there were 79 degree-granting programs in creative writing in 1975; today, there are 1,269! . . . It's safe to say that the university now rivals, if it hasn't surpassed, New York as the economic center of the literary fiction world" ("MFA vs NYC," in Chad Harbach, *MFA vs NYC* [New York: n+1/Faber & Faber, 2014], 12). As Harbach notes, this provides support for working writers—and also for the universities with which they are affiliated. Donnelly, citing Harbach, puts the number of MFA programs at 854, which seems high. See Elizabeth Donnelly, "27 Writers on Whether or Not to Get Your MFA,"

10 September 2014, www.flavorwire.com/476264/27-writers-on-whether
-or-not-to-get-your-mfa/view-all (accessed 12 September 2014).

21. Howard Singerman, *Art Subjects: Making Artists in the American University*
(Berkeley: University of California Press, 1999).

22. The training of artists has been examined by historians of art. See, for in-
stance, Nikolaus Pevsner, *Academies of Art: Past and Present* (Cambridge: Cam-
bridge University Press, 1940); "History of Art Education," http://ntieva
.unt.edu/HistoryofArtEd/index.html (accessed 15 September 2014).

23. Singerman, *Art Subjects*, 6.

24. Ibid.

25. Ibid.

26. This statistic was compiled from information from the National Center for
Education Statistics for the academic year 2009–10. To arrive at this statis-
tic, I combined MFA degrees in art, studio art, drawing, multimedia, paint-
ing, sculpture, printmaking, ceramic arts, fiber arts, metal arts, and "fine
arts, other." I did not include craft, digital arts, or "visual and performing
arts, general." As a result, the number is approximate. See Table 290, "Digest
of Education Statistics: Bachelor's, Master's, and Doctor's Degrees Conferred
by Degree-granting Institutions, by Sex of Student and Discipline Division:
2009–10," https://nces.ed.gov/programs/digest/d11/tables/dt11_290.asp
(accessed 21 July 2016).

27. The CAA now makes available an online guide to graduate visual arts pro-
grams. The most recent version at the time of writing is *Graduate Programs
in the Visual Arts: The CAA Directory* (New York: College Art Association, 2013).

28. Lane Relyea, *Your Everyday Art World* (Cambridge, MA: MIT Press, 2013).

29. In contrast to MFA programs in the visual arts, most MFA programs in cre-
ative writing are university-based, perhaps because writing seems more akin
to the routine tasks of academics or perhaps because writing, as opposed
to visual art, does not require the extensive infrastructure that art schools
provide.

30. Mark McGurl, *The Program Era: Postwar Fiction and the Rise of Creative Writing*
(Cambridge, MA: Harvard University Press, 2009).

31. Gerald Graff, *Professing Literature: An Institutional History* (Chicago: Univer-
sity of Chicago Press, 1987), 138.

32. This is a distinction of Elif Batuman. See Dwight Garner, "Creative Writing,
via a Workshop or the Big City," *New York Times*, 26 February 2014, C1.

33. Donald Hall, "Poetry and Ambition," *Kenyon Review* 5, no. 4 (1983); availale
online at http://www.poets.org/viewmedia.php/prmMID/16915 (accessed
22 February 2012). These are also termed "McWorkshop Poems" (Interview).

34. Pierre Bourdieu, *The Field of Cultural Production* (New York: Columbia Uni-
versity Press, 1993); Mustafa Emirbayer, "Manifesto for a Relational Soci-
ology," *American Journal of Sociology* 103 (1997): 281–317.

35. A. O. Scott, "The Paradox of Art as Work," *New York Times*, 11 May 2014,
AR20.

36. Mary Jane Jacob and Michelle Grabner, *The Studio Reader: On the Space of Artists* (Chicago: University of Chicago Press, 2010); Joe Fig, *Inside the Painter's Studio* (Princeton: Princeton Architectural Press, 2009). The former industrial quarters of lower Manhattan and the boroughs provide such spaces, although rents keep rising. I discuss the role of space in the education of visual artists later in this book.

37. See Myers, *The Elephants Teach*, 2–3, for vigorous debates about the value of training in creative writing. He quotes the poet Allen Tate as remarking, "The academically certified Creative Writer goes out to teach Creative Writing, and produces other Creative Writers who are not writers, but who produce still other Creative Writers who are not writers" (147).

38. Although, as Myers points out, *creative* writing was a new skill (*The Elephants Teach*, 13).

39. Mary Anne Staniszewski, *Believing Is Seeing: Creating the Culture of Art* (New York: Penguin, 1995), 165.

40. Quoted in Judith Adler, *Artists in Offices: An Ethnography of an Academic Art Scene* (New Brunswick, NJ: Transaction, 1979), 17.

41. Deborah Solomon, "How to Succeed in Art," *New York Times*, 27 June 1999, available online at http://www.nytimes.com/1999/06/27/magazine/how-to-succeed-in-art.html (accessed 19 May 2012).

42. Adler, *Artists in Offices*, 3.

43. Howard Becker, Blanche Geer, Everett Hughes, and Anselm Strauss, *Boys in White: Student Culture in Medical School* (Chicago: University of Chicago Press, 1961); Charles Bosk, *Forgive and Remember: Managing Medical Failure* (Chicago: University of Chicago Press, 1979).

44. Other professional schools fall between these models. MBAs may learn techniques of economic analysis, but lack a defined set of skills or body of theory. Divinity schools, linked to denominational traditions, as well as schools of social work, also lack full consensus. A business leader does not require an MBA, although it may help her to secure a position; for divinity students, a degree is essential or optional depending on the denomination, judged by whether they appear to parishioners as sanctioned by the divine more than by a worldly institution.

45. For poetry, see Arielle Greenberg, "A (Slightly Qualified) Defense of MFA Programs: Six Benefits of Graduate School," http://www.poets.org/view media.php/prmMID/5894 (accessed 22 February 2012).

46. Olivia Gude, 2009 Lowenfeld Lecture, National Art Education Association, 20 April 2009, https://naea.digication.com/omg/Art_Education_for_Demo cratic_Life (accessed 15 September 2014).

47. Larry Witham, *Art Schooled: A Year among Prodigies, Rebels, and Visionaries at a World-Class Art College* (Lebanon, NH: University Press of New England, 2012), 6.

48. James Elkins, *Why Art Cannot Be Taught* (Urbana: University of Illinois Press, 2001), 91–92.

49. Boris Groys, "Education by Infection," in Steven Henry Madoff, ed., *Art School (Propositions for the 21st Century)* (Cambridge, MA: MIT Press, 2009), 25–32 (quotation on 27).

50. Howard Singerman, lecture at California State University, Long Beach, 23 September 2000, quoted in Audrey Chan, "Jason Kunke, Joint Rolling and Witchcraft," March 2006, http://audreychan.net/jason-kunke-joint -rolling-witchcraft (accessed 9 July 2014).

51. Data made available by the Strategic National Arts Alumni Project. (Respondents may have graduated at any time.) See http://www.snaap.indiana .edu/.

52. Ashley Mears, "Seeing Culture through the Eye of the Beholder: Four Methods in Pursuit of Taste," *Theory and Society* 43 (2014): 291–309.

53. For a detailed account of a similar program by a journalist, see Witham, *Art Schooled.*

54. Eitan Wilf (*School for Cool: The Academic Jazz Program and the Paradox of Institutional Creativity* [Chicago: University of Chicago Press, 2014], 22) reports similarly that many jazz educators were "highly ambivalent" about his attending classes, which he attributes to a history of racial misrepresentation. For my research, race was not an issue, but the anxieties of evaluation were.

55. Here the life stage of the ethnographer plays a role. In my research on fantasy-role play gaming, conducted in my twenties, I could take notes until 5:00 a.m. (Gary Alan Fine, *Shared Fantasy: Role-Playing Games as Social Worlds* [Chicago: University of Chicago Press, 1983]). No longer.

56. Paul Dimaggio and Walter W. Powell, "The Iron Cage Revisited: Institutional Isomorphism and Collective Rationality in Organizational Fields," *American Sociological Review* 48 (1983): 147–60.

57. Samuel Shaw, "Scene Logics: Local Visibility in a Global Field," 2013, unpublished manuscript.

58. Bourdieu, *The Field of Cultural Production.*

59. Alison Gerber, *Art Work? Making Cents and Nonsense of Art* (Stanford: Stanford University Press, 2017).

60. With such small numbers, diversity becomes a challenge. I was told that one year the department was considering admitting two minority students, and a member of the faculty was heard to remark that "we only need one."

61. In the late 1990s only one of every thirty-two applicants was admitted by the UCLA graduate art department (Solomon, "How to Succeed in Art").

62. Yves-Alain Bois, personal communication, 2014.

63. Relyea, *Your Everyday Art World*; François Cusset, *French Theory: How Foucault, Derrida, Deleuze and Co. Transformed the Intellectual Life of the United States* (Minneapolis: University of Minnesota Press, 2008).

64. I do not discuss connections with undergraduate students, but MFA students teach, mentor, and are sometimes intimate with their younger colleagues.

CHAPTER ONE

1. Howard Singerman, *Art Subjects: Making Artists in the American University* (Berkeley: University of California Press, 1999), 4.
2. Michael Kimmelman, *The Accidental Masterpiece: On the Art of Life and Vice Versa* (New York: Penguin, 2005), 81.
3. Singerman, *Art Subjects*, 4.
4. Luc Boltanski and Laurent Thevenot, *On Justification: Economies of Worth* (Princeton: Princeton University Press, 2006).
5. For a discussion of the "hostile worlds" framework of valuations that argue for what can be monetized and what is seen as outside the economic order, see Viviana Zelizer, *The Purchase of Intimacy* (Princeton: Princeton University Press, 2007).
6. Tasos Zembylas, "The Concept of Practice and the Sociology of the Arts," in Tasos Zembylas, ed., *Artistic Practices: Social Interactions and Cultural Dynamics* (London: Routledge, 2014), 7–16, especially 7.
7. Pierre Bourdieu, *Outline of a Theory of Practice* (Cambridge: Cambridge University Press, 1977).
8. Ludwig Wittgenstein, *Philosophical Investigations* (Oxford: Blackwell, 1958).
9. Ryan Shultz, "Portraits of the Modern World: Reality, Representation, and Artifactuality," MFA thesis, Department of Art Theory and Practice, Northwestern University, 2009, 6–9.
10. Many, indeed most, artists incorporate a dual process of slow and fast cognition, making some decisions rapidly and relying on deep consideration for others. Artists rely on intuitive, pragmatic decisions, but also base other, perhaps larger, choices on thoughtful consideration. For a related argument, although one tied to forms of discourse and explanation, see Stephen Vaisey, "Motivation and Justification: A Dual-Process Model of Culture in Action," *American Journal of Sociology* 114 (2009): 1475–1515.
11. See Catherine Wagley, "Slacker Art," *Daily Serving*, 15 June 2012, http://dailyserving.com/2012/06/slacker-art/ (accessed 22 July 2016).
12. Tim Tomlinson, "The MFA vs. the Portable MFA," in New York Writers Workshop, *The Portable MFA in Creative Writing* (New York: Writer's Digest Books, 2006), 1–10, especially 7.
13. Heather Darcy Bhandari and Jonathan Melber, *Art/Work* (New York: Free Press, 2009), 14.
14. Esau McGhee, "A Space beyond Institutionalization," MFA thesis, Department of Art Theory and Practice, Northwestern University, 2013, 3.
15. Roger White, *The Contemporaries: Travels in the 21st Century Art World* (New York: Bloomsbury, 2015), 51.
16. Charlotte Burns and Pac Pobric, "Art School: Beyond the Reach of the 99%" *Art Newspaper 257* (8 May 2014), http://www.theartnewspaper.com/articles/Art-school-beyond-the-reach-of-of-the-/32405 (accessed 27 May 2014).

17. Leslie King-Hammond, in "Art Schools: A Group Crit," *Art in America,* May 2007, 99–113, quotation on 102; Timothy Allen Jackson, "Ontological Shifts in Studio Art Education: Emergent Pedagogical Models," *Art Journal* 58 (Spring 1999): 68–73, especially 68.

18. Chandra Mukerji, "Having the Authority to Know," *Sociology of Work and Occupations* 3 (1976): 63–87.

19. Judith Adler, *Artists in Offices* (New Brunswick, NJ: TransAction, 1979), 6.

20. Boris Groys, "Education by Infection," in Steven Henry Madoff, ed., *Art School (Propositions for the 21st Century)* (Cambridge, MA: MIT Press, 2009), 25–32, especially 29.

21. Howard Becker, "Arts and Crafts," *American Journal of Sociology* 83 (1978): 862–89.

22. I am grateful to Andreas Fischer for raising this argument.

23. Adriana Magnolia Ruvalcaba, "An Interview with MFA Student Macon Reed," 12 April 2013, http://gallery400.uic.edu/interact/inside-stories/an-interview-with-mfa-student-macon-reed (accessed 13 May 2014).

24. The ideas of Andreas Fischer shaped this paragraph and subsequent discussion.

25. When technique is "transparent" or lacks explicit signification of content, "conversation can slip to the content" (Andreas Fischer, personal communication, 2016).

26. Leo Steppat, "Can Creative Art Be Taught in College?" *College Art Journal* 10, no. 4 (Summer 1951): 385.

27. Jeff Burton and Andrew Hultkrans, "Surf and Turf," *Artforum International* 36, no. 10 (Summer 1998): 106–13, especially 106.

28. Singerman, *Art Subjects.* See also Thierry de Duve, "When Form Has Become Attitude—and Beyond," in *The Artist and the Academy: Issues in Fine Art Education and the Wider Cultural Context* (Southampton, UK: John Hansard Gallery, 1994), 23–40, especially 23. Boris Groys (*Going Public* [New York: Sternberg Press, 2010], 105) argues that this is a function of genre. New media production requires more skills, although in the case of my sites these skills are not taught in graduate classroom settings.

29. Howard Risatti, "Protesting Professionalism," *New Art Examiner* 18, no. 6 (February 1991): 23; cited in Singerman, *Art Subjects,* 3.

30. In our sociology department, we may admit students who have never taken a course in sociology, as long as we believe that they have explained their commitment and had success in other areas. Many have not majored in sociology in college. Such openness appeared much less likely in the art programs that I observed, with only a very few students not having received a BFA (or occasionally BA, a less rigorous degree) in art.

31. Sarah Thornton (*Seven Days in the Art World* [New York: W. W. Norton, 2008], 48) notes that the only place in which life drawing occurred at CalArts was in the animation program.

32. Deborah Solomon, "How to Succeed in Art," *New York Times*, 27 June 1999, http://www.nytimes.com/1999/06/27/magazine/how-to-succeed-in-art.html (accessed 19 May 2012).

33. Eric Fischl and Michael Stone, *Bad Boy: My Life On and Off the Canvas* (New York: Crown, 2012), 47.

34. Daniel Clowes, *Art School Confidential* (Seattle: Fantagraphic Books, 2006).

35. Kit White, *101 Things to Learn in Art School* (Cambridge, MA: MIT Press, 2011), 2–3.

36. I am grateful to Hannah Wohl (personal communication, 2016) for this point, and her finding that this "geeking out" is more common among artists than among dealers or collectors.

37. Howard Singerman, in "Art Schools: A Group Crit," *Art in America*, May 2007, 99–113, especially 101.

38. Thomas Gieryn, "What Buildings Do," *Theory and Society* 31 (2002): 35–74. The examination of science places is an emerging area in science studies, but less so in art studies; an exception is the work of Richard Lloyd, *Neo-Bohemia: Art and Commerce in the Post-Industrial City* (New York: Routledge, 2010).

39. Thomas Gieryn, "City as Truth-Spot: Laboratories and Field-Sites in Urban Studies," *Social Studies of Science* 36 (2006): 5–38.

40. Columbia College, working with a prominent design firm, created a more open design, eliminating "discrete disciplinary spaces" and incorporating "controlled flexibility." An instructor commented, "We wanted the space to look like art school," at which a male colleague joked, "Beat-up-able."

41. The economy of grants is a major difference between the arts and the sciences. Elaborate laboratory facilities gratify scientists, who bring money to the university through their grant overhead and the benefits from their patents. Such is not the case with artists, since even if they sell their work, the university does not profit directly.

42. This constitutes what sociologists of technology refer to as an affordance: that the structure of objects or places permits (and constrains) particular forms of action.

43. I do not discuss how students find apartments, but this is a spatial matter, particularly in areas with a high cost of living, like Chicago (or New York or Los Angeles). Their space in school must be coordinated with their space in the city, and this connects to their personal relations and desires of partners. Many UIC students now live in Pilsen, a formerly working-class, Mexican American area, recently colonized by artists and other young professionals. Many Northwestern students live in Rogers Park or Uptown, diverse and reasonably affordable Chicago neighborhoods.

44. Thornton, *Seven Days in the Art World*, 61.

45. Lane Relyea, *Your Everyday Art World* (Cambridge, MA: MIT Press, 2013), 70.

46. McGhee, "A Space beyond Institutionalization," 4.

47. Students in the photography and ceramics program had spaces in the main art building on campus.

48. Thornton, *Seven Days in the Art World*, 60–61.

49. Students at Northwestern share a small kitchen and dining area.

50. James Elkins, *Art Critiques: A Guide*, 2d ed. (Washington, DC: New Academia Publishing, 2012), 37–39.

51. Sophia Krzys Acord, "Art Installation as Knowledge Assembly," in T. Zembylas, ed., *Knowledge and Artistic Practices* (London: Routledge, 2014), 161.

52. Wendy Griswold, Gemma Mangione, and Terrence McDonnell, "Objects, Words, and Bodies in Space: Bringing Materiality into Cultural Analysis," *Qualitative Sociology* 36 (2013): 343–64.

53. Pierre Bourdieu, "The Historical Genesis of a Pure Aesthetic," in Pierre Bourdieu, *The Field of Cultural Production* (New York: Columbia University Press, 1993), 254–66, especially 257.

54. Bruno Latour, *Reassembling the Social: An Introduction to Actor-Network Theory* (New York: Oxford University Press, 2005).

55. Terrence McDonnell, "Cultural Objects as Objects: Materiality, Urban Space and the Interpretation of AIDS Media in Accra, Ghana," *American Journal of Sociology* 115 (2010): 1800–1852.

56. Arjun Appadurai, "Commodities and the Politics of Value," in Arjun Appadurai, ed., *The Social Life of Things* (Cambridge: Cambridge University Press, 1986), 3–63, especially 3–6.

57. Igor Kopytoff, "The Cultural Biography of Things: Commoditization as Process," in Appadurai, ed., *The Social Life of Things*, 64–91, especially 64.

58. Sharon Zukin, *Loft Living: Culture and Capital in Urban Change* (New Brunswick, NJ: Rutgers University Press, 1989).

CHAPTER TWO

1. Sarah Thornton, *Seven Days in the Art World* (New York: W. W. Norton, 2008), 50.

2. Dave Hickey, *The Invisible Dragon*, revised and expanded ed. (Chicago: University of Chicago Press, 2009).

3. Tom Wolfe, *The Painted Word* (New York: Farrar, Straus, and Giroux, 1975).

4. This attitude might be different in the art centers of Los Angeles and New York (including New Haven) where, for some students, a close connection exists with leading gallerists. Complaints that students are too involved in the market are often heard in these programs, but in an art world such as Chicago, the ties between dealers and students are thin and occasional.

5. Luc Boltanski and Laurent Thévenot, *On Justification: Economies of Worth* (Princeton: Princeton University Press, 2006).

6. David Stark, *The Sense of Dissonance: Accounts of Worth in Economic Life* (Princeton: Princeton University Press, 2011).

7. Viviana Zelizer, *The Purchase of Intimacy* (Princeton: Princeton University Press, 2007).

8. Stark, *The Sense of Dissonance.*
9. Hickey, *The Invisible Dragon*, 5, 8.
10. Ibid., 60.
11. Terry Smith, quoted in Patricia Bickers, ed., "The Future of Art Education," *Art Monthly* (October 2008), 9.
12. I am grateful to Hannah Wohl for this point.
13. Thornton, *Seven Days in the Art World*, 63.
14. Ibid., 63.
15. Raphael Fleuriet, "Les arts méta-plastiques," in *Archipelago* (Evanston: Department of Art Theory and Practice, Northwestern University, 2014), 5.
16. Boris Groys, *Going Public* (New York: Sternberg Press, 2010), 11.
17. Theodore Schatzki, "Art Bundles," in Tasos Zembylas, ed., *Artistic Practices: Social Interactions and Cultural Dynamics* (London: Routledge, 2014), 17–31, especially 30.
18. Nicolas Bourriaud, *Relational Aesthetics* (Paris: Les Presses du Réel, 1998). See also Craig Smith, *Relational Art: A Guided Tour* (London: I. B. Tauris, 2016).
19. I am grateful for the comments of Sophia Acord on this point.
20. This project pays tribute to the work of Thomas Hirschhorn in his community art projects.
21. Matti Bunzl, *In Search of a Lost Avant-Grade* (Chicago: University of Chicago Press, 2014), 91.
22. Daphne Demetry, Jessica Thurk, and Gary Alan Fine, "Strategic Poverty: How Social and Cultural Capital Shapes Low Income Life," *Journal of Consumer Culture* 15 (2015): 86–109.
23. Some artists shift styles frequently, such as Picasso, Gerhard Richter, or Robert Morris. But even here they typically produce a series of pieces that recognizably belong together or share an animating idea.
24. Hannah Wohl, personal communication, 2015.
25. James Elkins, *Why Art Cannot Be Taught* (Urbana: University of Illinois Press, 2001), 21.
26. Charlotte Burns and Pac Pobric, "Art School: Beyond the Reach of the 99%," *Art Newspaper* 257 (8 May 2014), http://www.theartnewsppaer.com/articles/Art-school_beyond-the-reach-of-the-/32405 (accessed 27 May 2014).
27. Yvonne Rainer, in Peter Nesbett and Sarah Andress, eds., *Letters to a Young Artist* (New York: Parte Publishing, 2008), 41–43, especially 42.
28. This is particularly challenging when an avant-garde artist wishes to work with traditional support personnel. See Howard Becker, *Art Worlds* (Berkeley: University of California Press, 1982), 26.
29. Clement Greenberg, "Modernist Painting," http://www.sharecom.ca/greenberg/modernism.html (accessed 29 September 2014).
30. Thierry de Duve, "When Form Has Become Attitude—and Beyond," in Nicholas de Ville and Stephen Foster, eds., *The Artist and the Academy: Issues in Fine Art Education and the Wider Cultural Context* (Southampton, UK: John Hansard Gallery, 1994), 23–40, especially 36.

31. Interdisciplinarity is less present at Illinois State, where the department is organized by genre: painting, printing, photography, and ceramics. Photographers like Marissa Webb were primarily judged by the photography faculty.
32. Nathalie Heinich, "Practices of Contemporary Art: A Pragmatic Approach to a New Artistic Paradigm," in Tasos Zembylas, ed., *Artistic Practices: Social Interactions and Cultural Dynamics* (London: Routledge, 2014), 32–43, especially 36.
33. Elkins, *Why Art Cannot Be Taught*, 72.
34. Jordan Anderson, "That's the First Place They'll Look," MFA thesis, University of Illinois at Chicago, 2014, 1.
35. Kenneth Clark, "The Future of Painting," *The Listener*, 2 October 1935, 543–44, quotation on 543.
36. Douglas Crimp, "The End of Painting," *October* 16 (1981): 69–86.
37. Anderson, "That's the First Place They'll Look," 1.
38. Thornton, *Seven Days in the Art World*, 64.
39. Ron Eyerman and Lisa McCormick, *Myth, Meaning, and Performance* (Boulder, CO: Paradigm, 2006); Sophia Acord and Tia DeNora, "Culture and the Arts: From Art Worlds to Arts in Action," *Annals of the American Academy of Political and Social Science* 619 (2008): 223–37.
40. Susie Scott, Tamsin Hinton-Smith, Vuokko Härmä, and Karl Broome, "Goffman in the Gallery: Interactive Art and Visitor Shyness," *Symbolic Interaction* 36 (2013): 417–38.
41. The classic instance of this intrusion is the performance sponsored by German artist Tino Sehgal, who creates "constructed situations" in museum spaces, including two dancers touching and kissing, re-creating some of the erotic poses in classical art. That this was sponsored by the Museum of Contemporary Art in Chicago made it part of the discourse to which students were exposed.
42. Julie Potratz, "Thesis Paper," University of Illinois at Chicago, May 2014, 7.
43. Pablo Helguera, *Art Scenes: The Social Scripts of the Art World* (New York: Jorge Pinto Books, 2012), 23.
44. According to Noah Horowitz (*The Art of the Deal: Contemporary Art in a Global Financial Market* [Princeton: Princeton University Press, 2011]), these forms of documentation are sold at a lower price point than work created to be sold.
45. To make the point about the extent of commodification, I learned of a sociology student who was writing her dissertation on the price structure of "panty auctions." These are internet sites where enterprising women would sell their worn underwear to the highest bidder.
46. Potratz, "Thesis Paper," 11.
47. A faculty member explained, if I understood correctly, that this student claimed to have rented a room across the street from a Chicago hotel, and to have set up a video camera filming a guest room.

48. Randy Kennedy, "The Demented Imagineer," *New York Times Magazine*, 12 May 2013, 38–43, especially 42.
49. For this see the work of Eviatar Zerubavel, notably *Social Mindscapes: Invitation to a Cognitive Sociology* (Cambridge, MA: Harvard University Press, 1997) and *The Fine Line: Making Distinctions in Everyday Life* (Chicago: University of Chicago Press, 1991).
50. Barry Schwabsky, "Agony and Ecstasy: The Art World Explained," *The Nation*, 1 December 2008, 30–33, especially 30.
51. Heinich, "Practices of Contemporary Art," 35.
52. George Dickie, *Art and the Aesthetic* (Ithaca: Cornell University Press, 1974); Judith Adler, *Artists in Offices* (New Brunswick, NJ: Transaction, 1979), 135.
53. Thornton, *Seven Days in the Art World*, 51.
54. Becker, *Art Worlds*, 40–67.
55. Heinich, "Practices of Contemporary Art," 35.
56. The faculty defended her right to produce texts, but criticized the texts themselves.
57. Ludwig Fleck, *Genesis and Development of a Scientific Fact* (Chicago: University of Chicago Press, 1981).
58. Adler, *Artists in Offices*, 135.
59. Ibid., 141–42.
60. David Bodhi Boylan, MFA thesis, University of Illinois at Chicago, May 2014, 1.
61. Alfred Schutz and Thomas Luckmann, *The Structures of the Life-World*, trans. Richard M. Zaner and H. Tristram Engelhardt, Jr. (Evanston: Northwestern University Press, 1973).
62. Eviatar Zerubavel, *Social Mindscapes: An Invitation to Cognitive Sociology* (Cambridge, MA: Harvard University Press, 1997).
63. Roger White, *The Contemporaries: Travels in the 21st Century Art World* (New York: Bloomsbury, 2015), 53.
64. Erving Goffman, *Frame Analysis: An Essay on the Organization of Experience* (Cambridge, MA: Harvard University Press, 1974).
65. Becker, *Art Worlds*.
66. Eitan Y. Wilf, *School for Cool: The Academic Jazz Program and the Paradox of Institutional Creativity* (Chicago: University of Chicago Press, 2014), 150.
67. Bruce Ferguson, in "Art Schools: A Group Crit," *Art in America*, May 2007, 99–113, quotation on 104.
68. Jerry Jacobs, *In Defense of Disciplines: Interdisciplinarity and Specialization in the Research University* (Chicago: University of Chicago Press, 2013), 28–37.
69. Helguera, *Art Scenes*, 55.
70. This references—but differs from—Barnett Newman's famous quip, "Aesthetics is for painting as ornithology is for the birds." Newman seems to suggest that painters do not need aesthetic theory, while my informant refers to the distance between historians and artists. I am grateful to Sophia Acord for this reference.

71. In contrast, some universities such as Princeton do not offer an MFA in visual arts. Emory University recently eliminated their program.

72. At one program I was told that there had been intimate relationships between members of the faculty that had gone bad. I have no independent knowledge of this.

73. Illinois State students can meet their requirement through courses in visual culture.

74. Each semester a session was held in which two graduate students—one in art history and one in art—described their work to a group of colleagues and faculty.

75. Kit White, *101 Things to Learn in Art School* (Cambridge, MA: MIT Press, 2011), section 8.

76. Mierle Laderman Ukeles, in Nesbett and Andress, eds., *Letters to a Young Artist*, 76.

77. Elkins, *Why Art Cannot Be Taught*, 58.

78. Hal Foster, "Archives of Modern Art," *October* 99 (Winter 2002): 81–95, quotation on 81.

79. Pierre Bourdieu, "The Historical Genesis of a Pure Aesthetic," in Pierre Bourdieu, *The Field of Cultural Production: Essays on Art and Literature* (New York: Columbia University Press, 1993), 254–66, quotation on 256.

80. For the impact of invisible colleges in diffusing innovation within science, see Diana Crane, *Invisible Colleges: Diffusion of Knowledge in Scientific Communities* (Chicago: University of Chicago Press, 1972).

81. Lee Ann Norman, "Kenya (Robinson)," *Bomblog*, 20 March 2013, http://bombsite.com/issues/1000/articles/7120 (accessed 15 July 2013).

82. I don't suggest that older artists were never referenced. Giotto, Vermeer, and Watteau were mentioned, but these classical references were relatively uncommon—rare enough that I made a note of them.

83. Fred Davis, "Decade Labeling: The Play of Collective Memory and Narrative Plot," *Symbolic Interaction* 7 (1984): 15–24.

84. Richard Roth, "The Crit," *Art Journal* 58 (Spring 1999): 32–35, especially 34.

85. Lily Chumley (*Creativity Class: Art School and Culture Work in Postsocialist China* [Princeton: Princeton University Press, 2016], 146–47) in her examination of art training in China finds a similar emphasis on the personal, an approach often emphasized by the instructors.

86. Within sociology (and other disciplines) there is a space—although a small and contentious space—in which practitioners can write about their own experience in a form of practice known as auto-ethnography. See, for example, the best of this genre: Carolyn Ellis, *Final Negotiations: A Story of Love, Loss, and Chronic Illness* (Philadelphia: Temple University Press, 1995).

87. Eric Fischl and Michael Stone, *Bad Boy: My Life On and Off the Canvas* (New York: Crown, 2012), 37.

88. Helguera, *Art Scenes*, 43.

89. Matt Morris, "A Set of Hips Set in Clouds," MFA thesis, Northwestern University, Department of Art Theory and Practice, June 2014.
90. Marissa Webb, unpublished artist statement, Illinois State University, 5 November 2013.
91. James Elkins, *Art Critiques: A Guide*, 2d ed. (Washington, DC: New Academia Publishing, 2012), 128. For faculty as therapists—and their limits—see Adler, *Artists in Offices*, 138.
92. David Halle, *Inside Culture* (Chicago: University of Chicago Press, 1994).
93. Boltanski and Thévenot, *On Justification*.
94. Schutz and Luckmann, *The Structures of the Life-World*.
95. Gary Alan Fine, "Sticky Cultures: Memory Publics and Communal Pasts in Competitive Chess," *Cultural Sociology* 7 (2013): 395–414.
96. Robert Witkin, *The Intelligence of Feeling* (London: Heinemann, 1974).
97. One should not draw too firm a line between art practice and other disciplines, such as sociology. The identity category to which sociologists belong affects their problem selection, methodology, and argument (and perhaps their presentation of findings). Knowledge from outside is inevitably shaped by personal, experienced knowledge.

CHAPTER THREE

1. Ben Shahn, *The Shape of Content* (Cambridge, MA: Harvard University Press, 1957), 1.
2. Milton Babbitt, "Who Cares If You Listen?" *High Fidelity*, February 1958, 38–40, 126–27.
3. This argument, pitting highbrow culture against middlebrow taste, was common in the 1950s when Babbitt wrote. For an admirable discussion of this debate, see Herbert Gans, *Popular Culture and High Culture: An Analysis and Evaluation of Taste* (New York: Basic Books, 1974).
4. Clement Greenberg, *Art and Literature: Critical Essays* (Boston: Beacon Press, 1971).
5. Howard Singerman, *Art Subjects: Making Artists in the American University* (Berkeley: University of California Press, 1999), 8.
6. Tony Becher, *Academic Tribes and Territories: Intellectual Enquiry and the Cultures of Disciplines* (Milton Keynes, UK: Open University Press, 1989); Jerry Jacobs, *In Defense of Disciplines: Interdisciplinarity and Specialization in the Research University* (Chicago: University of Chicago Press, 2013), 3.
7. The desire for judgmental control is often discussed by scholars who examine professions. Artists do not often define themselves as a profession in the same way as the enshrined professions, but in universities, faculty and students see themselves as part of a discipline. For discussions of professionalization, see Robert Dingwall and Philip Lewis, eds., *The Sociology of the Professions: Lawyers, Doctors, and Others* (New York: St. Martin's, 1983).

8. Stephen Turner, "What Are Disciplines? And How Is Interdisciplinarity Different?" in Peter Weingart and Nico Stehr, eds., *Practicing Interdisciplinarity* (Toronto: University of Toronto Press, 2000), 50; Jacobs, *In Defense of Disciplines*, 29.

9. The controversy surrounding the photographs of Robert Mapplethorpe and Andres Serrano, and the "Sensation! Show" at the Brooklyn Museum exemplify what happens when the public becomes actively engaged in the art world. See Steven Dubin, *Arresting Images: Impolitic Art and Uncivil Actions* (New York: Routledge, 1993).

10. Esau McGhee, "A Space beyond Institutionalization." MFA thesis, Department of Art Theory and Practice, Northwestern University, 2013.

11. Singerman (*Art Subjects*, 9) distinguishes between professions that practice primarily outside the university, such as architecture, and those that operate within, such as literary criticism.

12. Mark McGurl, *The Program Era: Postwar Fiction and the Rise of Creative Writing* (Cambridge, MA: Harvard University Press, 2009), x.

13. Andrew Abbott, *The System of Professions: An Essay on the Division of Expert Labor* (Chicago: University of Chicago Press, 1988).

14. David Stark, *The Sense of Dissonance: Accounts of Worth in Economic Life* (Princeton: Princeton University Press, 2011).

15. Nancy Wisely and Gary Alan Fine, "Making Faces: Portraiture as a Negotiated Worker-Client Relationship," *Work and Occupations* 24 (1997): 164–87.

16. Henry Kingsbury, *Music, Talent, and Performance: A Conservatory Cultural System* (Philadelphia: Temple University Press, 1988). For Kingsbury both the conservatory and music itself constitute cultural systems. Students learn musicality through the teaching of music.

17. Boris Groys, *Going Public* (New York: Sternberg Press, 2010), 55.

18. Nathalie Heinich, "Mapping Intermediaries in Contemporary Art according to Pragmatic Sociology," *European Journal of Cultural Studies* 15 (2012): 695–702.

19. Singerman, *Art Subjects*, 11; Roger Geiger, *To Advance Knowledge: The Growth of the American Research Universities, 1900–1940* (New York: Oxford University Press, 1986), 22.

20. Lane Relyea, *Your Everyday Art World* (Cambridge, MA: MIT Press, 2013), 160–61.

21. Ibid., 37.

22. Barry Schwabsky, "Permission to Fail: MFAs Aren't a Problem: It's Artists Being Content with What They Know," *The Nation, 21* January 2014; available online at http://thenation.com/article/178023/permission-fail?page =full (accessed 2 February 2014).

23. Clifford Geertz, *Local Knowledge* (New York: Basic Books, 1983).

24. Becher, *Academic Tribes and Territories*, 22–24.

25. Jeffrey Alexander, "Iconic Experience in Art and Life: Surface/Depth Beginning with Giacometti's *Standing Woman*," *Theory, Culture, and Society* 25 (2008): 1–19.

26. Ron Eyerman and Magnus Ring, "Towards a New Sociology of Art Worlds: Bringing Meaning Back In," *Acta Sociologica* 41 (1998): 277–83.

27. Ian Sutherland and Sophia Krzys Acord, "Thinking with Art: From Situated Knowledge to Experiential Knowing," *Journal of Visual Art Practice* 6 (2007): 125–40, especially 127; Robert Witkin, "Constructing a Sociology for an Icon of Aesthetic Modernity: Olympia Revisited," *Sociological Theory* 15 (1997): 101–25, especially 103.

28. Sophia Krzys Acord and Tia DeNora, "Culture and the Arts: From Art Worlds to Arts-in-Action," *Annals of the American Academy of Political and Social Sciences* 619 (2008): 223–37, especially 226.

29. Hans Abbing, *Why Are Artists Poor? The Exceptional Economy of the Arts* (Amsterdam: Amsterdam University Press, 2004), 269.

30. David Bodhi Boylan, MFA thesis, University of Illinois at Chicago, May 2014, 4.

31. In one critique, a faculty member tells a student, "It seems kind of didactic. It tries to teach us something." The student comments, "I have a tendency to give away the story" (Field Notes). The idea of didacticism echoes the perspective on "objectivation" in Peter Berger and Thomas Luckmann, *The Social Construction of Reality* (New York: Anchor, 1966).

32. This argument corresponds with that of Wendy Griswold in her model of the "cultural diamond," as in *Cultures and Societies in a Changing World*, 4th ed. (Newbury Park, CA: Sage, 2013), 14–16.

33. Roger White, *The Contemporaries: Travels in the 21st Century Art World* (New York: Bloomsbury, 2015), 35. In White's case, it is a faculty member who desires a cold read.

34. Bruno Latour, *Reassembling the Social: An Introduction to Actor-Network Theory* (New York: Oxford University Press, 2005).

35. Timothy Van Laar and Leonard Diepeveen, *Active Sights: Art as Social Interaction* (Mountain View, CA: Mayfield, 1998), 19.

36. Pinar Oner Yilmaz, "Jenyu Wang's Call to the World: Mind the Gap," 28 April 2014, http://gallery-40.uic.edu/blog/jenyu-wangs-call-to-the-world-mind-the-gap (accessed 28 April 2014).

37. Gail Gomez, "An Interview with MFA Student Ben Murray," 25 March 2013, http://gallery400.uic.edu/interact/inside-stories/an-interview-with-mfa-student-ben-murray (accessed 1 August 2014).

38. Singerman, *Art Subjects*, 163. The valuation of language arrived earlier than the embrace of theory, dating to postwar and 1960s art education. Talk need not incorporate theoretical models of the kind that I discuss subsequently.

39. Hayden White, "The Question of Narrative in Contemporary Historical Theory," *History and Theory* 23 (1984): 1–33.

40. Roger White, *The Contemporaries*, 22.

41. Sophia Krzys Acord, "Beyond the Head: The Practical Work of Curating Contemporary Art," *Qualitative Sociology* 33 (2010): 447–67, especially 450; Pierre Bourdieu, *The Field of Cultural Production* (New York: Columbia University Press, 1993).

42. Michel Anteby, *Manufacturing Morals: The Value of Silence in Business School Education* (Chicago: University of Chicago Press, 2013), 2.

43. John Van Maanen, "Observations on the Making of Policemen." *Human Organization* 32 (1973): 407–18.

44. Pablo Helguera, *Art Scenes: The Social Scripts of the Art World* (New York: Jorge Pinto Books, 2012), 34.

45. Nathalie Heinich, "Practices of Contemporary Art: A Pragmatic Approach to a New Artistic Paradigm," in Tasos Zembylas, ed., *Artistic Practices: Social Interactions and Cultural Dynamics* (London: Routledge, 2014), 32–43, quotation on 36–37.

46. Priscilla Adipa, "Engaging Spaces, Engaged Audiences: The Socio-Spatial Context of Cultural Experiences in Art Galleries and Art Museums," Ph.D. diss. (Sociology), Northwestern University, 2017.

47. Michael Jarvis, "Articulating the Tacit Dimension in Artmaking," *Journal of Visual Arts Practice* 6 (2007): 201–13, especially 202.

48. Elizabeth Mertz, *The Language of Law School: Learning to "Think Like a Lawyer"* (New York: Oxford University Press, 2007), vii.

49. For example, Malcolm Cowley, "Sociological Habit Patterns in Transmogrification," *The Reporter* 20 (20 September 1956): 41 and following; Michael Billig, *Learn to Write Badly: How to Succeed in the Social Sciences* (Cambridge: Cambridge University Press, 2013).

50. "The Instant Art Critique Phrase Generator," Code: 84623, http://www.pixmaven.com/phrase_generator.html (accessed 8 October 2014). This software is often referred to as "Critical Response to the Art Product," or CRAP, but it is significant that these artificial phrases are potentially meaningful, given the proper context.

51. Alex Rule and David Levine, "International Art English," 30 July 2012, http://canopycanopycanopy.com/international_art_english (accessed 7 March 2013). These authors trace the lexicon to the founding of the influential art theory journal *October* in 1976, as part of the search for more rigorous interpretive criteria. We might imagine Tom Wolfe suggesting that *October* reflected the fall of fine art appreciation.

52. Lee Ann Norman, "Kenya (Robinson)," *Bomblog*, 20 March 2013, http//bombsite.com/issues/1000/articles/7120 (accessed 15 July 2013).

53. Carol Becker, *Social Responsibility and the Place of the Artist in Society* (Chicago: Lake View Press, 1990), 10.

54. Jack Flam, ed., *Matisse on Art* (Berkeley: University of California Press, 1995), 2.

55. Robert Storr, in "Art Schools: A Group Crit," *Art in America*, May 2007, 99–113, quotation on 111.

56. Jane Chafin, "MFA: Is it Necessary?—The Debate," 12 July 2011, http://janechafinsofframpgalleryblog.blogspot.com/2011/07/mfa-is-it-necessary-debate.html (accessed 7 July 2014).

57. At Illinois State it is termed a "supportive statement."

58. Theses at the University of Chicago are now shorter, closer to the traditional artist statement, approximately a thousand words. (At Northwestern, the thesis should be about twenty-five hundred words).

59. Jennifer Liese, "Toward a History (and Future) of the Artist Statement," *Paper Monument* 4 (2014), available online at http://www.papermonument.com /web-only/toward-a-history-and-future-of-the-artist-statement/ (accessed 23 April 2014).

60. Natalie Adamson and Linda Goddard, "Artists' Statements, Origins, Intentions, Exegesis," *Forum for Modern Language Studies* 48, no. 4 (2012): 363–75, especially 365.

61. There is a long history of artists as writers. This is not entirely a twentieth-century phenomenon, but the expectation of artists participating actively in critical debates is relatively recent.

62. It is not only visual art in which theory is evident. One can find a related (if somewhat distinct) emphasis on theory in jazz education. See Eitan Y. Wilf, *School for Cool: The Academic Jazz Program and the Paradox of Institutionalized Creativity* (Chicago: University of Chicago Press, 2014), 142–43.

63. Some argue that formal theory has declined in art schools, replaced by open-ended, but still conceptual, discussions. See Relyea, *Your Everyday Art World*, 165.

64. Cited in Hilton Kramer, "The Happy Critic: Arthur Danto in *The Nation*," *New Criterion*, September 1987, available online at http://www.newcriterion .com/articles.cfm/The-happy-critic—Arthur-Danto-in—The-Nation—-5881 (accessed 10 October 2014).

65. Boris Groys, "Education by Infection," in Steven Madoff, ed., *Art School (Propositions for the 21st Century)* (Cambridge, MA: MIT Press, 2009), 25–32, especially 31.

66. Timothy Allen Jackson, "Ontological Shifts in Studio Art Education: Emergent Pedagogical Models," *Art Journal* 58 (1999): 68–73, quotation on 68.

67. As Andreas Fischer points out, there is considerable variability among faculty as to their embrace of theory, to the point that some are labeled "anti-theory." However, the term "anti-theory" suggests in its opposition the central place of theory in the academy.

68. Alexander Potts, personal communication, 2014.

69. W. J. T. Mitchell, "Medium Theory: Preface to the 2003 *Critical Inquiry* Symposium," *Critical Inquiry* 30 (Winter 2004): 324–35, quotation on 332.

70. Relyea, *Your Everyday Art World*, 159.

71. Singerman (*Art Subjects*, 204) speaks to the different versions or inflections of the "disciplinary language of studio art," recognizing that within a single faculty various dialects may be spoken. Larry Witham (*Art Schooled: A Year among Prodigies, Rebels, and Visionaries at a World-Class Art College* [Lebanon, NH: University Press of New England, 2012], 4) argues that art schools emphasize skill, expression, and attitude (theory) in different proportions.

72. James Elkins (*Art Critiques: A Guide*, 2d ed. [Washington, DC: New Academia Publishing, 2012], 70) argues that schools such as CalArts and Goldsmiths were particularly identified with high theory, pointing to distinctions among program cultures.

73. Gabriel Abend, "The Meaning of Theory," *Sociological Theory* 26 (2008): 173–99.

74. Elkins, *Art Critiques*, 67.

75. Jacques Lacan, *Écrits* (New York: W. W. Norton, 2007).

76. Sarah Thornton, *Seven Days in the Art World* (New York: W. W. Norton, 2008), 53.

77. Deborah Solomon, "How to Succeed in Art," *New York Times*, 27 June 1999, available online at http://www.nytimes.com/1999/06/27/magazine/how-to-succeed-in-art.html (accessed 19 May 2013).

78. Jenyu Wang, quoted in Yilmaz, "Jenyu Wang's Call to the World."

79. Raphael Fleuriet, "Les arts méta-plastiques," in *Archipelago* (Evanston: Department of Art Theory and Practice, Northwestern University, 2014), 1.

80. Singerman, *Art Subjects*, 4.

81. Archie Rand, in "Art Schools: A Group Crit," *Art in America*, May 2007, 99–113, quotation on 107–8.

82. Susan E. McKenna, "Theory and Practice: Revisiting Critical Pedagogy in Studio Art Education," *Art Journal* 58 (Spring 1999): 74–79, especially 75.

83. Quoted in Solomon, "How to Succeed in Art."

84. Ibid.

85. Howard S. Becker, Blanche Geer, Everett Hughes, and Anselm Strauss, *Boys in White: Student Culture in Medical School* (Chicago: University of Chicago Press, 1961).

86. Monet's fame and political connections were such that when his water lilies murals (*Nymphéas*) were donated in 1922, the French government reconstructed the Musée de l'Orangerie to display them.

87. I do not suggest that consensus reigns in the art world. Artist can be posed against artist, and certainly artist against dealer or collector.

88. Walter Benjamin, *The Work of Art in the Age of Mechanical Reproduction* (London: Penguin, 2008).

89. Randy Kennedy, "Outside the Citadel, Art That Nurtures," *New York Times*, 24 March 2013, AR1, AR17.

90. The Nazis promoted art for their own purposes (Eric Michaud, *The Cult of Art in Nazi Germany* [Stanford: Stanford University Press, 2004]), as did the United States in the Cold War era (Serge Guilbaut, *How New York Stole the Idea of Modern Art* [Chicago: University of Chicago Press, 1983]), but the Soviets were perhaps most focused on how art could serve interests of the state.

91. Only once did I hear a reference to Institutional Review Board (Human Subjects) approval, and on that occasion it was intended as an ironic and humorous commentary. While artists refer to research in other fields, these standards and requirements are not brought into the conversation.

92. Hal Foster, "The Artist as Ethnographer," in Hal Foster, ed., *The Return of the Real: The Avant-Garde at the End of the Century* (Cambridge, MA: MIT Press [October Books], 1996), 171–203, especially 171.

93. Carol Becker, *Social Responsibility and the Place of the Artist in Society* (Chicago: Lake View Press, 1990), 10.

94. Kendall Buster and Paul Crawford, *The Critique Handbook: A Sourcebook and Survival Guide* (Upper Saddle River, NJ: Pearson Education, 2007), 97.

95. See Amy Franceschini and Daniel Tucker, *Farm Together Now* (San Francisco: Chronicle Books, 2010).

96. I was told that one school admitted a "devout Christian," and this was widely discussed, but I was also informed that she was not politically conservative and that religion was not a part of her work (Field Notes).

97. Thornton, *Seven Days in the Art World*, 59. Lavine suggests that because the artists have made "compromises with the world," they are really center-left. Perhaps more precisely they fall in the well-known category of bourgeois Marxists.

98. She explained that some conservatives have done well, but others "just were not comfortable."

CHAPTER FOUR

I borrow the title of this chapter, playing off Kant's *Critique of Pure Reason*, from a handout by Dianna Frid at the University of Illinois at Chicago Department of Art. It is also found elsewhere on the internet.

1. Alexander Chee, "My Parade," in Chad Harbach, ed., *MFA vs. NYC: The Two Cultures of American Fiction* (New York: n+1/Faber and Faber, 2014), 83–103, quotation on 97.

2. Pierre Bourdieu, *The Rules of Art: Genesis and Structure of the Literary Field* (Stanford: Stanford University Press, 1996).

3. Luc Boltanski and Lucien Thévenot, *On Justification: Economies of Worth* (Princeton: Princeton University Press, 2006).

4. I was permitted to observe these meetings at one school.

5. Academic discursive styles differ by nation, or at least they used to. See Johan Galtung, "Structure, Culture, and Intellectual Style: An Essay Comparing Saxonic, Teutonic, Gallic and Nipponic Approaches," *Social Science Information* 20, no. 6 (1981): 817–56.

6. Jori Finkel, "Tales from the Crit: For Art Students, May is the Cruelest Month," *New York Times*, 30 April 2006, available online at http://www.nytimes.com /2006/04/30/arts/design/30fink.html (accessed 13 October 2014).

7. Creative writing programs have critiques that are central to pedagogy, but they are not public meetings at which everyone gets a chance to whack the piñata. These are private sessions, typically with a single writer and a group of students.

8. Roger White, *The Contemporaries: Travels in the 21st Century Art World* (New York: Bloomsbury, 2015), 16.

9. James Elkins, *Art Critiques: A Guide, 2d ed.* (Washington, DC: New Academia Publishing, 2012); Kendall Buster and Paula Crawford, *The Critique Handbook: A Sourcebook and Survival Guide* (Upper Saddle River, NJ: Pearson, 2007).

10. Elkins, *Art Critiques,* 73.

11. Ibid., 22.

12. Brad Troemel, "Why MFA Critiques Are Futile Exercises," *DIS Magazine* 201, http://dismagazine.com/discussion/32434/brad-troemel-mfa-critiques/ (accessed 18 November 2013).

13. For published descriptions of critiques at UIC see Marc Parry, "A Sociologist Asks What Happens When Art Goes Academic," *Chronicle of Higher Education,* 22 July 2014, available online at http://www.chronicle.com/article/A -Sociologist-Asks-What/147791 (accessed 17 December 2016); Alex Rauch, "For Art Students, the Final Critique," UIC News Center, 18 December 2012, http://news.uic.edu/for-art-students-semester-boils-down-to-critiques (accessed 12 May 2014).

14. Joe Scanlon, personal communication, 2014. This reflects the hostile worlds of valuation described by Viviana Zelizer, *The Purchase of Intimacy* (Princeton: Princeton University Press, 2007).

15. University of Chicago wins my culinary award for a Chinese luncheon banquet the day I attended.

16. Sarah Thornton, *Seven Days in the Art World* (New York: W. W. Norton, 2008), 71.

17. First-year students are not evaluated, and advice is provided to the thesis committee of the third-year students. For the other schools, discussion of students occurs in a separate faculty meeting.

18. Nina Eliasoph and Paul Lichterman, "Culture in Interaction," *American Journal of Sociology* 108 (2003): 734–94.

19. Gary Alan Fine, "Small Groups and Culture Creation: The Idioculture of Little League Baseball Teams," *American Sociological Review* 44 (1979): 733–45.

20. Regional cultural differences may play a role (here between Chicago and downstate). As noted earlier, there are differences between East Coast critiques that have a reputation for being blunt and hostile, and West Coast critiques that are more relaxed. See Finkel, "Tales from the Crit."

21. Priscilla Adipa, "Engaging Spaces, Engaged Audiences: The Socio-Spatial Context of Cultural Experiences in Art Galleries and Art Museums," Ph.D. diss. (Sociology), Northwestern University, 2017.

22. Howard Singerman, *Art Subjects: Making Artists in the American University* (Berkeley: University of California Press, 1999), 211.

23. For an example of a student destroying a painting mid-critique, see Mostafa Hedday, "Watch an Artist Have a Meltdown and Destroy a Canvas with Panache," *Hyperallergic,* 21 May 2013, http://hyperallergic.com/71665/watch -an-artist-have-a-meltdown-and-destroy-a-canvas-with-panache/ (accessed 13 October 2014). The author suggests that this destruction might be "high-concept work masquerading as viral fodder."

24. Buster and Crawford, *The Critique Handbook*, 93–94.
25. See, for example, Richard Roth, "The Crit," *Art Journal* 58 (Spring 1999): 32–35. The satiric film *Art School Confidential* (2006, dir. Terry Zwigoff) also has a scene that is set in a critique.
26. Daniel Tucker, personal communication, 2015.
27. Finkel, "Tales from the Crit."
28. Thornton, *Seven Days in the Art World*, 47.
29. Singerman, *Art Subjects*, 211.
30. Although my judgments are suspect (I still revere Monet), I found that many students produced more compelling and sophisticated work in their second year than in their first. Many faculty members agreed.
31. An example, perhaps, of such an educator, at Yale, is described by Finkel, "Tales from the Crit." One painting student "depict[ed] him naked, sliding down an icy slope, being sexually assaulted by a cow."
32. I was told that in one case the program was concerned about a harassment suit.
33. Flyer, "The Pure Reason of Critique," December 2013.
34. Thornton, *Seven Days in the Art World*, 54.
35. Boris Groys, *Going Public* (New York: Sternberg Press, 2010), 56.
36. Don Thompson, *The Supermodel and the Brillo Box* (New York: Palgrave Macmillan, 2014), 99.
37. Jordan Anderson, "Titles: For Work Present, Absent, Future, and Destroyed," MFA thesis, Department of Art, University of Illinois at Chicago, May 2014.
38. An emphasis on intentionality also suggests that there are no errors. This point is made in Eitan Wilf's examination of academic jazz education. Classes listen to jazz solos (with improvisations) in the belief that "the masters' solos cannot represent any mistake in terms of chord-scale theory and that every aspect of a master's solo can be justified in theoretical terms" (Eitan Wilf, *School for Cool: The Academic Jazz Program and the Paradox of Institutional Creativity* [Chicago: University of Chicago Press, 2014], 154). Of course, one first needs to be canonized as a master to receive this treatment.
39. Nathalie Heinich, "Practices of Contemporary Art: A Pragmatic Approach to a New Artistic Paradigm," in Tasos Zembylas, ed., *Artistic Practices: Social Interactions and Cultural Dynamics* (London: Routledge, 2014), 34.
40. Buster and Crawford, *The Critique Handbook*, 95.
41. Sophia Krzys Acord, "Beyond the Head: The Practical Work of Curating Contemporary Art," *Qualitative Sociology* 32 (2010): 447–67.
42. Howard Gardner, Mihaly Csikszentmihalyi, and William Damon, *Good Work: Where Excellence and Ethics Meet* (New York: Basic Books, 2001).
43. Jane Chafin, "MFA: Is It Necessary?—The Debate," 12 July 2011, http://jane chafinofframpgallery.blogspot.com/2011/07/mfa-is-it-necessary-debate.html (accessed 7 July 2014).
44. Howard Becker, *Art Worlds* (Berkeley: University of California Press, 1982), 40–67.

45. Erik Nylander ("Mastering the Jazz Standard: Sayings and Doings of Artistic Valuation," *American Journal of Cultural Sociology* 2 [2014], 66–96, especially 66) speaks of this as avoiding being an epigone or a heretic.

46. Pierre Bourdieu, *Science of Science and Reflexivity* (Chicago: University of Chicago Press, 2004).

47. Students must negotiate these multiple aesthetics. One former student, who attempted to take the advice of the faculty, found it maddening as he changed his practice to meet the varying demands of his teachers, who defined excellence in contradictory ways. He said that "at some point you have to just make the work and know you are going to piss off [some teachers]" (Interview).

48. See George Dickie, *Art and the Aesthetic: An Institution Analysis* (Ithaca, NY: Cornell University Press, 1974).

49. A few students left voluntarily, but in a two- (or three-) year program this was less common than among Ph.D. students during their five to eight years. By the time students discovered that the MFA was not for them, they were nearly done. Because of interpersonal conflict, one student was suspended from a program for a year, but he graduated with the next cohort.

50. A faculty member explained that this was brutally explicit at UCLA when he was a student. "We would have critiques and the next day . . . they would post all the graduate students in ranked order after the critique, best, worst. . . . And the last three or four were gone soon after . . . I was ranked good enough . . . but it was psychologically brutal" (Interview). The ranking process is one reason that Dave Hickey objects to critiques: "These crucibles . . . allow faculty members to poison and manipulate peer relations among their students" (David Hickey, in "Art Schools: A Group Crit," *Art in America*, May 2007, 99–113, quotation on 106). Some students discover that they are favored offspring; others, that they are orphans.

51. Nylander, "Mastering the Jazz Standard," 66.

52. Katri Huutoniemi, "Communicating and Compromising on Disciplinary Expertise in the Peer Review of Research Proposals," *Social Studies of Science* 42 (2012): 900–924.

53. Michele Lamont, *How Professors Think: Inside the Curious World of Academic Judgment* (Cambridge, MA: Harvard University Press, 2010); Boltanski and Thévenot, *On Justification*.

54. Michele Lamont and Katri Huutoniemi, "Comparing Customary Rules of Fairness: Evaluative Practices in Various Types of Peer-Review Panels," In Charles Camic, Neil Gross, and Michele Lamont, eds., *Social Knowledge in the Making* (Chicago: University of Chicago Press, 2011).

55. Phillipa Chong, "Legitimate Judgment in Art, the Scientific World Reversed? Maintaining Critical Distance in Evaluation," *Social Studies of Science* 43 (2013): 265–81.

56. Laurie Fendrich, in "Art Schools: A Group Crit," *Art in America*, May 2007, 99–113, quotation on 103.

57. Hakim explained that he altered the scale of his work, its subject matter, and style, because of negative feedback that suggested that his work was too commercial. Presenting commercial work—or praising commercialism—is taboo at these schools, even if Hakim wishes that it was not "out of the conversation" (Interview).

CHAPTER FIVE

1. Pablo Helguera, *Art Scenes: The Social Scripts of the Art World* (New York: Jorge Pinto Books, 2012), 11.
2. Howard Singerman, *Art Subjects: Making Artists in the American University* (Berkeley: University of California Press, 1999), 2.
3. Richard Lloyd, *Neo-Bohemia: Art and Commerce in the Post-Industrial City* (New York: Routledge, 2005).
4. Gary Alan Fine, "Justifying Work: Occupational Rhetorics as Resources in Restaurant Kitchens," *Administrative Science Quarterly* 41 (1996): 90–115.
5. Timothy Van Laar and Leonard Diepeveen, *Active Sights: Art as Social Interaction* (Mountain View, CA: Mayfield, 1998), 53–67.
6. Singerman, *Art Subjects*, 2.
7. Judith Adler, *Artists in Offices* (New Brunswick, NJ: Transaction, 1979), 135.
8. Lane Relyea, *Your Everyday Art World* (Cambridge, MA: MIT Press, 2013), 5.
9. There has long been pushback, but even if these artists wished to be only artists, they were categorized in much critical writing. Today shows consisting of all female artists or all black artists must justify themselves. See, for example, the "Champagne Life" show at London's Saatchi Gallery in 2016 (Nadia Khomami, "Saatchi Gallery to Show Its First All-Female Art Exhibition," *The Guardian*, 6 January 2016). https://www.theguardian.com/art anddesign/2016/jan/06/saatchi-gallery-first-all-female-art-exhibition-cham pagne-life. (Accessed July 29, 2016).
10. Guerrilla Girls, quoted in Peter Nesbett and Sarah Andress, eds., *Letters to a Young Artist* (New York: Darte Publishing, 2008), 53.
11. Anna Lepsch, "An Interview with MFA Candidate Elena Feijoo," 7 April 2014, http://gallery400.uic.edu/interact/inside-stories/an-interview-with -mfa-candidate-Elena-Feijoo (accessed 13 May 2014).
12. Samuel Shaw, "Scene Logics: Local Visibility in a Global Field," 2013, unpublished manuscript.
13. For a discussion of aesthetic communities developing within Chinese art schools, see Lily Chumley, *Creativity Class: Art School and Culture Work in Postsocialist China* (Princeton: Princeton University Press, 2016), chap. 6.
14. Michael Farrell, *Collaborative Circles: Friendship Dynamics and Creative Work* (Chicago: University of Chicago Press, 2001). Not all cohorts or programs are collaborative circles. The Northwestern cohort that titled their group show *Archipelago* (separate islands) would not be counted as a collaborative

circle with their vastly different styles, even if they were a group of friends whose interaction constituted a local art scene.

15. Randall Collins, *Interactive Ritual Chains* (Princeton: Princeton University Press, 2004).

16. Tim Tomlinson, "The MFA vs. the Portable MFA," in New York Writers Workshop, *The Portable MFA in Creative Writing* (New York: Writer's Digest Books, 2006), 1–10, especially 7.

17. Helguera, *Art Scenes*, 24.

18. Howard Becker, *Art Worlds* (Berkeley: University of California Press, 1982), 1; Theodore Schatzki, "Art Bundles," in Tasos Zembylas, ed., *Artistic Practices: Social Interactions and Cultural Dynamics* (London: Routledge, 2014), 20.

19. Daniel Silver, Terry Nichols Clark, and Clemente Navarro, "Scenes: Social Context in an Age of Contingency," *Social Forces* 88 (2010): 2293–324.

20. Peter Schjeldahl, "Why Artists Make the Worst Students," 13 February 1999, http://www.parshift.com/Speakers/Speak013.htm (accessed 21 October 2014).

21. Shaw, Scene Logics," 19.

22. Helguera, *Art Scenes*, 21.

23. Nicolas Bourriaud, *Relational Aesthetics* (Paris: Les Presses du Réel, 2002).

24. Relyea, *Your Everyday Art World*, 53.

25. Alison Gerber, "Making Cents and Nonsense of Art," 2013, unpublished manuscript, 37.

26. Ben Shahn, *The Shape of Content* (Cambridge, MA: Harvard University Press, 1957), 128.

27. Robert Storr, in "Art Schools: A Group Crit," *Art in America*, May 2007, 99–113, quotation on 113.

28. Kathleen Oberlin and Thomas Gieryn, "Place and Culture-making: Geographic Clumping in the Emergence of Art Schools," *Poetics* 50 (2015): 20–43. By "schools," Oberlin and Gieryn refer to collaborative circles of professional artists, not educational institutions. They find that labeled groups typically have members who reside in the same geographical area.

29. Raymond Parker, "Student, Teacher, Artist," *College Art Journal* 12, no. 1 (Autumn 1953): 27–30, especially 29.

30. Kerry James Marshall, quoted in Nesbett and Andress, eds., *Letters to a Young Artist*, 26.

31. Maria Adelmann, "Basket Weaving 101," in Chad Harbach, ed., *MFA vs. NYC: The Two Cultures of American Fiction* (New York: n+1/Faber and Faber, 2014), 45.

32. While universities located in small towns, such as Normal, Illinois, have their local bars, the absence of a robust nightlife culture may determine the students who apply and their activities after they enroll. Artists often think of themselves as needing late-night sociability. Certainly in Normal, there is not an art world scene, and this both protects and limits student engagement.

33. Thomas Nozkowski, in Nesbett and Andress, eds., *Letters to a Young Artist*, 48.

34. Boris Groys, "Education by Infection," in Steven Henry Madoff, ed., *Art School* (*Propositions for the 21st Century*), (Cambridge, MA: MIT Press, 2009), 25–32, especially 27.

35. Relyea, *Your Everyday Art World*, 62–64, 102–3.

36. Farrell, *Collaborative Circles*.

37. See Fabien Accominotti, "Creativity from Interaction: Artistic Movements and the Creativity Careers of Modern Painters," *Poetics* 37 (2009): 267–94.

38. Although my data are not complete (and I do not have data from Illinois State), most graduating MFA artists at UIC and Northwestern remain in Chicago for the immediate future. Some of my contacts have developed careers or found teaching jobs in the city. Others return to their home region. Many of the more ambitious move to New York, and, in a few cases, to Los Angeles.

39. I question the empirical accuracy of the generalization, but she makes a point that cohorts are distinctive, perhaps an attempt to erase some of the conflict in earlier cohorts. Another student of a later cohort notes that "our class is much less concerned with theory. . . . We're just more of a visual bunch" (Interview).

40. Judy Chicago, *Institutional Time: A Critique of Studio Art Education* (New York: Monacelli Press, 2014), 33–44; Richard Hertz, *Jack Goldstein and the CalArts Mafia* (Ojai, CA: Mineola Press, 2003), 52–87.

41. Dave Hickey, in "Art Schools: A Group Crit," *Art in America*, May 2007, 99–113, quotation on 107.

42. Heather Darcy Bhandari and Jonathan Melber, *Art/Work* (New York: Free Press, 2009), 5.

43. Larry Witham, *Art Schooled: A Year among Prodigies, Rebels, and Visionaries at a World-Class Art College* (Lebanon, NH: University Press of New England, 2012), 37.

44. David Birnbaum, "The Art of Education." *Artforum International* 45, no. 10 (Summer 2007): 474.

45. Jeff Burton and Andrew Hultkrans, "Surf and Turf," *Artforum International* 36, no. 10 (Summer 1998): 106–13, especially 106.

46. Carol Becker, *Social Responsibility and the Place of the Artist in Society* (Chicago: Lake View Press, 1990), 7, 12.

47. Al Muniz, Toby Norris, and Gary Alan Fine, "Marketing Artistic Careers: Pablo Picasso as Brand Manager," *European Journal of Marketing* 48 (2014): 68–88.

48. I am grateful to Larissa Buchholz for this insight.

49. Eric Fischl and Michael Stone, *Bad Boy: My Life On and Off the Canvas* (New York: Crown, 2012), 48.

50. Alexander Chee, "My Parade," in Harbach, ed., *MFA vs. NYC*, 100.

51. Most of the faculty are male, but my informant did not suggest that these were instances of harassment, nor did the informant refer to the sexual orientations of those involved.

52. Bhandari and Melber, *Art/Work*, 7; Richard Roth, "The Crit," *Art Journal* 58 (1), Spring 1999, pp. 32–35, p. 33. In this script a student comments, "You guys would kick Guston and Pollock and Rothko out on their asses."

53. Obscenity factories are found in spaces that are based on tight bonds and immediate action, places such as police work, political offices, and emergency rooms: the obscenity indicates how crucial and communal the work is. One expects more of this talk in art practice than in art history.

54. Quotation in Harbach, ed., *MFA vs. NYC*, 81.

55. Sarah Thornton, *Seven Days in the Art World* (New York: W. W. Norton, 2008), 58.

56. This difference in culture—and its potential effects—is noted in Louise Mary Roth, "Selling Women Short: A Research Note on Gender Differences in Compensation on Wall Street," *Social Forces* 82 (2003): 783–802, especially 785; Lauren Rivera, *Pedigree: How Elite Students Get Elite Jobs* (Princeton: Princeton University Press, 2015); Rosabeth Moss Kantor, *Men and Women of the Corporation* (New York: Basic Books, 1977).

57. This—along with different amounts of cultural capital—may help explain the difficulties of establishing careers for artists from the global periphery. I am grateful to Larissa Buchholz for this observation.

58. Gary Alan Fine, *Tiny Publics: A Theory of Group Action and Culture* (New York: Russell Sage Foundation, 2012).

59. Paul J. Dimaggio and Walter W. Powell, "The Iron Cage Revisited: Institutional Isomorphism and Collective Rationality in Organizational Fields," *American Sociological Review* 48 (1983): 147–60.

60. Witham, *Art Schooled*, 4.

61. Relyea, *Your Everyday Art World*.

62. James Elkins, *Why Art Cannot Be Taught* (Urbana: University of Illinois Press, 2001), 128.

63. Larry Witham (*Art Schooled*, 202) reports that representational painters at the Maryland Institute College of Art say that their brushstrokes are chunky, colorful, and short: Cézanne style.

64. Erving Goffman, *Interaction Ritual* (New York: Anchor, 1967).

65. Archie Rand, in "Art Schools: A Group Crit," *Art in America*, May 2007, 99–113, especially 107.

66. Adler, *Artists in Offices*; Hertz, *Jack Goldstein and the CalArts Mafia*; Fischl and Stone, *Bad Boy*; Chicago, *Institutional Time*.

67. Burton and Hultkrans, "Surf and Turf"; Solomon, "How to Succeed in Art," *New York Times*, 27 June 1999, available online at http://www.nytimes.com/1999/06/27/magazine/how-to-succed-in-art.html (accessed 19 May 2012).

68. James Elkins ("Being Behind the Times, Being Average," 2014, unpublished third chapter of *Art Critiques: A Guide*, 2) wisely emphasizes that peripheral institutions—not in size but in disciplinary centrality—tend not to produce cutting-edge work; too many of their faculty and students may not be actively engaged in significant art centers or the institution may discourage

this. Savannah College of Art and Design, no tiny institution, places such emphasis on job placement that the (deliberately) unsalable conceptual art produced at Northwestern is discouraged (Interview).

69. According to *U.S. News and World Report*, University of Chicago was rated 33, tied with UIC, in the 2016 MFA rankings of fine arts programs.

70. Nathalie Heinich, "Practices of Contemporary Art: A Pragmatic Approach to a New Artistic Paradigm," in Tasos Zembylas, ed., *Artistic Practices: Social Interactions and Cultural Dynamics* (London: Routledge, 2014), 32–43, especially 40.

71. Farrell, *Collaborative Circles.*

72. The assessment of the mix varies. Esau McGhee speculated that reputation is 50 percent based on an artist's persona, 30 percent on his or her network, and 20 percent on the work itself (Interview).

73. Lucien Karpik, *Valuing the Unique: The Economics of Singularities* (Princeton: Princeton University Press, 2010).

74. Elkins, "Being Behind the Times, Being Average," 1.

75. Pierre-Michel Menger, *The Economics of Creativity: Art and Achievement under Uncertainty* (Cambridge, MA: Harvard University Press, 2014).

76. Gary Alan Fine, *Players and Pawns* (Chicago: University of Chicago Press, 2015).

77. Helguera, *Art Scenes*, 19, 81.

78. Solomon, "How to Succeed in Art." Sadly for Ms. Brown, a hideously negative review of her first New York show in the *New York Times* made her quest more difficult, although the point still holds. See Michael Kimmelman, "Art in Review: Delia Brown," *New York Times*, 27 October 2000, available online at http://www.nytimes.com/2000/10/27/arts/art-in-review-delia-brown.html (accessed 24 October 2014). She still exhibits and receives strong reviews, but she might dream of what a glowing notice from Kimmelman could have meant. I admire her work, but I am no Kimmelman.

79. Chad Harbach, "MFA vs. NYC," in Harbach, ed., *MFA vs. NYC*, 9–28, especially 19.

80. Relyea, *Your Everyday Art World*, 22.

81. Heinich, "Practices of Contemporary Art," 40.

82. Solomon, "How to Succeed in Art."

83. Adler, *Artists in Offices*, 17.

84. Judith Kirshner, in "Art Schools: A Group Crit," *Art in America*, May 2007, 99–113, quotation on 109.

85. Michal McCall, "The Sociology of Female Artists," *Studies in Symbolic Interaction* 1 (1978): 298–319, especially 292–93, 311.

86. Adler, *Artists in Offices*, 17.

87. See Fredric Jameson, "Dirty Little Secret," in Harbach, ed., *MFA vs. NYC*, 263.

88. Harbach, "MFA vs. NYC," in Harbach, ed., *MFA vs. NYC*, 9–10.

89. Adler, *Artists in Offices*, 8.

90. Harold Wilensky, "The Professionalization of Everyone?" *American Journal of Sociology* 70 (1964): 137–58.

91. Ibid., 144.
92. Timothy Emlyn Jones, "The Studio-Art Doctorate in American," *Art Journal* 65, no. 2 (Summer 2006): 124–27.
93. Cited in Timothy Van Laar and Leonard Diepeveen, *Active Sights*, 25.
94. Singerman, *Art Subjects*, 175.
95. Van Laar and Diepeveen, *Active Sights*, 25.
96. Pierre Bourdieu, focusing on an earlier period in which separation from the French academy was necessary, underemphasizes the rise of the art school as an important structural factor that explains how contemporary art fields gain autonomy. I am grateful to Larissa Buchholz for emphasizing this point.
97. John Barth, *Further Fridays: Essays, Lectures, and Other Nonfiction, 1984–1994* (Boston: Little, Brown, 1995), 269, cited in Mark McGurl, *The Program Era: Postwar Fiction and the Rise of Creative Writing* (Cambridge, MA: Harvard University Press, 2009), 40.
98. Witham, *Art Schooled*, 250.

CHAPTER SIX

1. A. O. Scott, "The Paradox of Art as Work," *New York Times*, 11 May 2014, AR1.
2. Howard Singerman, *Art Subjects: Making Artists in the American University* (Berkeley: University of California Press, 1999).
3. This is an area in which location may have effects. Students in New York and Los Angeles may have greater connections and affiliations with a dealer-based market than those in regional centers, such as Chicago. Regional art programs are more insulated than those in artistic centers. As a result, the transition between school and market may be more stark, and students less prepared. This emphasizes the importance of place in this account. I thank Hannah Wohl for this insight.
4. Alison Gerber, "Art Work? Making Cents and Nonsense of Art," 2016, unpublished manuscript.
5. Kate Oakley, "From Bohemia to Britart: Art Students Over 50 Years." *Cultural Trends* 18, 2009, 281–94.
6. Viviana Zelizer, *The Purchase of Intimacy* (Princeton: Princeton University Press, 2005).
7. Noah Horowitz, *The Art of the Deal: Contemporary Art in a Global Financial Market* (Princeton: Princeton University Press, 2011); Richard Caves, *Creative Industries: Contracts Between Art and Commerce* (Cambridge, MA: Harvard University Press, 2000).
8. Pierre Bourdieu, *The Field of Cultural Production* (New York: Columbia University Press, 1993).
9. Ibid.
10. Richard Lloyd, *Neo-Bohemia: Art and Commerce in the Post-Industrial City* (New York: Routledge, 2010).

11. Pierre-Michel Menger, "Artistic Labor Markets and Careers," *Annual Review of Sociology* 25 (1999): 541–74, especially 566–69.

12. Ibid.

13. Diogo Pinheiro and Timothy Dowd, "All That Jazz: The Success of Jazz Musicians in Three Metropolitan Areas," *Poetics* 37 (2009): 490–506.

14. Alexandre Frenette, "Making the Intern Economy: Role and Career Challenges of the Music Industry Intern," *Work & Occupations* 40 (2013): 364–97.

15. Michael Baxandall, *Painting and Experience in Fifteenth Century Italy: A Primer in the Social History of Pictorial Style* (New York: Oxford University Press, 1973); Harrison White and Cynthia White, *Canvases and Careers: Institutional Change in the French Painting World* (New York: Wiley, 1965).

16. Olav Velthuis. *Talking Prices: Symbolic Meaning of Prices on the Market for Contemporary Art* (Princeton: Princeton University Press, 2005).

17. See Susan Jahoda, Blair Murphy, Vicky Virgin, and Caroline Woolard, "Artists Report Back: A National Study on the lives of Arts Graduates and Working Artists," 2014, http://BFAMFAPHD.com/#artists-report-back (accessed 17 November 2014).

18. Charlotte Burns and Pac Pobric, "Art School: Beyond the Reach of the 99%," *Art Newspaper*, 8 May 2014, http://www.theartnewspaper.com/arti cles/Art-school_beyond-the-reach-of-the-/32405 (accessed 27 May 2014). The authors find that the average wage for a craft and fine artist was $44,400 in 2012.

19. Because the 1,519 respondents (responding in 2011–13) graduated over the course of decades, the precise amount of debt is a function of inflation. Data made available by the Strategic National Arts Alumni Project; see http://www.snaap.indiana.edu/.

20. Quoted by Tim Tomlinson, "The MFA vs. the Portable MFA," in New York Writers Workshop, *The Portable MFA in Creative Writing* (New York: Writer's Digest Books, 2006), 1–10, quotation on 1.

21. Noah Bradley, "Don't Go to Art School," 26 June 2013, http://archive.con stantcontact.com/fs128/1102382269951/archive/1114524124147.html (accessed 2 September 2013).

22. Larry Witham points out that the Maryland Institute College of Art provides need-based scholarships for undergraduate students, but notes that colleges depend on federal loans. See *Art Schooled: A Year among Prodigies, Rebels, and Visionaries at a World-Class Art College* (Lebanon, NH: University Press of New England, 2012), 295.

23. As of 2014, graduate MFA tuition at SAIC was $44,010. In contrast, if an MFA student at Northwestern were to pay full tuition (none of them does), the cost would be $46,836.

24. Burns and Pobric, "Art School."

25. Howard Singerman, now on the faculty of Hunter College, emphasized the class structure of universities. He distinguished among MFAs at UCLA, USC,

and CalArts, with the larger number of students in the California State system. He noted about his own institution that it is considered a "local" institution, in contrast to the "national" Columbia, explaining that Hunter graduates provide much of the "infrastructure" of the New York art world (personal communication, 2014).

26. Robert Storr, Convocation Address, College Art Association, published 17 September 2013, http://www.collegeart.org/features/robertstorrconvation address (accessed 25 September 2013).

27. Gerber, "Art Work?" 21.

28. Alexandre Frenette and Steven Tepper, "What Difference Does It Make? Assessing the Effects of Art-Based Training on Career Pathways," in R. Comunian and A. Gilmore, eds., *Beyond the Campus: Higher Education and the Creative Economy* (New York: Routledge, 2016), 83–101, especially 90.

29. Perhaps the choice of labor has a certain romanticism attached to it. Being a construction worker may be more acceptable than being an accountant for the young artist. I am grateful to Amanda Anthony for this point.

30. Hans Abbing, *Why Are Artists Poor? The Exceptional Economy of the Arts* (Amsterdam: Amsterdam University Press, 2002), 346. But if artists continue for two years after graduation they tend to remain longer than those in other fields, even with low salaries.

31. Olav Velthuis uses the metaphor of "marriage" between dealer and artist.

32. Jeff Burton and Andrew Hultkrans, "Surf and Turf," *Artforum International* 36, no. 10 (Summer 1998): 106–13. The authors, writing about Los Angeles, quote faculty member Charles Ray as saying that if his students have not had a show or gallery representation by the time they have graduated, they are "losers." This was certainly not the case for the students that I observed in Chicago.

33. Kate Sierzputowski, "An Art Gallery on a Car," *Hyperallergic: Sensitive to Art and Its Discontents*, 1 May 2014, http://hyperallergic.com/123839/an-art -gallery-on-car/ (accessed 24 May 2014).

34. Larissa Buchholz, "The Global Rules of Art," Ph.D. diss., Columbia University, 2013.

35. Howardena Pindell, in Peter Nesbett and Sarah Andress, eds., *Letters to a Young Artist* (New York: Darte Publishing, 2008), 65.

36. Katherine Giuffre, "Sandpiles of Opportunity: Success in the Art World," *Social Forces* 77 (1999): 815–32.

37. Baxandall, *Painting and Experience in Fifteenth Century Italy*.

38. Svetlana Alpers, *Rembrandt's Enterprise: The Studio and the Market* (Chicago: University of Chicago Press, 1988).

39. White and White, *Canvases and Careers*.

40. Jason Foumberg, "Networking-ism," *New City*, 6 February 2014, 8.

41. Pedro Vélez, "Eye Exam: Friends Curating Friends," *New City, 2013,* http:// art.newcity.com/2013/02/05/eye-exam-friends-curating-friends/ (accessed 3 November 2014).

42. Lane Relyea, *Your Everyday Art World* (Cambridge, MA: MIT Press, 2013), vii.

43. Ibid., 14–15.

44. This is not so different from other disciplines, where being on the East Coast or near a major city can bestow reputational advantages from the networks surrounding the schools.

45. Martin's networks contributed to his being hired as a lecturer at the School of the Art Institute of Chicago.

46. Robert Witkin, "Constructing a Sociology for an Icon of Aesthetic Modernity: Olympia Revisited," *Sociological Theory* 15 (1997): 101–25, especially 103.

47. Samuel Shaw, "Scene Logics: Local Visibility in a Global Field," unpublished manuscript, 2013.

48. Gerber, "Art Work?" 38.

49. Similar claims were made about female chess players. See Gary Alan Fine, *Players and Pawns: How Chess Builds Community and Culture* (Chicago: University of Chicago Press, 2015).

50. Roger White, *The Contemporaries: Travels in the 21st Century Art World* (New York: Bloomsbury, 2015), 45.

51. Judith Adler, *Artists in Offices* (New Brunswick, NJ: Transaction, 1979), 137.

52. Ibid.

53. Robert Storr, in "Art Schools: A Group Crit," *Art in America*, May 2007, 99–113, quotation on 113.

54. James Elkins, *Why Art Cannot Be Taught* (Urbana: University of Illinois Press, 2001), 67.

55. The idea is found in the parable of the talents in the Gospel of Matthew (25:29) in the New Testament. The term was coined by Robert Merton, "The Matthew Effect in Science," *Science* 159 (1968): 56–63.

56. For this phenomenon see Judith Dobrzynski, "Why Does Contemporary Art Make for Wildly Popular Blockbusters?" 19 June 2017, https://aeon.co /ideas/why-does-contemporary-art-make-for-wildly-popular-blockbusters (accessed 3 July 2017).

57. Sierzputowski, "An Art Gallery on a Car."

58. Barry Schwabsky, "Agony and Ecstasy: The Art World Explained," *The Nation*, 1 December 2008, n.p.

59. Amanda Anthony and Amit Joshi, "(In)Authenticity Work: Constructing the Realm of Inauthenticity through Thomas Kinkade," *Journal of Consumer Culture* 17, no. 3 (2017): 752–53.

60. Elkins, *Why Art Cannot Be Taught*, 109.

61. Dave Hickey, in "Art Schools: A Group Crit," *Art in America*, May 2007, 99–113, quote on 106.

62. Deborah Solomon, "How to Succeed in Art," *New York Times*, 27 June 1999, available online at http://www.nytimes.com/1999/06/27/magazine/how-to -succeed-in-art.html (accessed 19 May 2012).

63. Adler, *Artists in Offices*, 10.

64. Jeff Burton and Andrew Hultkrans, "Surf and Turf," *Artforum International* 36, no. 10 (Summer 1998): 106–13.

65. D. G. Myers, *The Elephants Teach: Creative Writing since 1880* (Englewood Cliffs, NJ: Prentice-Hall, 1996), 5.

66. I often heard sarcastic resentment directed toward the university, certainly not unique to art programs. Tenure permits artists to attack their institution while maintaining their career. Biting the hand that feeds you is academic lunch.

67. Alison Gerber, "Making Cents and Nonsense of Art," 2013, unpublished manuscript. For creative writing, see Myers, *The Elephants Teach*, 6.

68. Gerber, "Making Cents and Nonsense of Art," 19.

69. Storr, Convocation Address.

70. Eric Fischl and Michael Stone, *Bad Boy: My Life On and Off the Canvas* (New York: Crown, 2012), 45.

71. Boris Groys, *Going Public* (New York: Sternberg Press, 2010), 59.

72. Sophia Krzys Acord, "Art Installation as Knowledge Assembly," in Tasos Zembylas, ed., *Knowledge and Artistic Practices* (London: Routledge, 2014), 151–65, especially 153.

73. Jordan Kantor, "Back to School: Jordan Kantor on Curatorial Returns to the Academy," *Artforum International* 45, no. 7 (March 2007): 129.

74. At the opening, many students dress up for the occasion. For this event that reflects two years of hard work, financial sacrifice, and social support, some students invite family and friends to attend.

75. Sophia Krzys Acord, "Beyond the Head: The Practical Work of Curating Contemporary Art," *Qualitative Sociology* 33 (2010): 447–67, especially 454.

76. Leslie King-Hammond, in "Art Schools: A Group Crit," *Art in America*, May 2007, 99–113, especially 104.

77. Adler, *Artists in Offices*, 140.

78. Pierre Bourdieu, *Distinction: A Social Critique of the Judgment of Taste* (Cambridge, MA: Harvard University Press, 1984), 175–76.

79. Sarah Thornton, *Seven Days in the Art World* (New York: W. W. Norton, 2008), 59.

80. Galleries are by no means identical. Some favor work that is oriented to a consumer market, and others choose work that is riskier, more edgy. Some galleries focus on established artists, some on those in mid-career, and some on those who are "emerging." In New York, this is sometimes spoken of as the distinction between uptown and downtown galleries.

81. Dave Hickey, in "Art Schools: A Group Crit," *Art in America*, May 2007, 99–113, quotation on 106.

82. Quoted by Howard Singerman, in "Art Schools: A Group Crit," *Art in America*, May 2007, 99–113, especially 101.

83. Data from the Strategic National Arts Alumni Project from respondents who received MFA degrees in visual arts, responses collected from 2011 to 2013

(respondents may have graduated in any year). See http://www.snaap.in
diana.edu/.

84. David Halle, *Inside Culture* (Chicago: University of Chicago Press, 1993);
Gary Alan Fine, *Everyday Genius: Self-Taught Art and the Culture of Authen-
ticity* (Chicago: University of Chicago Press, 2004). Hannah Wohl (personal
communication, 2016) notes that upper-echelon gallerists distinguish be-
tween buyers and collectors. The latter purchases works based on their eco-
nomic and art-historical valuation; the former, for their visual appeal. The
common usage of the terms overlaps, and I have used the label "collector"
in this chapter and throughout the book.

85. Elizabeth Murray, in Nesbett and Andress, eds., *Letters to a Young Artist*, 23.

86. Relyea, *Your Everyday Art World*, 36.

87. Menger, "Artistic Labor Markets and Careers," 570.

88. Abbing, *Why Are Artists Poor?* 84–85.

89. Anonymous, "A Note to the Reader from the Young Artist," in Nesbett and
Andress, eds., *Letters to a Young Artist*, 9–10, especially 9.

90. Luc Boltanski and Laurent Thévenot, *On Justification: Economies of Worth*
(Princeton: Princeton University Press, 2006).

91. Howard S. Becker, *Art Worlds* (Berkeley: University of California Press, 1982).

92. Raymonde Moulin and Alain Quemin, "La certification de la valeur de l'art:
Experts et expertises," *Annales ESC* 6 (1993): 1421–45.

CHAPTER SEVEN

1. The classic sociological statement that doubts the ideology of genius is
Howard Becker, *Art Worlds* (Berkeley: University of California Press, 1982).

2. Thomas Gieryn, "Three Truth-Spots," *Journal of the History of the Behavioral
Sciences* 38 (2002): 113–32.

3. Theater and music programs may be more like visual arts programs in this
regard.

4. Howard Becker, "Arts and Crafts," *American Journal of Sociology* 83 (1978):
863–89.

5. Gabriel Abend, "The Meaning of 'Theory,'" *Sociological Theory* 26 (2008):
173–99.

6. Ludwig Fleck, *Genesis and Development of a Scientific Fact* (Chicago: Univer-
sity of Chicago Press, 2001).

7. Dissertation defenses are technically public, but few outsiders attend. Some
schools have private art critiques, made up of relevant faculty and a single
student, a model closer to the standard university model of the thesis de-
fense, found at Northwestern in the spring quarter or at Illinois State when
a student meets with the faculty members in her area of practice.

8. Daphne Demetry, Jessica Thurk, and Gary Alan Fine, "Strategic Poverty: How
Social and Cultural Capital Shapes Low-Income Life," *Journal of Consumer
Culture* 15 (2015): 86–109.

9. Richard Lloyd, *Neo-Bohemia: Art and Commerce in the Post-Industrial City* (New York: Routledge, 2010); Daniel Silver, Terry Clark, and Clemente Jesus Navarro Yanez, "Scenes: Social Context in an Age of Contingency," *Social Forces* 88 (2010), 2293–324.

10. Lane Relyea, a prominent art critic, at Northwestern is a notable exception and served as department chair.

Index

Abramović, Marina, 81
abstraction, xiv, 69, 154
academization. *See under* art
Acconcj, Vito, 81
actants, 66, 111
aesthetic citizens, 12, 231
aesthetics. *See* beauty
alcohol. *See* drinking
American Community Survey, 3
Anderson, Laurie, 83
art: academization of, 2–5, 6, 7, 10,
42, 45, 54–55, 104, 106, 135,
159, 182–87, 192, 207, 222,
230–31, 234n5, 235n15; as
action, 66; appropriation in, 84;
canon of, 92–93; civic pleasure
and, 1; as commodity, 66; com-
munity and, 70, 116, 154, 159,
167, 220; conflict in, 107; craft
tradition of, 44–45; as discipline
(*see* discipline); discourse in,
103, 108, 116–22, 126, 130,
155–59; divinity of, 1; emotion
of, 115–16; exhibition of, 65;
formalism of, 145; history and
memory in, 93–95, 101–2; and
human spirit, xi; intellectual
engagement in, 4; as invest-
ment, 217; meaning of, 70, 108,
110, 111–13, 232; as occupa-
tion, 4, 42 (*see also* discipline);
personal significance of, xiv,
xv, 18–19, 22, 32, 36, 40, 41,
79, 83, 98–100, 102; persuasion
and, 116; as philosophy, xvii;

politics and, xvii, 131–35, 136,
158, 174; professionalism of,
xi, 3, 70, 106, 136, 159, 163,
183, 205, 218, 247n7; quality
of, 161; research and, 134; as
scene, 167–69, 200; in series,
73; title of, 154; tools and, 49,
54, 57, 128; tradition and,
10; trash and, 53; value of,
67–68, 191
art academies, 55–56, 185
art history, 11, 89–92
artists: audiences for, 190–91, 204–
5, 217, 221; becoming, xi, xvii,
16, 18–19, 21–22, 36, 40, 42,
66, 220, 221; "brand" of, 73; as
bureaucrats, 182–83; as culture
shapers, xi; community and
culture of, 41, 113, 139, 163,
171–72, 204, 227; definition of,
67, 82, 164; deviance of, 174–
77, 227; diversity of, xv, 227;
early education of, 3, 12; as
entrepreneurs, 46; explanation
of work by, 110–11; failure of,
9; and genius, 220; individual-
ity of, 69; intentions of, 3, 11,
21, 41, 46, 47, 54, 87, 105, 111,
153–59, 160, 161; laziness of,
48–49; political views of, xv, 2;
speed of production by, 47–48,
239n10; as students, 92; turn-
ing points in development of,
20; as workers, 44, 48–49; writ-
ing skills of, 122–24, 251n61